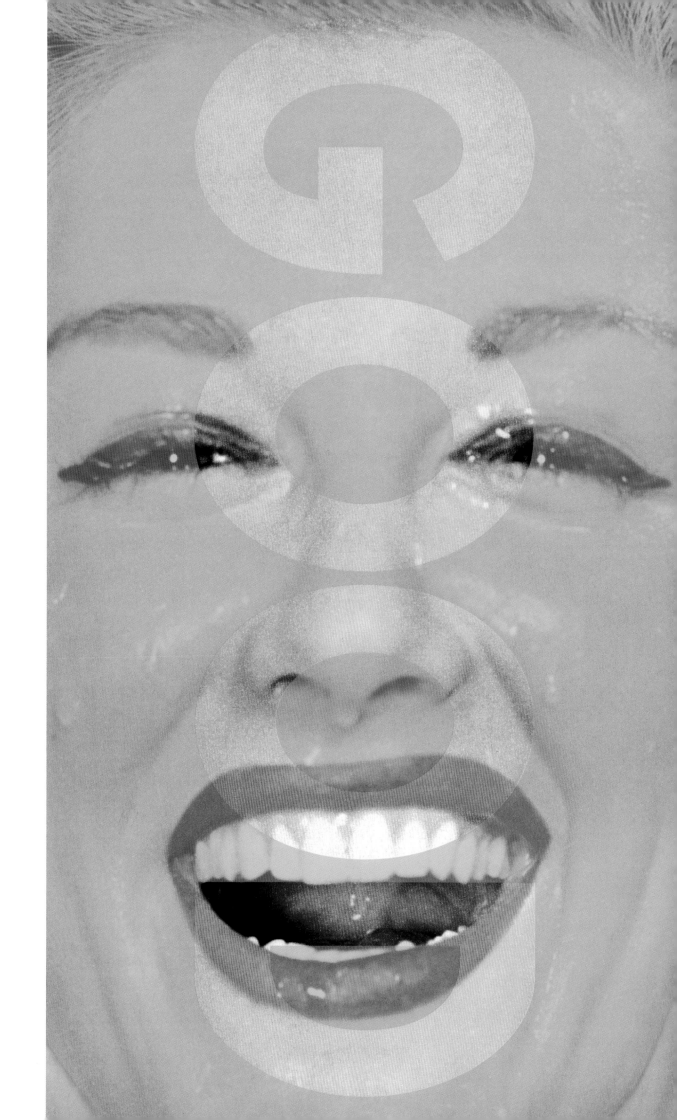

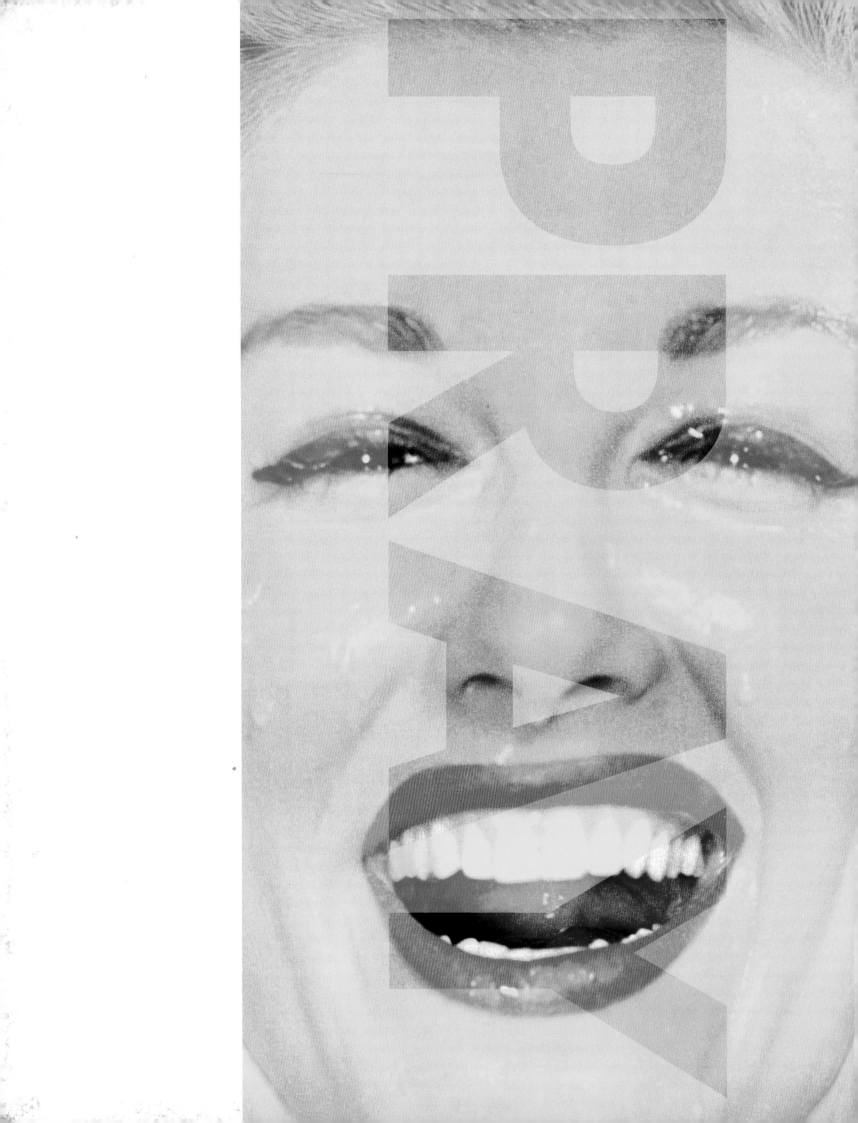

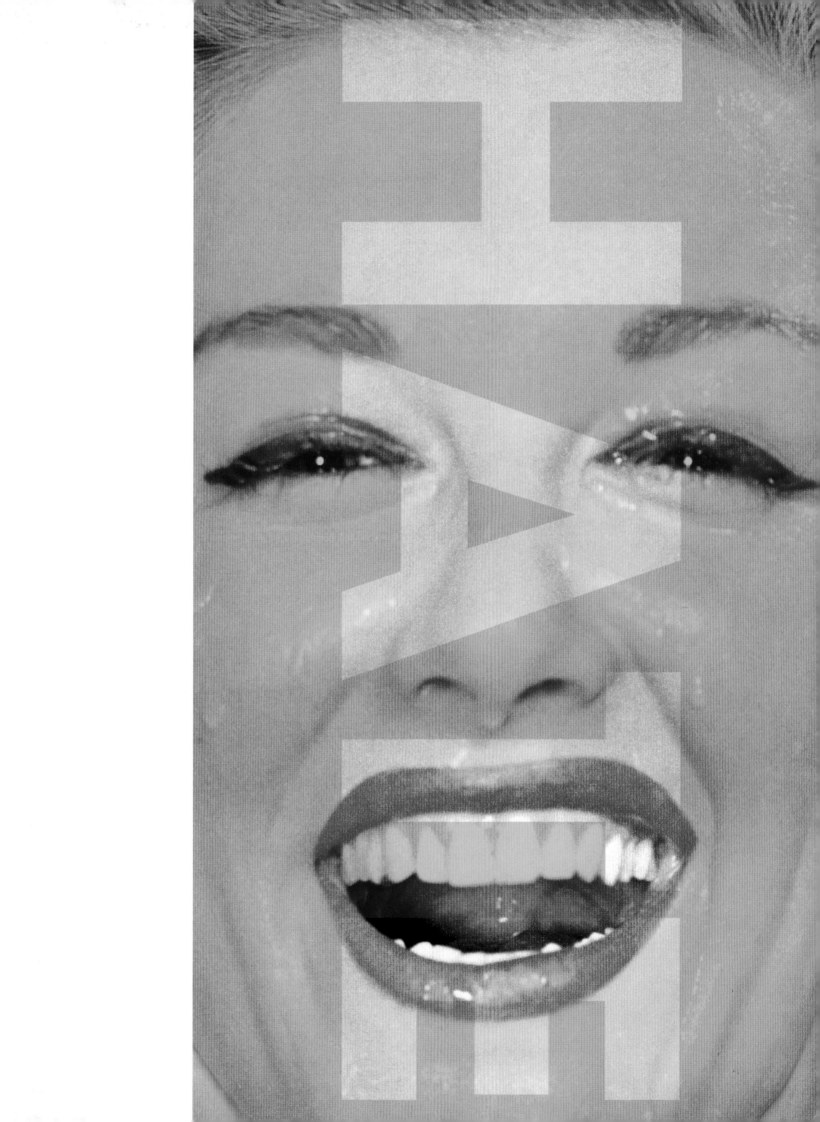

BARBARA KRUGER

By ALEXANDER ALBERRO, MARTHA GEVER, MIWON KWON, and CAROL SQUIERS

Introduction by HAL FOSTER

With additional essays by BARBARA KRUGER

RIZZOLI
NEW YORK

New York · Paris · London · Milan

First published in the United States of America in 2010
by Rizzoli International Publications, Inc.
300 Park Avenue South
New York, NY 10010
www.rizzoliusa.com

Publication © 2010 Rizzoli International Publications, Inc.
All images © Barbara Kruger
Seriously Playful © 2010 Hal Foster
A Message from Barbara Kruger: Empathy Can Change the World
© 2010 Miwon Kwon
Like TV: On Barbara Kruger's Twelve © 2007 Martha Gever.
Reprinted by permission of the author and the College Art
Association.
Picturing Relations: Images, Text, and Social Engagement
© 2010 Alexander Alberro
Barbara Kruger at Mademoiselle © 2010 Carol Squiers
Irony/Passion and *Utopia: The Promise of Fashion When Time
Stands Still* © 1979 Barbara Kruger. Reprinted with permission
from *Remote Control: Power, Cultures, and the World of
Appearances*, published by The MIT Press.
Work and Money © 1981 Barbara Kruger. Reprinted with
permission from *Remote Control: Power, Cultures, and the
World of Appearances*, published by The MIT Press.
Decadism © 2004 Barbara Kruger. Reprinted with permission
from *Money Talks*, published by Skarstedt Fine Art.

DESIGNED BY Lorraine Wild, Jennifer Rider, and Victoria Lam,
Green Dragon Office, Los Angeles

PHOTOGRAPHY CREDITS
All artwork © Barbara Kruger. Pages 1–10: Courtesy Sprüth
Magers, London; 21–26, 152–55: Photography © Frederik Nilsen;
28–31, 69, 116–20, 129, 188–89, 210–11, 233: Courtesy of the artist
and Mary Boone Gallery; 56–57: Courtesy Wexner Center for
the Arts, The Ohio State University, Columbus, Ohio; 46, left:
Photo by Timothy P. Karr; 46, right, 68 all, 78 bottom: Public
Art Fund, Inc., New York; 48–49, 51 bottom: Photo by Marian
Harders; 52: Photo by Dorothy Zeidman; 57: Photo by Aleece
Dimas; 70–71: © Gene Ogami; 76–77 © Oren Slor, 1988; 82–83:
© Gerald F. Jones, Atlanta; 142–47: © Jesse David Harris; 156–57:
© 2008 Philip Scholz Rittermann; 162–63: © Barbara Kruger
and Kestnergesellschaft; 164–69: Photo © Ruth Clark, 2005;
174–75: © Sprüth Magers Lee, London; 186–87, 190, 206–9:
Photo by Zindman/Fremont; 218–19: Photos by Mali Olatunji;
220, top, 221: © Mary Heitner; 222–23: Photos © Paula Court;
236–39, 243, 246–48: Photos by Brian Forrest; 240: Photography
by Inez van Lamsweerde and Vinoodh Matadin; pp. 294–95:
Courtesy Skarstedt Fine Art.

Distributed to the U.S. trade by Random House, Inc.

First edition

2010 2011 2012 2013 2014 / 10 9 8 7 6 5 4 3 2 1
ISI ': 978-0-8478-3325-2

Library of Congress Control Number: 2009939884

Printed in China

Works appearing on pages 1–10: **UNTITLED (GOOD)**, **UNTITLED (PRAY)**,
UNTITLED (HATE), **UNTITLED (HELP)**, **UNTITLED (ENVY)**, **UNTITLED (FATE)**,
UNTITLED (FEAR), **UNTITLED (EVIL)**, **UNTITLED (LUST)**, **UNTITLED (LOVE)**,
2001.

MAY 0 5 2010

CONTENTS

ACKNOWLEDGMENTS

I would like to thank Chip Leavitt and Lara Leavitt of Lumiere. For more than two decades Chip has shared his great skills, acuity, and commitment, which, along with Lara's kindness and good humor, have made them a pivotal part of my production and a pleasure to work with. I wish to extend special thanks to Ron Warren of Mary Boone Gallery for his many efforts on this book's behalf. I would also like to thank Lorraine Wild of Green Dragon Office for her brilliance and friendship, both of which were invaluable in realizing this book, along with the talents of Jennifer Rider and Victoria Lam. I also want to thank Julie Di Filippo at Rizzoli for her visual understanding and much appreciated patience. And lastly, but most certainly, Charles Miers, at Rizzoli, whose unwavering support of my work has made this book possible. —BARBARA KRUGER

HAL FOSTER

Seriously Playful

FOR MORE THAN THREE DECADES Barbara Kruger has produced a provocative body of work, cracking open her appropriated images with her invented texts, hoisting the everyday assumptions of contemporary society on its own petards. She has done this creatively critical work at every scale, from matchbook covers to giant billboards, and across many media, from simple photomontages to complex screen-and-audio installations. Always alert to questions of audience and address, Kruger forever seeks new ways to push her practice into the public realm, drawing political debate into art and vice versa.

For some viewers this has made Kruger too political: we know her positions, this line goes; they are feminist and anti-capitalist in a way that advances little more than her own version of knowing better and living otherwise. For others Kruger is not political enough: according to this argument, her work, informed by her early experience as a graphic designer (for *Mademoiselle* and other publications), is in bed with the sexist consumerism it claims to challenge, and so not feminist and anti-capitalist at all. Of course both takes are only that—reflex reactions that let us off easy, that allow us not to look, read, and think further—and they miss the point.

In fact, if there is a consistent motive in Kruger, it is to question any assumed authority, to suspect any univocal position; and if there is a consistent method, it is to proceed by implication in the strongest sense—to trace the ties to capital, power, words, and images that bind us all. To be sure, Kruger is critical, but hers is a critique that does not pretend to stand apart, outside of marketplace or ideology, love or war. On the contrary, she has done more than any artist to alert us to the extended reach of these things in our everyday lives. "Outside the market there is nothing," Kruger remarked in 1987 with her characteristic mix of insight and wit, "not a piece of lint, a cardigan, a coffee table, a human being."[1] "There's a politic in every conversation we have," she added in 1990, "every deal we make, every face we kiss."[2] This worldview is not defeatist, as is sometimes charged; it is lucid. And the work that rises from it is not aridly conceptual, as is often claimed; Kruger is emphatically visual. Far from opposed to seduction, her art calls not only for new sorts of pleasure but also for new subjects for them.

—————— **1** ——————
Barbara Kruger quoted in Carol Squiers, "Diversionary (Syn)tactics: Barbara Kruger Has Her Way with Words," *ARTnews* 86 (February 1987), 84.

—————— **2** ——————
Barbara Kruger, *Remote Control: Power, Cultures, and the World of Appearances* (Cambridge, MA: MIT Press, 1993), 6; all other references to this volume are included in the text.

"To question the seemingly natural appearance of images through the textual commentary which accompanies them" (218): this is how Kruger described her practice in 1981, and it remains true, though she has always questioned language, too, turning round on it as well. As Craig Owens demonstrated brilliantly, Kruger transforms stereotypes into "apotropes," that is, images that betray the mission of the stereotype to arrest the viewer, to suspend us with its "Medusan gaze."[3] And she does much the same thing with language, where the cliché is turned against its own imperative to stun our thinking, to keep it obedient and rote. Although her art is one of striking declarations (Kruger calls her method "direct address"), it is equally one of troubling paradoxes: she catches language out as it attempts to beguile us. More than any other artist, Kruger toils in words and images as Roland Barthes once defined them—"an immense halo of implications, of effects, of echoes, of turns, returns, and degrees"—and, accordingly, her practice highlights "the desires, the fears, the appearances, the intimidations, the advances, the blandishments, the protests, the excuses, the aggressions, the various kinds of music out of which active language is made."[4]

The fact that Kruger uses "active language" is central to the purpose of her art, which is to trouble "common sense" (especially regarding gender), as well as to its legibility, which allows this troubling to be felt by all. Key here is her strategy of mimicry, which Kruger has made as important for feminist art as Homi Bhabha has for postcolonial discourse. "We are very good mimics," she wrote in a 1982 statement. "We replicate certain words and pictures and watch them stray from or coincide with your notions of fact and fiction" (216). This mimicry is undertaken not only to foil particular expectations of male viewers, but also "to welcome a female spectator into the audience of men" (220).

Does this sound too theoretical? It did to her early detractors. Kruger emerged in a heady time for critical theory, to be sure, and her criticism, like her art, attests to her involvement with different thinkers. For example, when she writes of history as "a univocal voice-over, an instructor of origin, power, and mastery" (12), we hear an echo of Walter Benjamin; when she speaks of "a culture ruled by images" that places us "elsewhere, not in the real but in the represented" (97, 5), we are reminded of the Situationist critique of spectacle; and her frequent cautions about the web of "power" in everyday life call to mind the writings of Michel Foucault.

————————— 3 —————————
See Craig Owens, "The Medusa Effect, or, The Specular Ruse," *Beyond Recognition: Representation, Power, and Culture* (Berkeley: University of California Press, 1992).
————————— 4 —————————
Roland Barthes, "Lecture," *October*, no. 11 (Spring 1979): 7, 11.

Projected as abstractions, "mastery," "spectacle," and "power" can appear so total as to produce a sense of helplessness, and Kruger is not immune to this effect ("We are clasped in a relentless tango of remote controllings" [47], she writes of television). Yet Kruger also insists that we can "decline" the subject-positions assigned to us by custom and capital, and that we can choose to be open to histories of discontinuity "and, one might add, difference" (13). Moreover, she always gives a feminist turn to critical theory: for example, her emphatic questioning of binary thinking evokes Jacques Derrida, but his deconstruction is revised with a feminist eye to sexual difference. And her points have a street-smart purchase that all these theorists lack. The upshot is that Kruger is as keen a critic of the language of lived patriarchy as we have.

"The richness and complexity of theory should periodically break through the moats of academia," Kruger wrote in 1992, "and enter the public discourse via a kind of powerfully pleasurable language of pictures, words, sounds, and structures" (223). She has acted on this mandate not only in her art but also in her writing, pushing wide her range of fields (fine arts, popular culture, movies, television . . .), subjects (Yvonne Rainer, Chantal Ackerman, Andy Warhol, Samuel Fuller, Howard Stern . . .), and venues (*Artforum*, *Village Voice*, *Esquire*, the *New York Times* . . .). Her ethic of pleasure is as strong as her commitment to discourse. In 1991 Kruger reframed "esthetic emotion" as "a showing and telling as it is" but retained its old sense, too, as "a kind of 'felt' moment, a visual resonance," and concluded: "I think I could go for that esthetic. I think I could second that emotion"(9). Here she not only departs from the suspicion, in early feminist theory, of the image as mere vehicle of male desire, but also anticipates the concern, in contemporary discourse, with the political valence of affect.[5] First and last Kruger has advocated the pleasure of interruption—in particular that of "the muteness of picturing [interrupted] with a seriously playful display of language" (97). Her visual voice is not super-egoic, but it is conscientious, and I am very grateful to have had her seriously playful display before my eyes and in my head for the last thirty years.

[5]

For example, early on Kruger was alert to the way, in the electronic age, that "narrative has leaped from the page to the screen," and that "truth has been splintered into an aerosol of demi-articulate self-interest which recomposes not into language, but into picture" (*Remote Control*, 7, 229).

PLENTY, 2008. Video billboard at 8410 West Sunset Boulevard.
Women in the City, West of Rome public art project, West Hollywood, Los Angeles.

(22–23)
PLENTY, video details.

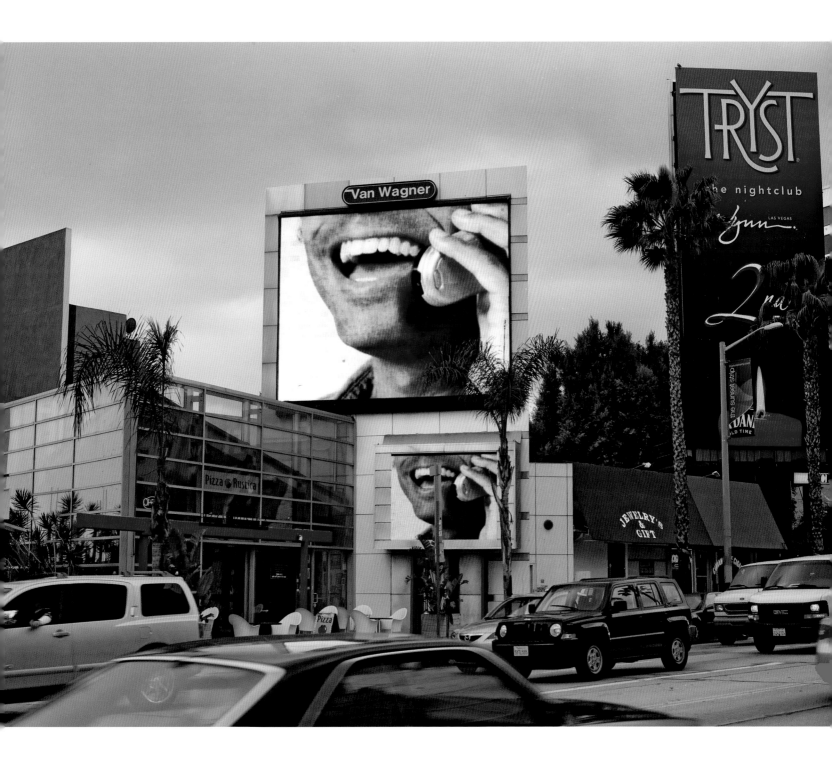

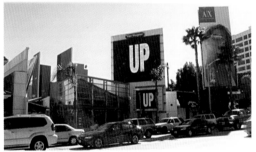
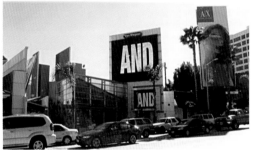
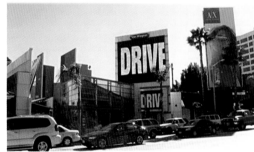
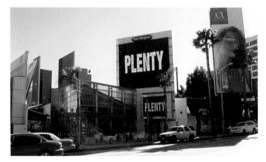
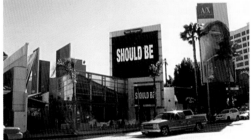
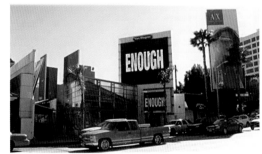
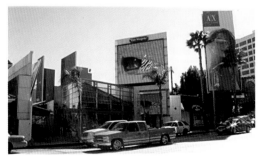
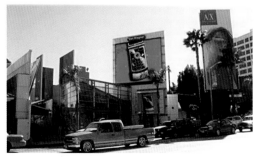

PLENTY, 2008. Video billboard at 9039 Sunset Boulevard (Key Club).
Women in the City, West of Rome public art project, West Hollywood, Los Angeles.

24

PLENTY, 2008. Video billboard on the top tier of LACMA West, visible from Fairfax Avenue at 6th Street. *Women in the City*, West of Rome public art project, Los Angeles.

UNTITLED (IN VIOLENCE), 2008. Photographic digital print on vinyl. *People Weekly* exhibition, James Gallery, CUNY Graduate Center, New York City, October 2, 2008–February 28, 2009.

UNTITLED (THE SECRET OF THE DEMAGOGUE), 2008. Photographic digital print on vinyl. *People Weekly* exhibition, James Gallery, CUNY Graduate Center, New York City, October 2, 2008–February 28, 2009.

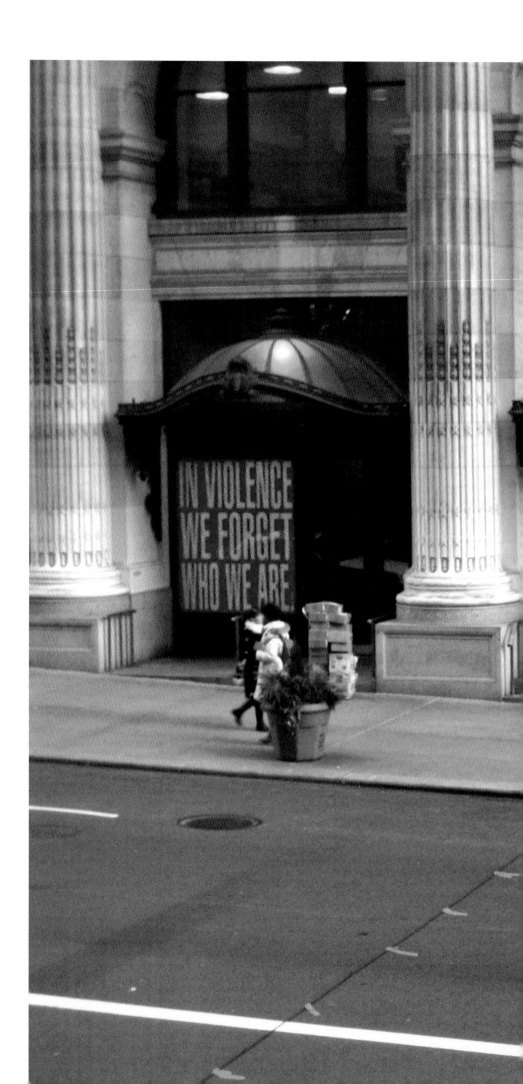

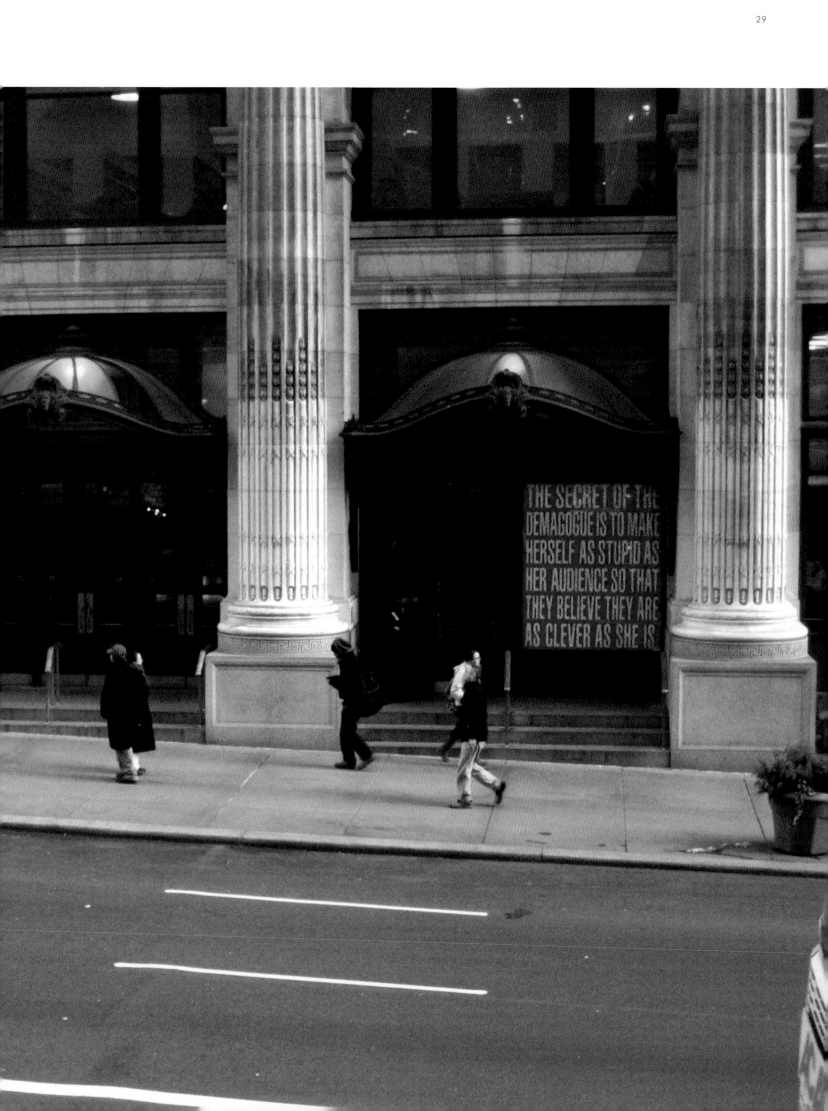

UNTITLED (IN VIOLENCE), 2008. Digital video, 20 seconds.
People Weekly exhibition, James Gallery, CUNY Graduate Center,
New York City, October 2, 2008–February 28, 2009.

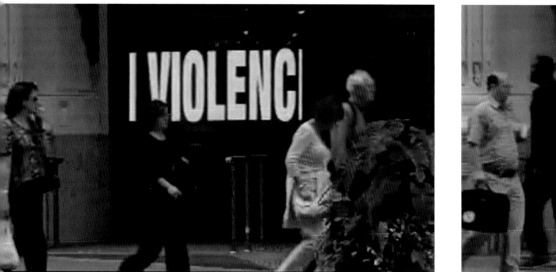

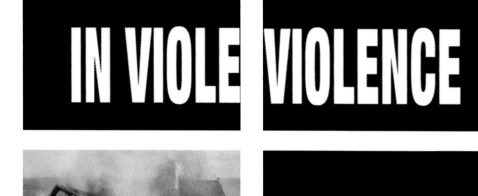

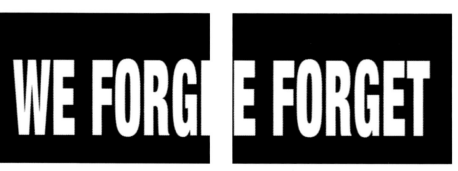

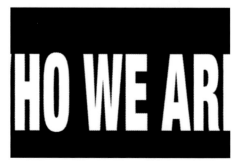

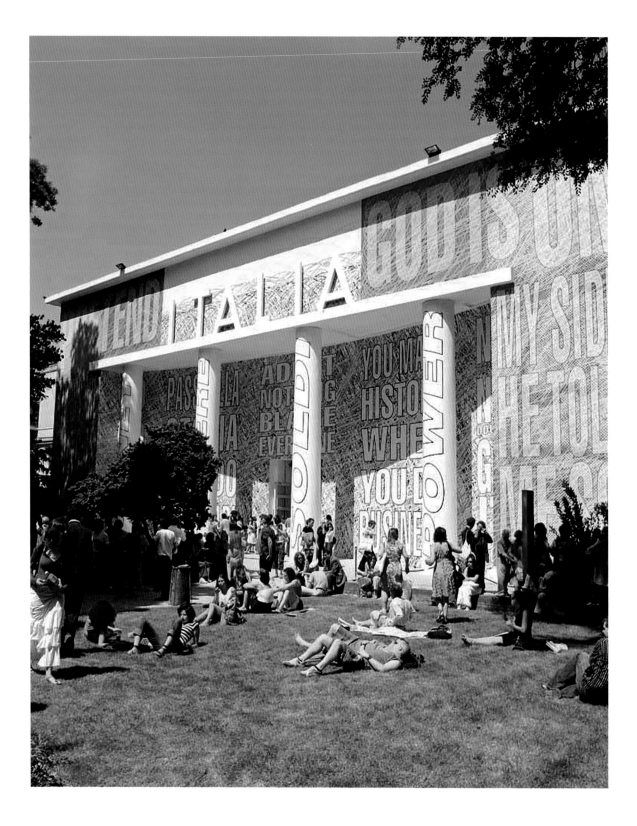

UNTITLED (**FACADE**), 2005. *The Experience of Art*,
Italian Pavilion, 51st Venice Biennale, Venice, Italy.

(34–37)
Designs for the Italian Pavilion, 51st Venice Biennale, Venice, Italy, 2005.

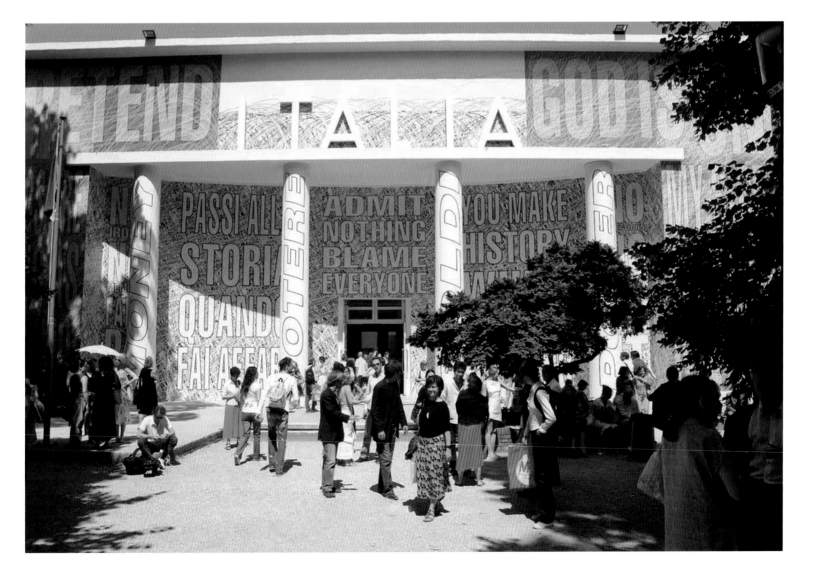

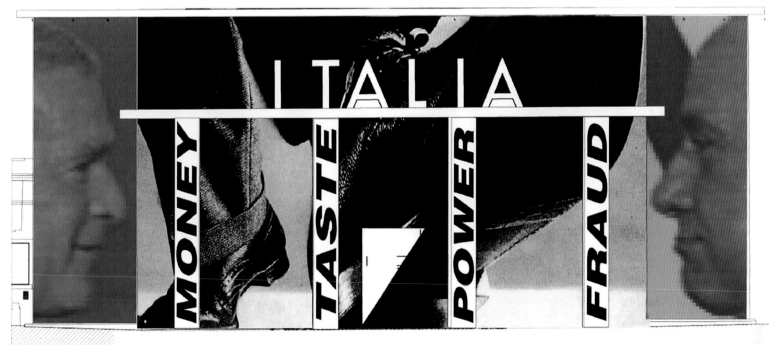

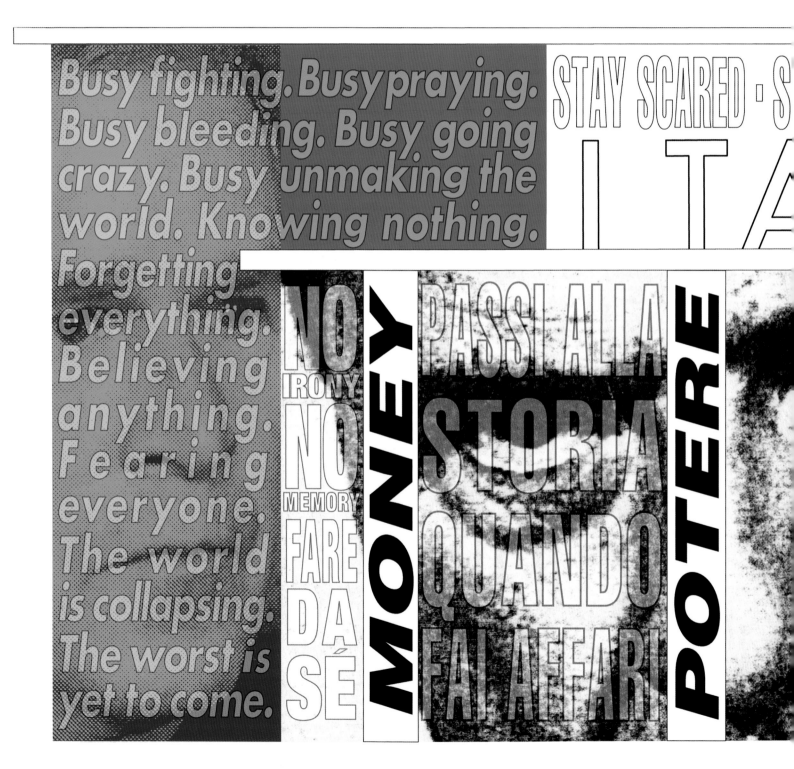

Busy fighting. Busy praying. Busy bleeding. Busy going crazy. Busy unmaking the world. Knowing nothing. Forgetting everything. Believing anything. Fearing everyone. The world is collapsing. The worst is yet to come.

STAY SCARED · S

I TA

NO IRONY NO MEMORY

FARE DA SÉ

MONEY

PASSI ALLA STORIA QUANDO FAI AFFARI

POTERE

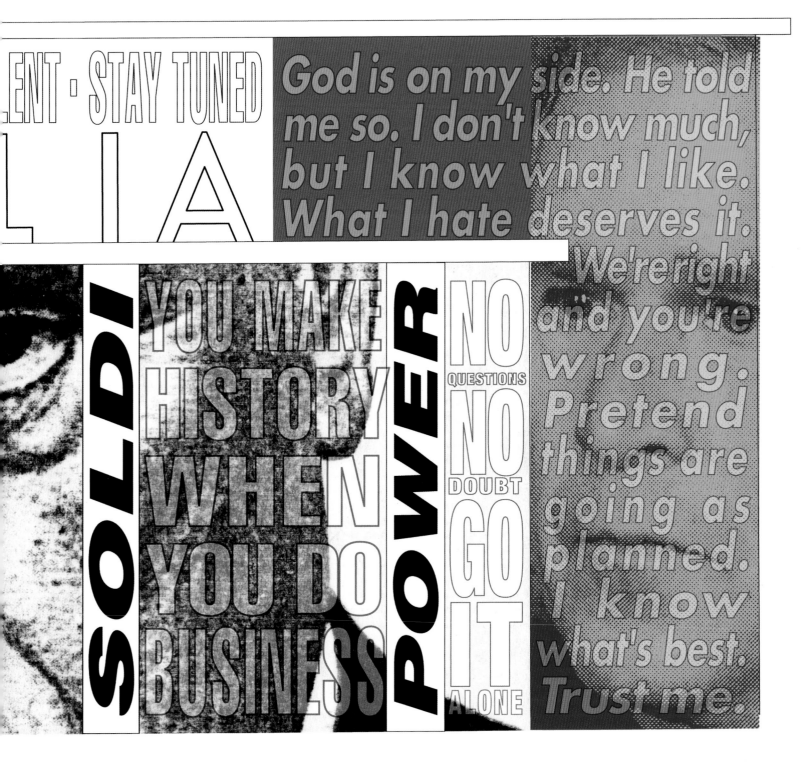

ENT · STAY TUNED
LIA

God is on my side. He told me so. I don't know much, but I know what I like. What I hate deserves it. We're right and you're wrong. Pretend things are going as planned. I know what's best. Trust me.

SOLD!

YOU MAKE HISTORY WHEN YOU DO BUSINESS

POWER

NO QUESTIONS
NO DOUBT
GO IT ALONE

SHOPPING, 2002. Schirn Kunsthalle/Kaufhof Department Store Facade, Frankfurt am Main, Germany.

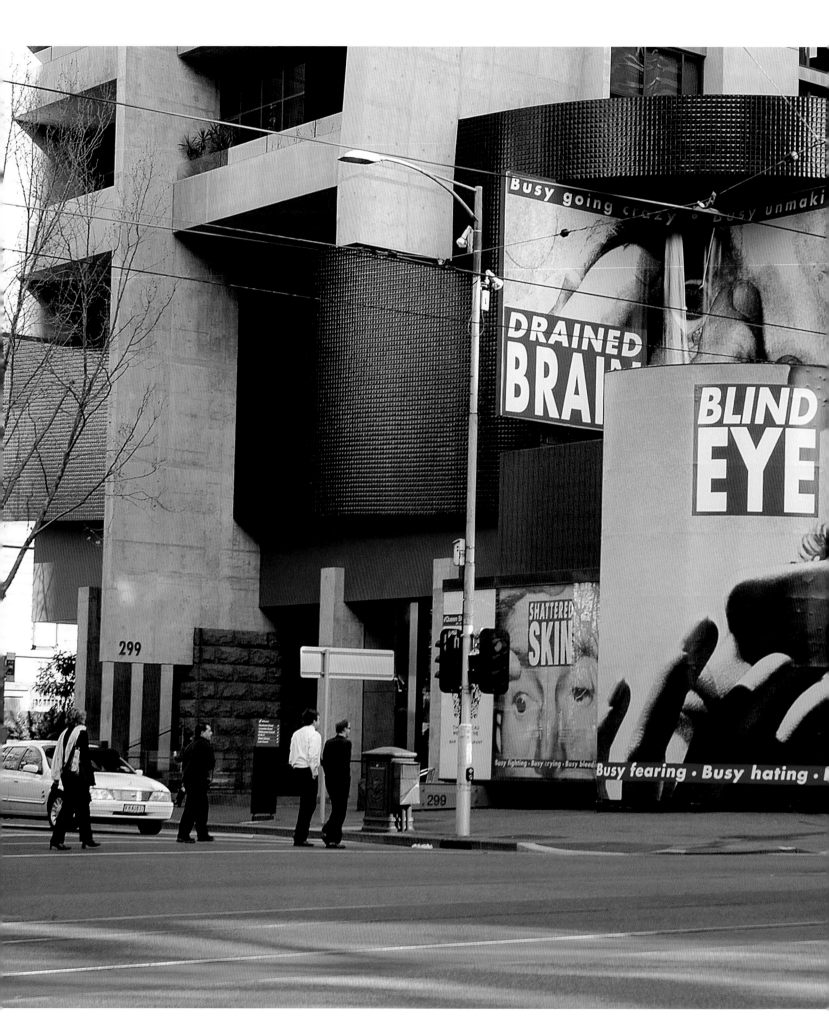

IT'S A SMALL WORLD BUT NOT IF YOU HAVE TO CLEAN IT, 2000.
Poster project, Public Art Fund, New York City.

43

Floor mosaics, 1998. Fisher College of Business.
The Ohio State University, Columbus, Ohio.

HELP!, January–March 1991. Bus shelter project, Public Art Fund, Queens, New York City.

46

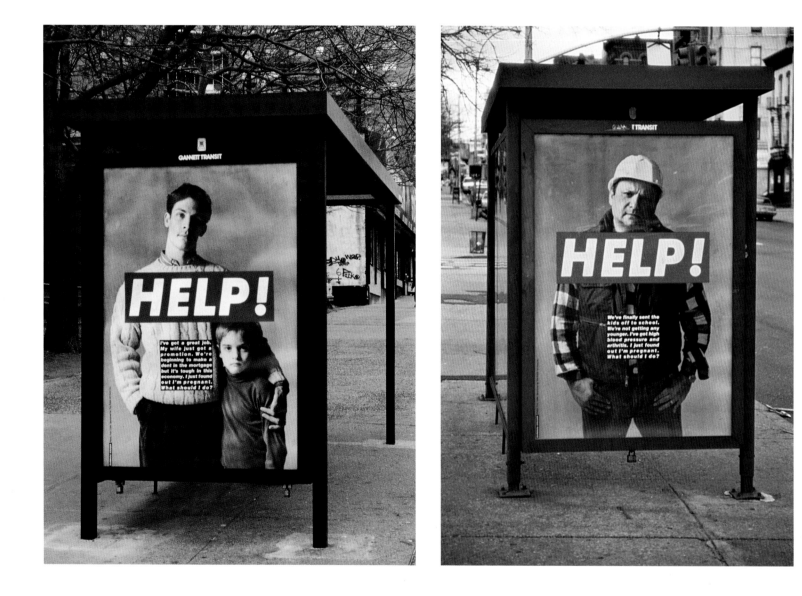

HELP!

Graduation is coming and I've got a good job lined up. I want to get my life together. But my girlfriend is seeing other guys and I just found out I'm pregnant. What should I do?

Bus wrap, November 1–30, 1997. Public Art Fund, New York City.

48

(top) Bus wrap designs, 1997. Public Art Fund, New York City.

(below) Bus wrap, 2002. Palazzo delle Papesse, Siena, Italy.

(opposite, bottom) Bus wrap, November 1–30, 1997. Public Art Fund, New York City.

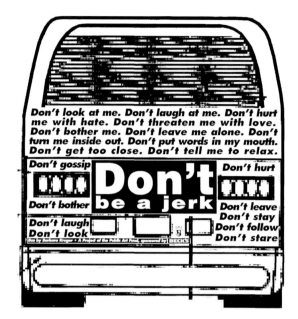

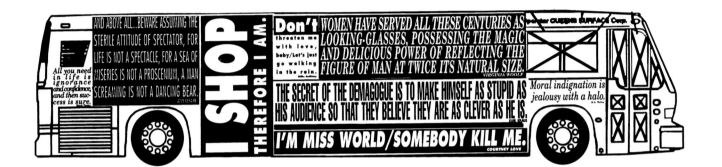

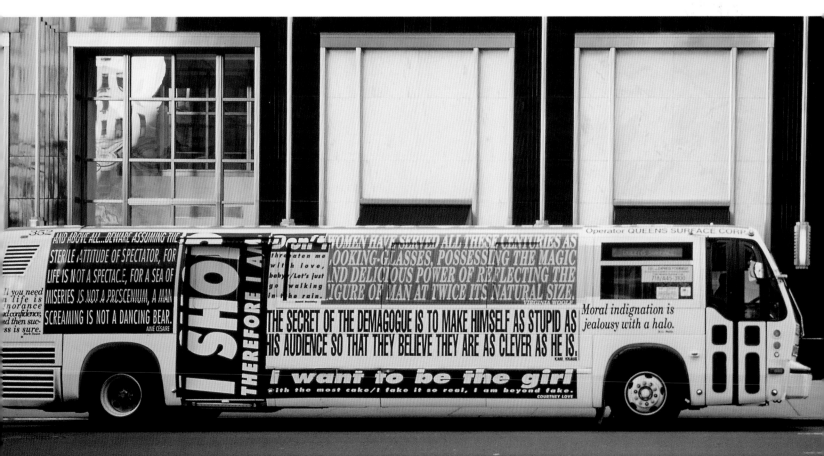

YOU BELONG HERE, 1998. Front view of site-specific installation, Parrish Art Museum, Southampton, New York, July 19–September 6, 1998.

52

You are re
and deciding
irony or pass
it is irony. You th
a distancing me
you can escape co
You don't belabor t
know that irony is rife
lucky this isn't passion, be
You only employ the declara
neutralize information through displa
want. You know how to locate and stroke a
You are a child of inheritance but prefer not to disc
You live in a bad neighborhood but it feels good to yo
material. You bypass the correlations between sexuality, calls
aware that saying, naming, and pointing are the handiest forms of appropriation.

ading this

whether it is

on. You think

k it is exercising

anism. You think

ification. You can't.

point, because you

ith forgiveness. You are

use passion never forgets.

in a parodistic context. You

You do what you can to get what you

ency. You are aware of obligatory concerns.

. You sometimes act like you're not a professional.

think violence provides interesting visual and textual

, race, property, style, fear, duty, authority, and power. You are

Work and Money

Whether rendered by hand or caught by camera, a picture is never opaque. To say that it is, to speak of a mysterious evocativeness, results in just another promotional mystification. We see an image and we start guessing meanings. We can embroider stories or supposed narratives. Photography's ability to replicate, its suggestion of evidence and claim to "truth" point to its problematic powers but also suggest a secular art which can connect the allowances of anthropology with the intimacies of a cottage industry. It is a trace of both action and comment. In my work I try to question the seemingly natural appearance of images through the textual commentary that accompanies them. This work doesn't suggest contemplation: it initially appears forthright and accessible. Its commentary is both implicit and explicit, engaging questions of definition, power, expectation, and sexual difference. Some of us, with one or two feet in the "art world," might think that our work is all cut out for us, while others are interested in changing the pattern and defining different procedures. Many of us also work in areas outside of our art production. Whether out of necessity or adventure, we are at the same time secretaries, paste-up people, billing clerks, carpenters, and teachers. At times our jobs inform our work and vice versa. For instance, teaching, which is a collective process within the hierarchies of education and academia, intervenes in the production of cultural work. Art schools reproduce artists and, in turn, art. It's all work. And most people work for money. But unlike laborers who sell moments of their lives for a short reprieve at the end (the awaited or dreaded retirement), artists buy work time with job money. Of course, whether this routine is really necessary depends on the good or bad fortune of your fortune: whether you must really work for your money or are merely waiting to inherit it. Money talks. It starts rumors about careers and complicity and speaks of the tragedies and triumphs of our social lives. It makes art. It determines who we fuck and where we do it, what food we eat, whether we are cured or die, and what kind of shoes we wear. On both an emotional and economic level, images can make us rich or poor. I'm interested in work which addresses that power and engages both our criticality and our dreams of affirmation.

Backdrop design for Rage Against The Machine tour, 1997.

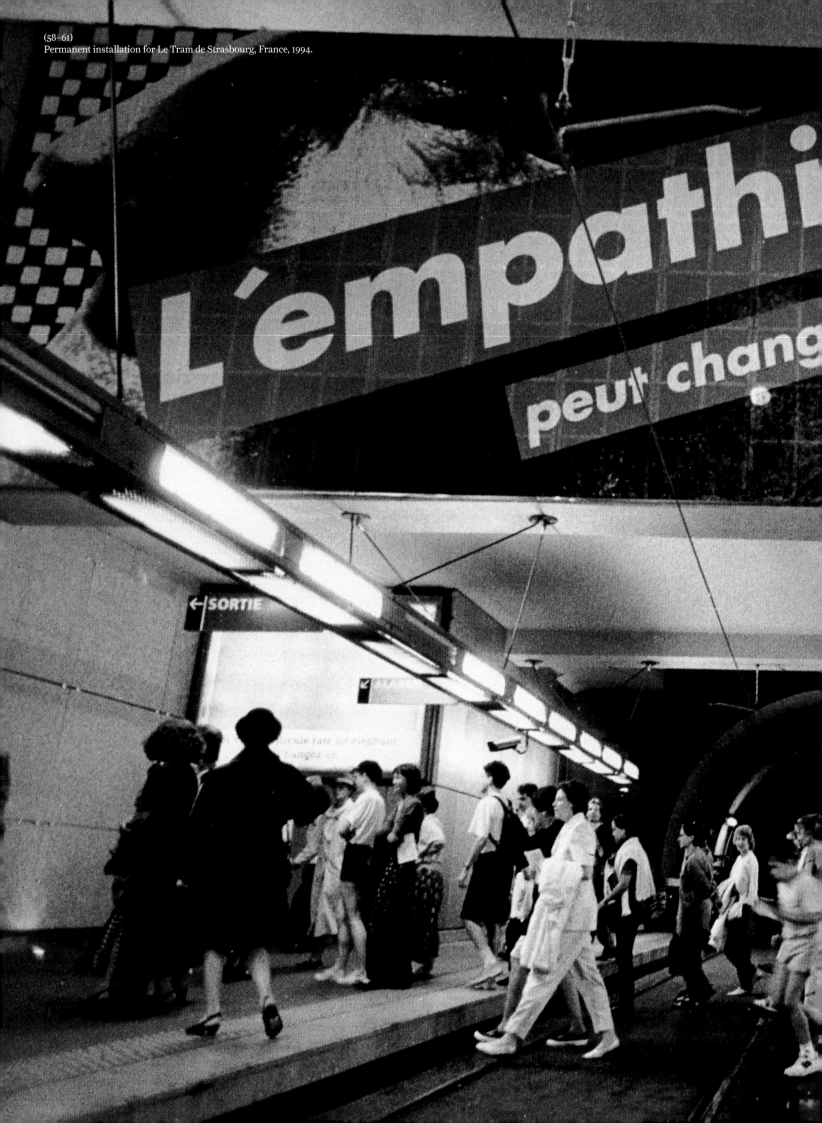

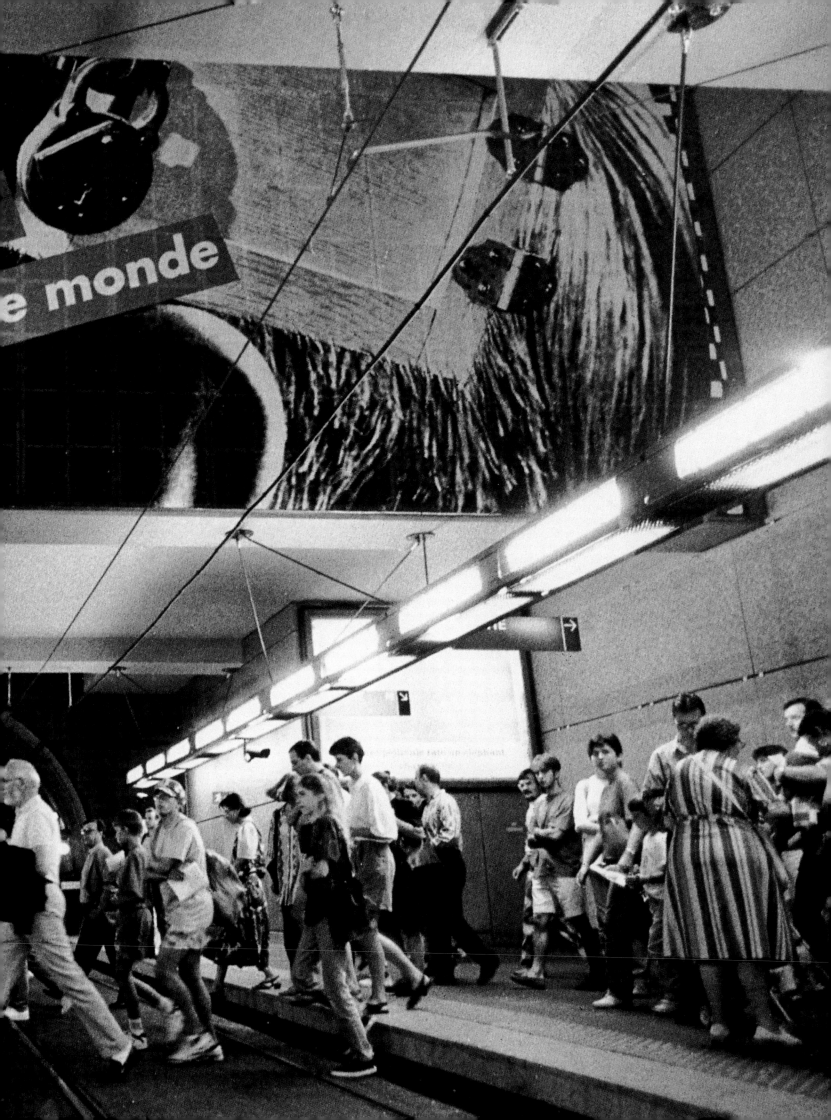

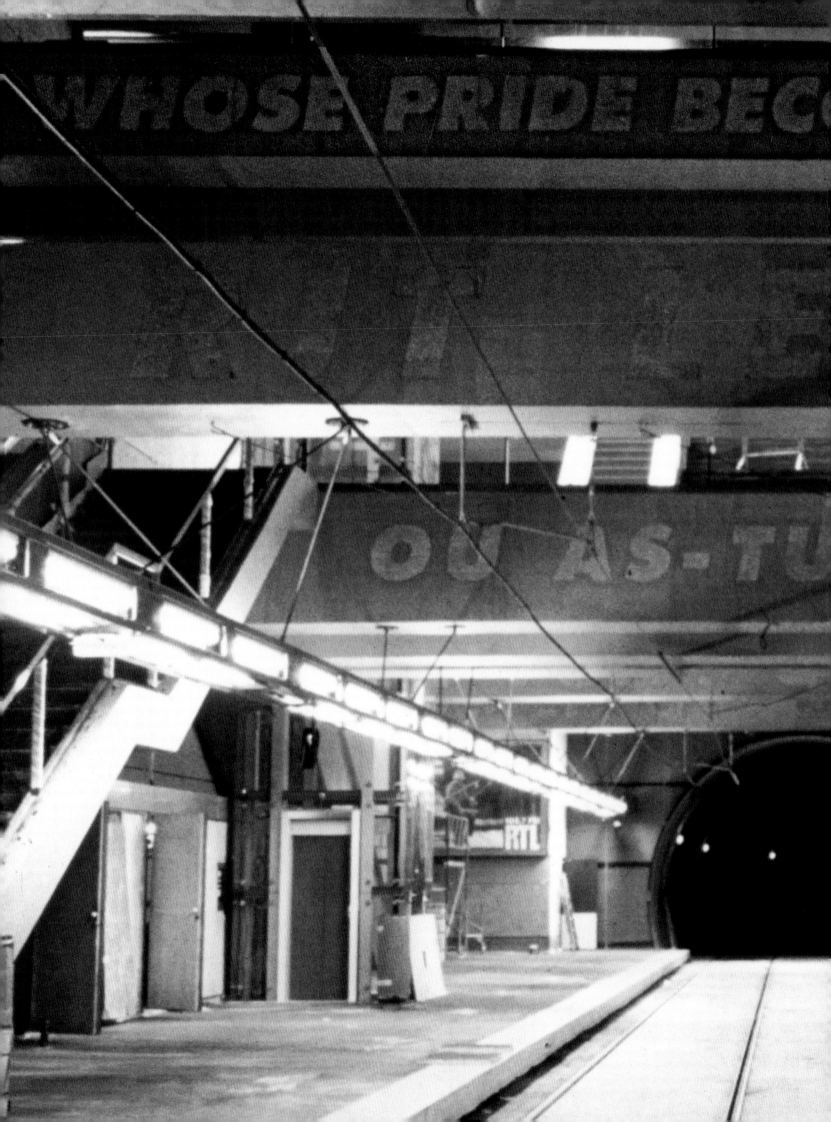

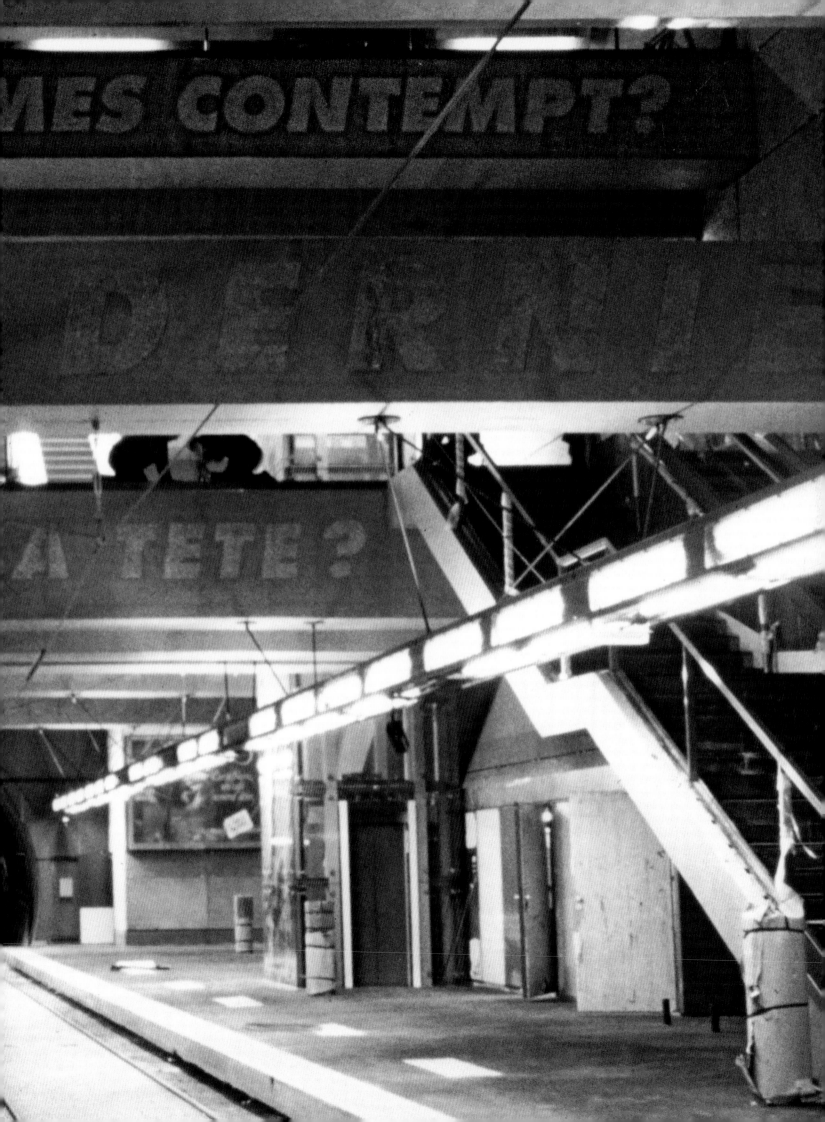

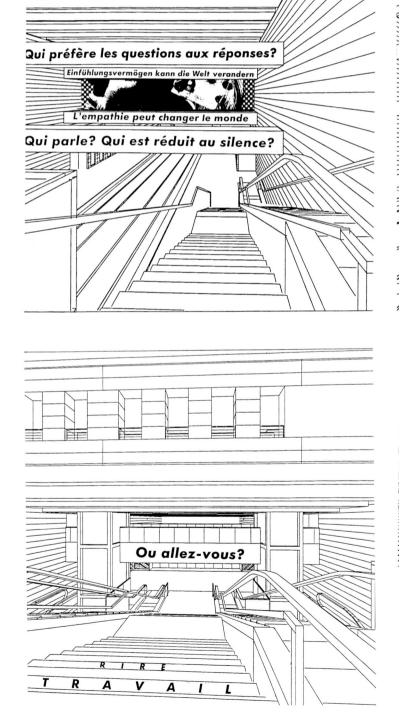

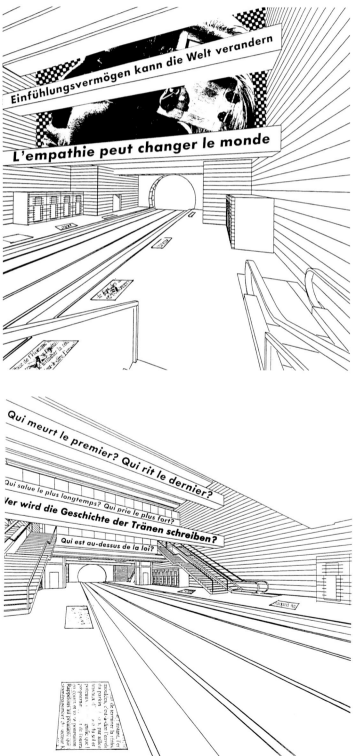

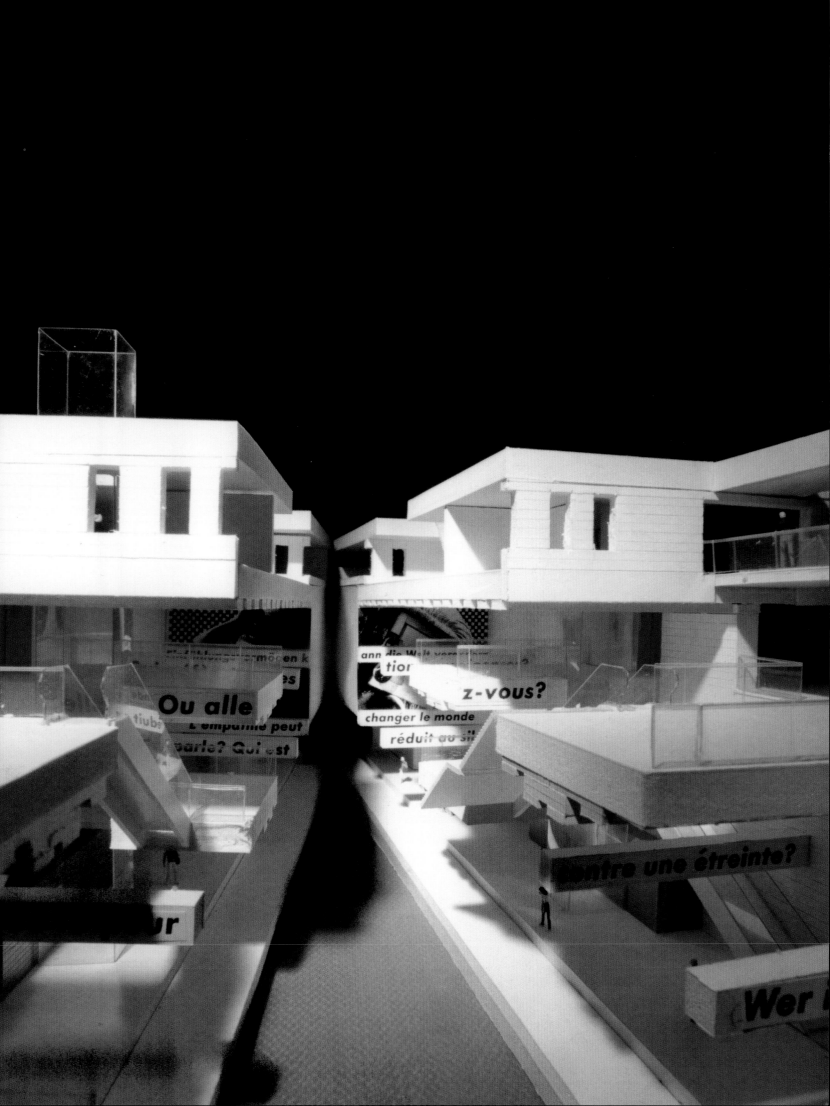

Permanent installation for Le Tram de Strasbourg, France, 1994.

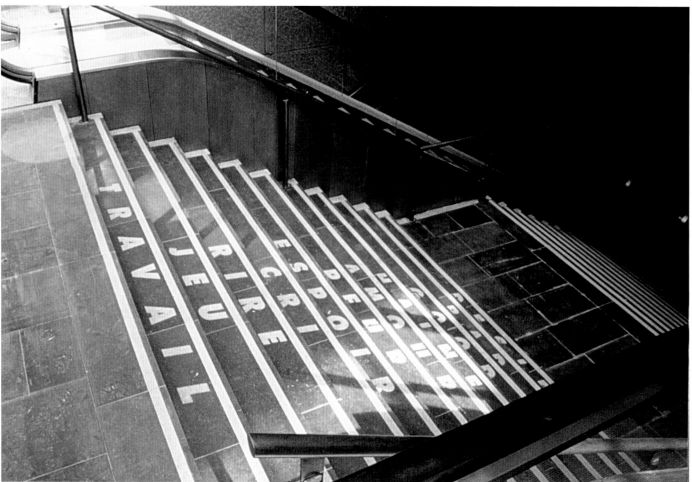

TU SEI UN FILO PASSATO ATTRAVERSO
LA CRUNA DI UN AGO. TU SEI UNA
TRAMA DI MOMENTI ACCUMULATI CHE
SI AMMASSA IN GIORNI NOTTI E ANNI.

(opposite, top) **EMPATHY CAN CHANGE THE WORLD**, 1991.
Poster project, Wuppertal, Germany.

(opposite, bottom) **LOOK FOR THE MOMENT WHEN PRIDE BECOMES CONTEMPT**, 1991.
Billboard project, Wuppertal, Germany.

(below) **UNTITLED** (**QUESTIONS**), January 1991.
Mary Boone installation, 417 West Broadway, New York City.

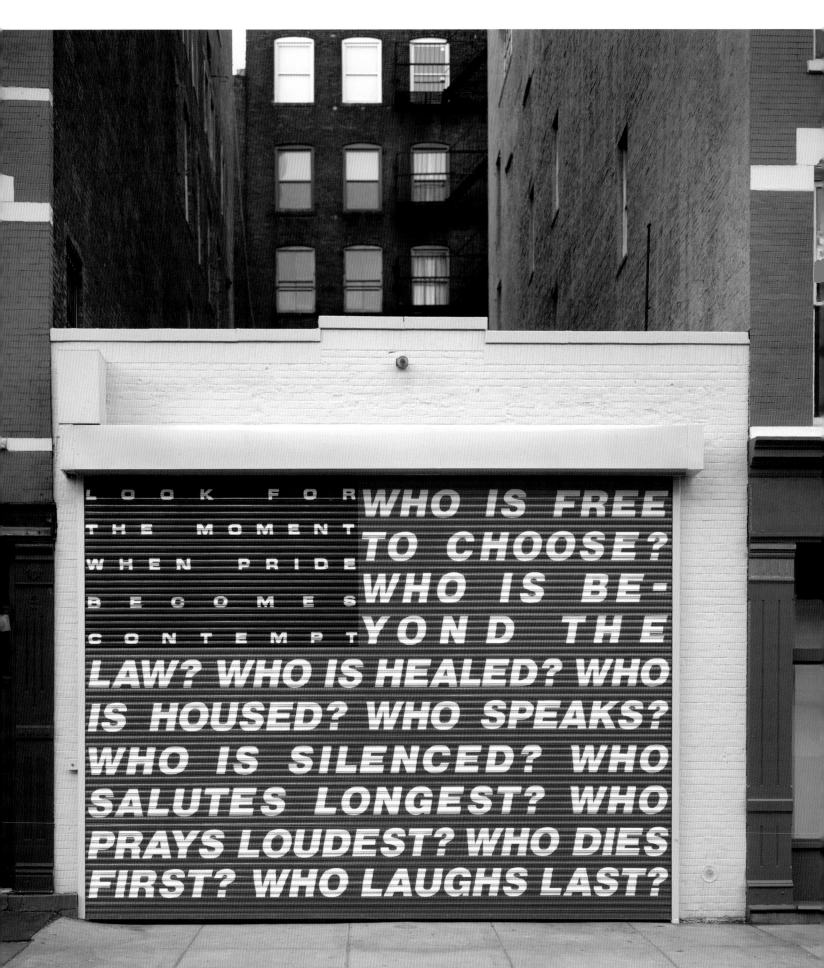

UNTITLED (QUESTIONS), 1989–90. Mural, south wall of the Temporary
Contemporary, the Museum of Contemporary Art, Los Angeles.

70

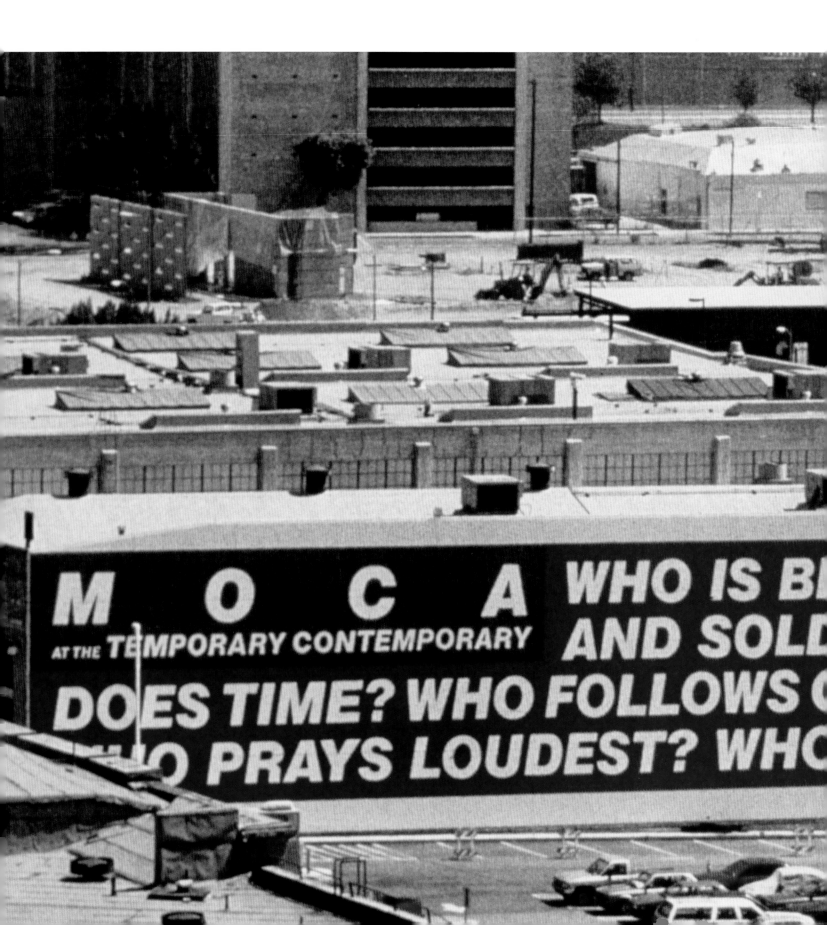

(this page) Bus shelter, 2005. Glasgow, Scotland.

(opposite) Billboard project, 2005. Train Station, Glasgow, Scotland.

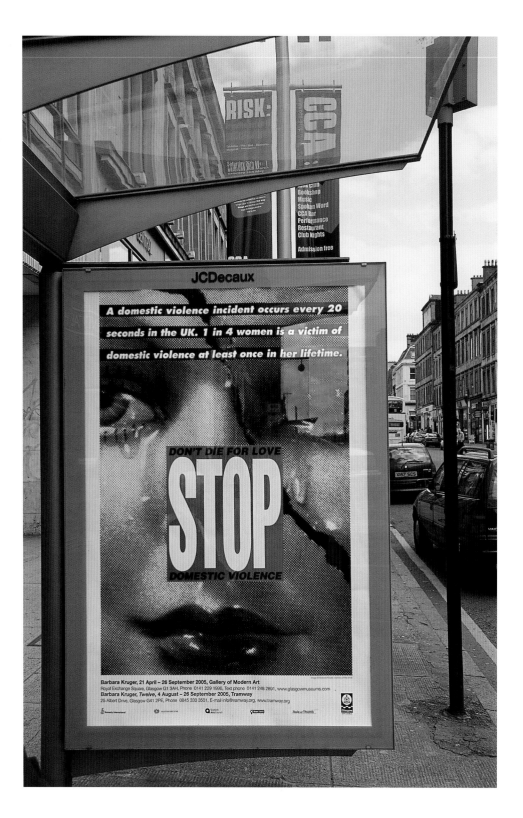

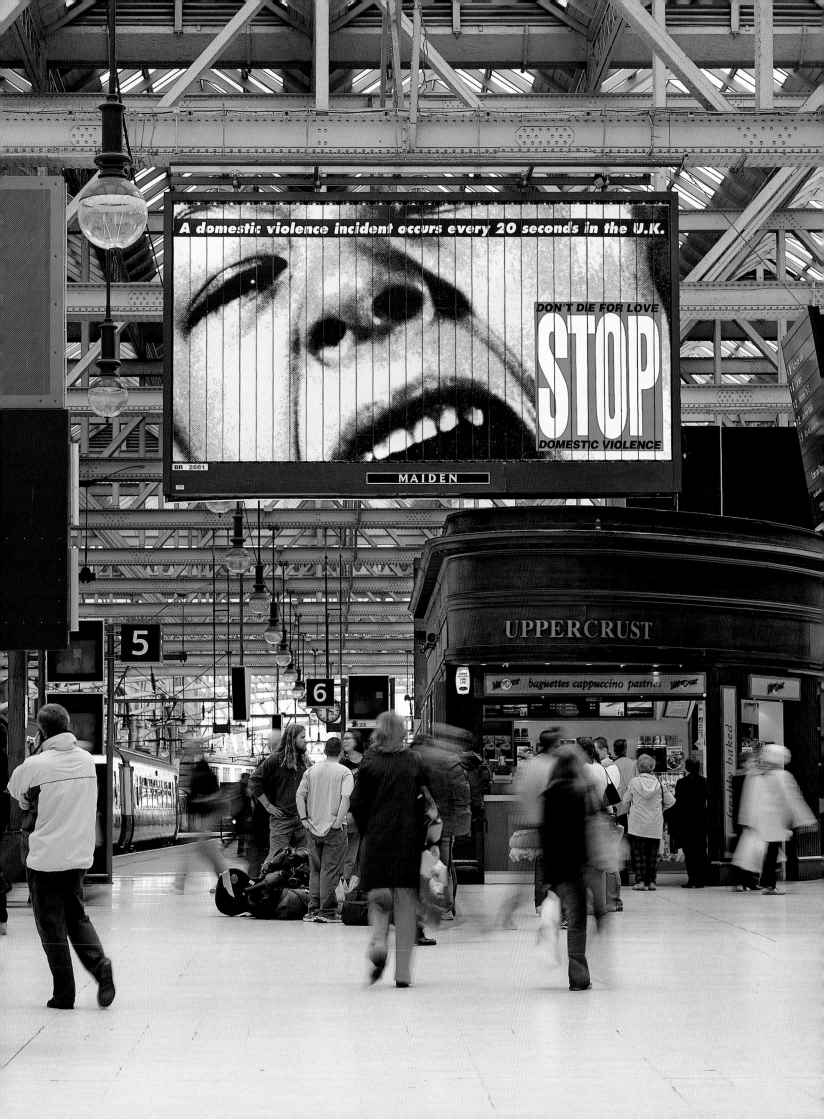

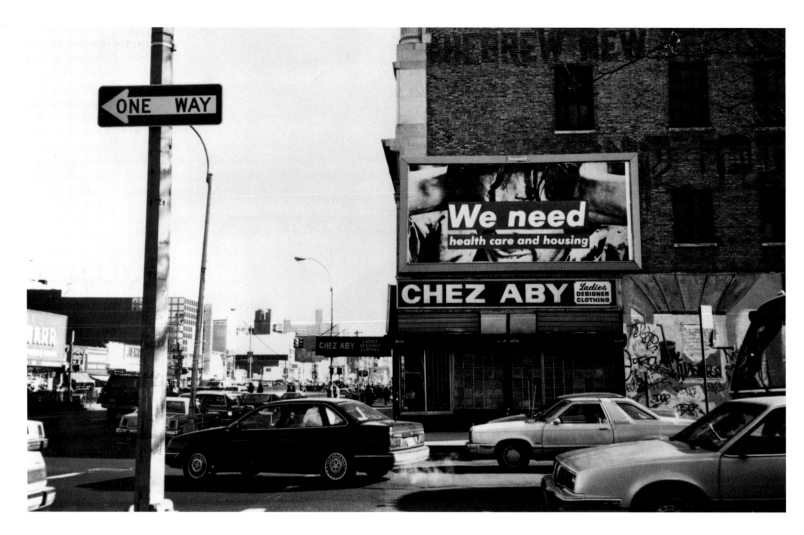

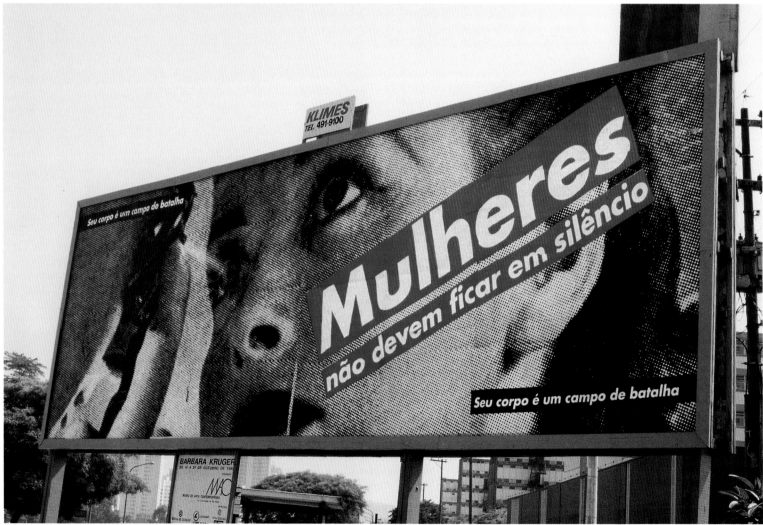

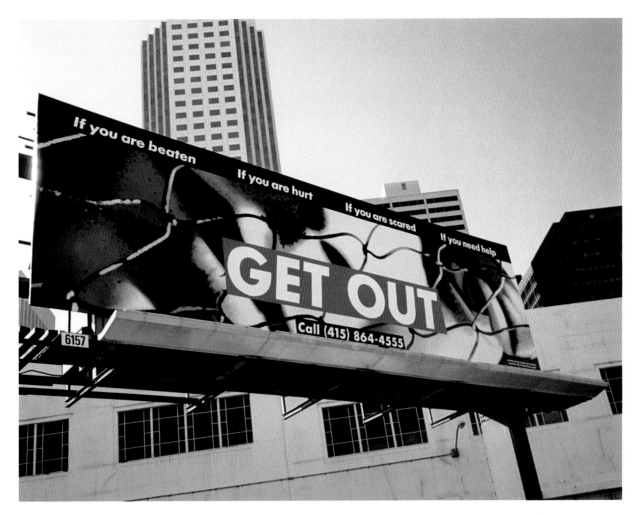

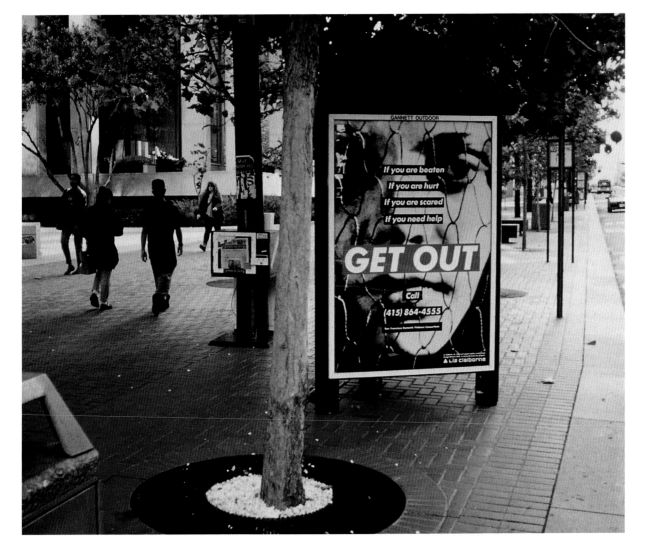

(opposite, top)
WE NEED HEALTH CARE AND HOUSING, 1989. Billboard project, New York City.

(opposite, bottom)
UNTITLED (WOMEN WILL NOT BE SEEN AND NOT HEARD), 1992. Billboard project for Museu de Arte Contemporanea, São Paulo, Brazil.

(this page)
Billboards for Liz Claiborne, Inc., 1991. Women's Work Project on Domestic Violence, San Francisco.

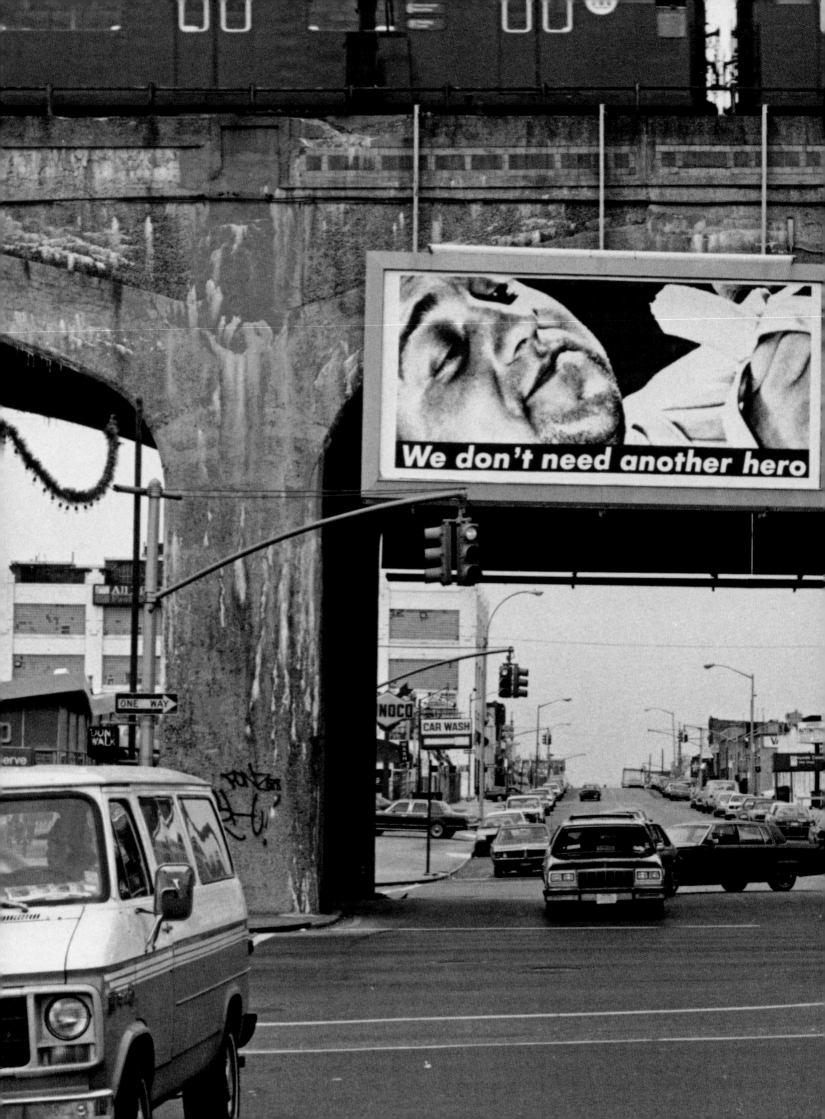

We don't need another hero

(top) **FRAGILITÉ**, 2002. Printemps de Septembre, Toulouse, France.

(right) **DON'T BE A JERK**, 1996. Bus placard project, New York City.

(opposite) Poster design for **THE DECADE SHOW: FRAMEWORKS OF IDENTITY IN THE 1980S**, May–August 1990, New York City.

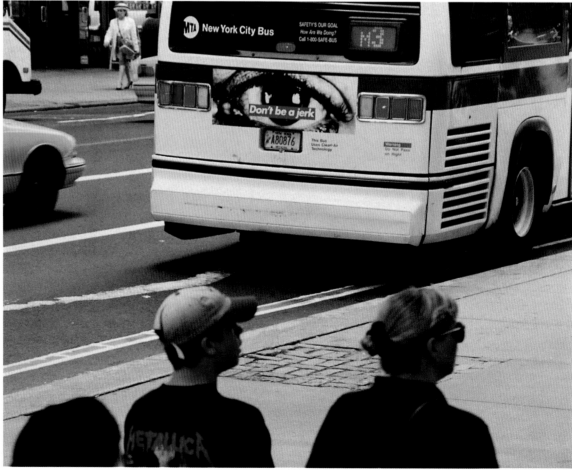

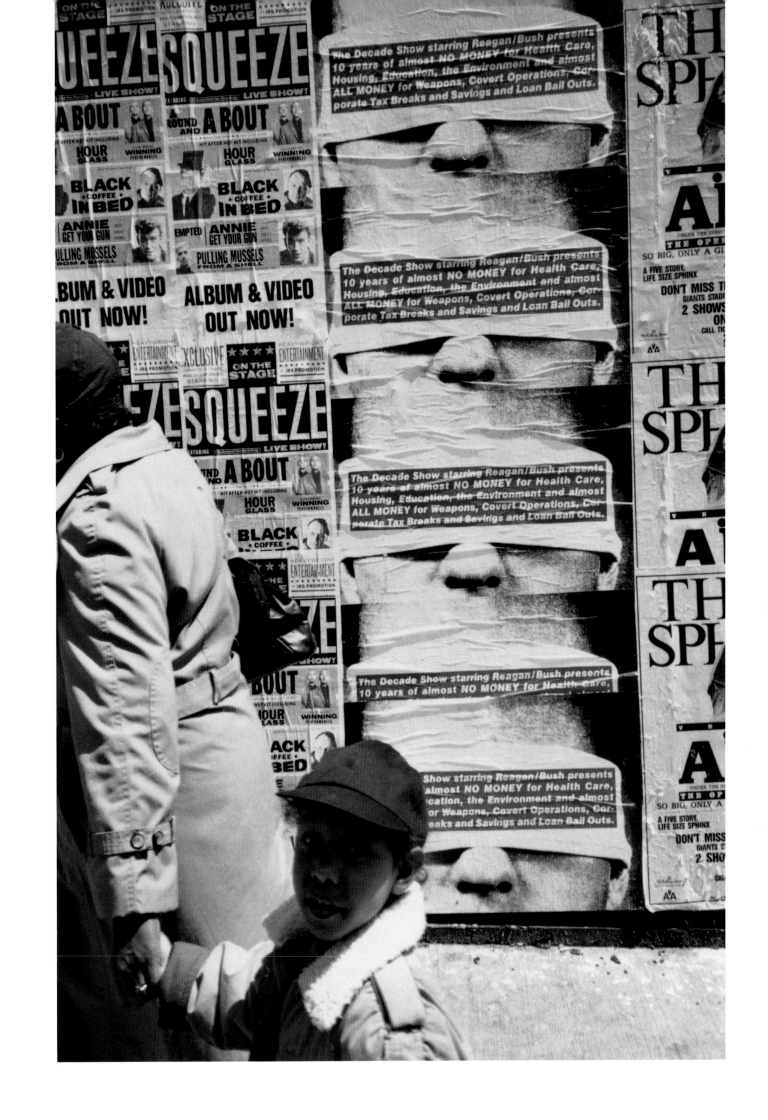

(this page) **YOUR BODY IS A BATTLEGROUND**, 1990.
Billboard project, Wexner Center for the Arts, Columbus, Ohio.

(opposite) **UNTITLED** (**DON'T BE A JERK**), 1996.
Billboard, Melbourne, Australia.

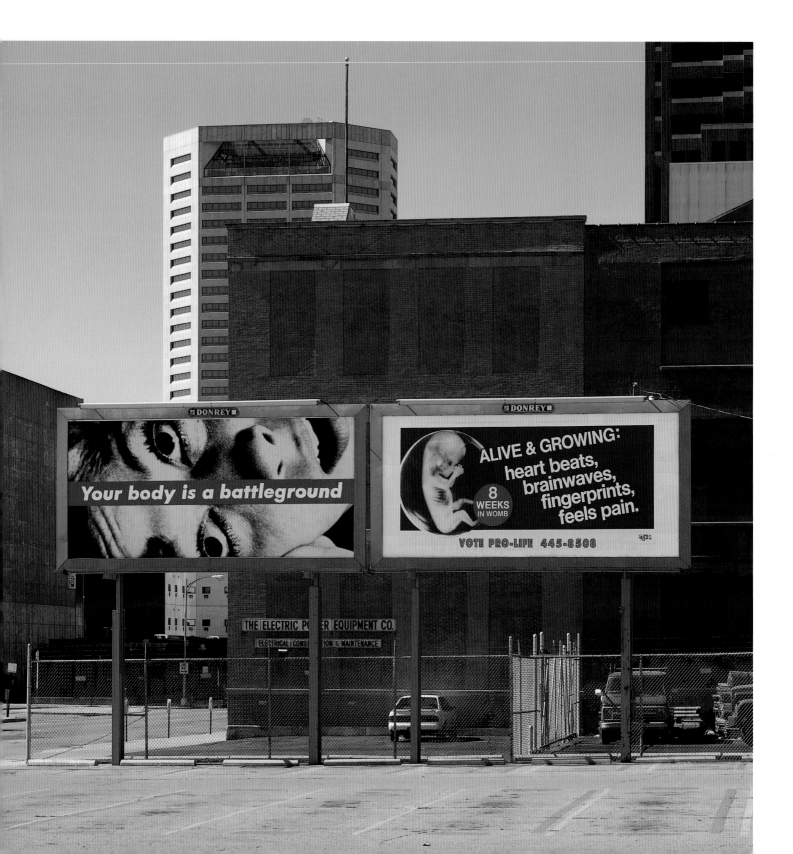

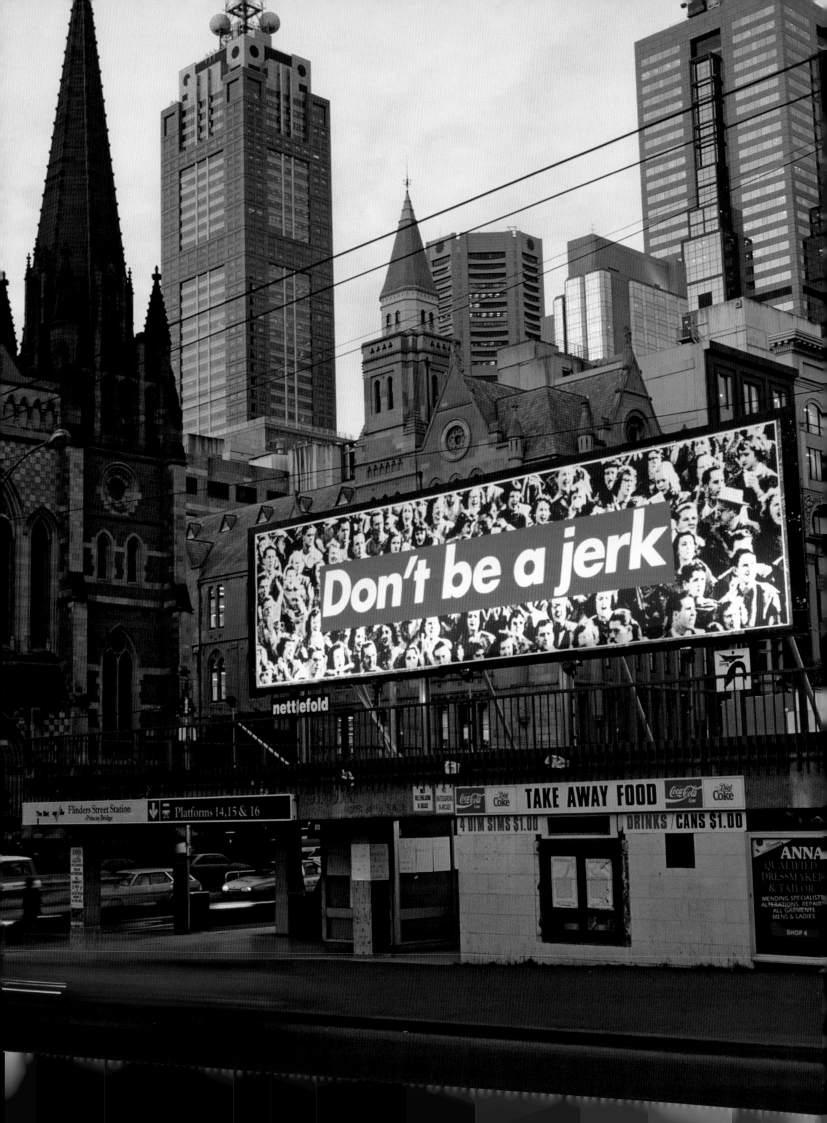

(this page) **UNTITLED** (**SURVEILLANCE IS YOUR BUSYWORK**), 1985.
Bus placard project for Nexus Contemporary Art Center, Georgia.

(opposite) **UNTITLED** (**SURVEILLANCE IS YOUR BUSYWORK**), 1985.
Billboard for Film in the Cities, Minneapolis.

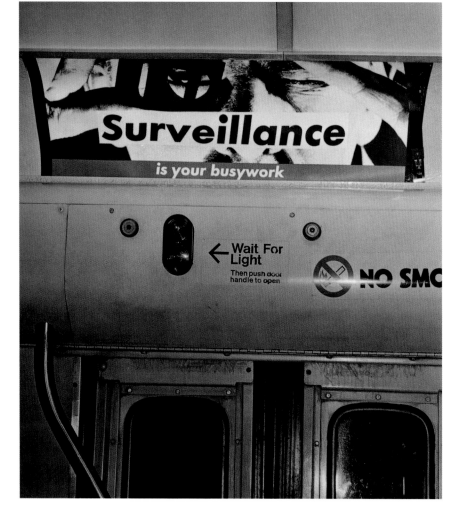

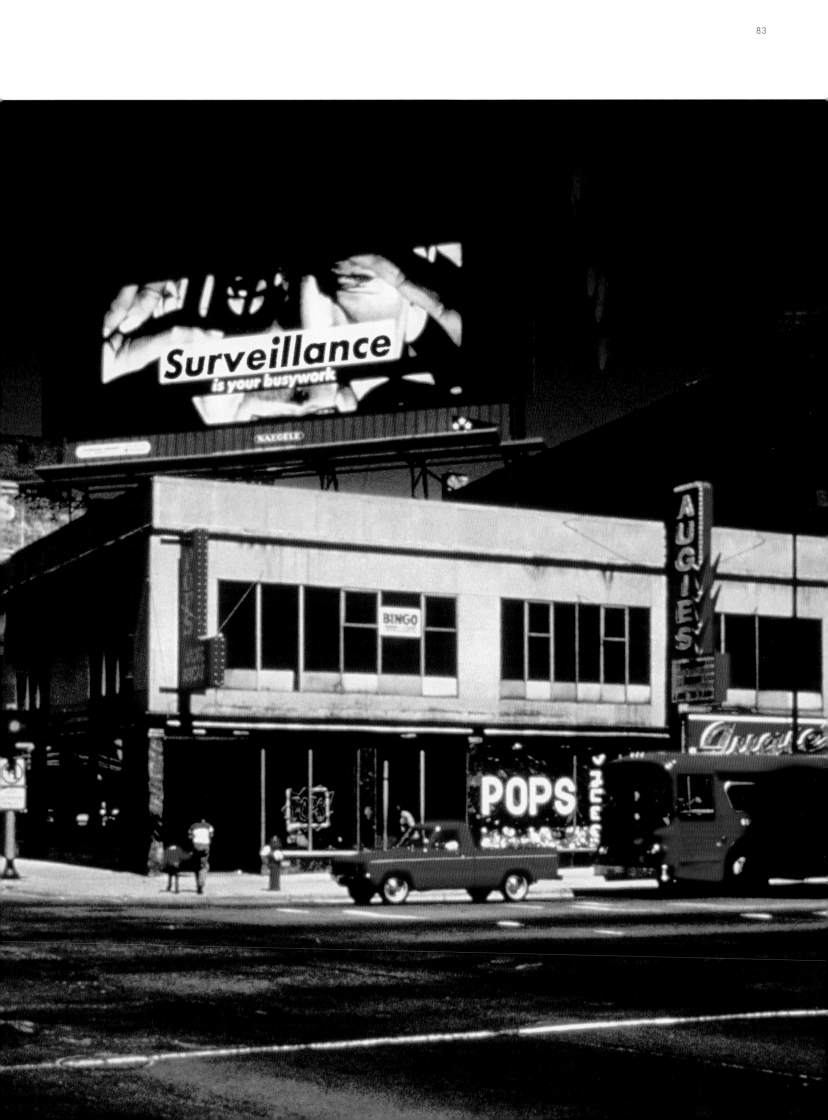

(top left) **UNTITLED** (**YOUR BODY IS A BATTLEGROUND**), 1990. Subway poster, Berlin.

(top right and opposite, top) **UNTITLED** (**YOUR BODY IS A BATTLEGROUND**), 1991. Warsaw, Poland.

(below and opposite, bottom) **UNTITLED** (**YOUR BODY IS A BATTLEGROUND**), 1989. Poster for March on Washington in support of legal abortion, birth control, and women's rights, New York City.

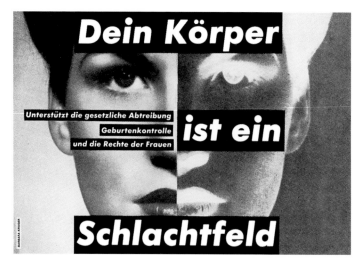

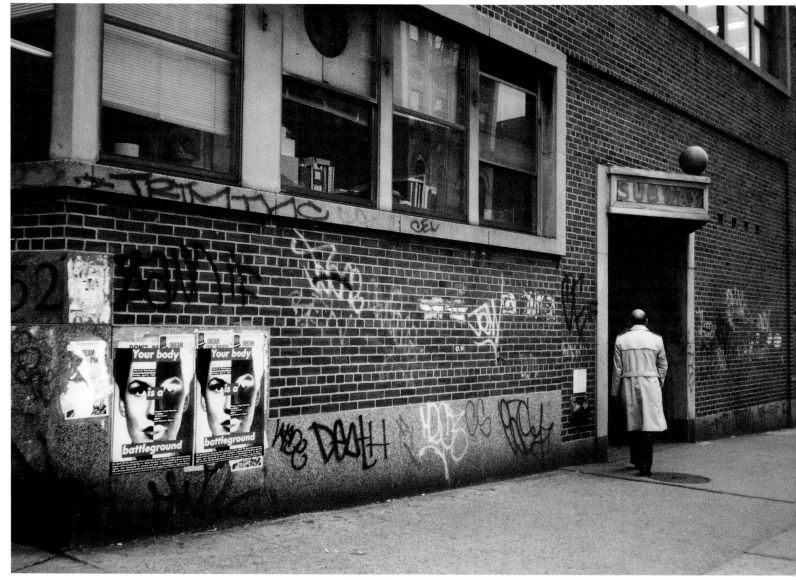

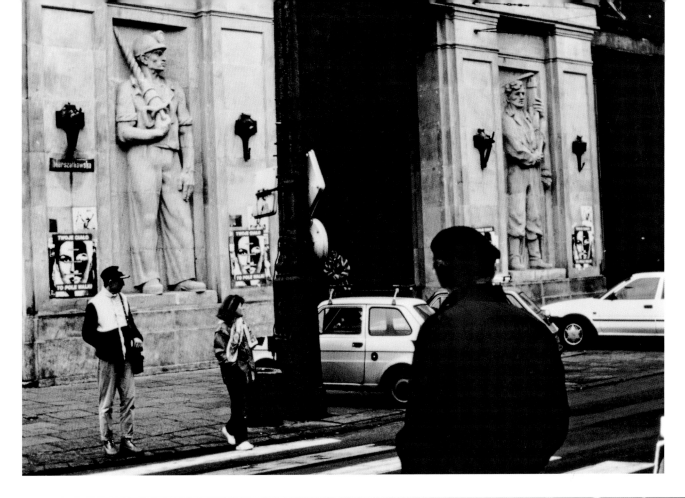
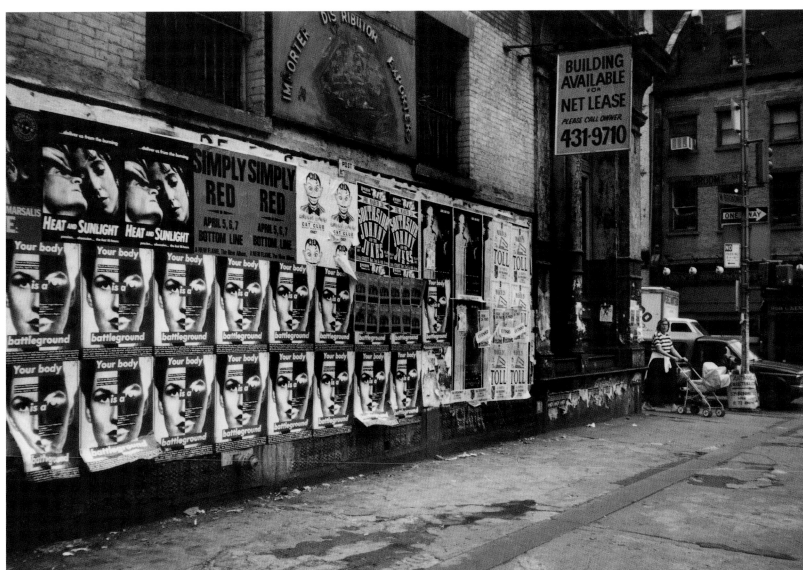

UNTITLED (YOUR BODY IS A BATTLEGROUND), 1990.
Poster for Arts Pro-Choice art sale and benefit for the
National Abortion Rights Action League, New York City.

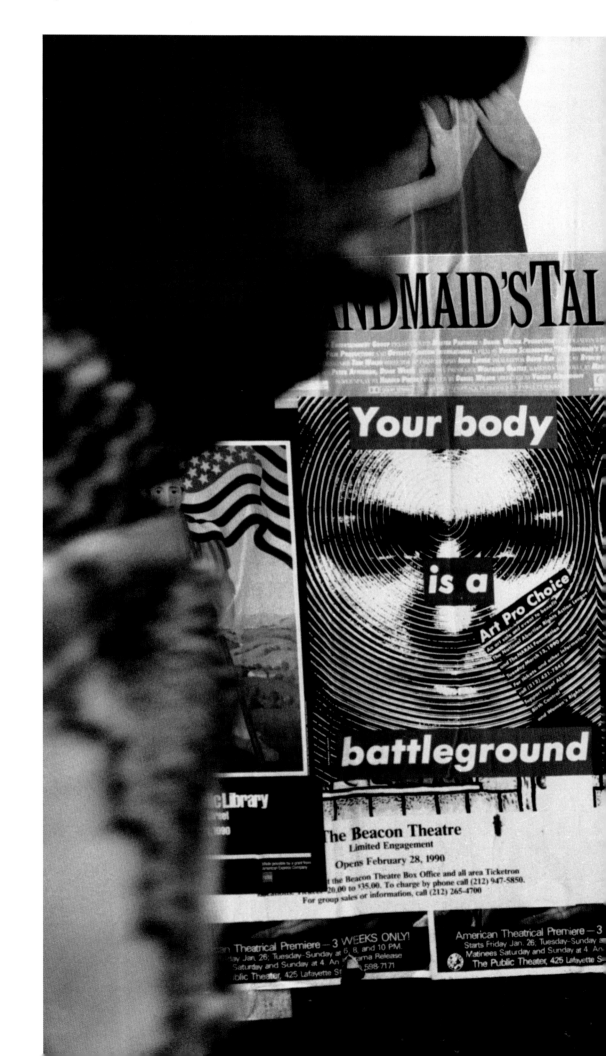

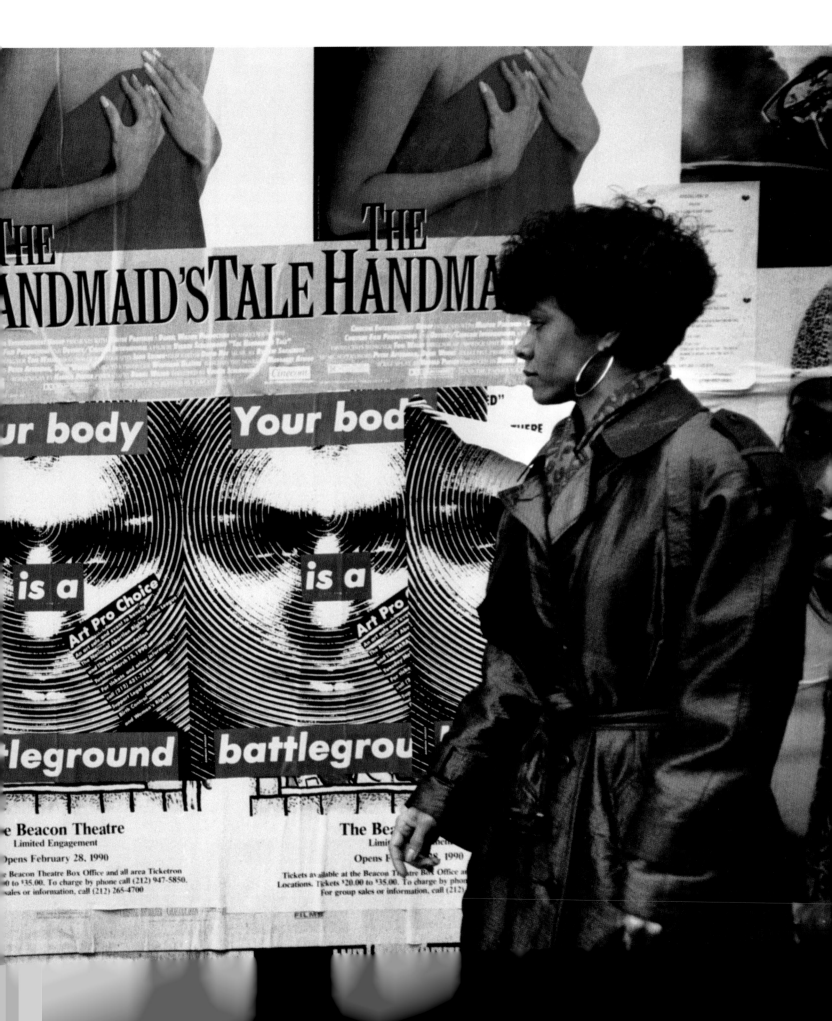

Barbara Kruger

Your body

March on Washington
Sunday, April 9, 1989

is a

Support Legal Abortion
Birth Control
and Women's Rights

battleground

On April 26 the Supreme Court will hear a case which the Bush Administration hopes will overturn the Roe vs. Wade decision, which established basic abortion rights. Join thousands of women and men in Washington D.C. on April 9. We will show that the majority of Americans support a woman's right to choose. In Washington: Assemble at the Ellipse between the Washington Monument and the White House at 10 am; Rally at the Capitol at 1:30 pm

MIWON KWON

A Message from Barbara Kruger: Empathy Can Change the World

IN A 1984 ESSAY ENTITLED "From Faktura to Factography," art historian Benjamin H. D. Buchloh traces the emergence and development of photomontage in the early twentieth century, especially its mobilization among a group of avant-garde artists in post-Revolution Soviet Union. Tracking the work of El Lissitzky and Aleksandr Rodchenko in particular through the 1920s, Buchloh conveys the urgency and optimism with which these and other Soviet artists invested in photomontage as a means not only to produce new images that could adequately address a growing mass audience, but also to transform existing systems of representation and communication, that is, institutions of production, distribution, and reception. Incorporating earlier modernist aesthetic (or anti-aesthetic) experiments from Cubism and German Dada with the tools of mass communication, such as typography, graphic design, exhibition design, advertising, and propaganda, Soviet artists embraced technology and media in an "attempt to establish an operative aesthetic framework that could focus attention simultaneously on the existing needs of mass audiences [for education and enlightenment] and on the available techniques and standards of the means of artistic production."[1]

According to Buchloh, however, the optimism of the Soviet artists for such a liberatory art that could positively impact society on a mass scale, an optimism famously shared by German cultural theorist Walter Benjamin, was soon proved to have been a "naïve utopianism."[2] In Buchloh's genealogy of photomontage, its radical possibilities give way to their co-optation in the 1930s by both totalitarian regimes and American capitalism.

Lissitzky's and Benjamin's media optimism prevented them from recognizing that the attempt to create conditions of a simultaneous collective reception for the new audiences of the industrialized state would very soon issue into the preparation of an arsenal of totalitarian, Stalinist propaganda in the Soviet Union. What is worse, it would deliver the aesthetics and technology of propaganda to the Italian Fascist and German Nazi regimes. And only a little later we

--------- 1 ---------

Benjamin H. D. Buchloh, "From Faktura to Factography," originally published in *October*, no. 30 (Fall 1984); reprinted in Richard Bolton, ed., *The Contest of Meaning: Critical Histories of Photography* (Cambridge, MA: MIT Press, 1992), 62.

--------- 2 ---------

See Walter Benjamin's 1935 essay "The Work of Art in the Age of Mechanical Reproduction," in *Illuminations: Essays and Reflections* (New York: Schocken Books, 1969), 217–51.

UNTITLED (YOUR BODY IS A BATTLEGROUND), 1989. Poster for March on Washington.

see the immediate consequences of Lissitzky's new montage techniques and photofrescoes [i.e., photomurals] in their successful adaptation for the ideological needs of American politics and the campaigns for the acceleration of capitalist development through consumption. Thus, what in Lissitzky's hands had been a tool for instruction, political education, and the raising of consciousness was rapidly transformed into an instrument prescribing the silence of conformity and obedience.[3]

Despite Buchloh's bleak and definitive claim of the end of photomontage as "a tool for instruction, political education, and the raising of consciousness" in the 1930s, Barbara Kruger's work since the late 1970s proves otherwise. She is rightfully positioned as a key figure within the histories of postmodern art, appropriation art, the "Pictures Generation," and feminist art of the 1980s. But beyond these categorizations, Kruger's photo-text compositions—smart and seductive like the best of advertising, bold and forceful like effective propaganda—inherit the legacy of the Soviet experiments of the 1920s and recharge it to continue the agitation, provocation, and ultimately the political education and the raising of consciousness of her (mass) audience in the twenty-first century.

The artist's overall project, however, is not to retrieve a "pure" art that failed to deliver because it was hijacked by ruthless dictators or corrupted by a profit-driven free-market political economy. Rather, through her deceptively simple questions and declarative sentences—sometimes accusations, sometimes directives, sometimes invectives, sometimes pleas, sometimes admonitions, sometimes condemnations, sometimes reminders—combined with potent images ripe for melodramas, delivered in various forms appropriated from mass media and consumer culture (magazine and newspaper pages, shopping bags, matchbooks, posters, T-shirts, billboards, etc.), and occupying spaces of high art and urban streets, Kruger interrogates the mechanisms of power and social exchange that organize our daily lives and relationships. Although some works are produced for specific occasions of political protest and serve an instrumental function (such as the *Your Body Is a Battleground* posters she produced in 1989 for a march on Washington to support legal abortion, birth control, and women's rights), Kruger doesn't instruct us on what position to take so much as reveal how positions are made: what we take to be our naturally or innately personal positions and identities are, in fact, publicly constructed. Her work demands that each of us recognize the fact that our identities and positions, our mark of difference from one another in terms of gender, class, race, age, religion, etc., are defined within the structuring powers of language, image, and space, that is, cultural systems of representation.

Much of the important literature on Kruger's work over the past three decades has emphasized the deconstructive operation of her seemingly simple image-text compositions, which consistently have highlighted and stymied the desire for mastery over meaning and self (a mastery that is accomplished at the expense or subjugation of others). Many notable critics, including Craig Owens, Kate Linker, Hal Foster, and Mignon Nixon, among others, writing within the theoretical frameworks of poststructuralism and psychoanalysis, both crucial to the side-by-side development of postmodern art criticism and the art of Kruger's generation, have expertly analyzed the decentering of subjectivity, the breakdown of cultural stereotypes, and the questioning of the politics of representation that happen in and through Kruger's work.[4] How these operations ultimately "make a space for another kind of viewer,"[5] and by extension another way of being in the world, has been a long-term political and aesthetic imperative for Kruger.

In Mignon Nixon's 1992 interpretation, the unceasing movement in Kruger's work between "this/ that is me" and "this/that is not me," between positions of domination and submission, between aggressor and victim, produces a space of fantasy for the viewer. Understood psychoanalytically, fantasy is a charged space of psychical oscillation, a setting for the breakdown of identity, within which the viewer experiences at once an unsettling and unsettled back and forth

——————— 3 ———————
Buchloh, "From Faktura to Factography," 69.
——————— 4 ———————
See Craig Owens, "The Medusa Effect, or, The Specular Ruse" (1983), in *Beyond Recognition: Representation, Power, and Culture* (Berkeley: University of California Press, 1992), 191–200; Hal Foster, "Subversive Signs," in *Recodings: Art, Spectacle, Cultural Politics* (Port Townsend, Washington: Bay Press, 1985), 99–118; Kate Linker, *Love for Sale: The Words and Pictures of Barbara Kruger* (New York: Harry N. Abrams, Inc., 1990); Mignon Nixon, "You Thrive on Mistaken Identity," *October*, no. 60 (Spring 1992): 58–81.
——————— 5 ———————
Artist's words in W. J. T. Mitchell, "An Interview with Barbara Kruger," *Critical Inquiry*, vol. 17, no. 2 (Winter 1991): 435.

between identification and disidentification, between affirmation of a stable identity and freedom from it. For Nixon, this space of fantasy as staged by Kruger's work draws out *and* repudiates the pleasure of, on the one hand, mastery over a fixed sense of self and meaning and, on the other hand, the pleasure of movement, of not being bound to one position, definition, or meaning. Nixon argues:

> So it is not only fantasy's undoing of subjectivity that plays out here, but also subjectivity's containment of fantasy, and it is in the tension between these two refusals, this crossing up of pleasure—pleasure in movement and pleasure in mastery, the two both elicited and denied—that the viewer is caught. Kruger, then, repeatedly enacts a double rupture of desire: she simultaneously frustrates the desire for possession of the image, using such devices as cropping, fragmentation, and superimposition, and blocks the desire for movement, or loss of subjectivity, by insistently reasserting the static formula of the stereotype.[6]

Beginning in the early 1990s, Kruger would take the mental space of fantasy as described above to the scale of architecture in installations covering all surfaces of a gallery space—walls, floor, and ceiling—fully enveloping the viewers *inside* her compositions in a visual and physical equivalent of surround sound. In fact, Nixon's essay was in part inspired by Kruger's move to a larger scale of operation. In installations at Rhona Hoffman Gallery, Chicago, 1990; Kölnischer Kunstverein, Cologne, Germany, 1990; Mary Boone Gallery, New York, 1991 and 1994; Serpentine Gallery, London, 1994; and Deitch Projects, New York, 1997 (the last using video and projected texts), Kruger positioned her viewers within a phenomenologically assaultive environment, dwarfing them both physically and psychologically with gigantic images and words (something like the thundering voice of God or Big Brother).

Now the challenging declarations and questions, formerly contained within the framework of Kruger's discrete pictures, issue forth from beneath our feet and above our heads. The experience of decentered subjectivity and the pleasure and displeasure that accompany it become inescapably embodied. There is no point from which a viewer can take in the entire work any longer or feel whole in him or herself. It is not possible to be outside of representation. In fact, representation literally overwhelms and controls us in these installations rather than the other way around. At once reminiscent of El Lissitzky's 1920s allover exhibition designs for the education of the Soviet masses, and contemporary supergraphics belonging to commercial spaces of consumerism and entertainment, Kruger situates her viewers in a spectacle of her own making to jar us out of our habituated passivity within the all-encompassing, familiar condition of spectacle culture in general. In what could be mistaken as a move that is complicit with late-capitalist spectacle culture, Kruger daringly mimics its vacant formalities in order to "put some meaning into it."[7] That is, Kruger's combined textual, visual, and architectural address in these installations forces her viewers to experience in a visceral way the queasy feelings that accompany the recognition of one's own smallness, pettiness, prejudice, lust, arrogance, greed, ignorance, anger, fear, and powerlessness.

Whether her work utilizes short declarative sentences ("You are not yourself," "A picture is worth more than a thousand words," "My god is better than your god," "All violence is the illustration of a pathetic stereotype," "We don't need another hero," etc.), or poses open-ended questions ("Who will write the history of tears?" "How dare you not be me?" "Do I have to give up me to be loved by you?" "Why are you here?" "What do you want?" etc.), Kruger has consistently put her viewers/readers on the spot, dislodging us not only from the comfort zone of "knowing" what we think we see, read, experience, or believe, but also who we think we are. This dislodging of meaning and subjectivity, or their opening up to multiple possibilities, has been valued within postmodernist art discourse of the 1980s and '90s for its capacity to critically counter the ideological effects of essentialist certainty (especially as practiced by rulers and leaders of dominant cultural,

6

Nixon, "You Thrive on Mistaken Identity," 60.

7

Mitchell, "An Interview with Barbara Kruger," 448.

political, economic, and social institutions). But for Kruger, destabilization of meaning and subjectivity is not an end in itself. As she noted in a 1991 interview, she seeks: "Not just [to] make a statement about the dispersion of meaning, but [to] make [the dispersion] meaningful."[8]

The significance of this aspiration to make dispersion of meaning meaningful, rather than rendering it a mere mannerist exercise or a pretentious postmodernist conceit, can be seen in Kruger's lesser-known 1991 project for the Public Art Fund. For the project, she produced a series of posters for several bus shelters around the borough of Queens that offered complex multiple readings. At one level, this multiplicity was produced as a condition of the viewer's encounter with the work: depending on whether the viewer passed by the shelter quickly in a car, or more slowly walked past it, or was patiently waiting inside it for the arrival of her public transportation, the poster offered very different possibilities for meaning. At another level, the poster's internal composition generated a proliferation of such possibilities as well.

In each poster, we see a black-and-white photographic image of a person looking out at us. Their eyes gently meet ours, but their poses are ambiguous if not generic. They hold more or less affectless countenances that bespeak little on their own. But a large red rectangle positioned across the person's chest exclaims "Help!" charging their poses with a plaintive urgency. A viewer rushing past Kruger's poster would register this plea for help in an instant but in a distracted manner, perhaps not unlike all the other times that he or she would quickly notice but just as quickly ignore pleas for help from the needy on the streets of New York City. A captive viewer with more time to spare, however, finds an explanation of sorts in a text box below the "Help!" sign. Written in the first person, each story describes different personal circumstances but ends with the same statement and question.

A young teenage black boy in jeans and jean jacket, wearing his baseball cap backward: "Graduation is coming and I've got a good job

lined up. I want to get my life together. But my girlfriend is seeing other guys and I just found out I'm pregnant. What should I do?"

A middle-aged white man in a plaid shirt, vest, and construction hat: "We've finally sent the kids off to school. We're not getting any younger. I've got high blood pressure and arthritis. I just found out I'm pregnant. What should I do?"

A white male with his arm over the shoulder of a young boy/son: "I've got a great job. My wife just got a promotion. We're beginning to make a dent in the mortgage but it's tough in this economy. I just found out I'm pregnant. What should I do?"

"I just found out I'm pregnant. What should I do?" The viewer/reader initially follows the all-too-familiar, even stereotypical, storylines of everyday worries voiced by various men, young and old, black and white, only to be caught off guard, stunned even, by the momentous concluding remarks, which open up a vast psychic space of inconclusiveness and uncertainty. On the one hand, Kruger's move here is simple: she leads her viewer/reader through a comfortable and familiar process of identifying the text as the voice of the male subject pictured in the photograph (as if he is confiding his inner thoughts), only to radically explode the viewer's habituated complacency through a precisely orchestrated disconnection between the person pictured and the accompanying story. On the other hand, what Kruger achieves with the improbable textual imposition of a pregnancy upon the images of male bodies is to insist on the presence of *female* subjects despite their absence from view, interrupting the presumption of a masculine subjectivity as the ground of the representation. But more than this, the artist also insists on pregnant female *bodies*, as physical and biological, therefore as real and political (unavoidably, the project conjures up many issues related to reproductive rights and abortion), in a manner hardly seen in the realm of mass media or advertising, which trades instead in idealized and sexualized images of female bodies as commodity signs.

8

Ibid., 448.

Moreover, the posters in this case formally make up a double appropriation. The world of commercial advertisements of slick and "fast" graphics encouraging consumerism is crossbred with the vernacular culture of do-it-yourself cardboard signs made by the homeless or the needy that confess a personal predicament in order to inspire generosity from passersby in public places. In combining two different modes of public address, or two different worlds of public solicitation—one devoted to producing desire for the acquisition of more goods and the other pleading for a sympathetic response to a person's deprivation—Kruger captures in a single picture the gross disparities and contradictions that drive the socioeconomic reality of present-day capitalism.

Here, Kruger challenges the neglectful certainty and apathetic indifference with which her audience members customarily and complicitly engage with mass-media representations that construct subject positions, interpersonal relationships, and social realities. At the same time, she introduces into a typical advertising space of empty words and generic images a charged sense of embodied realities fraught with feelings of frustration and anxiety that pervade everyone's daily life—full of aspirations and obstacles, difficult and confusing, fractured with small worries and big decisions. She fulfills here a longstanding goal: "I think it's easy to be witty . . . and be seductive with pictures and words, and all that is very nice. But I think that it's important for me to somehow, through a collection of words and images, to somehow try to picture—or objectify, or visualize—how it might feel sometimes to be alive today."⁹

Most significantly, in paying close attention to Kruger's posters and recognizing the ambiguity of subjectivity articulated there, one cannot help imagining the "I" of the picture and text as potentially oneself or someone we know—worried about health, anxious about money, self-conscious about the body, and uncertain about the future. Unlike much of her earlier works in which the self-as-subject and Other-as-object distinction seemed emphatically drawn, even if oscillating and reversible, these bus shelter posters open up to an *intersubjective* movement in the viewer across the lines of class, race, and gender.

By invoking intersubjectivity instead of a decentered subjectivity, I am suggesting that Kruger's pleas for attention in this case do something opposite of what most such solicitations do. Instead of distancing us as separate from the help-seeker as Other (you are not me and your dilemma has nothing to do with me), the poster's various subjects invite us to imagine being in another person's shoes, or, more accurately in several other people's shoes: a teenage black boy ready to graduate from high school, a middle-aged construction worker worried about his high blood pressure, a young father anxious about meeting his mortgage payments, and, of course, the unseen pregnant woman uncertain about her future as a mother. Which is to say, through the voicing of seemingly banal and stereotypical everyday concerns that, even if not identical to one's own, register nonetheless as basic, familiar, and real, Kruger encourages the possibility of seeing another as a subject (like me) rather than an object among other objects. This capacity to experience another body/person as a subject rather than an object, to imaginatively take up another subject position as one's own instead of being repelled by it, is the basis of empathy, defined in Standard English dictionaries as the ability to understand and share the feelings of another.¹⁰ In advanced phenomenological discourse, empathy involves much more than mere sharing of feelings. Available to us through intersubjectivity, empathy is the foundation for the recognition of oneself as seen by the Other as well, and in this process the world becomes something that is shared by all rather than available exclusively to oneself (to be conquered, possessed, used).¹¹

This empathetic potentiality of the *Help!* bus shelter posters leads to a rethinking about Kruger's other, especially earlier, works. From the 1980s into the early 1990s, the effort to disrupt the familiar organization of image-text relationships, to destabilize the power of language to fix meaning and identities, and to insist on subjectivity as split or multiple or fluctuating rather than unified or whole, fixed and stable, carried a deep political purpose. Kruger was among those who led the charge. Her work has fought against the use of language, image, and space in the production of oppressive

———————— 9 ————————
Ibid., 445.
———————— 10 ————————
Einfühlung is the German word from which empathy is derived and is to be distinguished from sympathy, which describes the commiserating of feelings more often associated with suffering, sorrow, unhappiness, and distress.
———————— 11 ————————
For more on intersubjectivity and its relation to empathy, see the work of the "father" of phenomenology, Edmund Husserl.

and violent myths of a superior unity of any one group over another (the totalitarian, xenophobic, and patriarchal nightmares of past and present). Equally, she has refused the smooth absorption of language, image, and space within capitalist consumer culture and the mass-mediated "society of spectacle" for the production of an atomized and alienated conformity among its citizens. Kruger turned words and pictures that normally dominate us, either through force or excessive accessibility, into weapons to expose and undo the mechanisms of that domination. She has continued her smart and agile work to the present, shifting gears at times, to boldly confront what political theorist Sheldon S. Wolin has dubbed our present-day "inverted totalitarianism"[12] brought on by the corporatization of not only economic institutions but also of governments, cultures, religions, and other social institutions.

Even when the address of her pictures has been confrontational, oppositional, angry, assaultive, hyperbolic, seemingly divisive, one could argue that at the center of Kruger's practice has always been a call to the public, including friends and foes, for a more empathetic engagement with fellow human beings and the world. That is, the space of "fantasy" described earlier in this essay as a setting for the breakdown of stereotypical identity and oscillation of subjectivity is, and perhaps always has been, also a space for the possibility of intersubjective empathy. It is no accident that for one of her largest and rare permanent public art projects in Strasbourg, France, Kruger would send out most directly this simple message: "L'empathie peut changer le monde." Yes, "Empathy can change the world."[13]

In 2003, at St. Peter's Church in Cologne, Germany, Kruger covered the floor of the entire nave of the late Gothic sanctuary with a tightly cropped black-and-white photograph of a woman's hands, fingers entwined, clasped as if in prayer.[14] At the base of her wrists was a set of questions, bold white text on red ground:

Wer salutiert am längsten? [Who salutes longest?]
Wer betet am lautesten? [Who prays loudest?]
Wer stirbt zuerst? [Who dies first?]
Wer lacht zuletzt? [Who laughs last?]

The four questions of this installation were asked before, most notably in the outdoor mural for the Museum of Contemporary Art in Los Angeles in 1989–90. Taking up the entire southern wall of the Temporary Contemporary building (now called the Geffen Contemporary), these questions, alongside five others (Who is beyond the law? Who is bought and sold? Who is free to choose? Who does time? Who follows orders?) covered an area of 29 by 218 feet and were presented in a format of the American flag. Beyond the immediate context of downtown Los Angeles and the Japanese-American community of Little Tokyo, from which arose objections to the artist's original design,[15] these questions were a retort to the attacks on the arts that were fanatically waged by the conservative right to censor the work of those artists deemed obscene and lacking in moral values. Challenging the presumption of power and righteousness being wielded by the likes of Congressman Jesse Helms, political commentator Pat Buchanan, and evangelical Christian leader Jerry Falwell, Kruger's questions cut to the core of what was at stake during these "culture war" years in a country that supposedly champions freedom of expression and democratic principles of governance.

Posing the same questions in March 2003 in a new arrangement, activating an image of praying hands in a place of worship on the eve of another kind of war—the U.S. invasion of Iraq and the escalation of the "War on Terror"—Kruger once again agitated her viewers to critically consider the structuring conditions of power, perhaps even that of the ascribed power of the Almighty. Simultaneously implicating the politicized public prayers of George W. Bush

12
Sheldon S. Wolin, *Democracy Incorporated: Managed Democracy and the Specter of Inverted Totalitarianism* (Princeton: Princeton University Press, 2008).

13
The message was produced earlier in 1991 as billboards and posters in Germany: "Einfühlungsvermögen kann die Welt verändern."

14
The image of the hands was seen before in an early Kruger photo-text work, *Untitled (Perfect)* from 1980, in which more of the cardigan-clad woman's body was visible. Juxtaposed with the word "Perfect," the picture held a tension as to whether it should be read as sanctimonious or ironic.

15
Initially planned to be part of the group exhibition *A Forest of Signs: Art in the Crisis of Representation*, the mural was not installed until after the run of the show due to opposition from the local Japanese-American community. The original version proposed by the artist used the questions as a border around the perimeter of the mural surrounding the United States Pledge of Allegiance in the center. The residents in Little Tokyo, situated across the street and in close proximity to the MoCA building, protested the design's insensitivity to the history of Japanese-Americans who were interned during World War II as enemy aliens and who suffered the humiliation of having to recite the Pledge of Allegiance every morning during their internment. Kruger changed the design after meetings with community representatives and the mural remained for two years.

and Saddam Hussein, each calling upon his God to grant his wishes for a victorious conquest, as well as recalling the intimate private prayers of worry, fear, and the hope of mothers, wives, and sisters, Kruger's questions this time resonated differently also because of the use of the space by the congregation. When people gathered in the nave for religious service, obscuring Kruger's picture with folding chairs and their bodies, the questions seemed to get "absorbed" into their collective worship and vice versa. That is, as Kruger's picture framed the collective experience of prayer in the church, this experience also became part of Kruger's picture, activating the questions as if they were being directed at the worshipers and being asked by them at the same time. With the nave empty and all the worshipers gone home, Kruger's picture became an altogether different piece, with the questions seemingly posed to God himself: Who salutes longest? Who prays loudest? Who dies first? Who laughs last?

WE DON'T NEED ANOTHER HERO, 1986.
Billboard project Artangel, London.

97

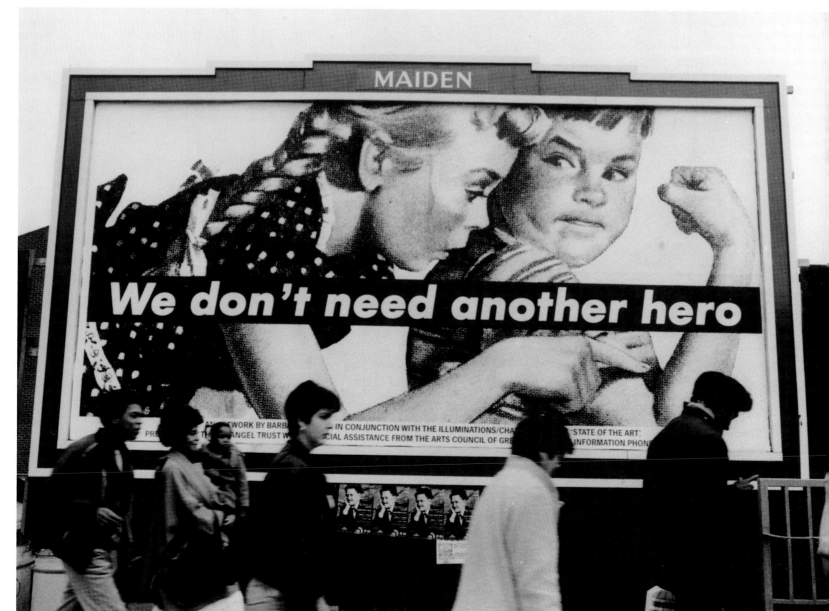

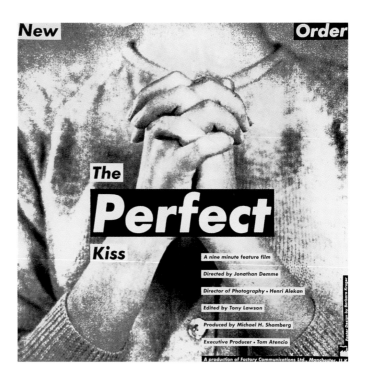

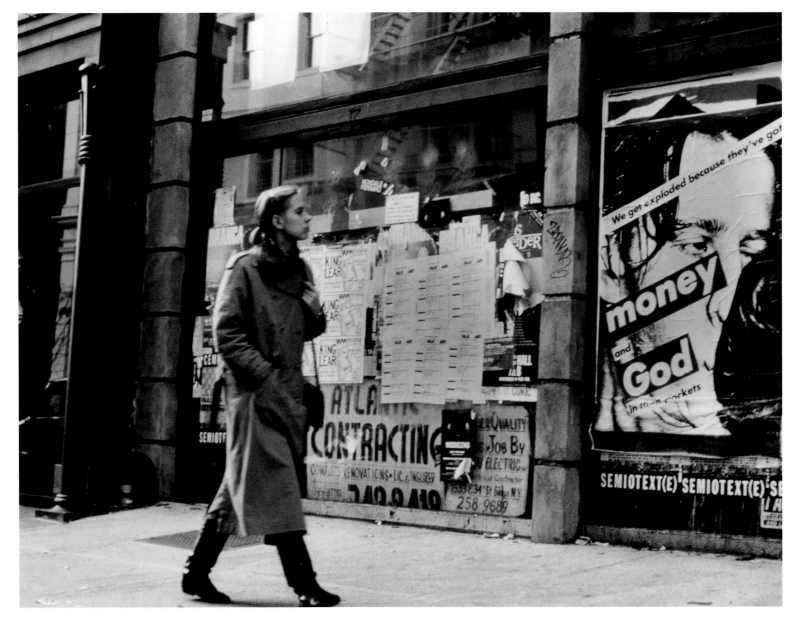

(opposite, top) **UNTITLED (PERFECT)**, 1980.

(opposite, bottom) **WE GET EXPLODED BECAUSE THEY'VE GOT MONEY AND GOD IN THEIR POCKETS**, 1985. Poster project, New York City.

(below) **NO THOUGHT/NO DOUBT/NO GOODNESS/NO PLEASURE/NO LAUGHTER**, 1989. Posters for Frankfurter Kunstverein and Schirn Kunsthalle.

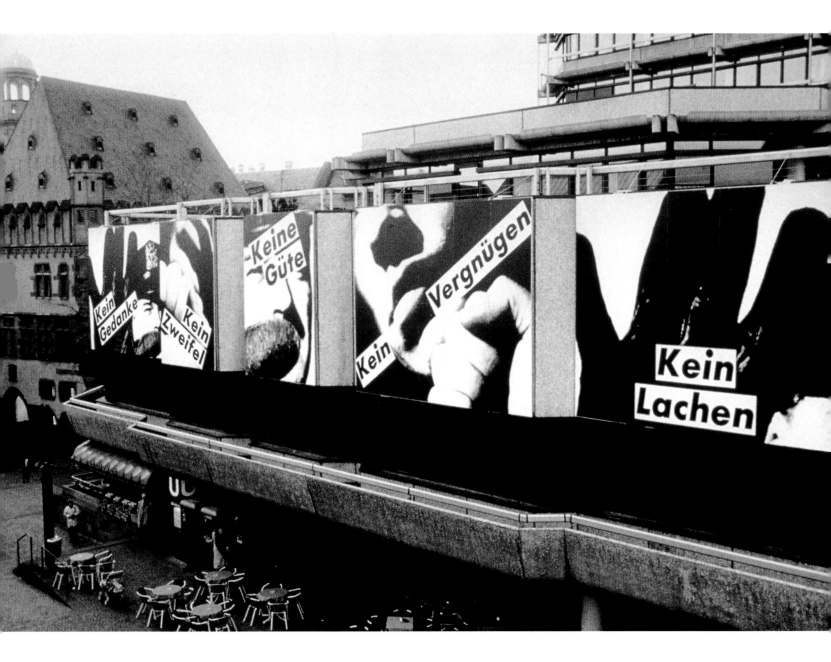

YOU CONSTRUCT INTRICATE RITUALS WHICH ALLOW YOU TO TOUCH THE SKIN OF OTHER MEN, 1982. Poster project, Amsterdam.

101

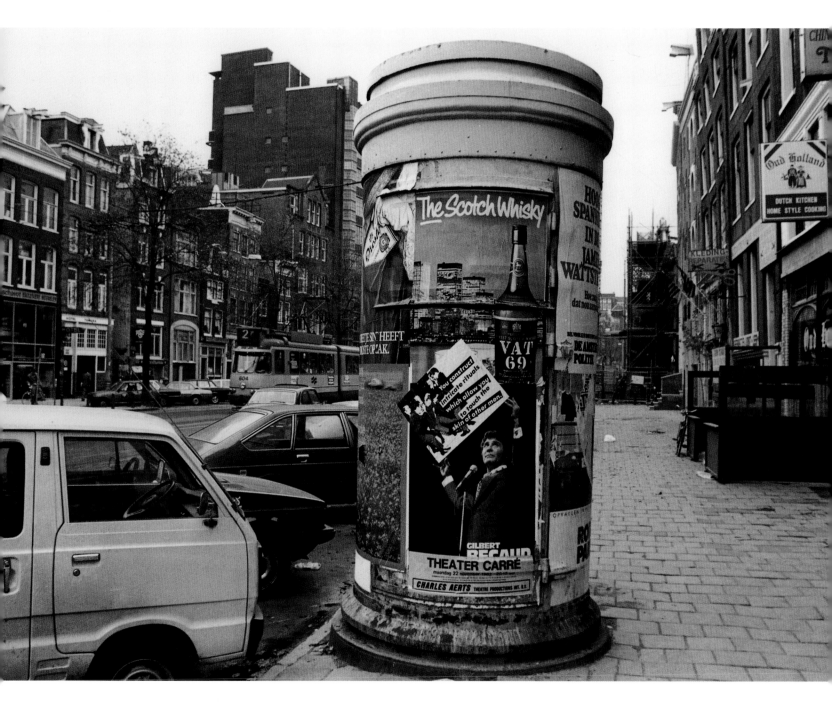

MESSAGE TO THE PUBLIC, 1983. Spectacolor light board project, Public Art Fund, New York City.

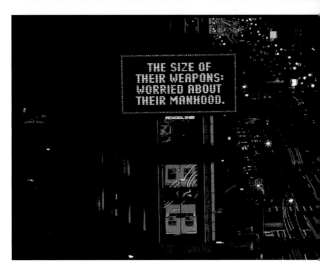

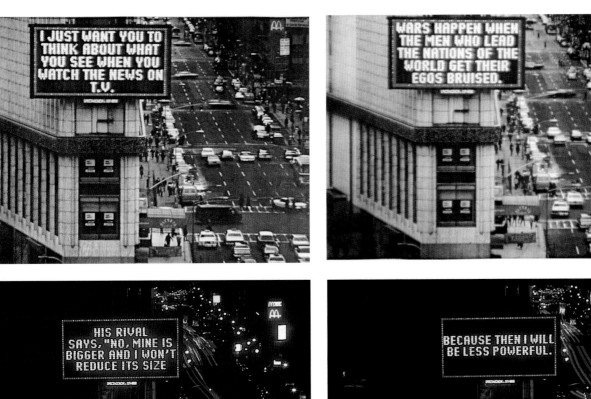

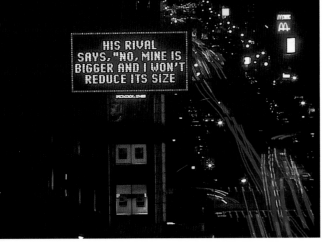

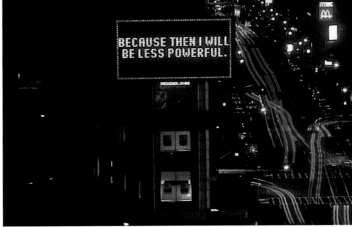

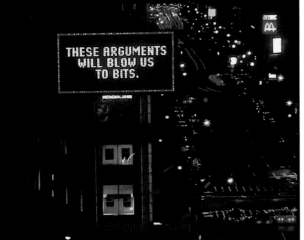

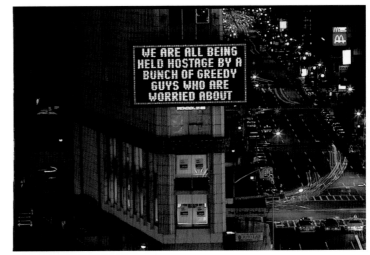

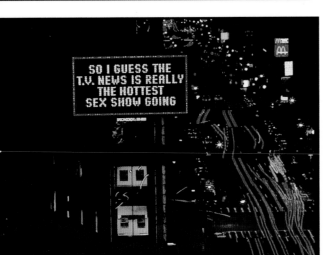

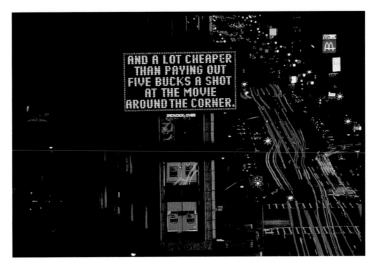

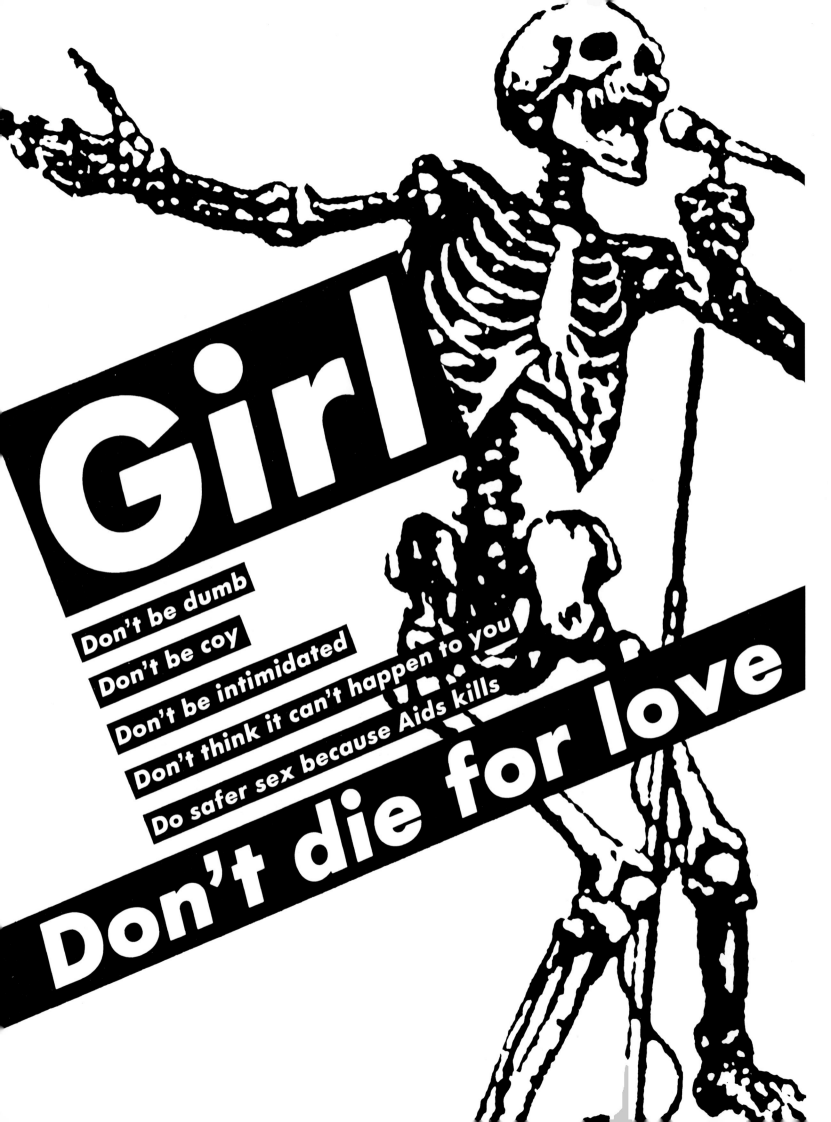

(opposite) Poster design for Visual AIDS, 1992.

(this page, top) **REMAKING HISTORY**, 1988. (bottom) **THE REGULATION OF FANTASY**, 1987–88. Poster designs and events organized by Barbara Kruger and Phil Mariani. A commission for the Dia Art Foundation.

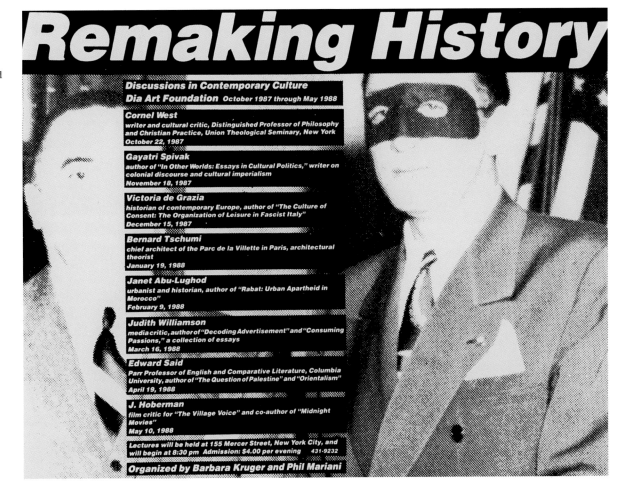

Remaking History

Discussions in Contemporary Culture
Dia Art Foundation October 1987 through May 1988

Cornel West
writer and cultural critic, Distinguished Professor of Philosophy and Christian Practice, Union Theological Seminary, New York
October 22, 1987

Gayatri Spivak
author of "In Other Worlds: Essays in Cultural Politics," writer on colonial discourse and cultural imperialism
November 18, 1987

Victoria de Grazia
historian of contemporary Europe, author of "The Culture of Consent: The Organization of Leisure in Fascist Italy"
December 15, 1987

Bernard Tschumi
chief architect of the Parc de la Villette in Paris, architectural theorist
January 19, 1988

Janet Abu-Lughod
urbanist and historian, author of "Rabat: Urban Apartheid in Morocco"
February 9, 1988

Judith Williamson
media critic, author of "Decoding Advertisement" and "Consuming Passions," a collection of essays
March 16, 1988

Edward Said
Parr Professor of English and Comparative Literature, Columbia University, author of "The Question of Palestine" and "Orientalism"
April 19, 1988

J. Hoberman
film critic for "The Village Voice" and co-author of "Midnight Movies"
May 10, 1988

Lectures will be held at 155 Mercer Street, New York City, and will begin at 8:30 pm Admission: $4.00 per evening 431-9232

Organized by Barbara Kruger and Phil Mariani

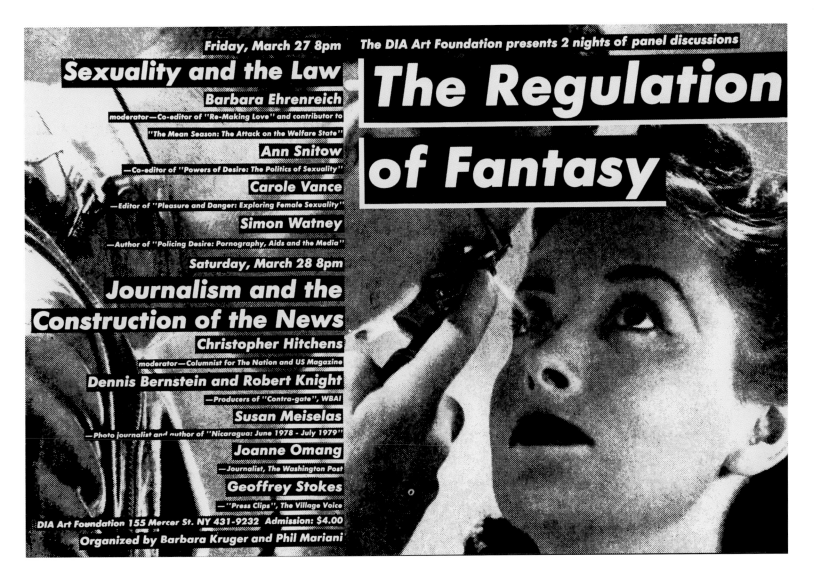

Friday, March 27 8pm The DIA Art Foundation presents 2 nights of panel discussions

Sexuality and the Law
The Regulation of Fantasy

Barbara Ehrenreich
moderator—Co-editor of "Re-Making Love" and contributor to
"The Mean Season: The Attack on the Welfare State"

Ann Snitow
—Co-editor of "Powers of Desire: The Politics of Sexuality"

Carole Vance
—Editor of "Pleasure and Danger: Exploring Female Sexuality"

Simon Watney
—Author of "Policing Desire: Pornography, Aids and the Media"

Saturday, March 28 8pm

Journalism and the Construction of the News

Christopher Hitchens
moderator—Columnist for The Nation and US Magazine

Dennis Bernstein and Robert Knight
—Producers of "Contra-gate", WBAI

Susan Meiselas
—Photo journalist and author of "Nicaragua: June 1978 - July 1979"

Joanne Omang
—Journalist, The Washington Post

Geoffrey Stokes
—"Press Clips", The Village Voice

DIA Art Foundation Poster 155 Mercer St. NY 431-9232 Admission: $4.00
Organized by Barbara Kruger and Phil Mariani

(106–11)
Barbara Kruger, in collaboration with Smith-Miller + Hawkinson Architects,
landscape architect Nicholas Quennell, and engineer Guy Nordenson.
IMPERFECT UTOPIA (under construction), 1987–96. A permanent outdoor installation
at the Joseph M. Bryan, Jr. Theater, North Carolina Museum of Art, Raleigh.

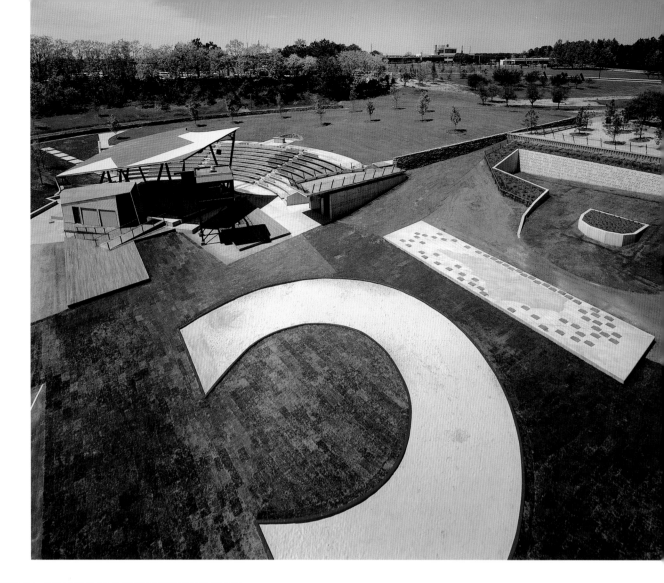

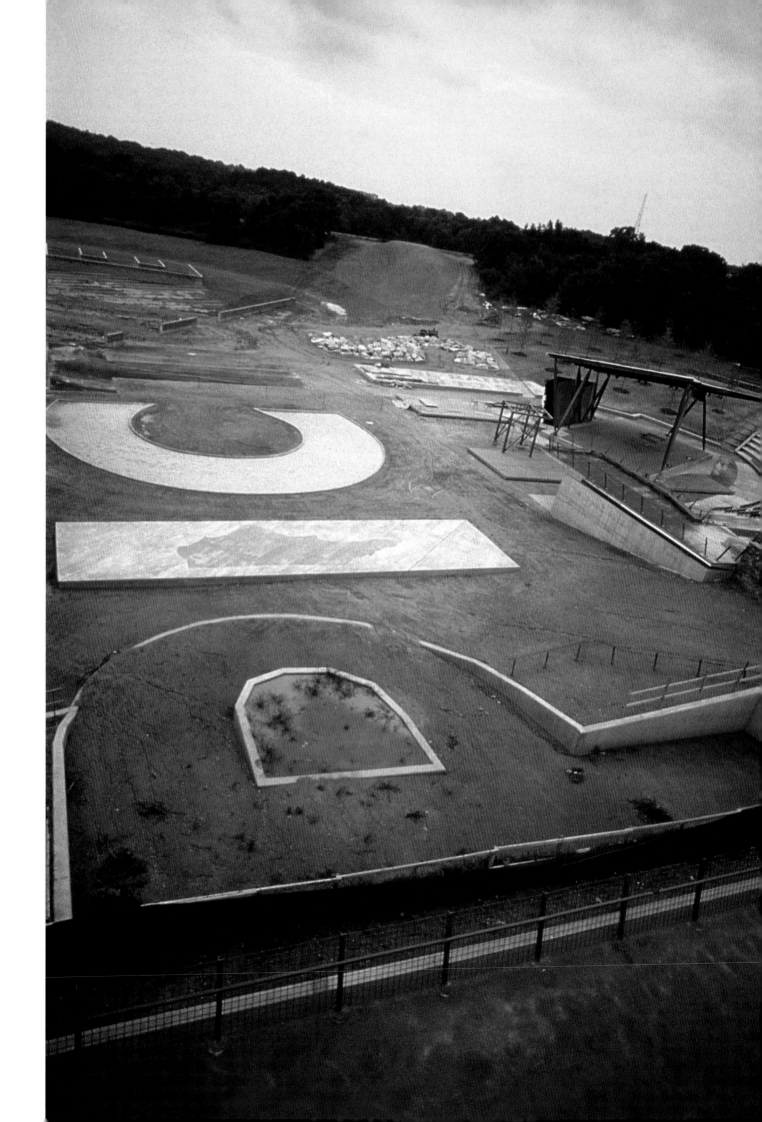

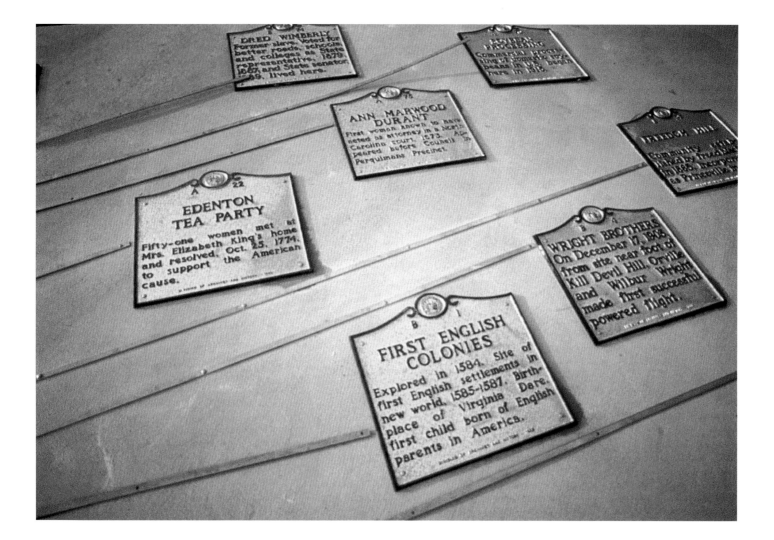

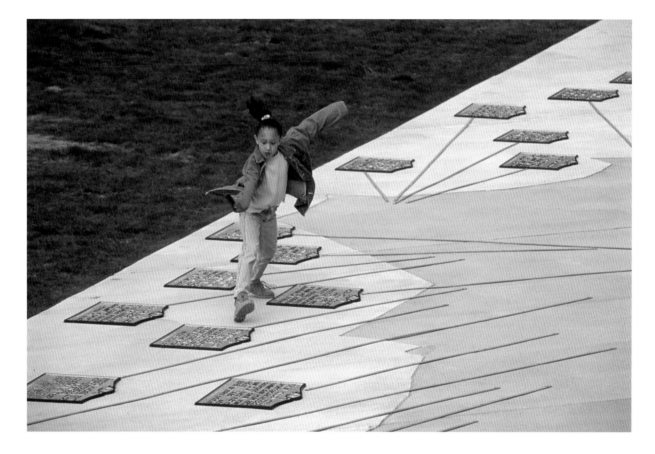

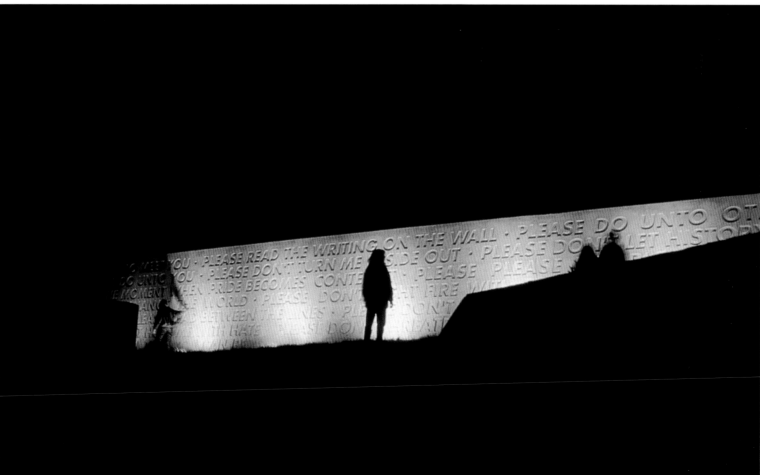

Barbara Kruger, in collaboration with Smith-Miller + Hawkinson Architects, "Unoccupied Territory," proposal for Los Angeles Arts Park, 1989.

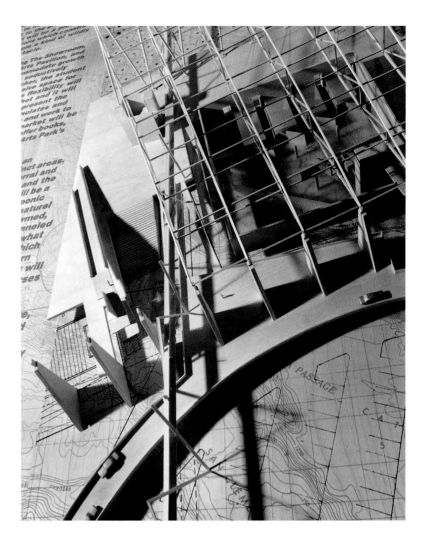

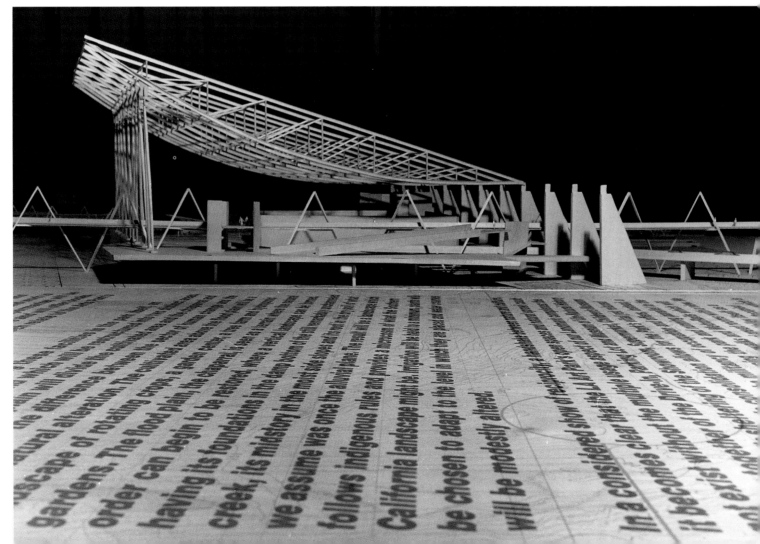

Barbara Kruger, in collaboration with Smith-Miller + Hawkinson Architects, Piers 62/63, section of proposed structure and realized project, Seattle, 1989.

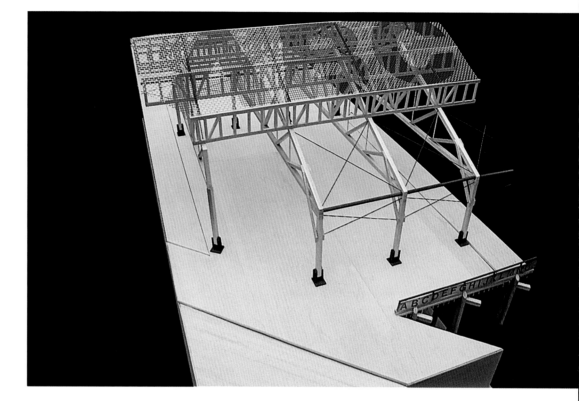

Video installation, 2005. Australian Centre for Contemporary Art, Melbourne, Australia.

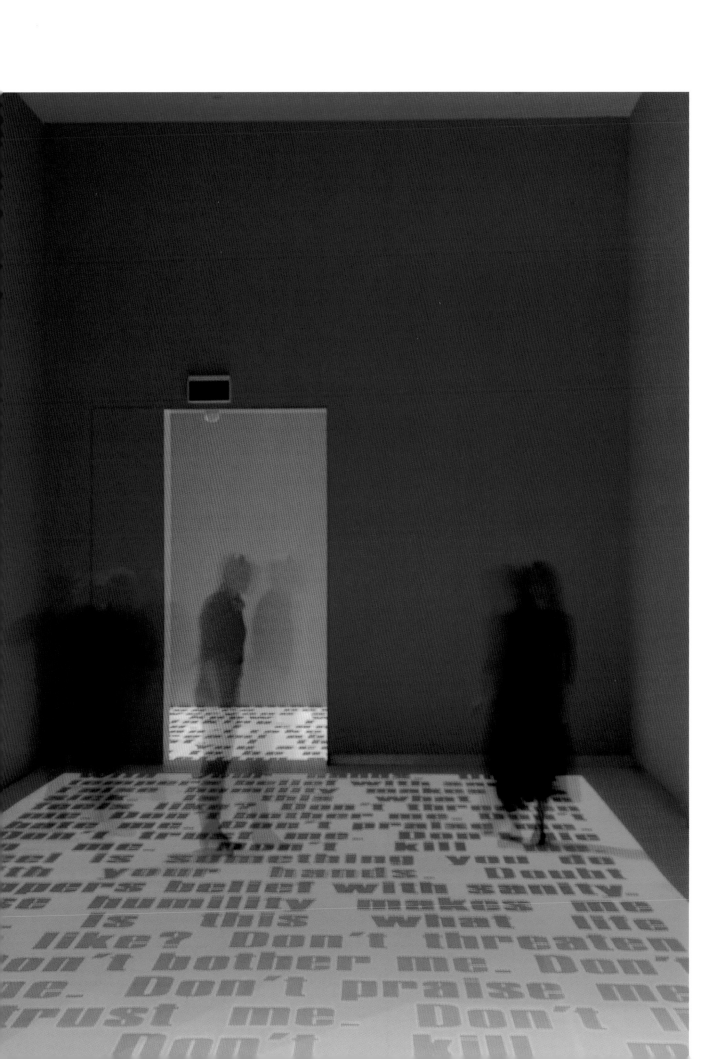

TWELVE, 2004. Multimedia installation, Mary Boone Gallery, New York City.

(118–19, 130–31)
TWELVE, installation views, Tramway, Glasgow, August 5–September 26, 2005.

(129)
TWELVE, video details.

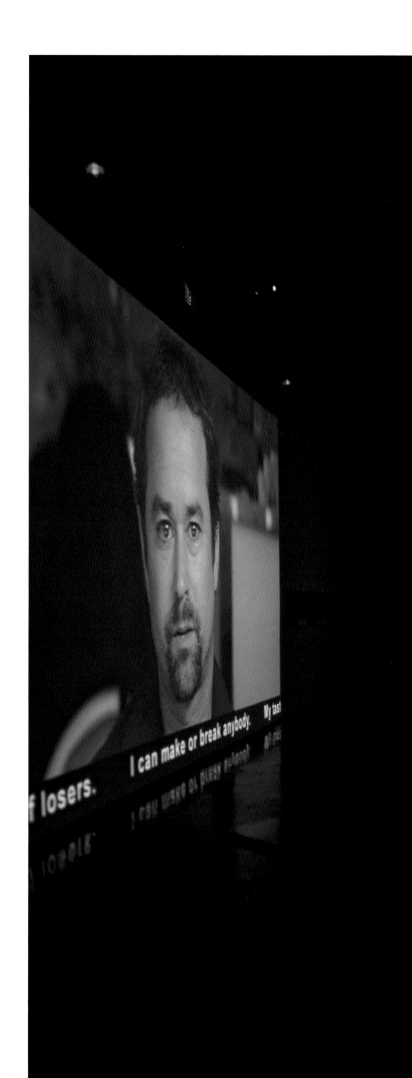

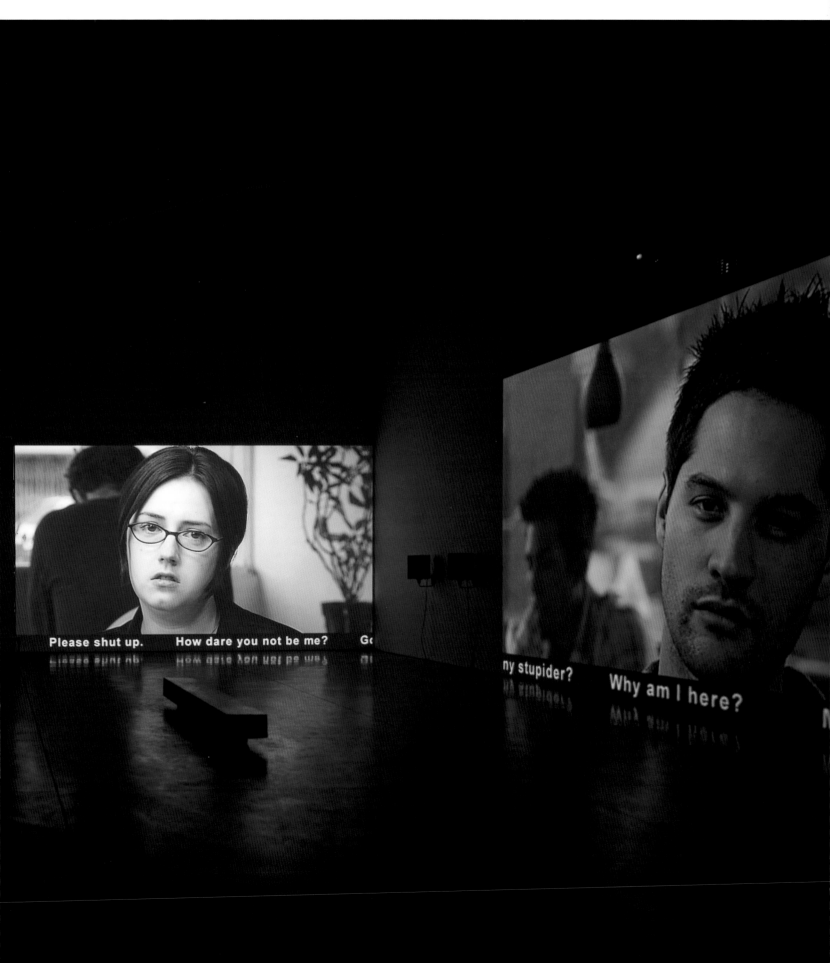

MARTHA GEVER

Like TV: On Barbara Kruger's Twelve

Technology, that relentless magic show, has changed our lives while both enlarging and shrinking the cultural field. It is now obvious that segments of society are not discrete categories, but rather simultaneous processes that collide, seep, and withdraw with, into, and from one another. —BARBARA KRUGER

STANDING

SOME YEARS AGO I was invited to contribute an article to an academic journal's special issue on video art, but the editor (of the journal, not the special issue) objected to the publication of my essay.[1] The problem, I was told, was that the piece was "sociological." This was in the 1980s, when this term was tainted by associations with empiricism. Although I protested the editor's rejection, I didn't object to this characterization of my article, which considered how institutional, economic, and political factors—all staples of sociological research—shaped the contours of what was then called video art.[2] This incident came to mind recently, when I started to think about writing an essay on Barbara Kruger's *Twelve*, because I seem to have upended my priorities. Here is a video installation that projects, literally, a cross section of contemporary interpersonal relations. As several reviewers have pointed out, the work enacts fraught communications ranging across the cultural landscape in a series of condensed exchanges among representative social types and groups—classmates and professional associates (including art critics), members of families, friends, and rivals.[3] Someone with a sociological mindset might propose analogies with Georg Simmel's catalogues of patterns of small-group interactions or Erving Goffman's studies of individuals' social strategies.

Such an approach might assay the compatibility of sociology and art criticism, but my interest in *Twelve* lies elsewhere—not in what it has to say about the

difficulties of social life in twenty-first-century America or the prevalence of petty insults and backbiting sarcasm in everyday conversation. It's not that these aspects of the piece are unremarkable. In fact, Kruger manages to hit these marks consistently and with an economy of words and images that we might expect from this artist, a feat that reminds us that the installation is the work of a virtuoso. Instead, what intrigues me about the work is how Kruger turns her twelve pithy teleplays into an experience of being inside a TV set and, after spending time inside, being left with a peculiar perspective, as if the place just exited is where televisual representations coincide with ordinary life. In writing about the work I am not so much concerned with what it tells us about the sorry state of interpersonal discourse as with how it reorients us to what we already know but might want to reconsider. In other words, I will concentrate on how the piece works, not on what it means, on how its social critique can be found in its architecture, not on the sociological theses it may illustrate.

CORPUS

The materials that Kruger employs in her work have been so varied that her use of video projection in *Twelve* might be dismissed as beside the point. But I think not, because video, which she has employed only rarely, allows her to take advantage of the malleability of this medium while summoning associations with the ubiquity of television. Kruger's 1997 show at Deitch Projects

[1] My article, "Pressure Points: Video in the Public Sphere," appeared in *Art Journal* 45, no. 3 (Fall 1985), guest-edited by Sara Hornbacher.

[2] On a 2005 panel at the Fabric Workshop in Philadelphia, organized by Mark Nash in conjunction with the exhibition *Experiments in Reality*, Michael Rush, who has written widely on video and new media, commented that video art has become a historical category, no longer applicable to current practices. Paradoxically, Rush's

assessment, with which I agree, signals the end of the decades-long struggle by many artists to achieve acceptance of video as an art form on a par with painting or sculpture, for example. The success of video art seems to have led to its irrelevance, when, without fanfare, video work has become commonplace in gallery and museum exhibitions, as well as in private art collections, but it is now classified under the broader rubric of "projected images" or "new media."

[3] See David Frankel's review of *Barbara Kruger*, Mary Boone Gallery, New York, *Artforum*, May 2004, 208; and Nancy Princenthal, review, *Art in America*, June–July 2004, 174–75.

The epigraph above is from Barbara Kruger, *Remote Control: Power, Cultures, and the World of Appearances* (Cambridge, MA: MIT Press, 1993), 4.

in New York City, entitled *Power/Pleasure/Desire/Disgust*, might be seen retrospectively as an anticipation of the 2004 installation. The former exhibition consisted of verbal statements inscribed on the walls, floor, and ceiling of the gallery, with three video monitors displaying different talking heads at the end of the long, narrow, cavelike room. The overall setting prompted corporeal metaphors for the authors of two notable descriptions of the piece. Lynne Tillman likened the exhibition to "a body, with words and sentences pulsing on the walls and floor. The space was active, alive, almost breathing." Gary Indiana recalled a "verbally seething skin projected onto architectural volumes."[4] *Twelve*, too, behaves like a self-contained organism, as it were, with gargantuan screens situated at right angles to one another that come alive as animated, speaking walls. Tillman also described what spectators encountered on the contiguous monitors of *Power/Pleasure/Desire/Disgust*, using words that could be applied to *Twelve*: "The characters talked about pain, need, desire, and they were sometimes angry and contemptuous."[5]

The departure taken in the newer installation has less to do with the comparatively uncluttered space—nothing beyond four synchronized tracks of recorded video, programmed to repeat nonstop—than with its reversal of the physical relationship between imagery and audience. In *Power/Pleasure/Desire/Disgust*, video rants confronted but did not enclose spectators; the texts printed on the gallery surfaces provided the enveloping environment. In *Twelve*, projected moving pictures depicting assorted people simultaneously constitute the entire show and define the exhibition space. Instead of two proximate bodies—one made of images and words next to the body of whoever ventures into the gallery—*Twelve* constructs a less distinct boundary between display and observer. Still, the two do not merge. The conventional model of a passive or disembodied viewer immersed in the active, moving image on screen—where "you enter the elsewhere of the moving image, and you leave your physical body behind"—does not apply.[6] The piece surrounds its audience with moving images and sounds, to be sure, but this audience must move within the piece, too. Corporeal bodies are not optional. Like certain buildings conceived with human movement, weight, and one's physical relationship to objects and other people in mind, *Twelve* is designed to be "decoded by the body" as much as by visual and aural means.[7]

The material structure of *Twelve* also recasts one of the features consistently identified in Kruger's work since the early 1980s: the impression of being addressed directly, which her images generate by using such pronouns as you, us, and we, combined with bold typography and other graphic methods that grab attention and implicate viewers.[8] Although the characters in *Twelve*—the head and shoulders of each one occupying a single frame—look straight at the camera when they speak, their lines are bits of dialogue with personae on other screens. Here, Kruger refuses to adhere to several conventions of cinematic or televisual production. She dispenses with the technique of shot-reverse shot montage that attempts to replicate realistic conversation. Instead the actors face front, with no intercutting, like people being interviewed in a documentary or a news program. But she also arranges them facing each other, so that they appear to be engaged in verbal exchanges not aimed at a hypothetical viewer but taking place between screens. The viewer, located between the talking heads, shares the point of view of the camera eye, as in classic narrative cinema, but is not sutured into the scene. She or he cannot occupy the imaginary place of the addressee because that person has not disappeared but remains visible, even if unseen by someone busy watching the speaker.

What may appear to be a minor adjustment of the dynamic between a spectator and Kruger's trademark combination of words and images produces an effect very different from direct address. No longer someone confronted with an arresting text that speaks with an insidious voice that seems to issue from her own psyche or from some higher authority that demands compliance, the spectator becomes a witness in the midst of a swiftly moving sequence of exchanges among others. The continual physical adjustments required by *Twelve* become one of its most powerful modi operandi. Although I hesitate to predict how someone else will

_____ 4 _____
Lynne Tillman, "Interview with Barbara Kruger," and Gary Indiana, "The War at Home," in *Thinking of You: Barbara Kruger*, exh. cat., ed. Ann Goldstein (Cambridge, MA: MIT Press, 1999), 194 and 9 respectively.

_____ 5 _____
Tillman, 194.

_____ 6 _____
Anthony McCall, in Malcolm Turvey et al., "Roundtable: The Projected Image in Contemporary Art," *October*, no. 104 (Spring 2003): 76. McCall describes the experience of viewing sculpture and moving images as "diametrically opposed" and says that the latter produces the effect of disembodiment.

_____ 7 _____
Kenneth Frampton, "Intimations of Tactility: Excerpts from a Fragmentary Polemic." *Artforum*. March 1981, 56. Writing about the neglect of sensuous experience in buildings designed for visual impact, Frampton remarks on the "nearness of tactility as distinct from the distance of sight" but adds that the two are "by no means mutually exclusive" (58).

_____ 8 _____
Many of the essays in the MoCA catalogue cited in note 4 discuss Kruger's use of "direct address" or "public address." In addition to Tillman, see, Rosalyn Deutsche, "Breaking Ground: Barbara Kruger's Spatial Practice," 76–84; and Ann Goldstein, "Bring in the World," 25–36.

respond to a particular work, it seems hardly controversial to propose that this installation both incorporates and disregards whoever ventures inside. In this respect, I find affirmation of my statement that standing or sitting surrounded by *Twelve*'s video projections is like being inside a TV set. But this is a TV set that makes it impossible either to indulge in passive engrossment or remain indifferent (gallery visitors who do the latter will most likely leave soon after entering the room). It is too overbearing and claustrophobic, too loud and confrontational, and the images are too monumental to permit attitudinal sloth.

MATTER

My reflections on *Twelve* really begin here, with an additional cryptic observation: the installation is televisual but not television. This is not television because there is no narrative, no plot, no individual identity, no specific references to events, whether fictional or otherwise, no "entertainment" but also no "information." I could go on. Obviously, I'm defining television in terms of programming formats and practices. Like any video work, *Twelve* necessarily employs the physical mechanisms of television that allow electronic impulses to register as pictures and sounds. In this respect, the installation's projection system does not depart significantly from the applied physics of an ordinary TV set. And although *Twelve* dispenses with much of what is considered the television formulary, Kruger wields the standard mimetic techniques that provide television programs with realist credentials—settings and props, costumes, makeup, and scripts that conform to plausible places and people—which underwrite the claim that TV reality mirrors life outside the box. The misunderstanding of *Twelve* as straightforward social commentary may stem from its accomplished televisual realism, although an astute analyst of institutionalized television like Kruger certainly knows how representational strategies achieve the conflation of media worlds and embodied worlds. A helpful example of how the reality effect is produced in a televisual context would be "reality-TV" shows, which engineer and edit social interactions according to the rules of Aristotelian drama. That is not to say there is

no connection between representational and existential realism. Both, of course, operate within the same specific cultural matrices. The connection applies also to *Twelve*. Because the protagonists Kruger invents sample television's semiotic categories—gender, age, dress, tone of voice, and cadence and volume of lines delivered, for instance—we can identify social types, figure out situations, or piece together relationships with minimal descriptive information. We recognize these folks, sort of, from TV, but some may also resemble people we know in the flesh.

The installation's twelve segments depict situations and characters who act and dress like people in generic TV shows or ads. There are a few children and a couple of adults well into middle age, but most are older teens or twentysomethings with practically flawless faces and practiced diction. The actors Kruger employs in *Twelve* could be bit players from the ranks of central casting (if such a movie production studio department still existed), enlisted to play stock characters. In this case, the types would include cynical political operatives; mean high-school girls; a group of ambitious, shallow, showbiz guys; a middle-aged black mother and her two petulant children; another family, white, in this case, with a father along with mother and two kids, all cranky; two young adult ex-best friends; two men with religious differences; and so forth. Individuals argue about dress, table manners, hairstyles, boyfriends, religious beliefs, and cars. They do so using different speech patterns and vocabularies, different types of excuses and insults, while gathered in different kinds of social clusters or different configurations of family.

As if to incorporate those who may feel disdainful of the middlebrow pills who play parts in the vignettes just noted, two more groupings seem to come from a more cultured habitat. One trio consists of two men and one woman who spout art-critical jargon. Another foursome conducts an acerbic debate about photographic ethics, taking positions on symbolic violence reminiscent of concerns raised in Susan Sontag's *On Photography*. These two sections seem less like generic TV than role-playing improvisations of art-world dissension. They also appear to be scripted specifically

for art-savvy audiences—in other words, those most likely to see *Twelve* who may pooh-pooh the importance of popular culture in their own lives. The incongruity becomes somewhat less extreme when a laugh track and snippets of applause, such as the sounds made by a live television audience, interrupt the discussion about fashions in art. By putting artists and art critics on the same plane as argumentative friends and belligerent families, Kruger makes a point about problematic arenas of social discourse from which no one is exempt. It's as if she wants to undercut any possibility of viewers' critical smugness when faced with an artwork that looks a lot like TV.

Although a blend of ingredients provides *Twelve* with realist reference points, more important are the connections Kruger makes to television as a popular cultural destination. Like sites explored in everyday life, TV worlds also have architectures that allow us to believe that we can roam about in their dematerialized landscapes, eavesdrop on their inhabitants, align ourselves with or distance ourselves from their characters, root for them or wish them ill, and situate all in coherent temporal and spatial situations. Kruger leaves many clues about the installation's affinity with televisual realism, but she also stresses its artifice. She does so with the sparest of means. For instance, rather than impersonating ordinary people in conversation as players in a circumscribed scenario, the actors in the various sections of *Twelve* perform snippets of what passes for social life on TV. For Kruger, television is raw material, her medium, with almost all narrative and historical elements removed, leaving only fleeting traces of affective moments that look and sound like those encountered on television.

DIGEST

Even though Kruger's installation would never be mistaken for the kind of television that has become a cultural fixture, she has produced a piece that can only come from an intimate involvement with TV. I've pointed out how *Twelve* differs from Kruger's previous work but should also note that she has paid attention to the pleasures and perils of mass media for years. This critical project informs not only her work shown in art-world venues—photo-text collages, sculptures, gallery and museum installations—but also in popular forums like magazine covers, billboards, matchbooks, and T-shirts, as well as in numerous reviews and commentaries written for newspapers and magazines. Against this backdrop, *Twelve* can be seen as the elaboration of what Kruger wrote about from 1979 to 1992 in her "TV Guides" column in *Artforum* and in related articles in other publications, including *Esquire* and the *New York Times*.[9]

A sample from one of Kruger's essays, "Arts and Leisures," a play on the name of the section of the Sunday *New York Times* in which it appeared on September 9, 1990, contains the gist of much of what she writes about mass media, and television in particular:

> Seeing is no longer believing. The very notion of truth has been put into crisis. In a world bloated with images, we are finally learning that photographs do indeed lie. In a society rife with purported information, we know that words have power, but usually when they don't mean anything. This concerted attempt to erase the responsibilities of thought and volition from our daily lives has produced a nation of couched-out soft touches, easily riled up by the alibis of "morality" and false patriotism. To put it bluntly, no one's home.[10]

This excerpt reads as a pretty standard, if well-phrased, portrait of the mindless population television has wrought, the kind of jaded judgment often uttered by undergraduates in cultural-studies classes. But Kruger doesn't end on this disparaging note; she goes on to credit art with the potential to glimpse alternatives available within, not outside, our media-inundated lives.

Here and elsewhere she steers clear of categorical reckoning, making this point emphatically as she records her responses to American TV shows, Howard Stern, Andy Warhol, and movies of all kinds. Despite the hortatory voices sometimes issuing from her images, Kruger's visual-verbal constructs, as well as her critical writings, tell us that she isn't interested in codified cul-

————————— 9 —————————
Kruger's writings on film and television in *Artforum* as well as other occasional pieces are collected in *Remote Control: Power, Cultures, and the World of Appearances* (Cambridge, MA: MIT Press, 1993).
————————— 10 —————————
Kruger, *Remote Control*, 4–5.

tural categories or excoriating moral values. What she demonstrates, as well as writes about, is a commitment to questioning cultural conditions, especially the concealed rhetorics of power sustained by complacency or complicity. Which brings me back to *Twelve*.

CONTAINMENT

An unruly, disputatious cast such as Kruger musters in *Twelve* might seem to invite chaos, devolving into an incoherent hodgepodge. But she solves this problem by implementing a few deceptively simple architectonic devices. Some of these borrow directly from television, while others invent new presentational techniques. (It is altogether possible that Kruger developed *Twelve* in a manner different from what I propose, beginning with an overall design, then crafting specific vignettes that might be described as the content. If such is the case, this does not require rethinking the analysis, because the two processes are both aspects of the finished piece.) Consider the arrangement of separate talking heads on walls facing each other, engaged in various kinds of verbal jousting. The fact that each character occupies a distinct wall is crucial to the reproduction of dialogue. The speaker's isolation—as each one responds to another's remarks as if taking up the gauntlet or aiming for the jugular—also emphasizes the failure of any kind of effective exchange of ideas or sentiments. As a dystopian mutation of Jürgen Habermas's public sphere, *Twelve* constitutes a place where any hope of communicative action that leads to understanding—the philosopher's antidote to rampant instrumentality—is dashed. In the midst of this panorama of discord, we are compelled to imagine why these people bother to spend time together. Attention is drawn to their relationships, which, like the characters, are generic—friends, colleagues, fellow students, families, lovers, rivals, or mere social acquaintances; those you live with, those you're related to, those you confide in, those with shared cultural references and values, those who want to verify your similarities or minimize differences, those who will never understand.

Such ruminations suggest the possibility of becoming an imaginary participant in at least some of what transpires. Identification is another feature of *Twelve* that Kruger deals with—or, I should say, thwarts—by setting up spatial relationships that set limits on how one navigates the installation's visual field. To see what is projected on any of the four walls, a spectator must be situated between them but can never be at the center, since in watching one screen another will remain impossible to see fully without swiveling, sometimes ninety degrees and sometimes one hundred eighty. Kruger's setup, where the four screens box in the projection space, produces a further frustration of the conventional dynamics of moving-image display. These screens are not just flat but impenetrable, as opposed to the seeming transparency of well-executed cinematic or televisual representations. The arrangement could be described as a case of "blocked vision," Anthony Vidler's term for the effect produced by Rachel Whiteread's sculptural cast of the interior space of a house but just as applicable here.[11] In other words, due to their location at the outer edges of the three-dimensional space within which the action takes place, the projected images do not suggest something beyond or behind what's visible—scenes expanding into offscreen space, say, or the illusion of depth produced by certain combinations of framing and focus.

Despite its construction using images that do not violate the rules of conventional perspective, any simulation of three-dimensional space beyond the frame is cancelled by the installation's spatial geometry, which locates the "action" in front of the screens, in the real space of the viewer rather than in the virtual space of the screen. Although the projected personae appear to occupy the same space—they seem to be speaking to one another—the space between them cannot be traversed without meeting resistance. Obstructing the otherwise unimpeded fictional space, of course, is the solid body of the viewer. To add to this list of obstacles to imaginary absorption, the brevity of each section—several last less than ten seconds—short-circuits identification temporally. Of course, personal connections may be triggered if watching and listening to the actors over the course of *Twelve* sparks an identification with television's phantom mass audience.

———————— 11 ————————

Anthony Vidler, *Warped Space: Art, Architecture, and Anxiety in Modern Culture* (Cambridge, MA: MIT Press, 2000), 147.

Yes, Kruger makes her elaborate orchestration of such formal elements as space, time, and scale appear effortless, as befits an accomplished artist. Yet she links these abstractions inexorably with specific cultural coordinates. The giant, elevated screens call to mind public video displays like those in Times Square or, on a smaller scale, at the local sports bar. Delineated space does not specify a topographic place, although this is not an utterly abstract dimension of *Twelve*. The historical location is undoubtedly the United States in the early twenty-first century. In addition to talk, specific cultural practices are enacted, most notably eating and drinking while sitting around dining-room tables (the two family groups), and in restaurants and cafeterias (the teenage girls, men accusing each other of repulsive mannerisms, photography disputants, and others). Dress and all other details of personal presentation—makeup, hairdos, gestures—barely register because these conform to contemporary American conventions.

Although visual cues alert us to *Twelve*'s kinship with ordinary television, beginning with the resemblance of many of the actors to characters we might see on TV, much is conveyed by vocal inflections. Emanating from speakers placed next to *Twelve*'s screens are whiny, angry, disingenuous voices like those narrating the break-ups and cruelties of daytime soaps; bickering, sarcastic wisecracks, and verbal one-upmanship heard on sitcoms and dramedies of the *Desperate Housewives* ilk or spoken by members of reality-TV families like the Osbornes or among competitors on the more recent spate of reality shows; teenage bossiness and snippiness familiar to viewers of *Laguna Beach*; and more. Accommodation never seems an option, and acceptance of differences seems unlikely. Instead, we get denigration of those perceived as inferior or disloyal or vulnerable and attempts to ostracize or embarrass. When a boy grabs a piece of bread off his sister's plate while they and their mother eat dinner, the girl yells, "Go eat your own food!" In a sarcastic retort worthy of someone on *The Simpsons* (or any other sitcom, for that matter), he shoots back, "Yo Miss Piggy I'm doin' you a favor." Then there's the bathos of a couple's face-off, with a man first pleading forgiveness (for exactly what is never clear) by intoning the cliché, "It won't happen again, I promise." But when the woman tells him she isn't going to take him back, he changes his tune: "This is over when I say it's over, OK?" She sobs and he continues his tirade, finally stomping off screen while demanding she get him a beer. Again, both truncated teleplays resonate effectively with the inflections of established TV genres.

Disaffection seems the shared condition of Kruger's protagonists, an impression that only intensifies with the superimposition of written texts along the bottom of the video frames. These crawling lines variously express the private thoughts of characters or phrases directed at them by a disembodied critic. The first kind of written commentary appears, for example, when one woman confronts another on the facing screen, accusing the other of stealing her boyfriend. She shouts at her former friend, "I loved him and you knew it. I trusted you," while beneath the image of the complainant run the crueler words, "I've had it with your bullshit. I'm sick of your lying . . . I hate the sound of your voice." Her counterpart, who speaks as an equally injured party, takes a more aggressive tone in the unspoken text that subtends her speech: "You're a fucked-up drama queen . . . It's all about you. So get out of my face . . ." The soundtrack carries a more civil version of how the characters regard one another; the silent text implies what they might say if they took off their gloves.

In a segment in which silent thoughts are articulated in a more impersonal register, four men apparently employed in the entertainment industry make competitive remarks about one another, ending with a series of insults about car ownership. While each actor appears on a separate wall, phrases of uncertain origin rush across the bottom of each screen: "You look like a winner but feel like a loser. Live like a loser. Die like a loser . . . Not famous enough. Not ruthless enough. Not cool enough. Not cruel enough. Not cute enough . . ." Perhaps these texts articulate self-recriminations. Or, like the unspoken words that run beneath the images

of the former women friends cited above, they could be read as what the men don't dare to say out loud. Or they may be aphorisms issued by an offscreen judge of the four craven characters. Detached from sync and from sound, the words float loosely. Because the source of these words remains unidentifiable, a definitive interpretation becomes likewise difficult to pin down. Still, such textual addenda amplify or complicate what's spoken, adding density to the already overcrowded parade of gabby personnel.

Adding another cognitive challenge, the lines of text sometimes move from left to right, but at other times the direction is reversed. The texts racing along also demand intensified concentration and can induce the frustration of trying to listen and read simultaneously, just like the annoying crawl feature of CNN and other cable news channels. Comprehension of the work demands more than cursory attention, making it necessary to stick around for at least two cycles of the twelve-part sequence. This implicit requirement, if satisfied, offers greater engagement for the audience, but not as passive observers. *Twelve* works only if the audience works.

<div align="center">DEVICE</div>

Although an assemblage of video projections, *Twelve* does not deal with television as a material object. Rather, television is the condition for the installation itself—for the characters, their gestures, lines of dialogue, the texts rushing across the bottom of the screens, and the rare visual and sound "special" effects. Repeated echoes of the current fashion in competitive challenges that has become a refrain on American television—familiar from reality-TV contests like *The Apprentice* or *Top Chef* or *Survivor*—can be heard as an insistent undercurrent of the piece. A teenage girl attacks a peer for dressing badly while getting ready for a trip to the mall: "She is, like, so wrong! I mean, look at that sweater . . . And the hair! Can we talk about the hair?" The four entertainment-industry guys use car talk as shorthand for discussions of personal status: "And what are you driving lately, a Corolla?" "Please, that's upmarket. I think I spotted him in a Kia. Two door." Members of a group of art aficiona-

dos debate whose critical criteria are best: "Oh no, here comes the theory vs. beauty riff." "I know. I'm so uncool. I just don't get it. I mean, how could you possibly think that a powerful painting could mean more than a pile of jargon?" An accumulation of such gatherings, *Twelve* constitutes a synthetic village. It's not a world I'd like to live in, although not very different from the one in which I do. It may be a relief to realize that participation in the act of spectatorship does not require membership in this fractious community. But, as I noted before, spending time in the company of *Twelve*'s shrill, overbearing cast compels bodily involvement, at the least. And no matter how vicious such repartee seems, at no point does *Twelve* impart the impression that TV should be turned off because it's a waste of time or reinforces not-so-nice sentiments better left unacknowledged. Instead, the installation proposes something more troubling, more complicated, and also more substantial. It amplifies the physical space of TV viewing to such a degree that this cultural practice cannot be dismissed as mere two-dimensional, superficial amusement. Those who see the medium as a sign of cultural disintegration, an invitation to drift into the shallows of distorted reality often associated with TV viewing, are not rewarded with immunity.

At the same time, Kruger neither encourages optimism nor advocates using art to invent a more democratic or less exploitative new world. In a catalogue essay from 1987 (that isn't at all outdated), she describes many indications of a not-so-obedient outlook that coexists alongside the craving for diversion: "Something may be stirring. Something located between theory, laughter, and the concretion of things."[12] Her refusal to supply a blueprint for what this "something" might look like should not be interpreted as either acquiescence or lack of political commitment. Rather, Kruger's cultural critique has always involved calling attention to power plays disguised as moral certainty. In *Twelve* the negation of moralism is especially bracing. Actors performing obnoxious examples of sanctimonious behavior have this effect. So, too, does Kruger's apparatus as a whole, which borrows pieces of televisual technology that accentuate TV's moral ambivalence.

———— 12 ————
Kruger, *Remote Control*, 231.

The substance of the interactions among characters and the individual personifications offer a replay of the kind of verbal vacuity and lackluster acting found across the TV spectrum, which is about what we'd expect from the most vulgar kind of entertainment. Meanwhile, *Twelve*'s citations of television's visual and aural inventiveness exhibit the aesthetic aspects of one of the guiltiest of guilty pleasures.

Twelve does not operate on a conceptual level alone. For my part, the associations I have proposed occurred as a critical riposte to physical participation in the piece. I found myself stopping short upon entering the noisy space bounded by moving images; staring in bewilderment at what appeared to be enormous TV screens, but soon moving toward the center of the gallery for a better view of the various minidramas; pivoting my body in order to keep up with the rapid relocation of words and images; grappling with the problem of simultaneously watching the faces that appeared to speak the words I could hear while reading the supplementary texts at the bottom of the screens; and, finally, needing to extricate myself from the barrage of sensory demands. I found myself attempting to figure out what was going on, who these people were and what the relationships between them could be—as happens routinely when watching TV. Less familiar was the sense of frustration when none of the dramatic moments congealed into narrative. But as each puzzle was quickly replaced by another, curiosity prevailed over impatience.

Eventually, the effort to dissect the piece into discrete stories or individual characterizations, a habit of narrative consumption, becomes impossible to sustain. Here is a room lined with overloaded displays of generic actors speaking dialogue peppered with catchphrases from a variety of pop-culture sources, a televisual spectacle with no plot points, no story arcs, no mysteries to solve or relationships to disentangle, not a single joke without sarcastic undertones, and not even a coherent persona with whom to sympathize or to despise. Yet the piece is as compelling as any tele-vision program, although different in its appeal. The structural dimensions of the installation—the volume of the soundtrack as well as the size of the projections, the enclosure formed by the four screens, the hypertrophy of all the elements combined—insistently elicit somatic resources. As I have argued, imaginary engagement may be trickier, certainly if conventional models of spectatorship are applied; even without the usual devices used to secure audience involvement, the work situates in the midst of the action those who enter. However, it does so with a twist: the viewer is never acknowledged as the subject addressed, the person for whose benefit the performances take place.

Hence, *Twelve* harbors a paradox, and it enacts or, rather, invites its audience to enact this paradox. The installation presents stripped-down televisual tropes that proceed as a series of spectacular but disconnected, schematic bits. The pageant may be devoid of narrative pleasure but still can be seen as a fascinating sampler of social pathology. One witnesses the piece as an outsider, someone occupying a ringside seat but with nothing in particular at stake. At the same time, active participation becomes imperative as soon as one enters the gallery and begins to maneuver within the installation. Once it's possible to get inside this prototypical TV not as a passage into the realm of fantasy but as a place where televisual reality is pieced together, one's corporeality becomes a vital—living, active—component of the apparatus's workings. Despite the estrangement *Twelve* encourages, the installation does not discourage engagement. The televisual impersonations of ordinary people in mundane situations blown up to gigantic proportions affirm television's importance as a cultural resource. A more subtle effect of the installation can be found in the space Kruger opens for an audience released from gripping identifications. Among *Twelve*'s array of stereotypical gestures, inflections, and conversational styles—the dramatic repertoire that TV uses to simulate social life—it's possible to find correspondences with conduct in our own untelevised lives.

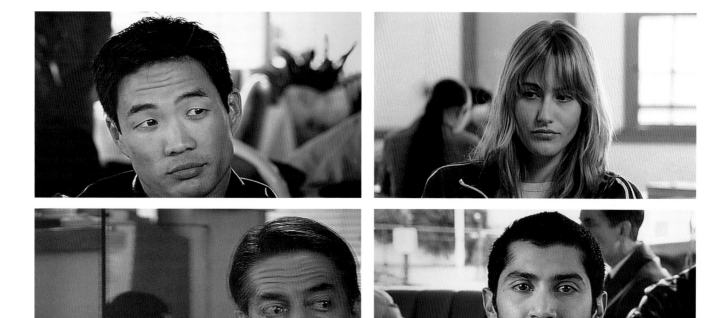

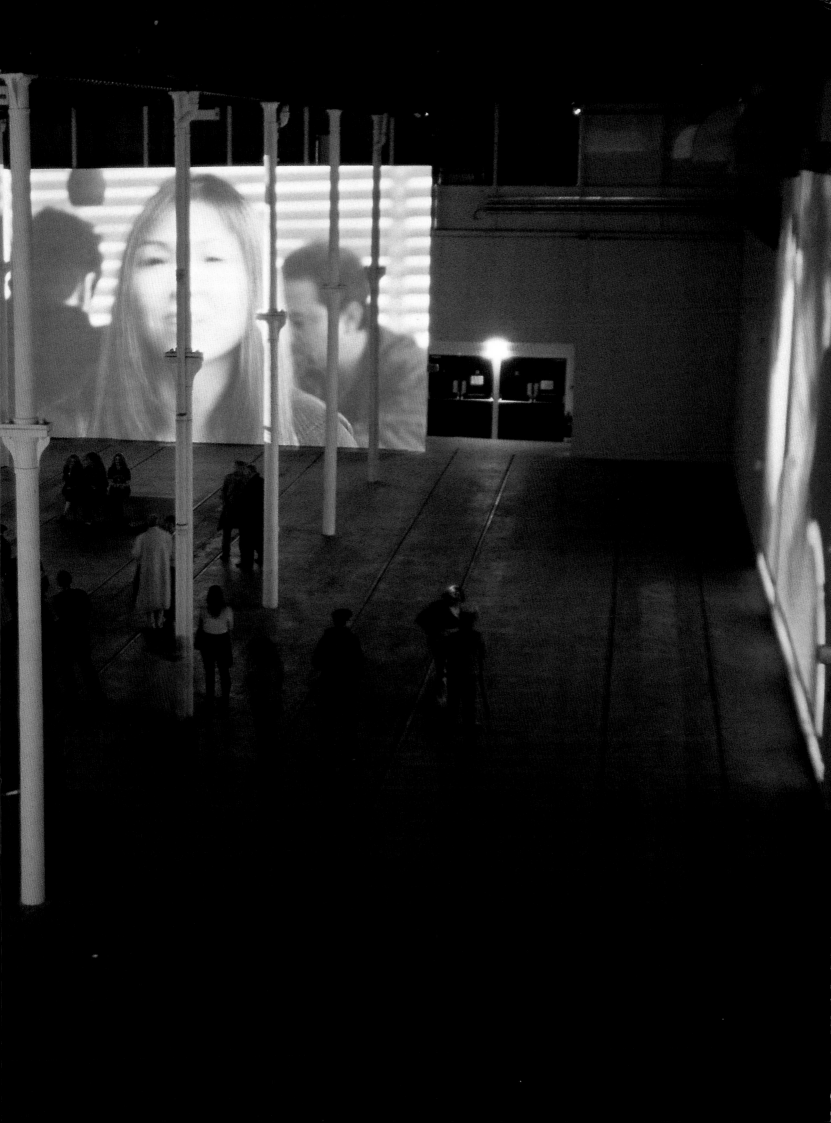

Installation views, **POWER/PLEASURE/DESIRE/DISGUST**, 1997.
Deitch Projects, 18 Wooster Street, New York City.

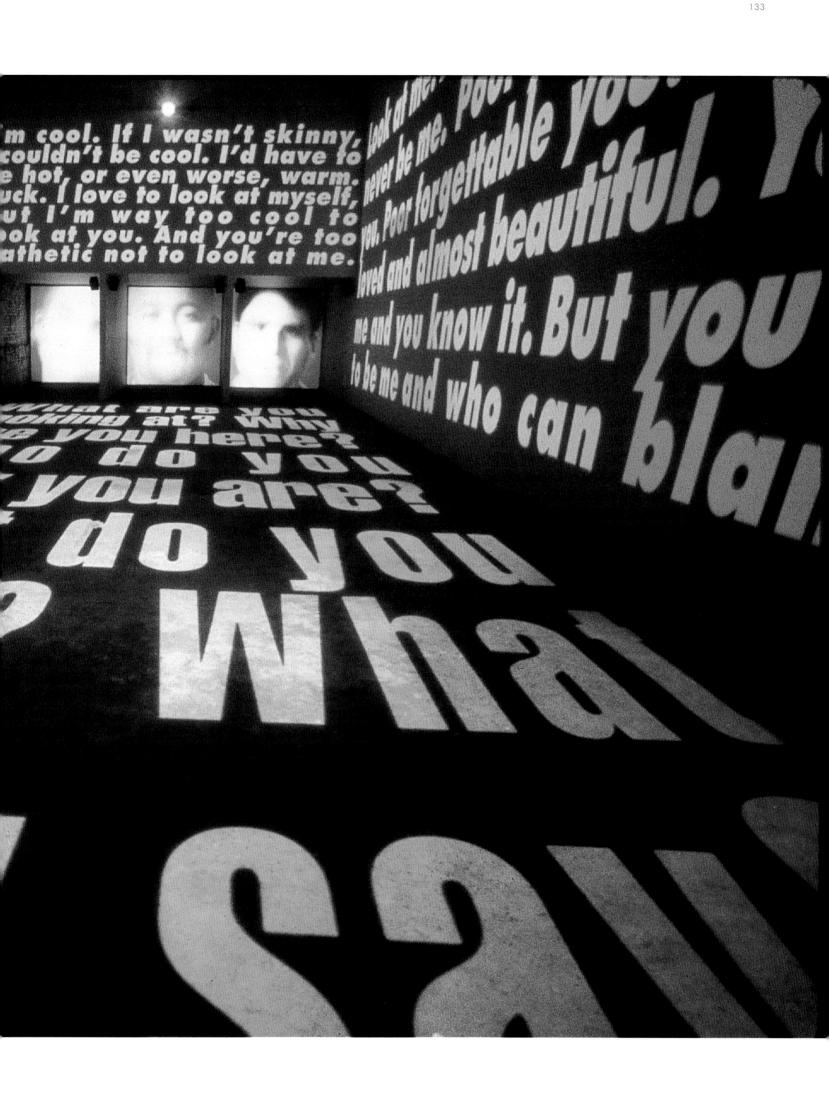

(this page) **POWER/PLEASURE/DESIRE/DISGUST**, 1997. Video details, Deitch Projects, 18 Wooster Street, New York City.

(opposite) **POWER/PLEASURE/DESIRE/DISGUST**, 1996. Video detail, Museum of Modern Art, Heide, Melbourne, Australia.

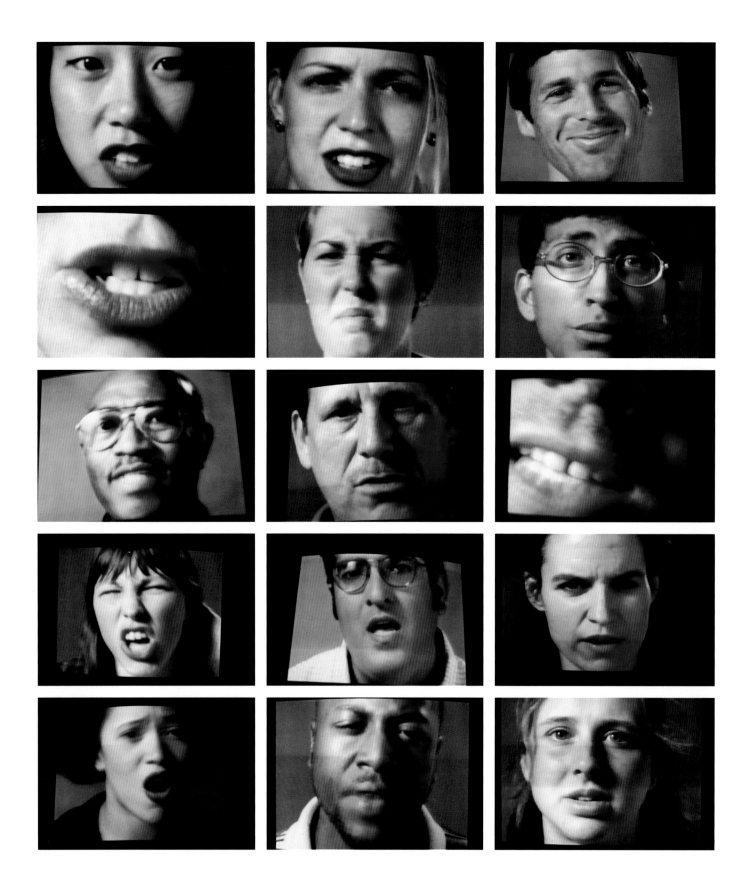

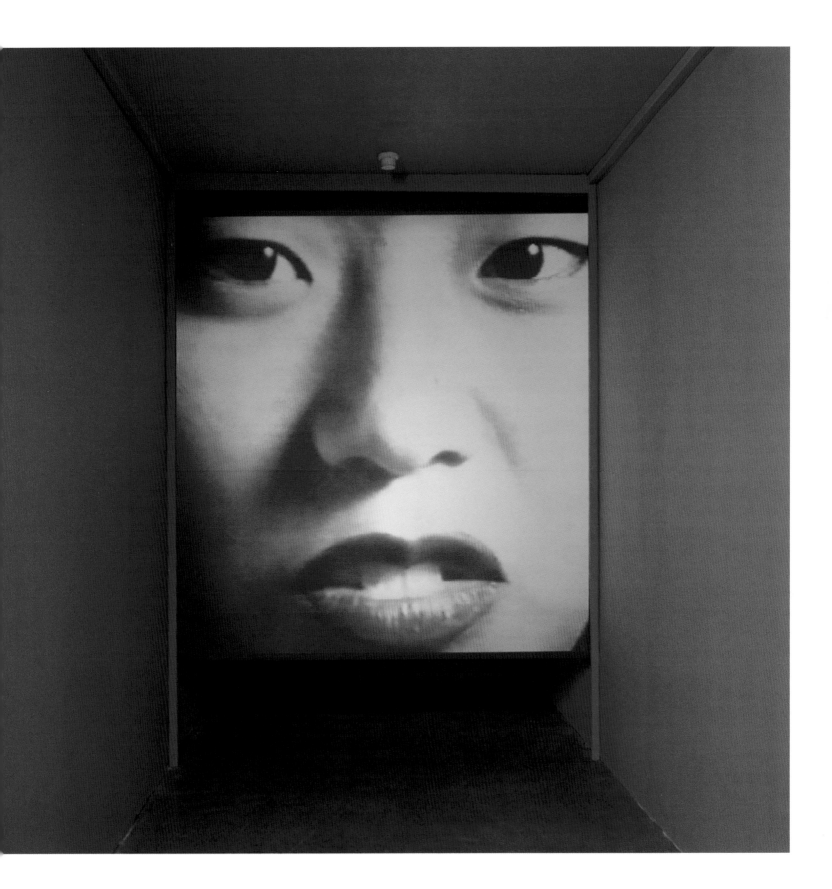

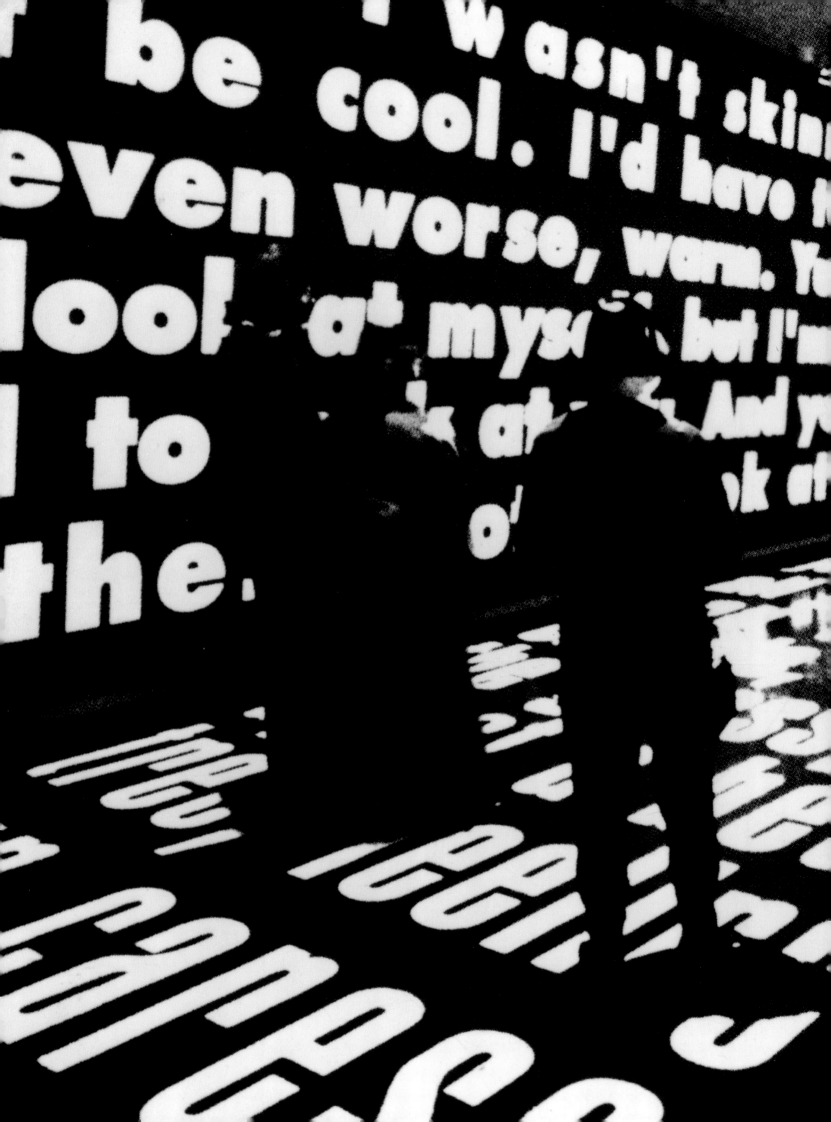

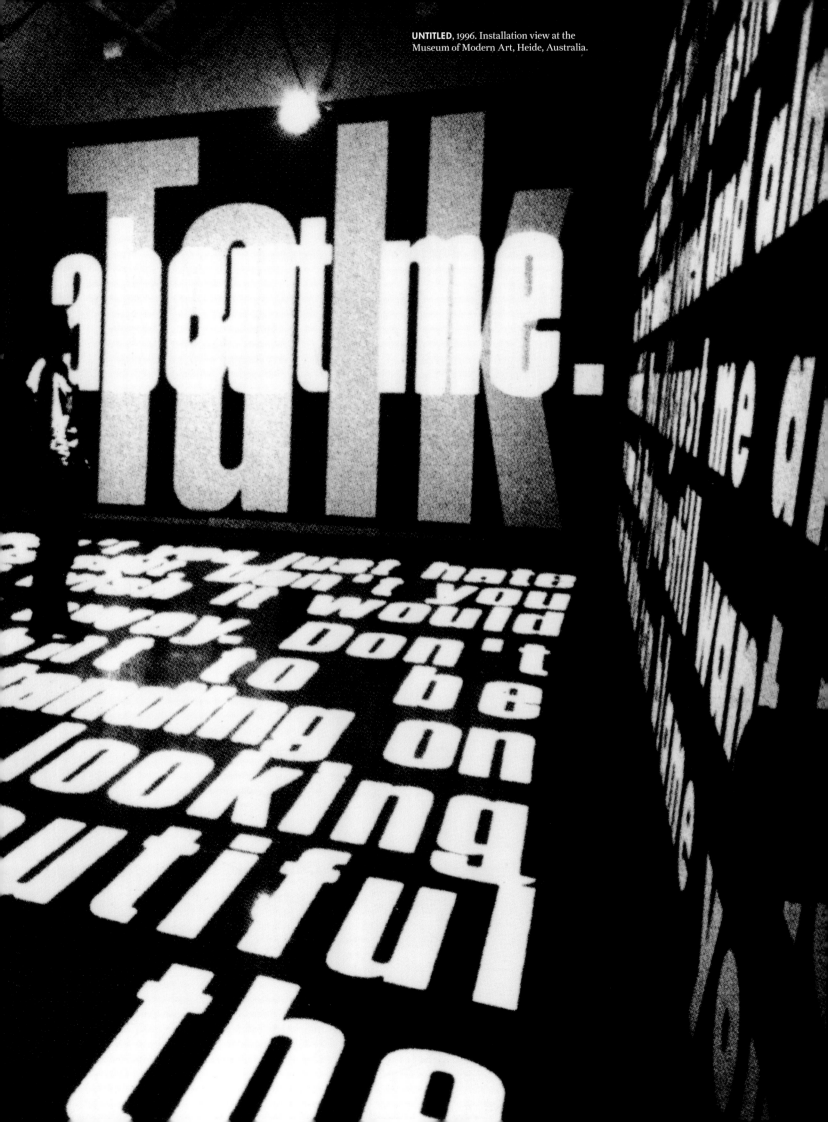

IT'S COOL TO BE KIND. LIVE AND LET LIVE, 1996. Video details of public service announcements, Wexner Center for the Arts, Columbus, Ohio.

138

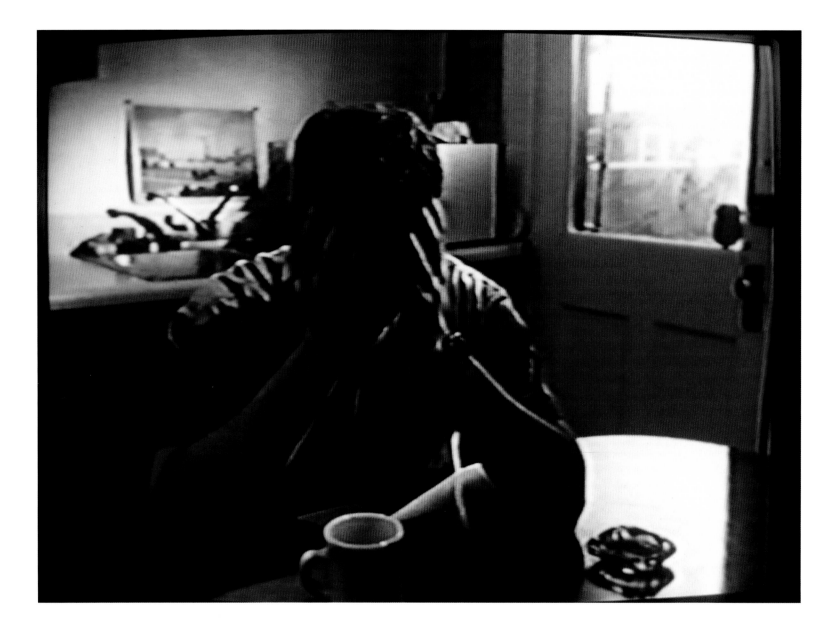

Don't be a monster.
Keep your hands to yourself.

Don't torture
Don't hate
Don't scream
Let it go

SILENT WRITINGS, 2009. A group exhibition at Espace Culturel Louis Vuitton, Paris.

140

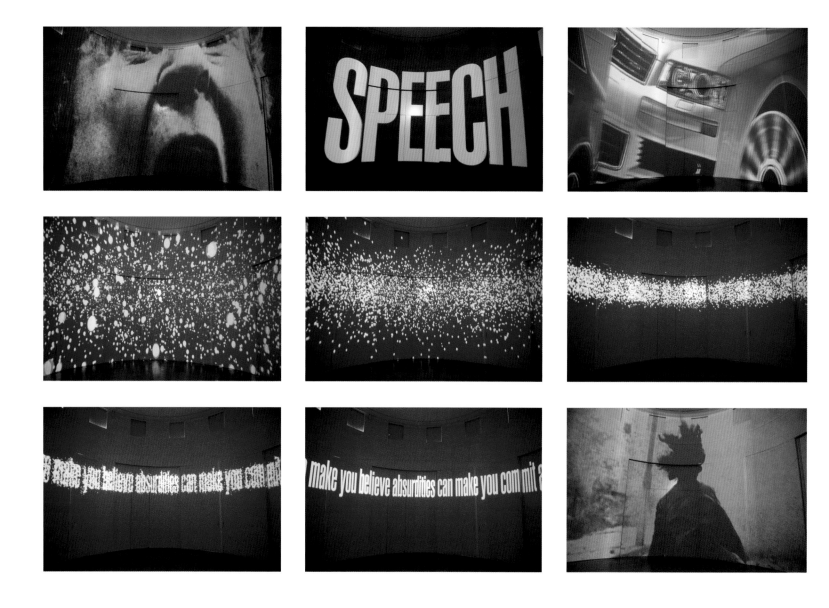

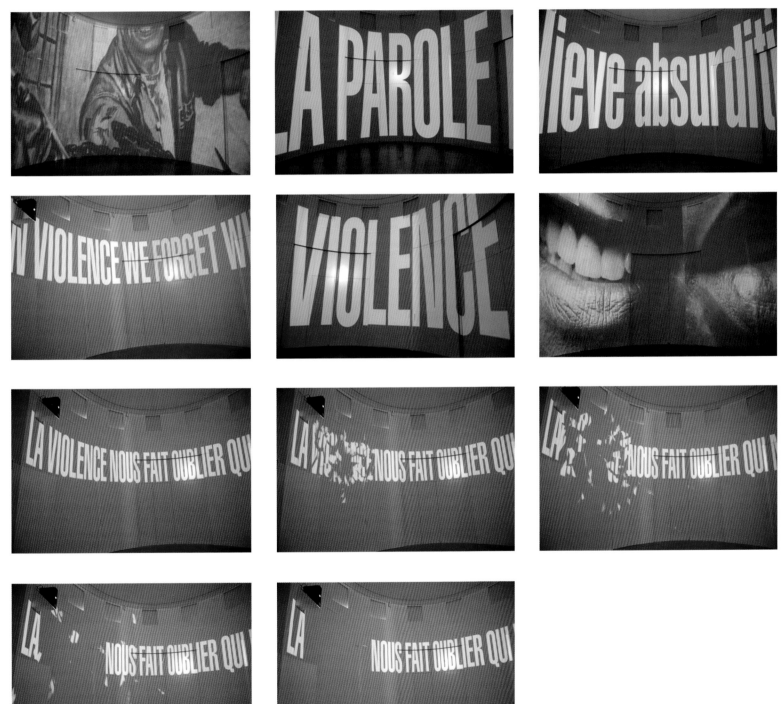

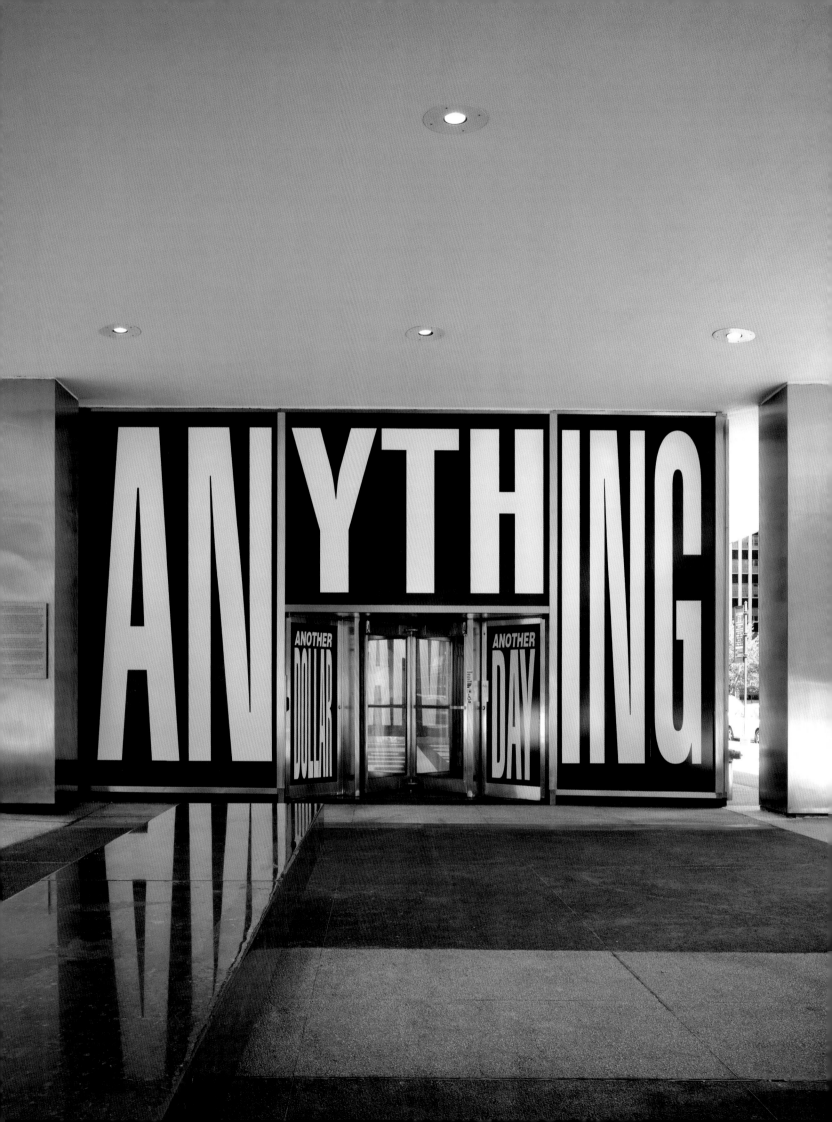

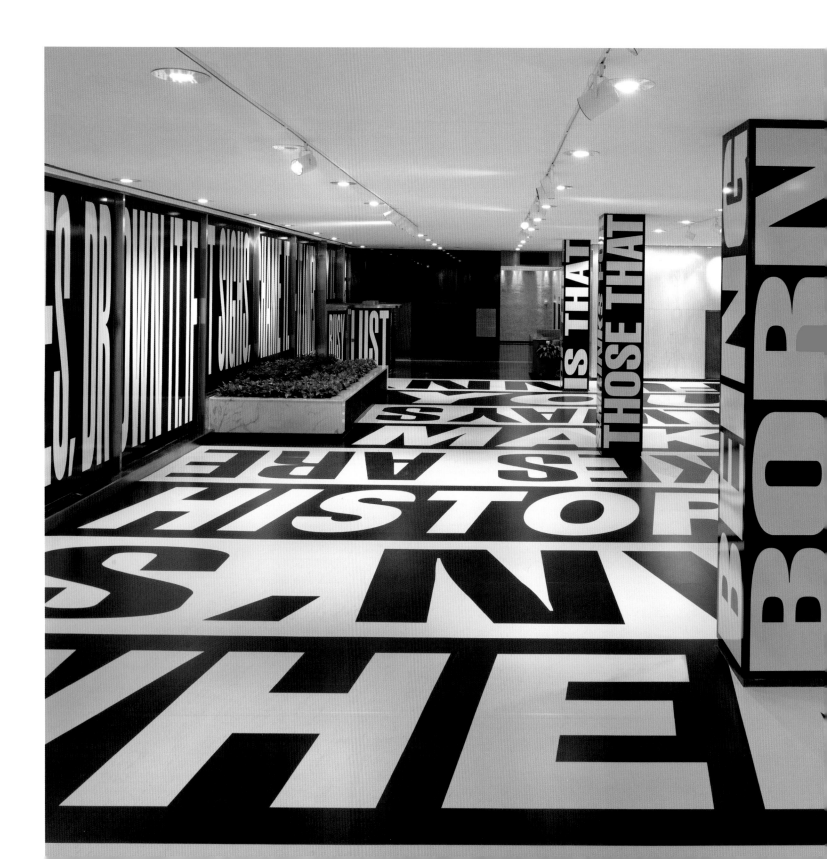

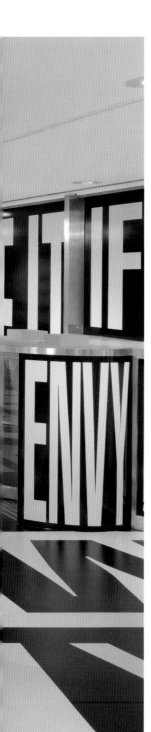

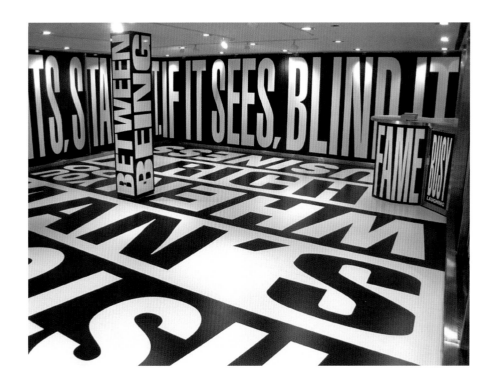

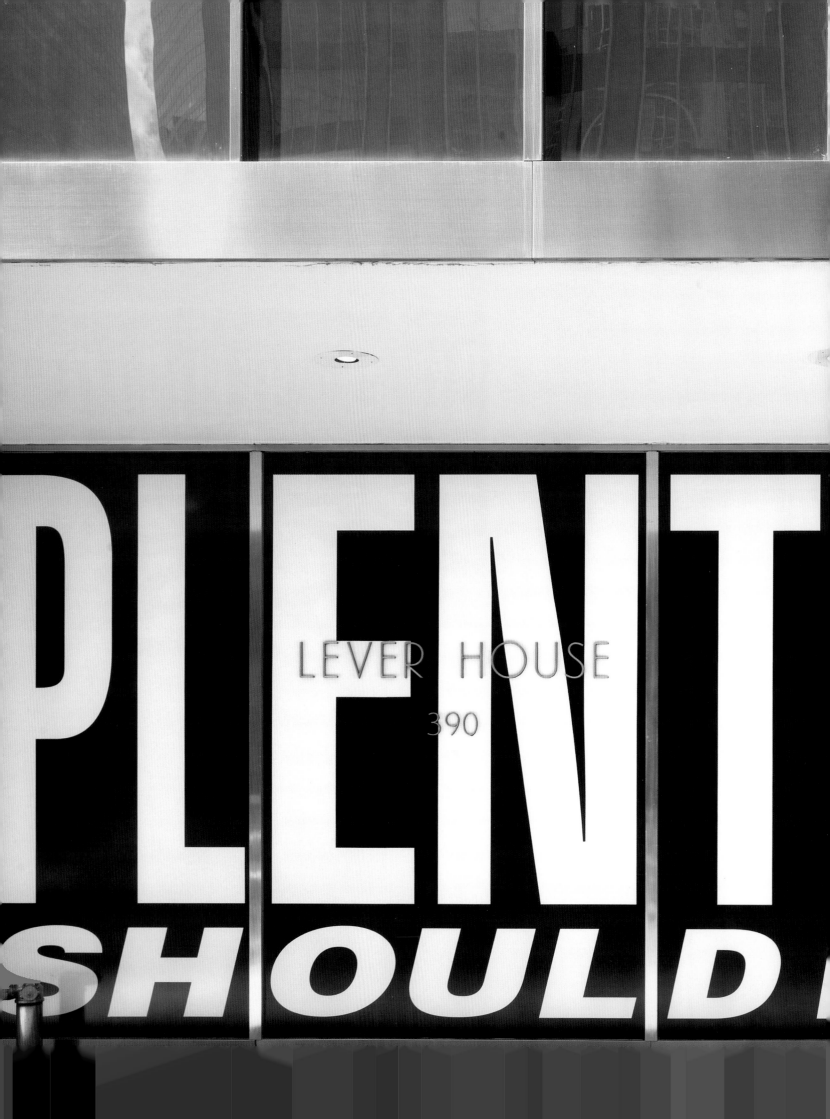

(148–51)
Installation views, **BETWEEN BEING BORN AND DYING,**
May 9, 2009–September 18, 2013. Moderna Museet, Stockholm.

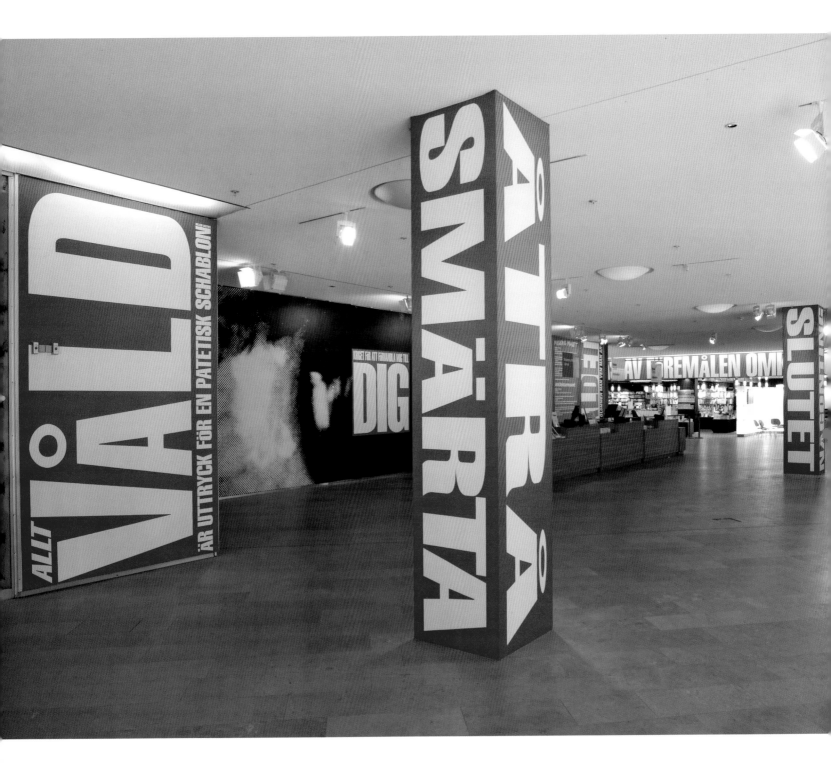

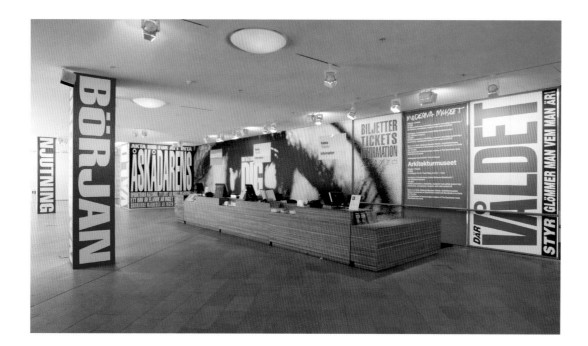

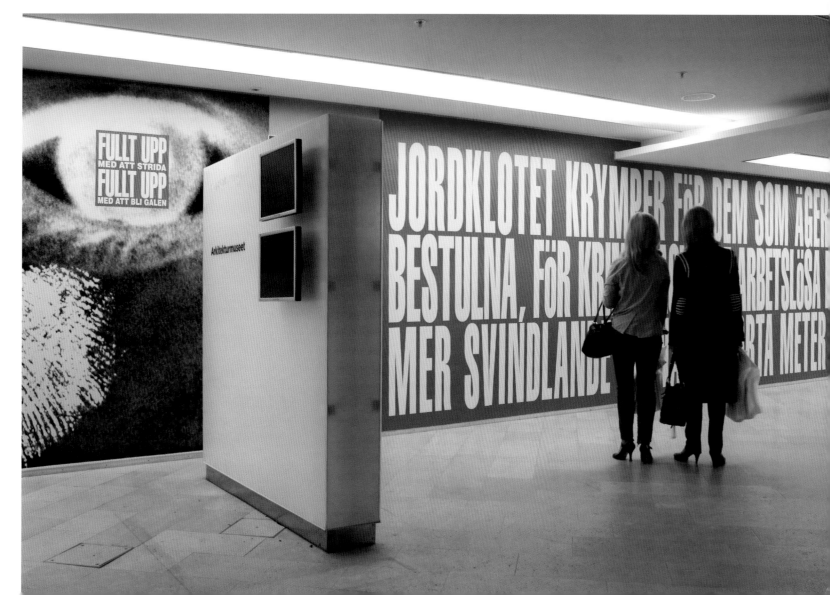

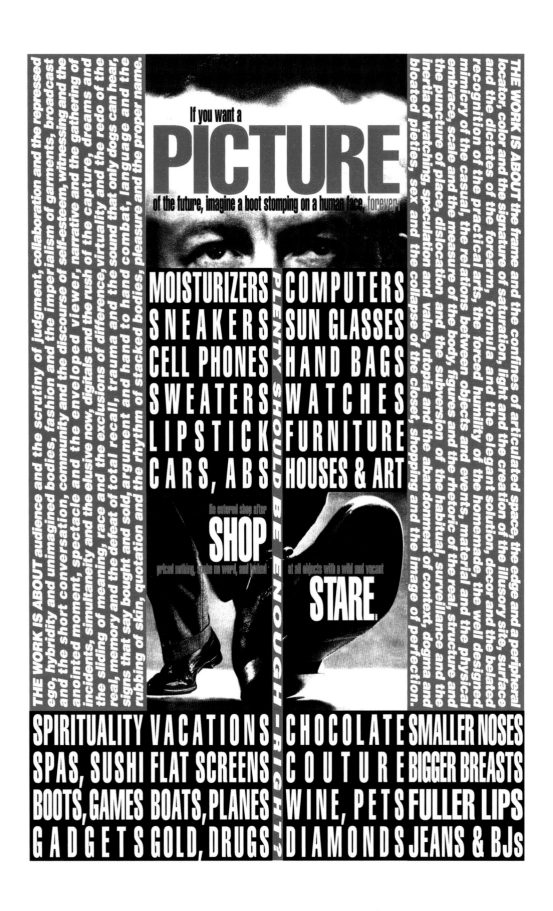

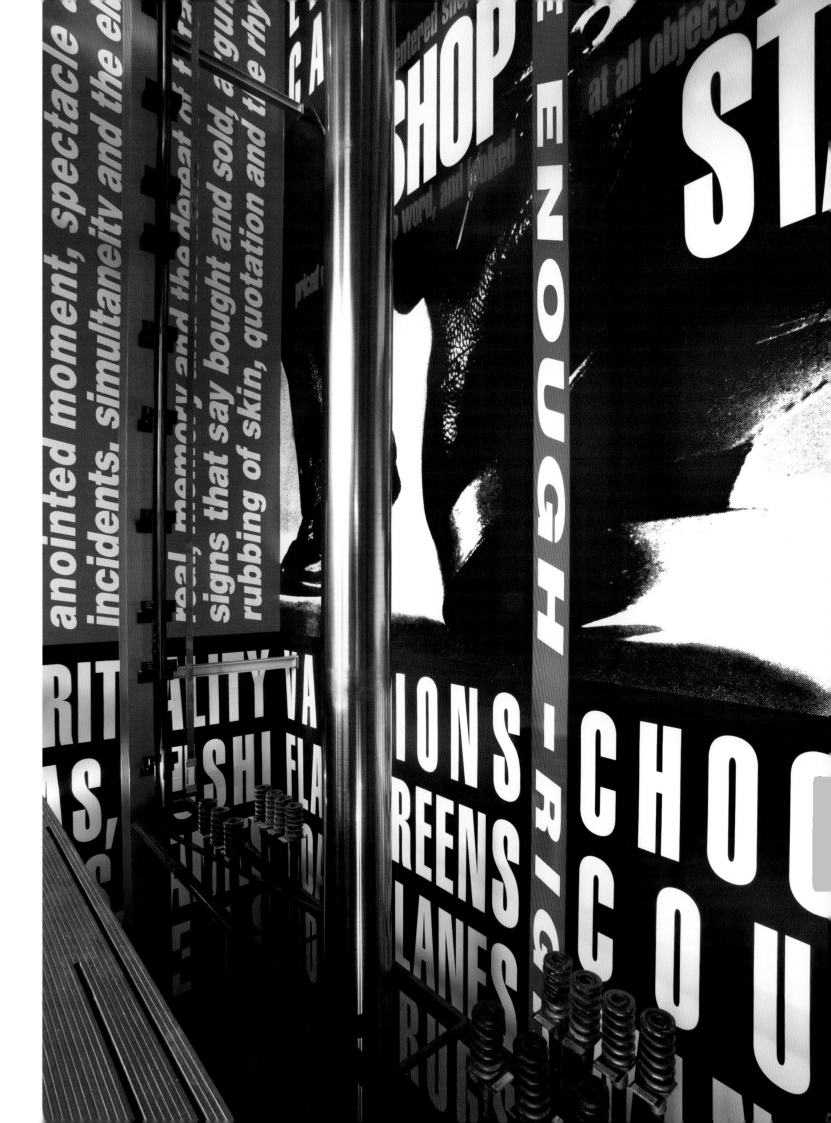

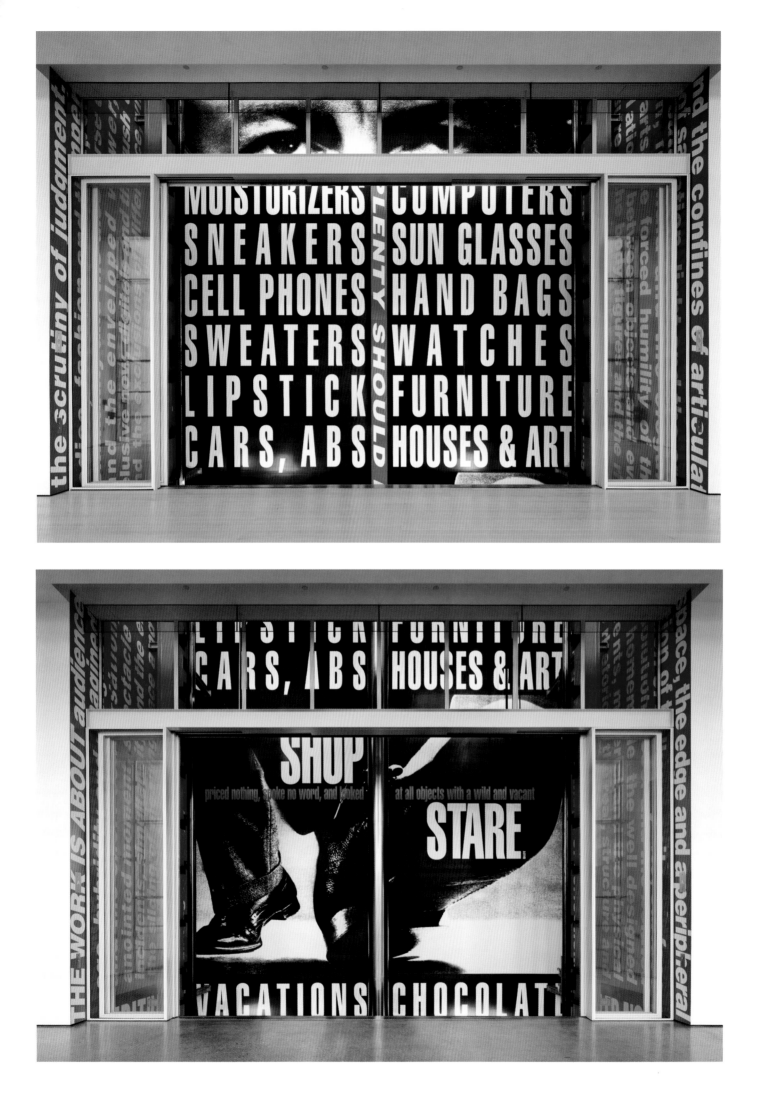

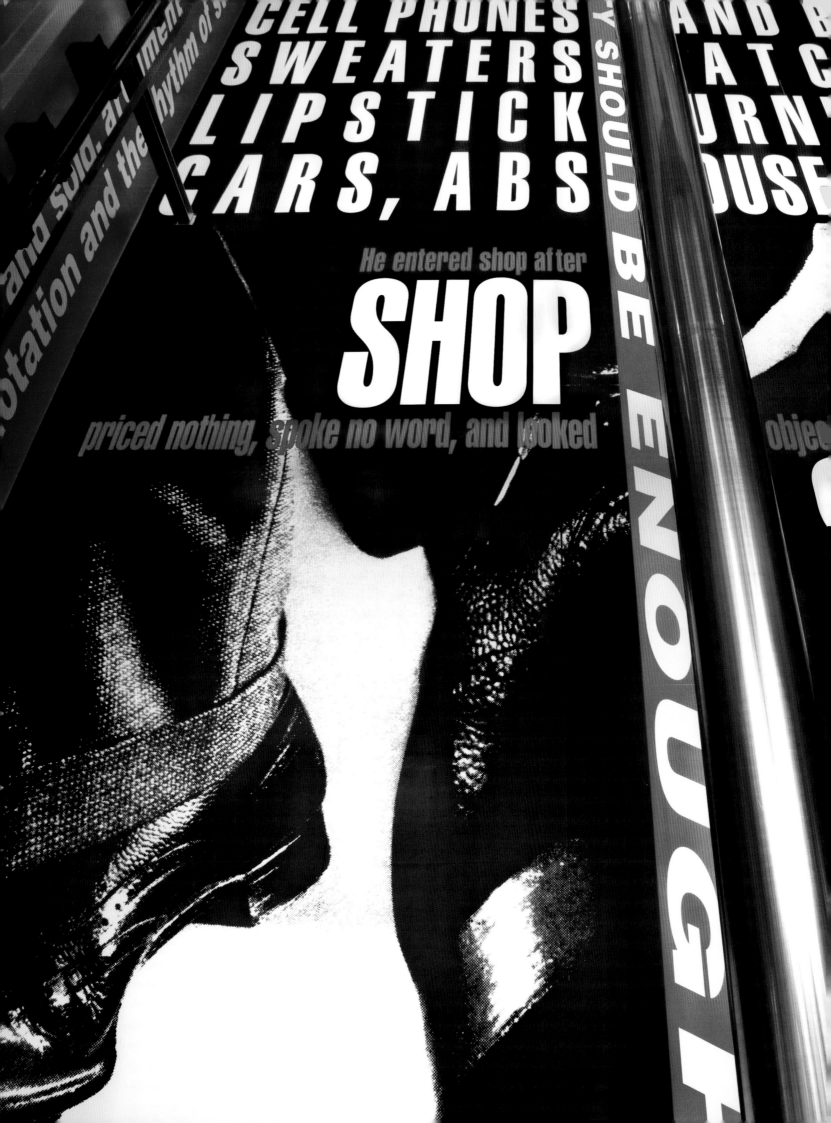

ANOTHER, 2008. Price Center, Stuart Collection,
University of California, San Diego.

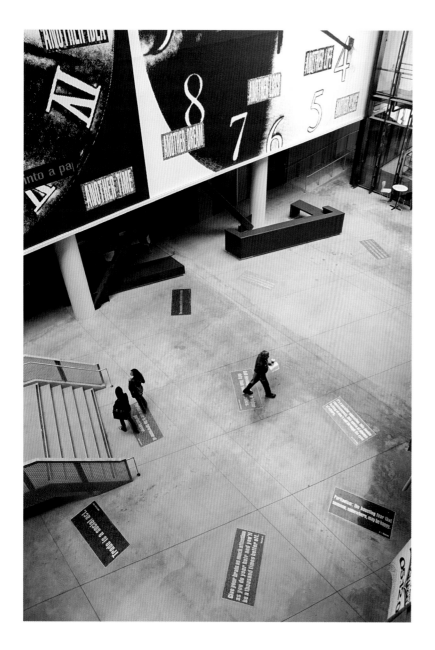

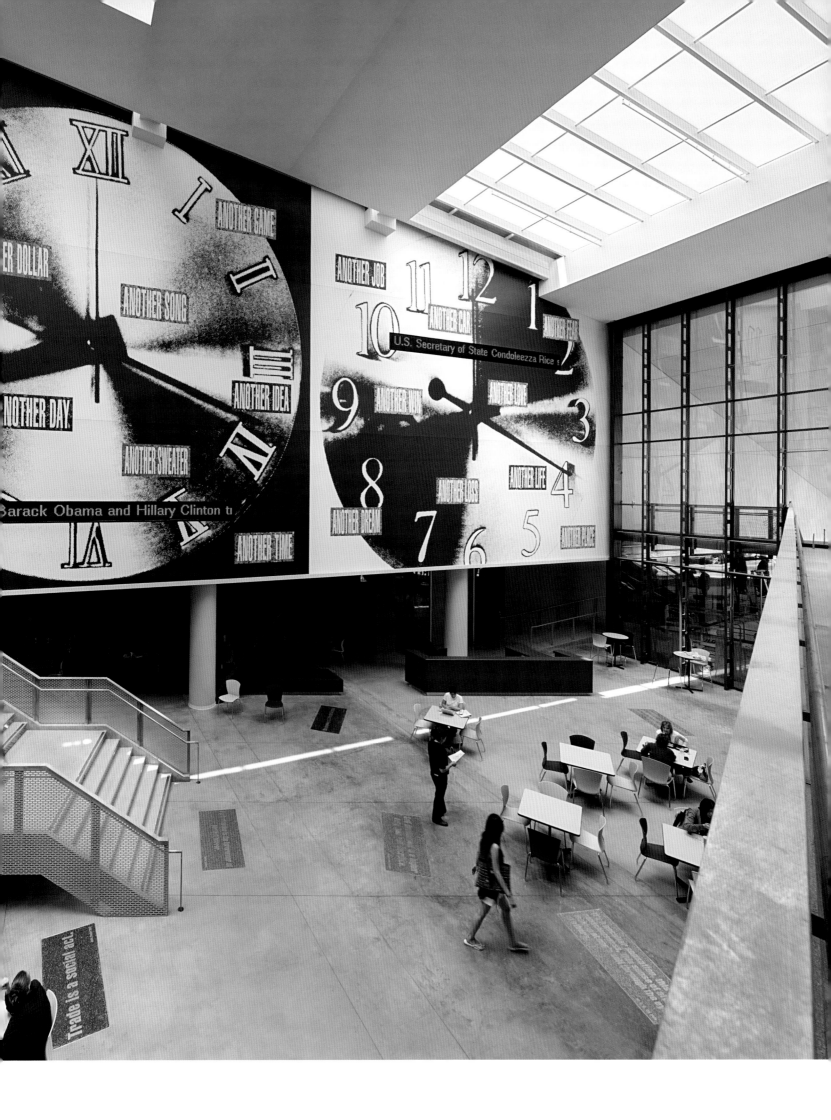

CONSIDER THIS exhibition design, 2007. LACMALab, Los Angeles County Museum of Art.

158

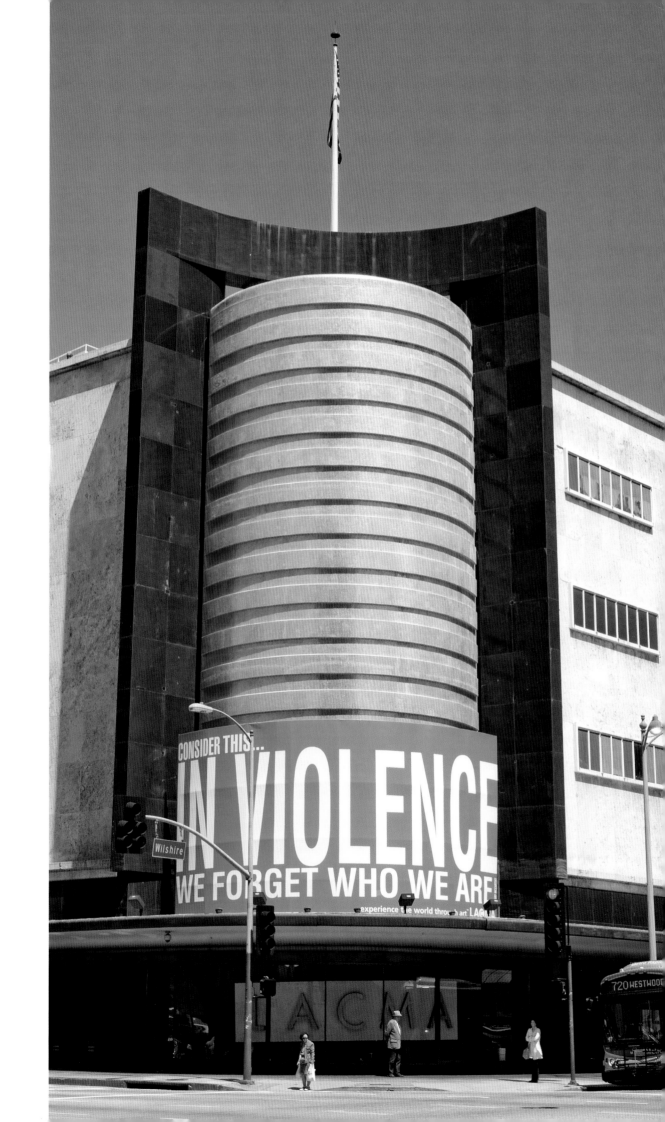

Photographic wall mural project for patients' rooms, 2008.
Oncology Section, UCLA Hospital, Santa Monica (unrealized).

ROOF

ACUTE CARE UNIT
(26 BEDS)

Installation views, **DESIRE EXISTS WHERE PLEASURE IS ABSENT**, 2006.
Kestnergesellschaft, Hannover, Germany.

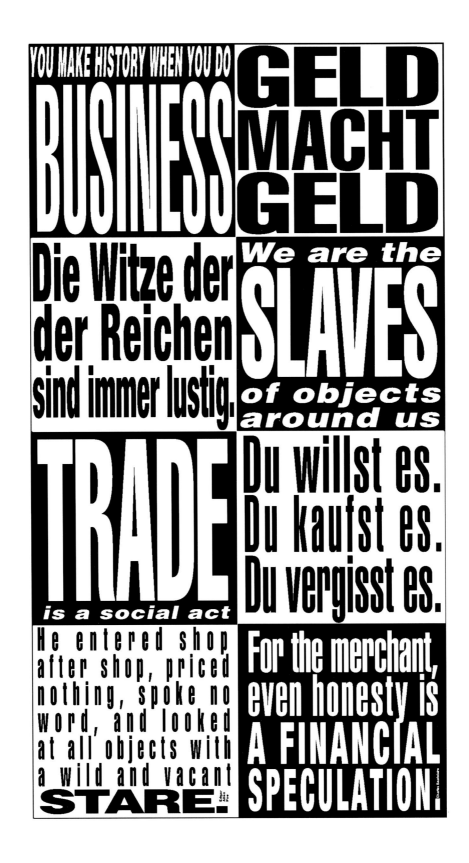

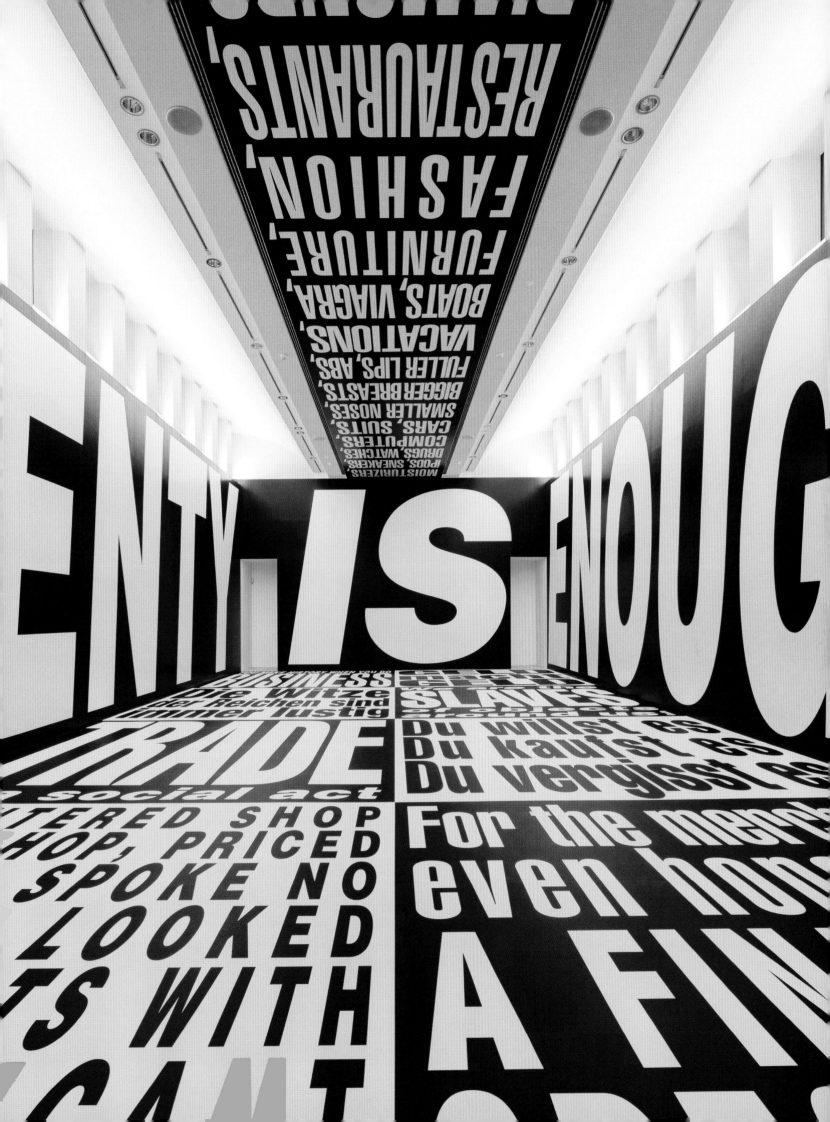

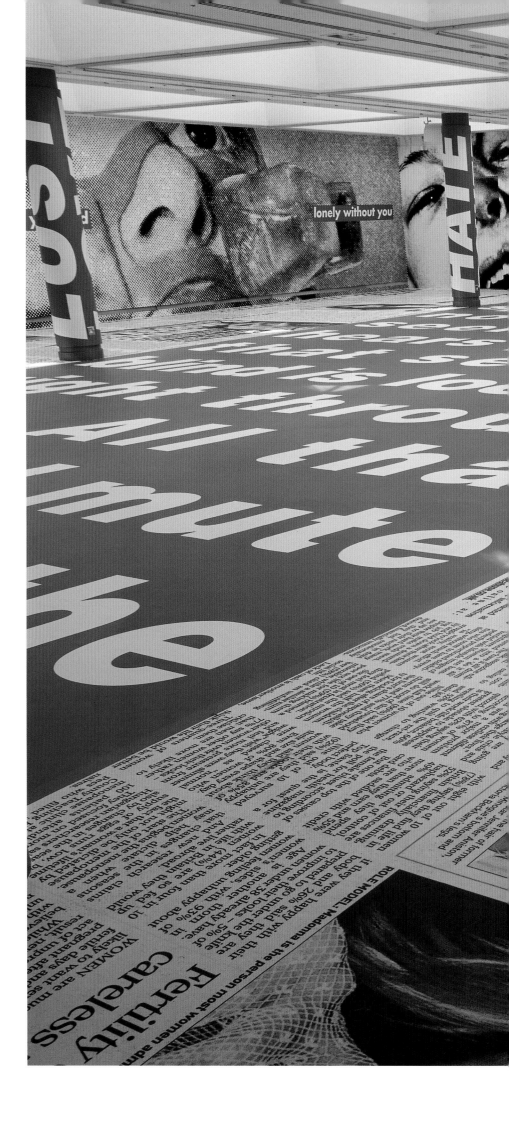

(164–69)
Installation views, 2005.
Gallery of Modern Art Glasgow, Scotland.

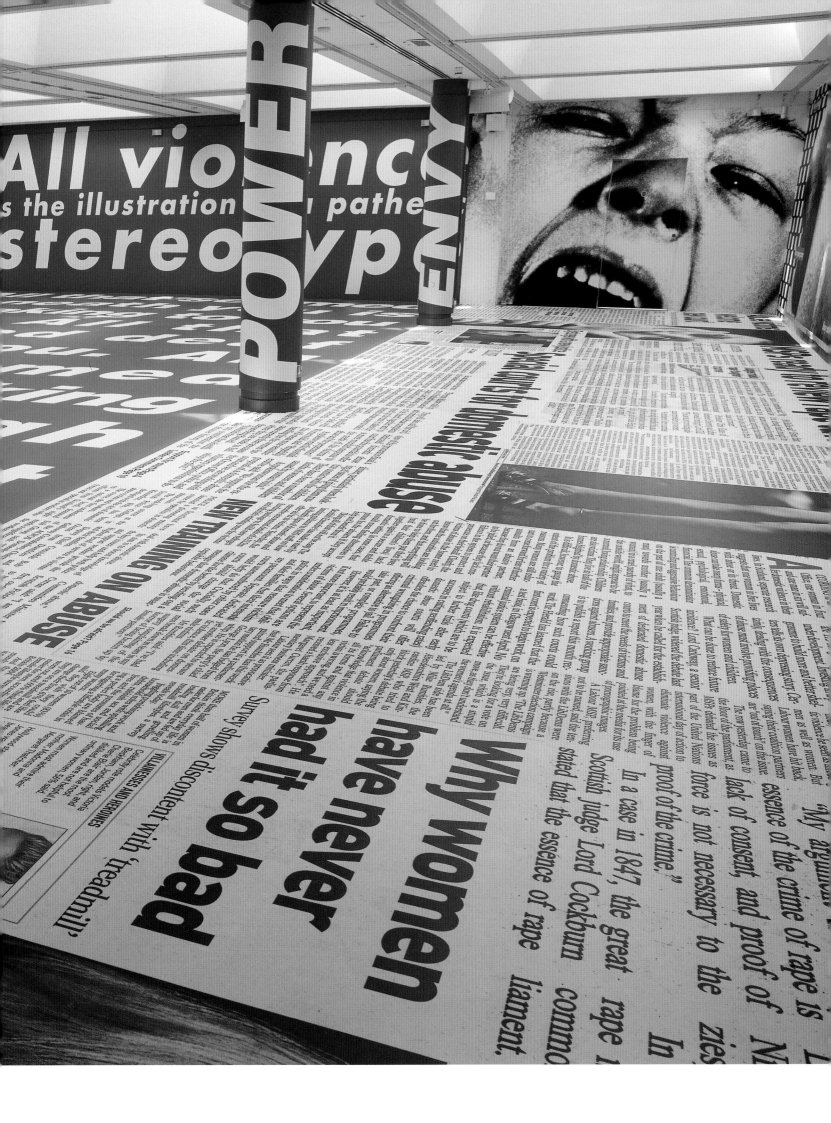

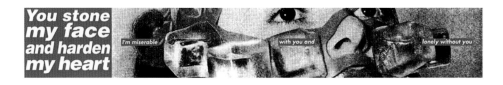

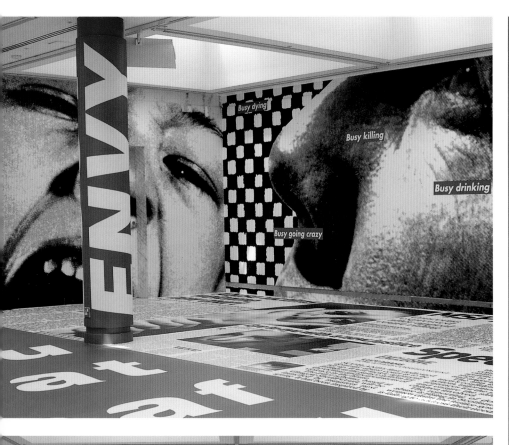

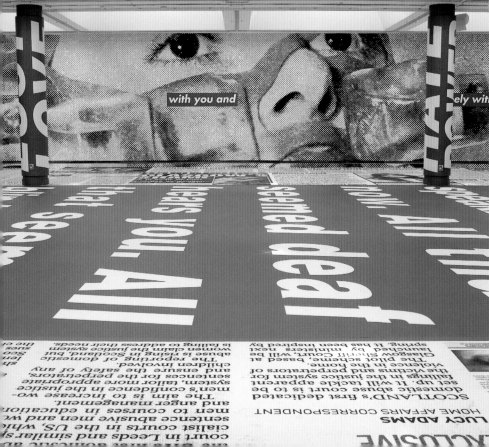

All that seemed beneath you is speaking to you now. All that seemed deaf hears you. All that seemed blind is looking right through you. All that seemed mute is putting the words right into your mouth.

GLASGOW'S SHAME

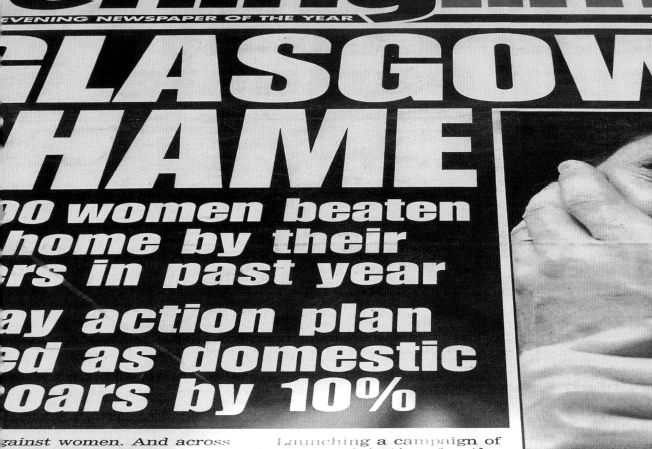

00 women beaten home by their rs in past year

ay action plan ed as domestic oars by 10%

against women. And across otland, there were almost 000 incidents – up 10% on previous year's figure. lmost 18,000 women tacted aid groups in sgow, with more than woman and children ed away from hostels se of lack of space.

Launching a campaign of 16 Days of Action for the Elimination of Violence Against Women today, city councillor Irene Graham said: "Male violence against women takes many forms, including domestic abuse, rape and sexual assault."

FULL STORY – PAGE 2

Don't I have to give up me to be loved by you?

Don't turn me inside out

Don't beat me

Don't betray me

Don't bury me

(170–73)
GO/**STAY**, 2005.
Double wall project,
Ludwig Forum,
Aachen, Germany.

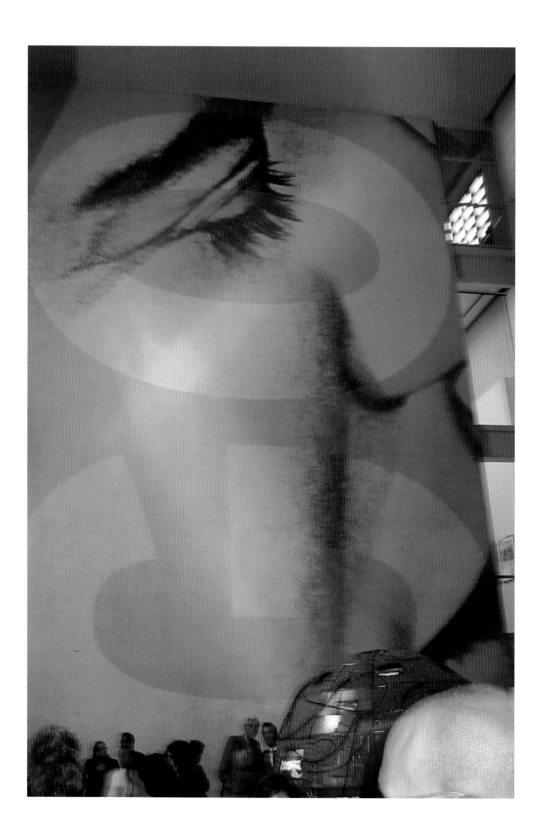

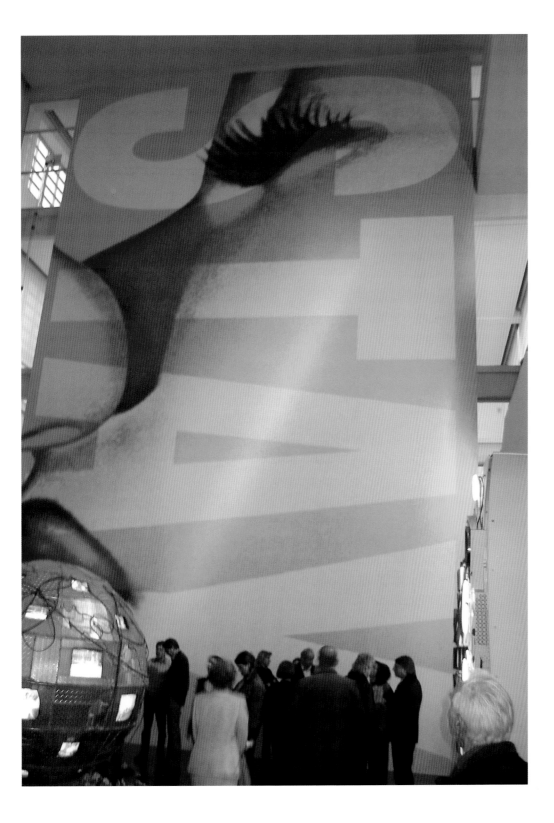

Installation view, 2003. Sprüth Magers Lee, London.

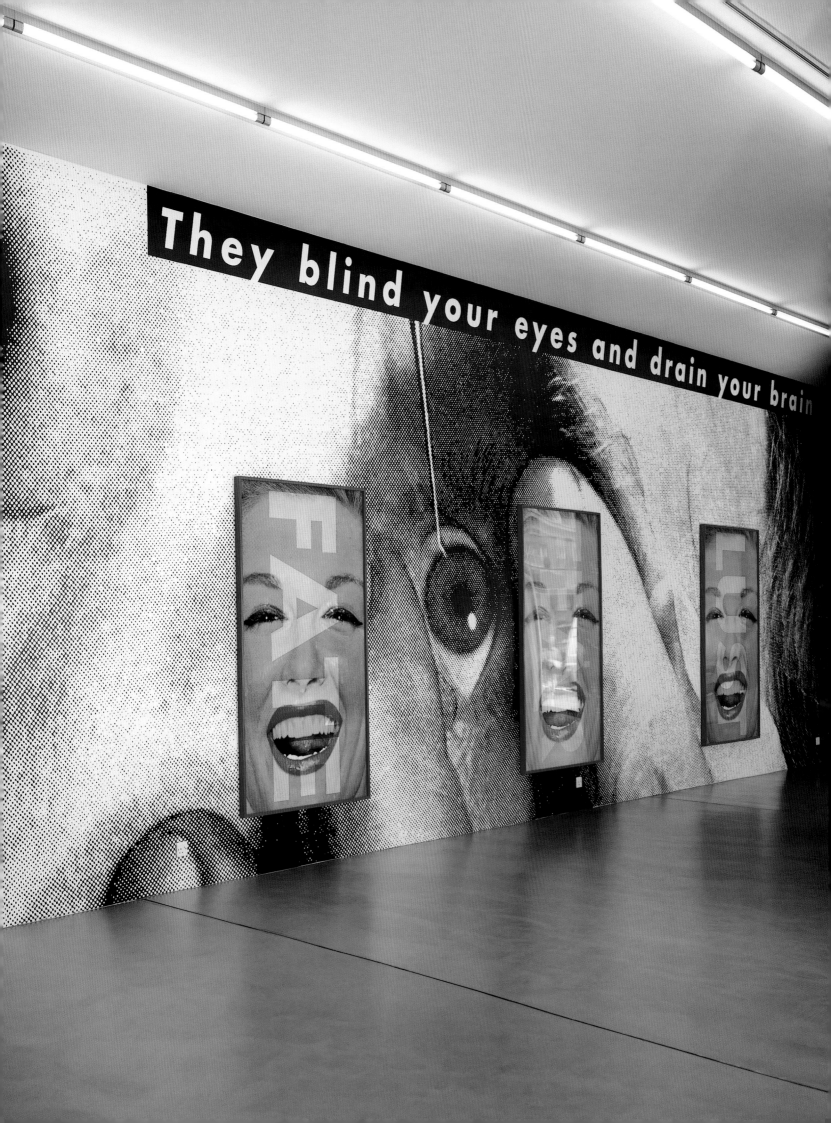

(176–79)
Kunst-Station St. Peter, 2003. Cologne, Germany.

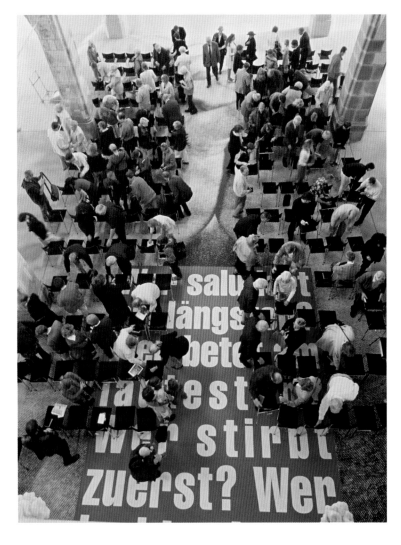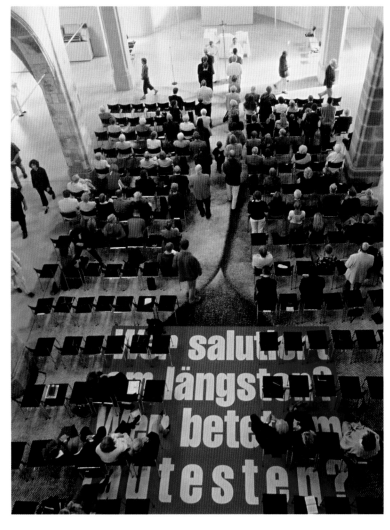
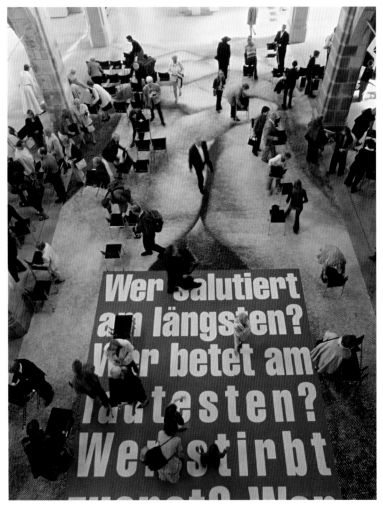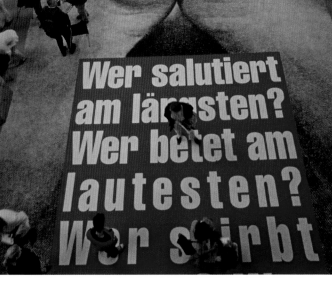

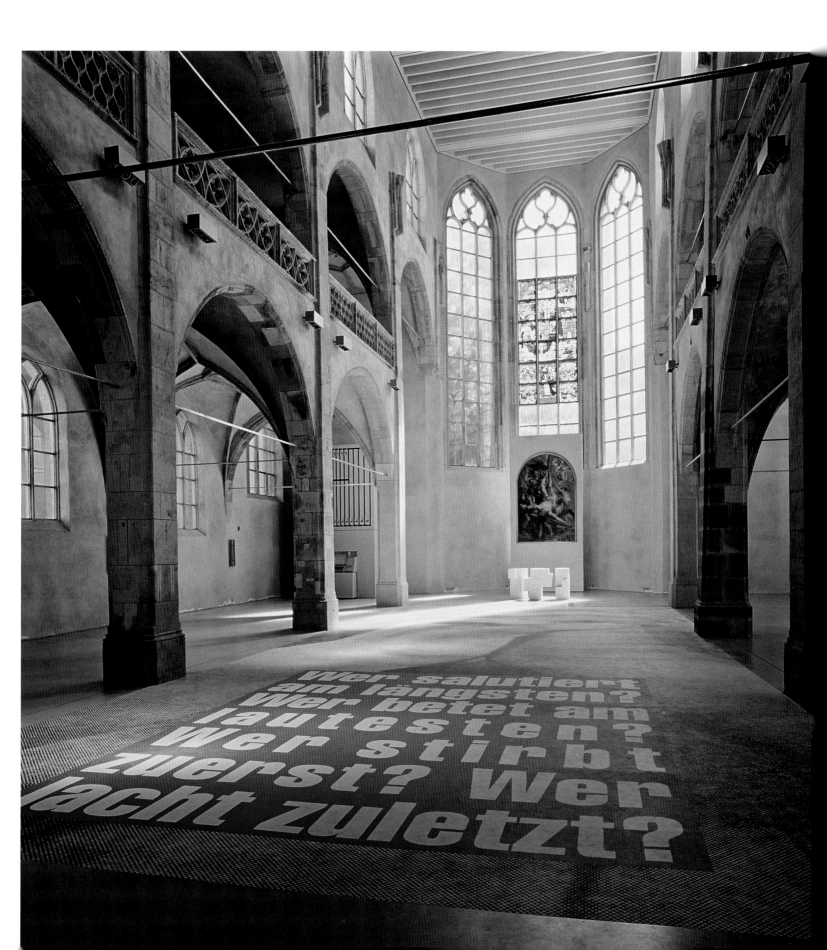

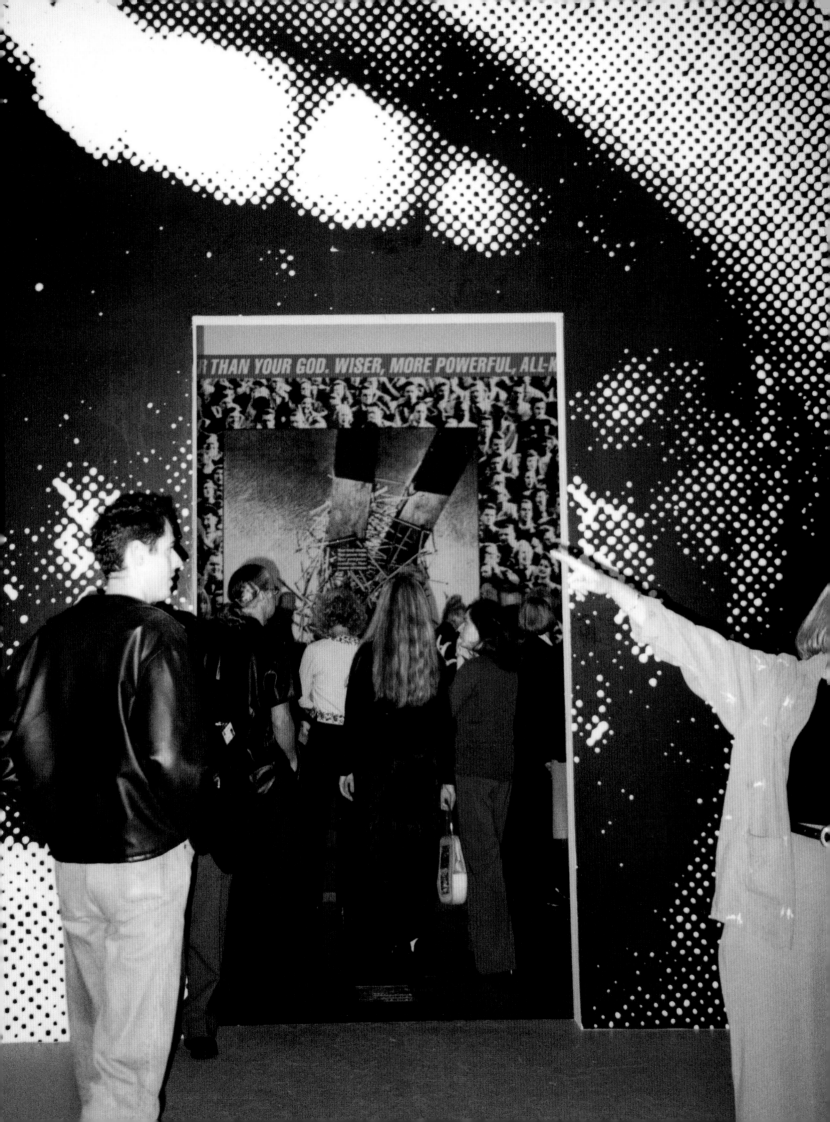

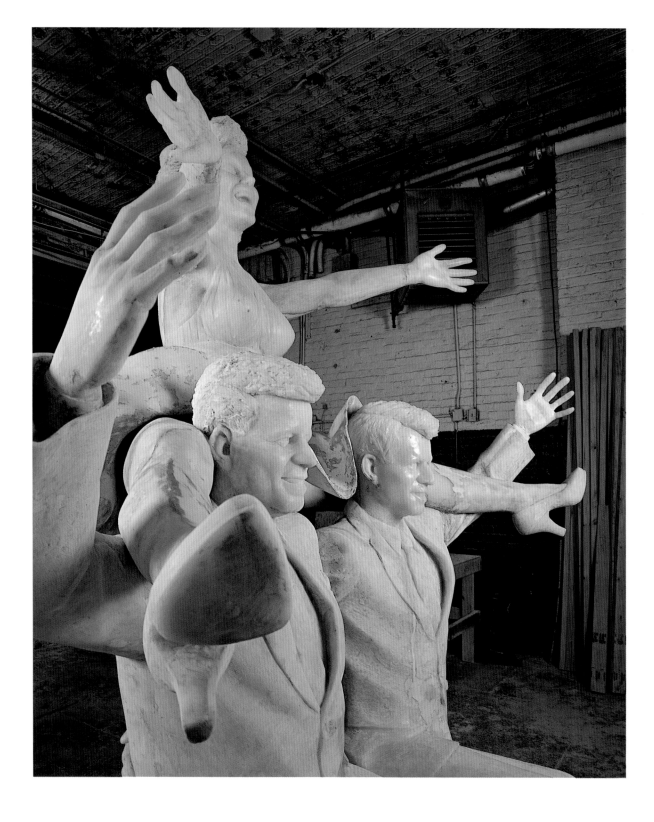

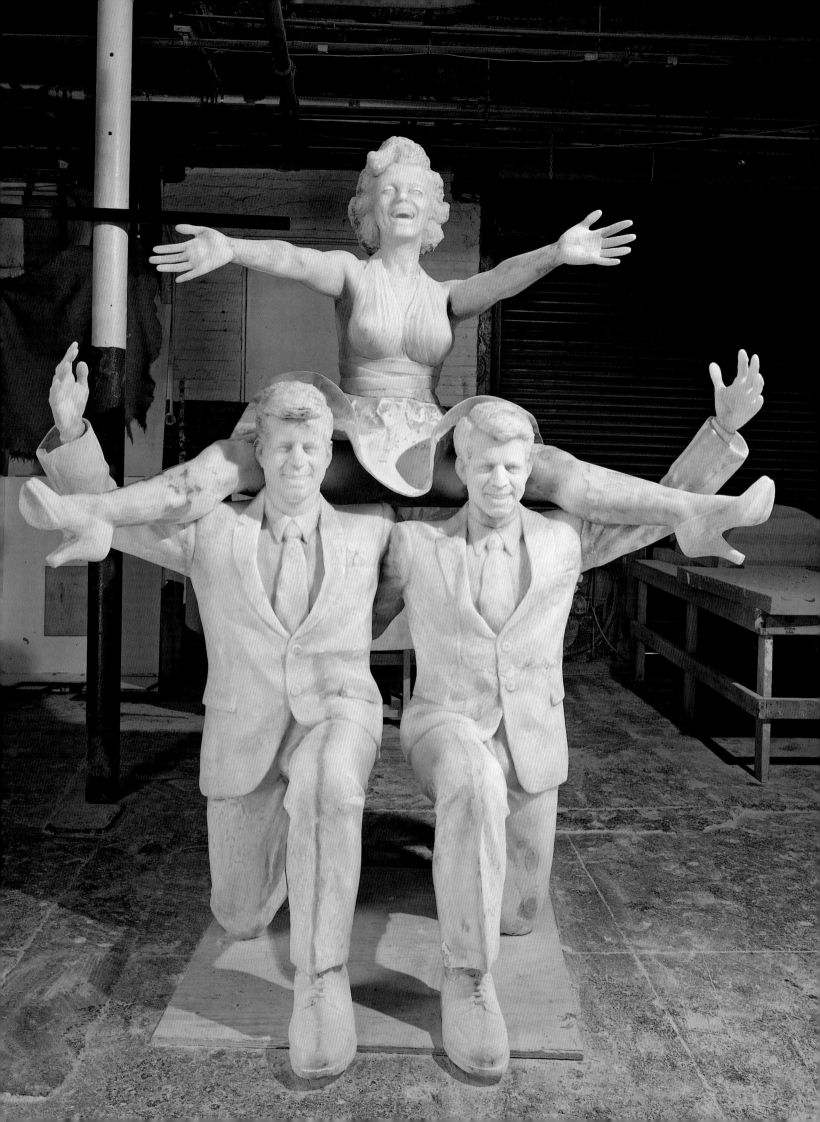

(top)
FAITH, 1997;
(bottom)
FAITH, 1997;
(opposite)
JUSTICE, 1997.
Installation
views,
Mary Boone
Gallery, 745
Fifth Avenue,
New York City,
October 31–
December 20,
1997.

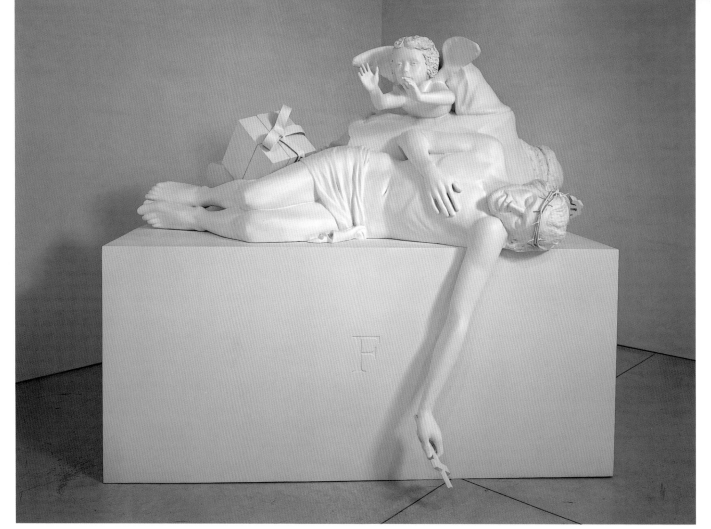

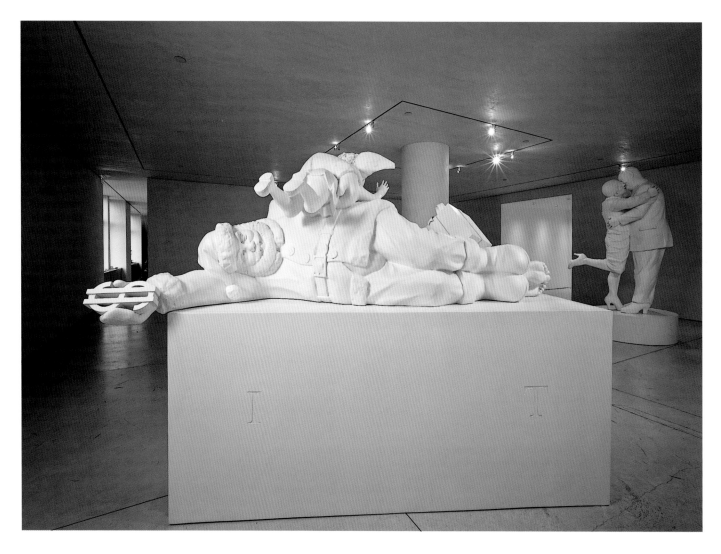

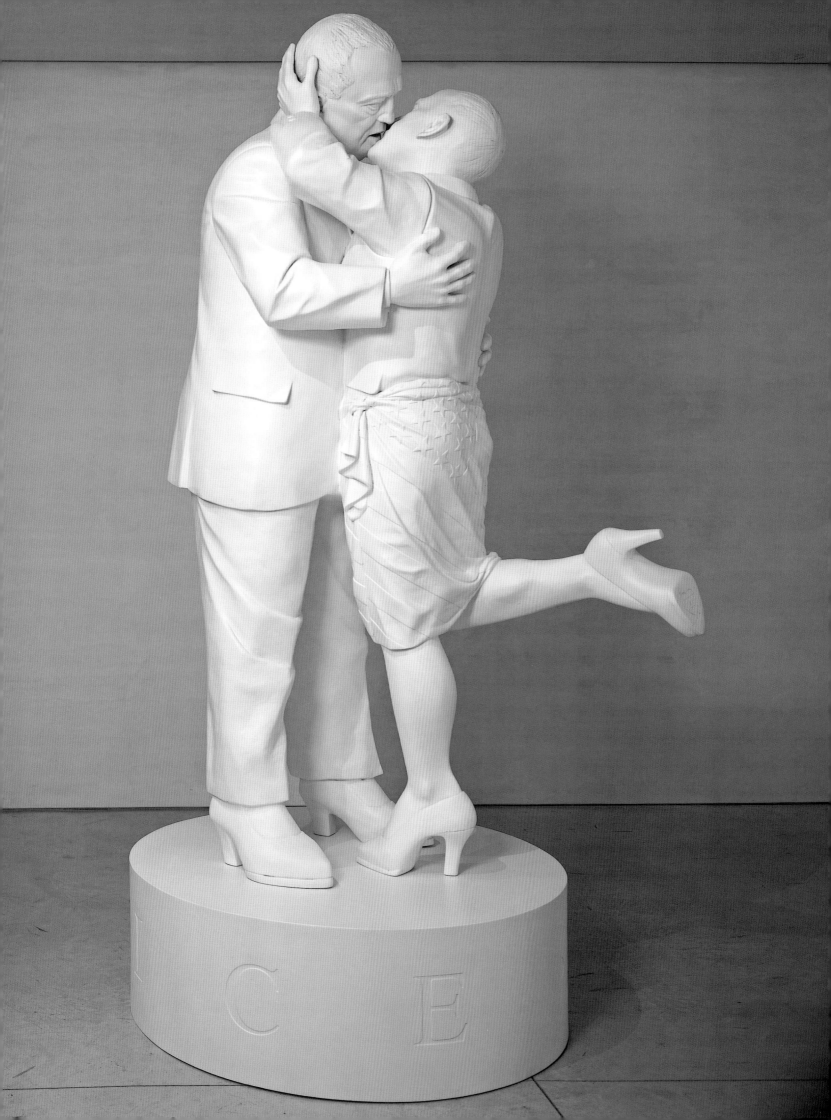

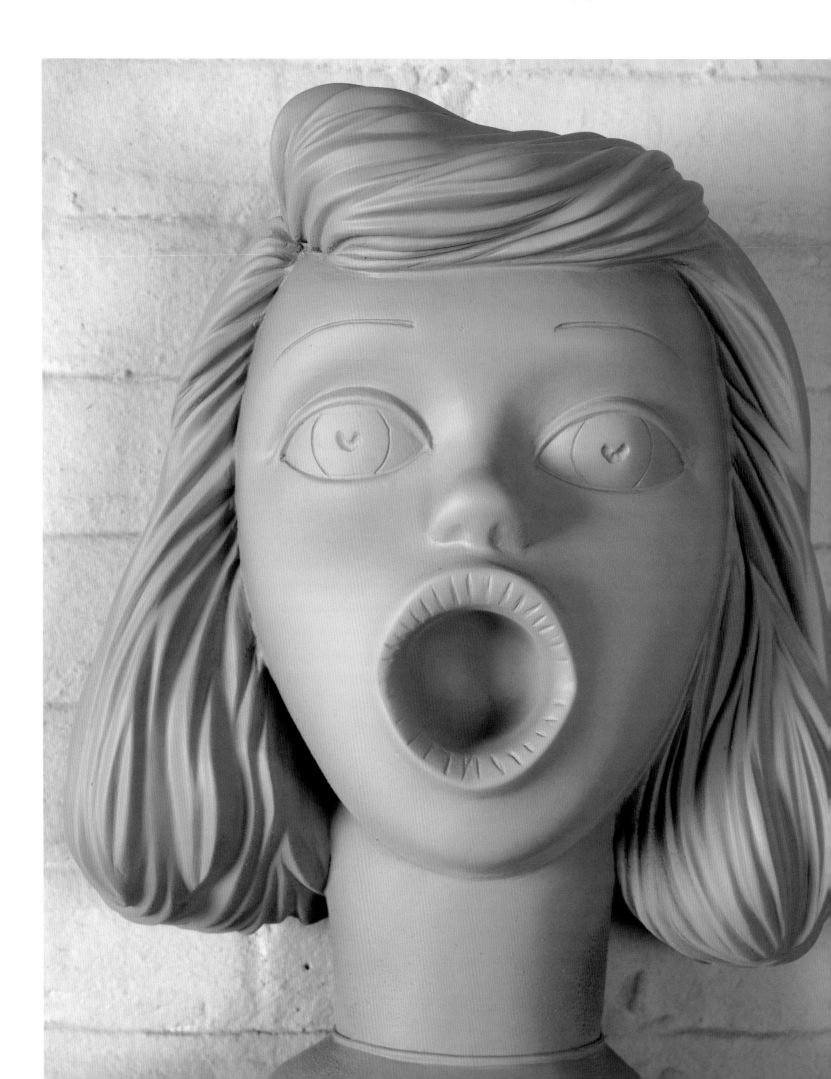

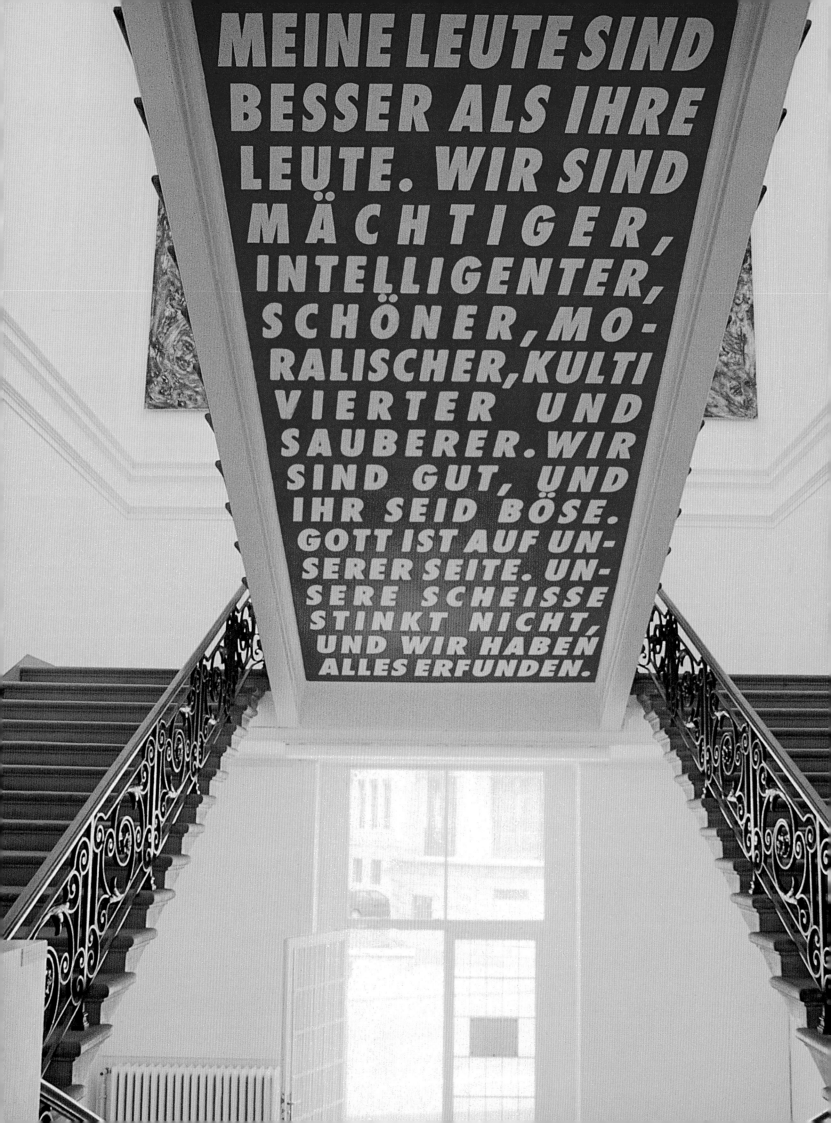

ALEXANDER ALBERRO

Picturing Relations: Images, Text, and Social Engagement

My attempts aim to undermine that singular pontificating male voiceover which "correctly" instructs our pleasures and histories or lack of them. I am wary of the seriousness and confidence of knowledge. I am concerned with who speaks and who is silent: with what is seen and what is not. —BARBARA KRUGER, 1982[1]

The richness and complexity of theory should periodically break through the moats of academia and enter the public discourse via a kind of powerfully pleasurable language of pictures, words, sounds, and structures. —BARBARA KRUGER, 1992[2]

BARBARA KRUGER'S WORK is neither moralistic nor judgmental. Rather, it is observational—it observes the complexities of cultural codes. These codes determine an array of social phenomena, including not only the dynamics of reciprocity, kindness, and benevolence but also those of cruelty, humiliation, and oppression. The work questions what it means to construct those codes: Who gets to construct them? In whose interests do they function? On what conditions do they depend? But it also questions the operation of the codes themselves, exploring their components and assessing their roles in the process of communication.

Cultural codes, Kruger's work repeatedly shows, are relational. They are produced in and through various representational systems, or languages. Moreover, codes have to be "decoded" or "interpreted," and are thus inherently inconstant and imprecise. The meaning we construe as decoders is never exactly that which has been encoded by the sender or deduced by other recipients. The decoder is as important as the encoder in the practice of interpretation—in the translation of a language (both in the sense of words and images) into meaning.[3] This is one of the central insights offered by Kruger's work.

1

Barbara Kruger, "Incorrect" (1982), *Effects* (1983); as republished in Barbara Kruger, *Remote Control: Power, Cultures, and the World of Appearances* (Cambridge, MA: MIT Press, 1993), 220.

2

Barbara Kruger, "Repeat After Me" (1992); first published in *Remote Control*, 223.

3

My discussion of communication not as a process but as articulation draws on Stuart Hall, "Encoding/decoding," in Stuart Hall, Dorothy Hobson, Andrew Lowe, and Paul Willis, eds., *Culture, Media, Language: Working Papers in Cultural Studies (1972–1979)* (Birmingham: Center for Contemporary Cultural Studies, 1980), 128–38, 294–95.

Installation view, **WORLD MORALITY** exhibition, 1994. Kunsthalle Basel, Switzerland.

Awareness of the powerful nature of cultural codes marks the difference between conceptual art of the 1960s and 1970s and postconceptualist practices such as Kruger's. Conceptual artists like Joseph Kosuth and Lawrence Weiner posited meaning as residing in material objects, abstract ideas, or temporal processes in the real world. Language, from this perspective, is purely formal and functions as a transparent medium between things and meaning. It is mimetic. For other conceptual artists, Ian Wilson, for instance, language is expressive. For them, it is the speaker, the artist, who, *through* language, imposes her unique meaning on the world: words and material objects mean what the artist intends them to mean. Therefore, to decode is to grasp exactly what was originally encoded. This fixation on the formal and normalistic nature of language blocked art's relation to other practices, as well as the more general relations among signification, ideology, and history.

The model of language developed by Kruger works through a different methodology—establishes a different kind of address—than that of these legacies of conceptual art. It no longer thinks of language as mimetic, let alone as an act of self-determination, articulation, identity formation, and enunciation. Neither things in themselves nor the individual users of language can fix meaning in language. Representation is a practice—a signifying practice that *articulates* meaning. Meaning is therefore not predetermined by reality, let alone by the intention of the sender, but is actively *produced* and has its own materiality and effectivity. This notion further implies that since art is the production of meanings, the subjective position of the viewer has to be taken into account. The artwork may signify in different ways for different viewers. Thus Kruger's art disregards conceptualist claims that language could assume the function of pure communication, of visual neutrality, in the way that abstract art had previously claimed neutrality and universal legibility.

However, while Kruger's artistic practice engages a different model of language than those adopted by conceptual art, it retains several crucial elements of conceptualism. For instance, from the beginning of the 1980s, Kruger has produced work that has assumed widely distributed forms, including pieces in newspapers, announcements on bus shelters, advertisements on billboards, posters on construction sites, messages on matchbooks, and various other easily disseminated objects. These are strategies that continue conceptual art's emphasis on the need to abandon traditional formats and categories altogether in order to make art broadly accessible.

The shift in perspective from a narrow concern with the object, or even with the context of placement, to a broader investigation of the artwork as a phenomenon of the apparatus of publicity, was perhaps best articulated by Dan Graham's works for magazine pages of the mid-1960s.[4] A case in point is his *Homes for America* (1966). This two-page illustrated magazine piece is embedded from the very beginning in the media channels in which most new art is initially received—that is, into the structure of an art journal. Of course, Graham's move was already largely anticipated by Edward Ruscha in the early 1960s, when, with projects such as *Twentysix Gasoline Stations* (1963) or *Some Los Angeles Apartments* (1965), he made the form of distribution the artwork's point of departure. Ruscha, whose commercial work as a magazine layout designer in the early 1960s was well known and admired, inverted Andy Warhol's practice of placing photographs of popular iconography on canvases and exhibiting these in a private gallery by inserting vernacular photographs directly into a limited-edition book that was disseminated as a work of art. But while these strategies to distribute art in greater numbers in effect redefined art's relationship to the viewer and enabled it to communicate with a wider audience than had previously been possible, it did little to enhance the audience's understanding. The new art eliminated conventional forms of distribution and altered the traditional limitations of the object, yet it remained incomprehensible to all but a small coterie of insiders who had the knowledge required to decode and discern its aesthetic dimension. Taking this limitation of conceptual art as a starting point, Kruger began in the early 1980s to place her art in public space with the recognition that if it was to be effectively received by a broad public and not experienced as an imposition,

4

See Dan Graham, "My Works for Magazine Pages: 'A History of Conceptual Art,'" in Gary Dufour, and Dan Graham, exh. cat. (Perth: The Art Gallery of Western Australia, 1985), 8–13.

it would have to do three things: first, it would have to construct a specific readership; second, it would have to address the specific needs and interests of its audience; and third, it would have to be articulated within forms of representation—primarily language, but also visual imagery—that are communicative and accessible, that are within the reading competence of the artwork's presumed spectators.

APPROPRIATION

To a generation steeped in movies and rock and roll . . . the return to imagery and to the play and disruption of narrative were welcome moves.
—BARBARA KRUGER, 1979[5]

Kruger has been making art since the late 1960s, but it was not until a decade later that she began to develop her signature work. Clipping pictures out of books and magazines found in flea markets and thrift shops, in the late 1970s Kruger amassed a large archive of photographic images featuring an array of body parts (hands and faces in particular), gestures, and expressions. Pictures from old photo journals, first-aid manuals, science textbooks and the like, were accumulated alongside glossy photos from mass-culture magazines. The pictures were then cropped, slashed with bands of Futura Bold type, rephotographed, and enlarged into high-contrast, black-and-white prints. More recently, the bands of type have been colored red.

Kruger's construction of a photographic archive is similar to the epistemological and historical project of her peer Sherrie Levine. Both artists began in the late 1970s to appropriate found photographs for use in their own artworks. Both reshot the appropriated photographs, changing the meaning of the originals in turn. However, Kruger's archive was remarkably different from the body of images assembled by Levine. Whereas the latter consisted exclusively of black-and-white art photography (photographs "after" photographs by, for instance, Edward Weston or Walker Evans), Kruger's archive included an array of vernacular images. As the contemporary critic Abigail Solomon-Godeau noted,

Levine's gambit of this period could only function "within the compass of the art world."[6] Kruger's, by contrast, is much more readily accessible to viewers far beyond that compass. Furthermore, whereas Levine acknowledges, albeit in an offhand way, the makers of the photographs she rephotographs, Kruger gives no credit to the original source. If Levine's work is primarily idea-based (i.e., once the basic idea of the project is conveyed the artwork need not be shown), Kruger's must be seen to be understood. Indeed, the design of Kruger's work is based on a journalistic (rather than fine art) use of photographs, de-emphasizing authorship and craftsmanship and focusing instead on variation in scale, subject matter, and juxtaposition in order to dramatize broad and topical themes in the most powerful manner. In this sense Kruger's work recalls the vocabulary of Richard Prince's early 1980s "Cowboy" series, which features an archive of cigarette advertisements appropriated from the pervasive Marlboro Man campaign. In addition to the actual appropriation and re-presentation of the image and its form, Prince cropped the copy from the advertisement. If Prince's artworks were accompanied by text, it was the slew of theoretical essays on postmodernism published in journals such as *October* and *Art in America* that directed their meaning. Kruger appropriates images without text. Her work also differs from Prince's (and Levine's for that matter) in its direct address to the viewer, an address that is largely due to her reinsertion of texts into her compositions.

Whereas many artists enlist titles or captions to anchor and become implicated in the play of meaning, Kruger places the text directly on the image—articulated not only as a signifying reference but as a visual element. Presumably, this is something that she learned during her decade-long apprenticeship as a graphic designer and picture editor in the magazine world.[7] But she could have just as easily picked it up by observing the agitprop graphics of punk rock promotional materials in the 1970s. Punk design introduced cut-ups and montage on record covers, flyers, and posters to a young audience that was not content with the status quo. Punk sought to interrupt and change the meaning of things, producing a culture and aesthetic that countered staid

[5] Barbara Kruger, "The Trap Door," *Ideolects: Film Journal of the Collective for Independent Cinema*, 9–10 (1979); as reprinted in *Remote Control*, 197.

[6] Abigail Solomon-Godeau, "Living with Contradictions: Critical Practices in the Age of Supply-Side Aesthetics" (1987); reprinted in Solomon-Godeau, *Photography at the Dock* (Minneapolis: University of Minnesota Press, 1991), 128.

[7] As Kruger puts it: "The biggest influence on my work, on a visual and formal level, was my experience as a graphic designer—the years spent performing serialized exercises with pictures and words. So, in a sort of circular fashion, my 'job' as a designer became, with a few adjustments, my 'work' as an artist." Barbara Kruger, "Pictures and Words: Interview with Jeanne Siegel," *Arts*, 61:10 (June 1987), 18.

conventions. Its direct connections to Situationist strategies were many—evident as much in its emphasis on détournement as on its mobilization of revolutionary slogans. Punk rock lyrics and song titles, such as the Sex Pistols's "Your future dream is a shopping spree" or the Clash's "Know Your Rights," evoke the graffiti on the streets of Paris in the spring of 1968. But they are also remarkably similar to Kruger's image-texts. Indeed, like punk designs, Kruger's early photomontages were formally chaotic, irregular, and harsh, while as cultural productions they appeared subversive in intent.

The image-text relationship in Kruger's work is ambivalent. Sometimes the text has more power, and sometimes the image diverts the text. It goes back and forth. Which of the two actually has primacy in any particular composition is less important than that the image-text captures the viewer's attention and troubles her preconceived notions. Roland Barthes, in his discussion of the interrelation between text and image within the context of photography, lays out two paradigmatic forms of interaction: in the first, "the image illustrate[s] the text ([makes] it clearer)," and in the second, "the text loads the image, burdening it with a culture, a moral, an imagination."[8] In fact, he states, since words cannot "'duplicate' the image," there is a new space of signification created "in the movement from one structure to the other [where] second[ary] signifieds are inevitably developed."[9] Kruger employs the "secondary signifieds" produced by the image-text combination as a means with which to merge something observational and critical with something more seductive. The work's direct mode of address depends on that combination, and its success is measured by its ability to communicate. Contrary to the avowed self-reflexivity and autonomy of the modernist artwork, Kruger's emphasis on communication helps to foreground the social dimension of the work of art. But it does so in a highly self-conscious way, which renders it significantly different from conventional documentary practice's belief in the possibility of the unmediated transmission of facts.

So Kruger, in the midst of the punk rock era, used the cold and highly instrumental picture editing and layout design of fashion magazines to produce image-texts rife with doubt. Skepticism and criticality became the predominant characteristics of her work. Picture-texts such as *Untitled (You Are Not Yourself)* (1982), and *Untitled (Your Fictions Become History)* (1983), with their ransom-note lettering and fragmented images of women's faces, or video installations such as *Power/Pleasure/Disguise/Disgust* (1997) or *Twelve* (2004), with their shouting texts and talking heads, do not trade in answers, they ask probing questions. They doubt the surety of all answers. The same is true of Kruger's installation using photography, magnesium tiles, and audio, *Untitled: Talk Like Us* (1994), which addresses the growing ubiquity of instrumentalized forms of communication. The works suggest that social interaction is becoming more and more based on commands and prohibitions, allowances and disallowances. While this can seem to offer a theory of power that dominates social experience leaving little room for resistance, Kruger's work continues to emphasize agency as much as structure: contemporary society is excessive in its demands for order precisely because those with the power to organize society recognize the proliferation of disorder. In this way it is not assumed that the commands and prohibitions have been successfully deployed. In fact, Kruger's understanding of the increasing use of instrumental signification suggests the very opposite. It is precisely because verbal violence and irrationality prevail that contemporary society tries to clamp down on the "openness" of meaning and expression.

REPRESENTATION

I want to put into question how representation works.
—BARBARA KRUGER, 1993[10]

Kruger was one of the first artists in the U.S. who set out to deconstruct the patriarchal underpinnings of conventional representation. One of the key questions

———— 8 ————
Roland Barthes, "The Photographic Message" (1961), reprinted in Roland Barthes, *Image Music Text*, trans. Stephen Heath (New York: The Noonday Press, 1977), 26.

———— 9 ————
Ibid.

———— 10 ————
Barbara Kruger, from "Barbara Kruger," *Inside the Art World: Conversations with Barbaralee Diamondstein* (New York: Rizzoli International Publications, 1994), 154.

confronted in the 1970s and '80s by artists informed by feminism was how to develop new vocabularies. How could linguistic structures of visual objects capable of counteracting the reigning, patriarchal forms of language and visuality be produced? These concerns were partially addressed by psychoanalytic theory, which by then had become a crucial theoretical apparatus for various articulations of feminism. Jacques Lacan, in particular, explained the structure through which access to the Other of language, codes, rules, and laws—what he referred to as the "Symbolic Order"—inevitably provides passage to public power and representation. Such insights assisted artists informed by feminist ideas about the politics of identity formation in exploring the effects of the inability, or *prohibition*, to speak—i.e., the exclusion from access to the power structure of the Symbolic Order—on the constitution, articulation, and representation of female subjectivity.[11]

The question of how to construct representation capable of transcending the parameters of patriarchal culture within the visual field has been at the center of Kruger's work as much as that of how to dismantle from within the governing forms of visuality and speech. Inevitably, these questions have led to an exploration of agency. Even if language, from Kruger's Lacanian point of view, speaks us, another equally important dimension of her work calls on the viewer to acknowledge that in certain contexts some subjects have more power to speak than others. Kruger's art therefore fuses a concentration on language and the Symbolic Order with a focus on what Michel Foucault referred to as discourse.[12]

In particular, Kruger immerses her work in the discourse of everyday life—the constancy of domestic routines, sexual identity, and so on—neatly designated by the slogan the "personal is political." Image-texts such as *Untitled (Your Comfort Is My Silence)* (1981), *Untitled (It's a Small World but Not if You Have to Clean It)* (1990), and *Untitled (We Have Received Orders Not to Move)* (1982), with their pronouns that directly address

viewers and require them to acknowledge their positions, bring women's lives and voices into popular discourse, and generate new perspectives in the process. In turn, a critical account of the psychical impact of patriarchy emerges. Indeed, much of Kruger's work implies that the denigration of domestic labor and of women's voices is a social construct, not a natural inevitability that has remained the same in all historical periods and meant the same thing in all cultures. It is only *within* a definite discursive formation that such hierarchies could appear as meaningful. They could not meaningfully exist outside specific discourses, i.e., outside the ways the hierarchies are represented in discourse, produced in knowledge, and regulated by the discursive practices and disciplinary techniques of a particular society and time.[13]

Like Foucault, Kruger, too, rejects the notion that power is unidirectional, radiating from one source. Rather, power relations, from her perspective, permeate all levels of social existence and are therefore to be found operating at every site of social life. Without denying that the state, the law, or the wealthy may have positions of dominance, Kruger emphasizes the many localized circuits, tactics, mechanisms, and effects through which power circulates. "There is," she maintains, "a politic in every conversation we have, every deal we make, every face we kiss."[14] Such an approach roots power in forms of behavior, bodies, and local relations, which greatly expands the scope of what is involved in representation.

SUBJECTIVITY

I'm interested in working with pictures and words, because I think they have the power to tell us who we are and who we aren't, who we can be and who we can never be. —BARBARA KRUGER, 1993[15]

The traditional conception of the human subject is of an individual who is fully endowed with consciousness; an autonomous and stable entity, the "core" of the self,

11
In a late 1990s interview, Kruger speaks about her interest, from an early moment, "in how identities are constructed." "Interview with Barbara Kruger by Lynne Tillman," in Ann Goldstein, *Thinking of You: Barbara Kruger*, exh. cat. (Los Angeles: Museum of Contemporary Art, and Cambridge, MA: MIT Press, 1999), 189. Later in the same interview Kruger states: "I've always been interested in how identity is constructed." (196)

12
The concept of discourse runs through much of Foucault's published work. See in particular his *The Archaeology of Knowledge and the Discourse on Language* (1969), trans. A. M. Sheridan Smith

(New York: Pantheon, 1982). Foucault described discourse as "a group of statements which provide a means for talking about—a way of representing the knowledge about—a particular topic at a particular historical moment." See Stuart Hall's excellent discussion of discourse in "The West and the Rest: Discourse and Power," in Bram Gieben and Stuart Hall, eds., *Formations of Modernity* (Cambridge: Polity Press, 1992), 291.

13
Thus, like Foucault's writings, Kruger's work focuses on the "uses and abuses" of power within various institutional apparatuses. Barbara Kruger, "I make work all about . . . power and its uses and abuses." "Interview with Barbara

Kruger by Lynne Tillman," *Thinking of You*, 193. And elsewhere: "I am interested in works that address these material conditions of our lives: that recognize the uses and abuses of power on both an intimate and global level." Barbara Kruger, "Incorrect" (1982), *Remote Control*, 220–21.

14
Barbara Kruger, "Arts and Leisure," *New York Times*, September 9, 1990; reprinted in *Remote Control*, 6.

15
Barbara Kruger, from "Barbara Kruger," *Inside the Art World: Conversations with Barbaralee Diamondstein*, 154.

and the independent source of knowledge and meaning. Kruger's conception of language and representation displaces the subject from that privileged position. Subjects may produce particular texts, but they are constituted and operate within the limits of a specific discursive context and culture. As such, to become a subject is to personify the particular forms of knowledge produced by the discursive context in which that subjectivity takes form. Image-texts such as *Untitled (How Come Only the Unborn Have the Right to Life?)* (1992), *Untitled (Your Fictions Become History)* (1984), or *Untitled (Your Manias Become Science)* (1981), pointedly address the relationship between discourse and power. They comment on the self-interested inner workings of discourse—on the ways in which discourse posits certain terms and points of view, which it presents as dominant, to delegitimize other equally valid terms and perspectives.

The direct address of Kruger's art calls on the viewer to "establish" herself quickly and self-consciously as a subject within its discourse. For instance, a work such as *Untitled (Your Gaze Hits the Side of My Face)* (1981), only makes sense if one identifies with one of the two locations of meaning indicated by the pronouns. Likewise, the meaning of such image-texts as *Untitled (Give Me All You've Got)* (1986), *Untitled (We Are the Objects of Your Suave Entrapments)* (1984), or *Untitled (It Is Our Pleasure to Disgust You)* (1982), depends on from which position the viewer identifies. So the viewer (who is also "subjected" to the discourse of the work) is presented with two modes of address, two points of identification: the position of the receiver ("you") and that of the sender ("me," "we," "our"). Individuals may differ as to their gender, class, racial and ethnic characteristics (among other factors), but they will not be able to take meaning of the works until they have identified with one of those proffered positions of address, subjected themselves to its rules, and hence become the subjects of its particular perspective. Artworks that explicitly advocate for the rights of women's control over their bodies, such as *Untitled (Your Body Is a Battleground)* (1989), only "make sense" for men, according to this theory, if men put themselves in the position of women—which is the ideal subject-position that the artwork constructs—and

consider the artwork from this female discursive viewpoint. Indeed, works like *Help!* (1991), a bus shelter project commissioned by the Public Art Fund in New York City—for which Kruger superimposed on an image of a man a text that concludes with "I just found out I'm pregnant. What should I do?"—employ the dynamics of identification to mobilize the concept of empathy. Projecting ourselves into the positions of other subjects, identifying with those points of view, subjecting ourselves to their meanings, and becoming their subjects, not only help us as spectators to empathize with other viewpoints but also prompt us to question how we situate ourselves within given discourses.[16]

Often with Kruger's work one must distinguish between the act of speaking and the words spoken. This allows a further distinction between the subject who speaks and the subject who is represented by the utterance. In most social exchanges, there is no need to distinguish between the two subjects because they are assumed to be the same. But in image-texts such as *Untitled (I Will Not Become What I Mean to You)* (1983), or *Untitled (We Are Not What We Seem)* (1988), the two are discrete. The subject who speaks and the subject of whom is spoken are necessarily distinguished for the statement to make sense. Such distinctions between the two subjects address the complex relation between representation and subjectivity. They reveal that all notions of personal identity involve elements of misidentification. Thus, Kruger's art produces its own kind of knowledge. Its underlying message is that meaning depends on perspective—on the position from which one decodes.

So Kruger's is a profoundly critical artistic practice. It troubles not only conventional notions of essentialism and individuality but also those of meaning production and interpretation. Her art operates across a broad range of beliefs, convictions, and philosophical assumptions that question how the subject is constructed in the context of contemporary society. Image-texts such as *Untitled (I Shop Therefore I Am)* (1987), or *Untitled (To Buy or Not to Buy)* (1987), do not necessarily focus on a strategy of feminist critique, but generally touch on conditions of contemporary society

16

Indeed, there is something about the terseness or quickness of the mode of address in Kruger's work—in its notions of direct address and short attention spans, as well as the way it constructs subjectivities—that connects very much with the language and address of the Internet today. The Internet is immersive; one speaks and writes through it. But it is also a reciprocal mode of address, with cameras on top of (or increasingly built into) computers, phenomena such as YouTube, Wikipedia, and the like. Although Kruger's work emerges from the perspective of someone raised in the pre-Internet era of television and movies, the direct address of the work and its quick read seem to have understood certain key logics of the Internet even before the medium was publicly released.

in which the process of consumption is perceived as the system within which subjectivity is constituted. Clearly the joke in inverting the most famous philosophical statement of the European Enlightenment, or what is surely the most cited phrase in William Shakespeare's oeuvre, now questions what constitutes the subject, or how the subject is constituted within consumer society. According to the obvious message of these works, the subject is today primarily established in the role of a consumer. "To be" becomes "to shop." So these works and their polemical statements address both a very prominent condition of experience in consumer society, and a philosophical and theoretical concept—namely, the critique of ideology known as "interpellation."

INTERPELLATION

I'm interested in how identities are constructed, how stereotypes are formed, how narratives sort of congeal and become history. —BARBARA KRUGER, 1999[17]

Interpellation is a crucial term in Barthes's analysis of mythology. In "Myth Today" (1957), he singles out interpellation as the dynamic element in the construction of myth, a duplicitous form of speech that directly addresses the subject at the same time as it conveys its message.[18] Myth, Barthes writes, is the complete system of public languages—textual and representational languages—most notably embodied in advertising and political ideology. The naturalization process that myth performs is enacted by—depends on—the interpellative act, which calls on the viewer or reader to recognize and identify with the myth.

The structure of interpellation becomes much more complex in the late 1960s writings of the French philosopher Louis Althusser. The latter's "Ideology and Ideological State Apparatuses" (1969), mobilizes Lacan's notion of the Symbolic Order, especially insofar as it takes the form of what Lacan called the "gaze," to analyze the operation of ideology.[19] Interpellation, in Althusser's model, describes the complete condition of ideological experience; the mechanism whereby subjects are invoked—"hailed" is his term—as the effects

of pre-established structures or institutions. This is, of course, a notion of the operation of contemporary ideological experience that is paralleled by the model of the "spectacle" that evolved in the late 1950s and early 1960s in the context of the Situationist International, and was crystallized in Guy Debord's *The Society of the Spectacle* (1967).[20] For both Althusser and Debord, the individual is constituted as a subject by a pre-given representation; the self-image presented through interpellation is the subject's identity. What vanishes in this is the distinction between subject and representation, for they are one and the same.

But Kruger's art goes beyond even these intricate theories of ideology. Whereas her work is partially in accordance with Althusser's and Debord's concepts of the subject's construction through ideology, it also posits the subject's formation within language as a moment of division. Entry into language is the condition for subjectivity and identity, but also, Kruger's artworks repeatedly show, for the unconscious, which functions to invalidate any attempt to capture the subject's reality. Not unity but division, not identity but non-identity, these are Kruger's terms for the constitution of the subject. From this perspective, there is no possibility of ideological apparatuses or spectacles achieving a complete closure that will hold human subjects in position. A representation can never fully capture a subject; its bids to fix the human subject in place must ultimately fail because the subject is as much the product as the producer of meaning. Meaning and subjectivity, Kruger's work shows, come into being together, each engendering the other in a dynamic process. For instance, people confronted by the same artwork—such as her 1998 installation on the facade of the Parrish Art Museum in Southampton, New York, with the text "If You're A Connoisseur Of All That Is Beautiful And Extraordinary, If You Like To Speculate In Objects And Ideas, If You Think Art Can Change The World, You Belong Here" running along the stairway leading into the faux-Renaissance building—will respond differently.[21] For the casual art viewers the composition will bluntly challenge their underlying assumptions about art; for the cognoscente it ironically will affirm

_____ 17 _____
Barbara Kruger, "Interview with Barbara Kruger by Lynne Tillman," *Thinking of You*, 189.

_____ 18 _____
Roland Barthes, "Myth Today," *Mythologies* (1959), trans. Annette Lavers (New York: Hill & Wang, 1983), 109–149.

_____ 19 _____
Louis Althusser, "Ideology and Ideological State Apparatuses" (1970), in *Lenin and Philosophy and Other Essays*, trans. Ben Brewster (London: Monthly Review Press, 1971), 121–76. Lacan develops the notion of the gaze in "The mirror stage

as formative of the function of the *I* as revealed in psychoanalytic experience" (1949), in *Écrits: A Selection*, trans. Alan Sheridan (New York: W. W. Norton, 1977), 1–7. According to Lacan, the subject is a representation of the gaze, which is a component of the Symbolic Order.

_____ 20 _____
Guy Debord, *The Society of the Spectacle*, trans. Donald Nicholson-Smith (New York: Zone Books, 1995). However, whereas ideology in Althusser's model is structured by language and institutions, for Debord and the Situationists social relations

in consumer society are primarily mediated through images, and it is precisely in visual representation that contemporary subjectivity is constituted.

_____ 21 _____
I have quoted only part of the entire text. The installation also features the statement "You Belong Here" running prominently along the top of the museum's exterior, and the words "Money" and "Taste" vertically flanking the entranceway.

their identity. In each case the subject is constitutive in that the interpretation or particular decoding is not inherent in the artwork—artists or art critics will interpret it differently again; but at the same time the subject is constituted by the artwork, in that, according to the interpretation, she is to a lesser or greater extent transformed by it.

Once again, then, as with most of Kruger's work, the subject is at once the producer and the product of the meaning of the representation; the viewer and the artwork both make their contribution in a powerful form of give-and-take. Both are perpetually and necessarily in process. Two sides of the same entity, to which, however, they do not add up.

Installation view, **WALL TO WALL** exhibition, January 19–February 27, 1994. Serpentine Gallery, London.

201

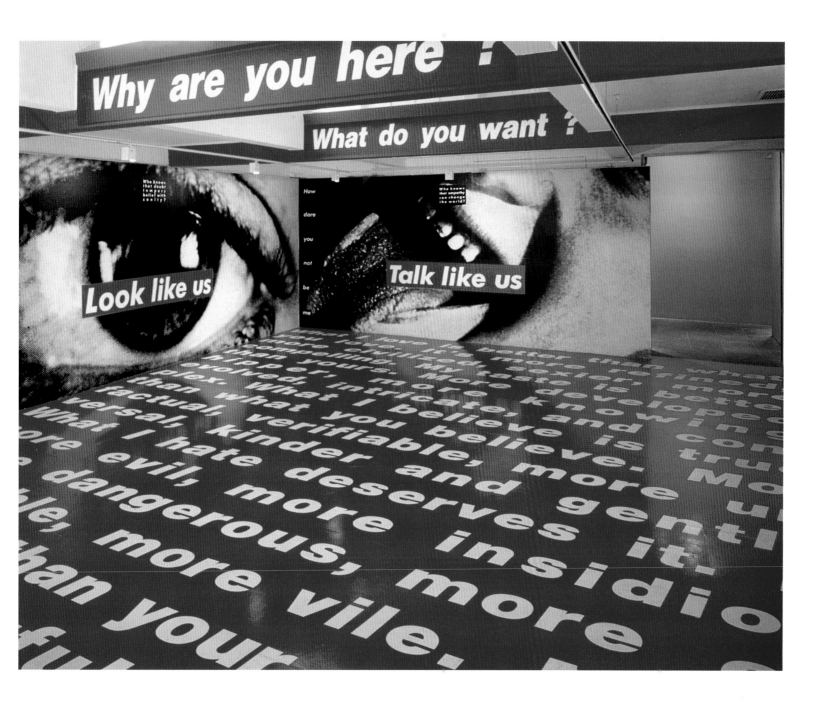

(202–5)
Installation views, 1992. Magasin—Centre National d'Art Contemporain, Grenoble, France.

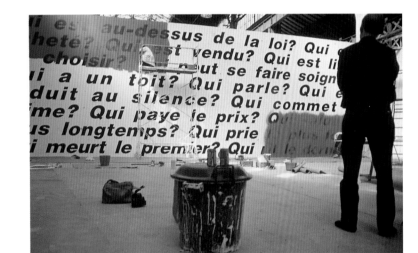

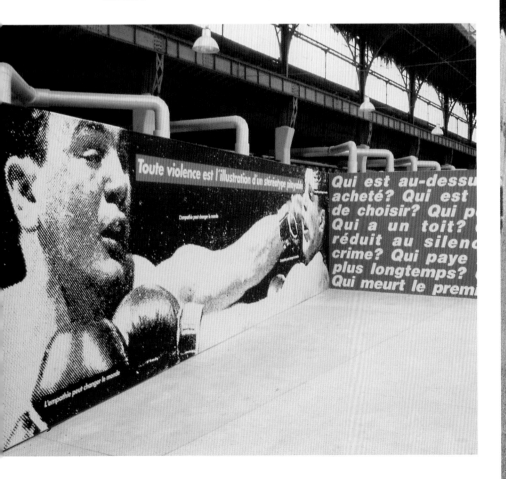

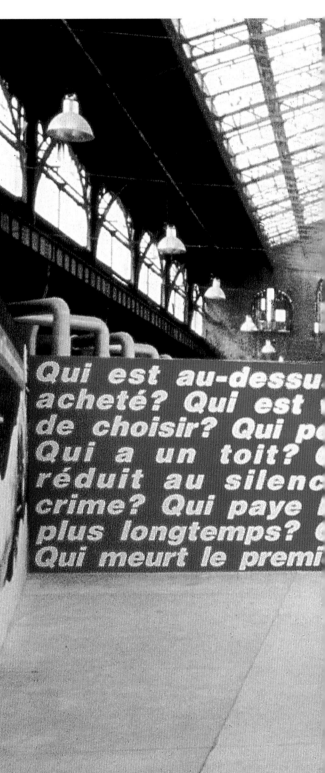

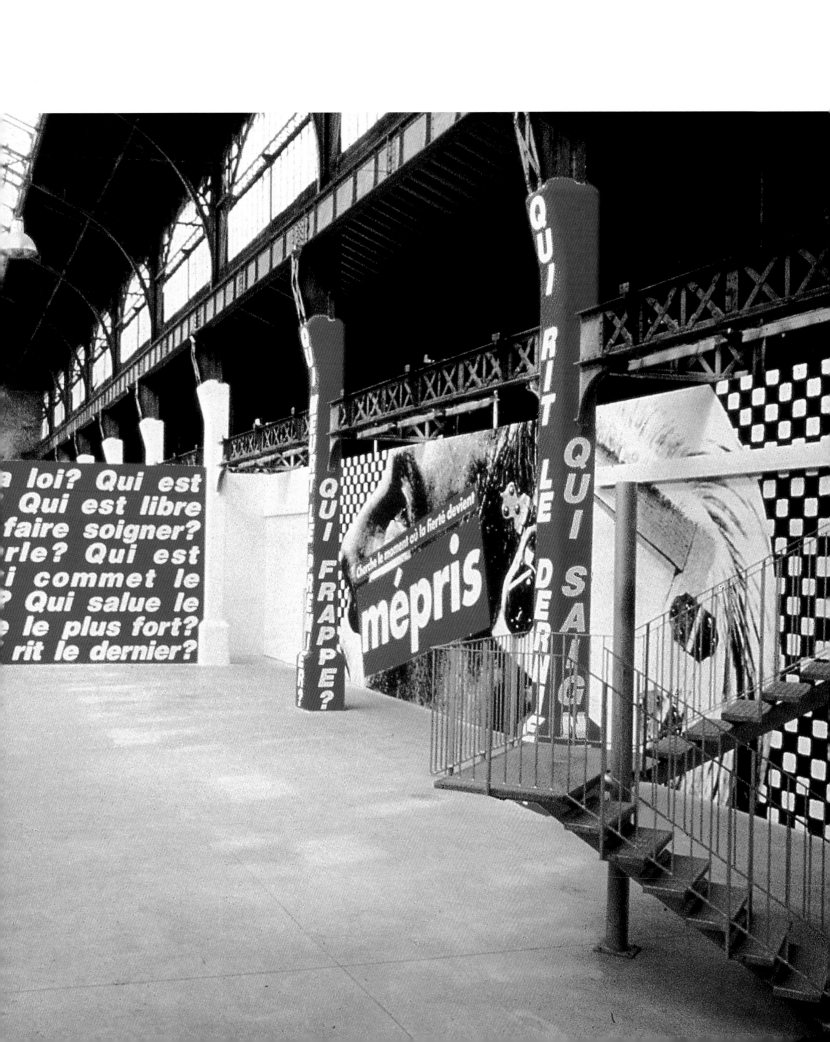

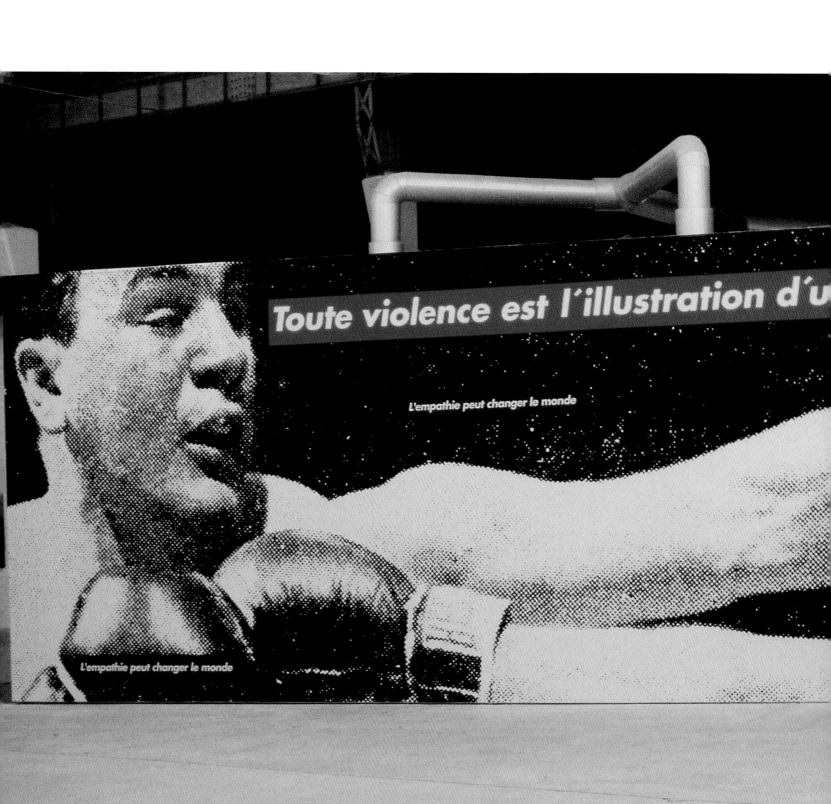

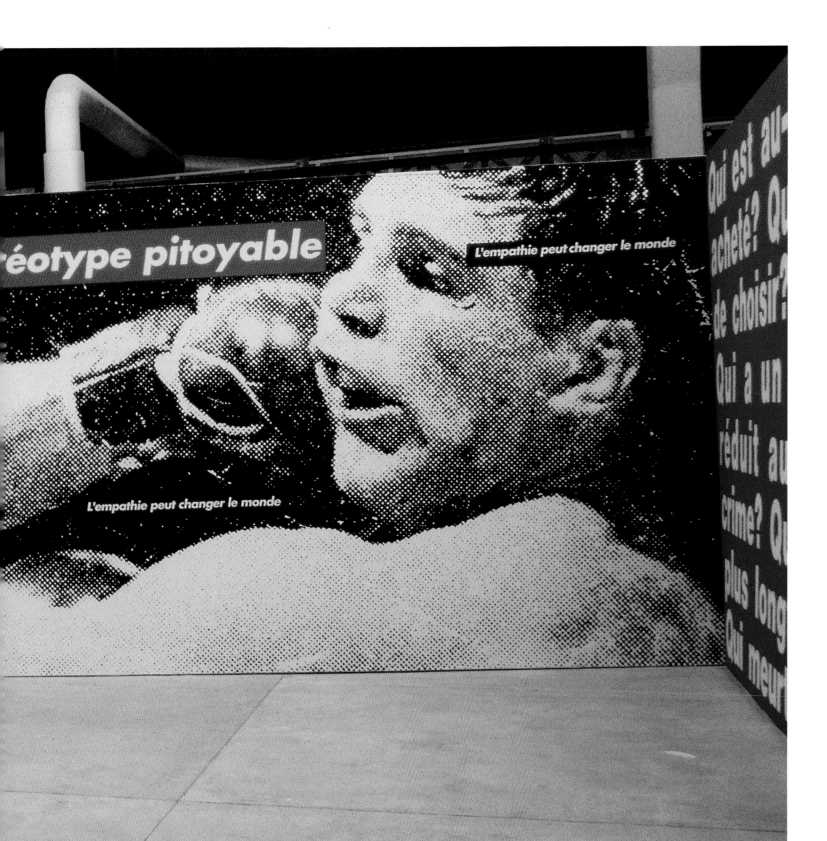

(206–9)
Installation views, **BARBARA KRUGER**,
January 1991. Mary Boone Gallery, New York City.

humble
they act
some-
times
it away-
never give
and they
lose it
want to
They don't
them hot-
makes
power
because
anyone
look up to
Do n
hebe kike yid hymie
spic wop dago mex
cunt gash snatch
pussy spook sambo
nigger boogie slant
nip chink jap faggot

All violence
is the illustration of a pathetic
stereotype

homo fairy hebe kike
yid hymie spic wop
dago mex cunt gash
snatch pussy spook
sambo nigger boogie
slant nip chink jap
faggot queer homo

pledge

d to the pussy for which it stands?

Who will w

Who knows what power makes the moment? Who prefers questi

what's on your
mind. All
seemed blin
ees throu
All th
in
med s
u. All th
med
is pa
ittin

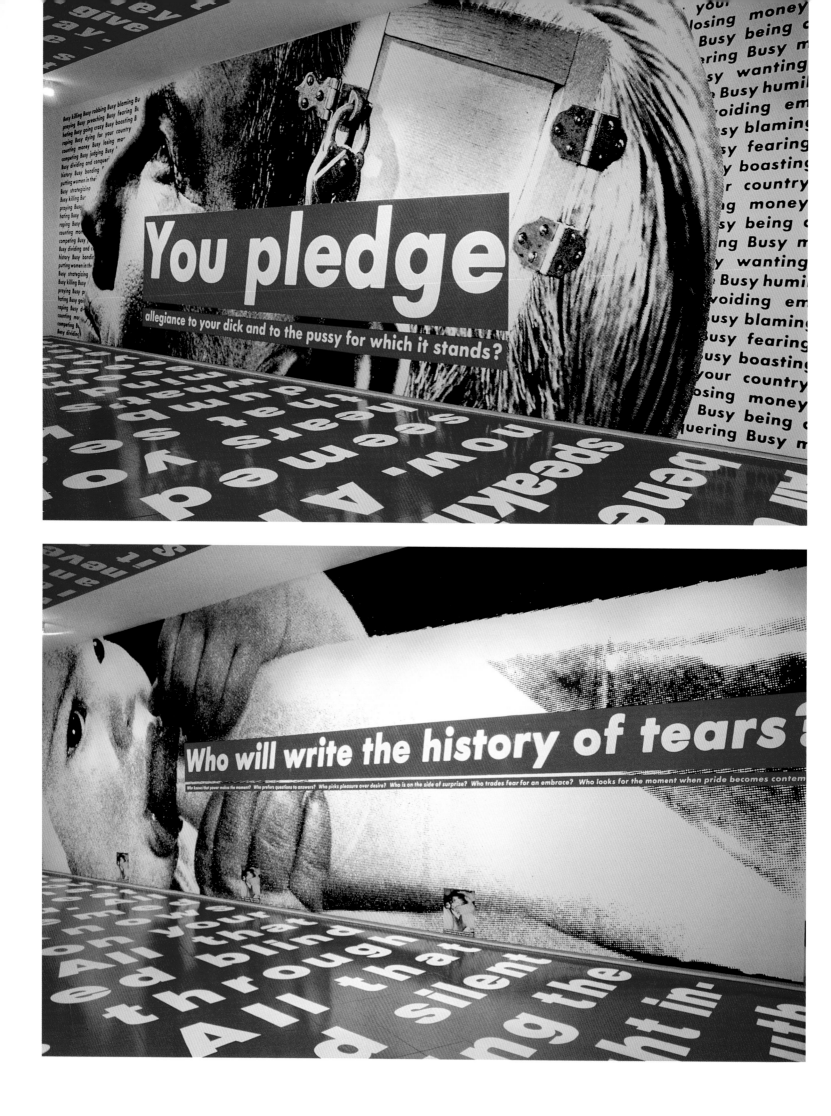

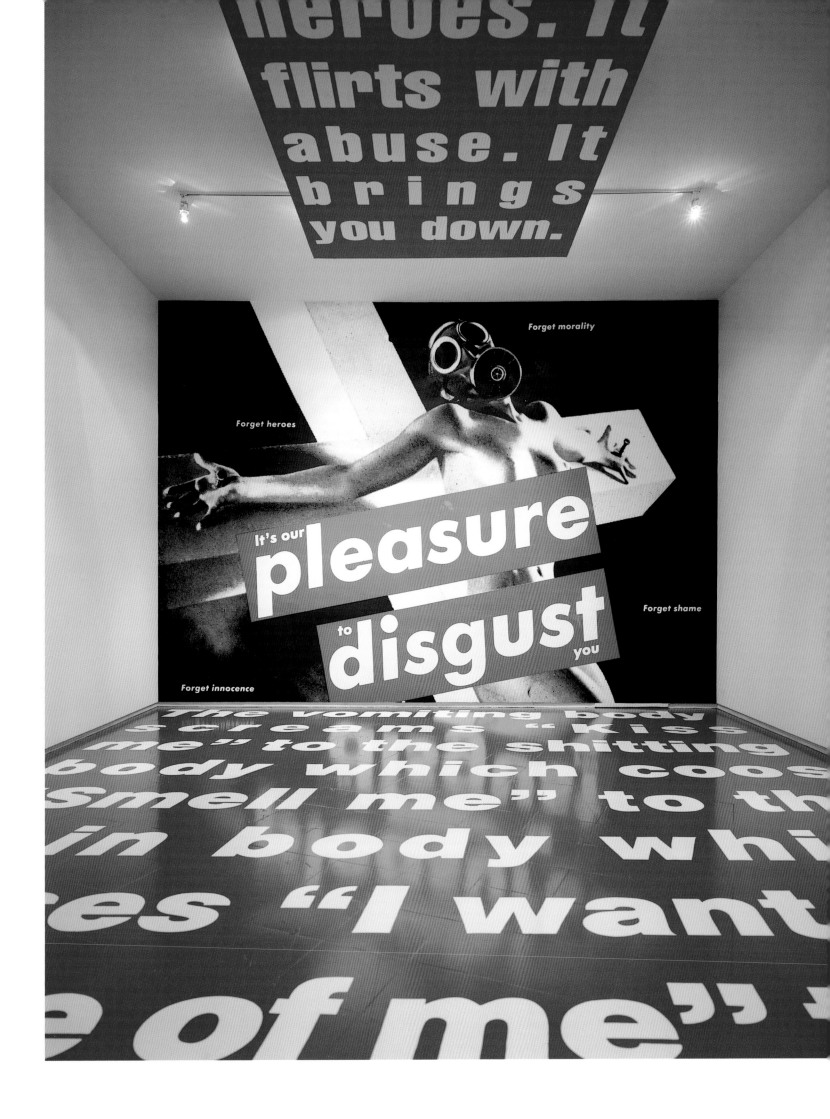

Installation views, **BARBARA KRUGER**, March 1994.
Mary Boone Gallery, New York City.

210

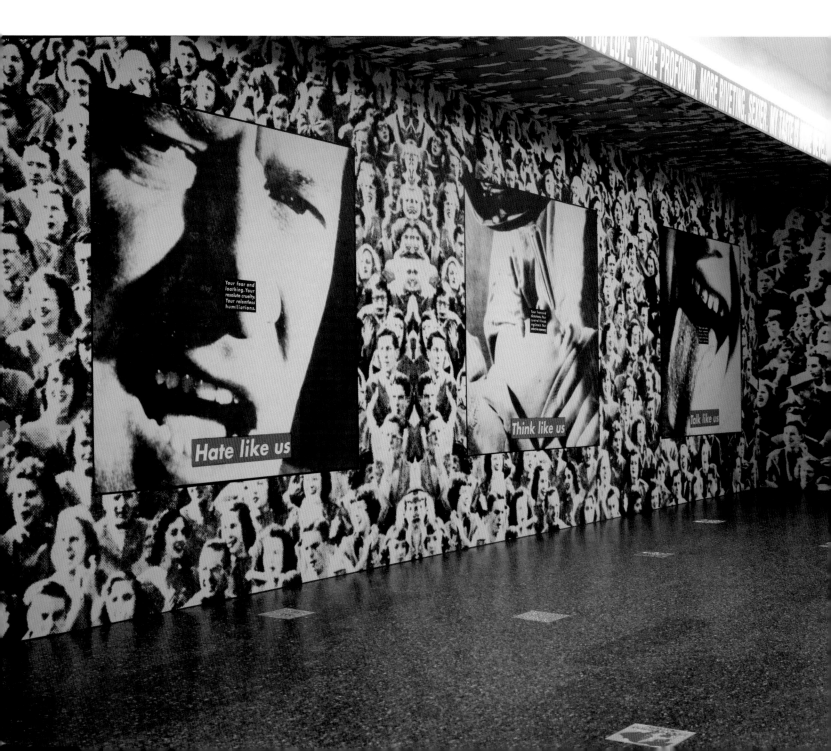

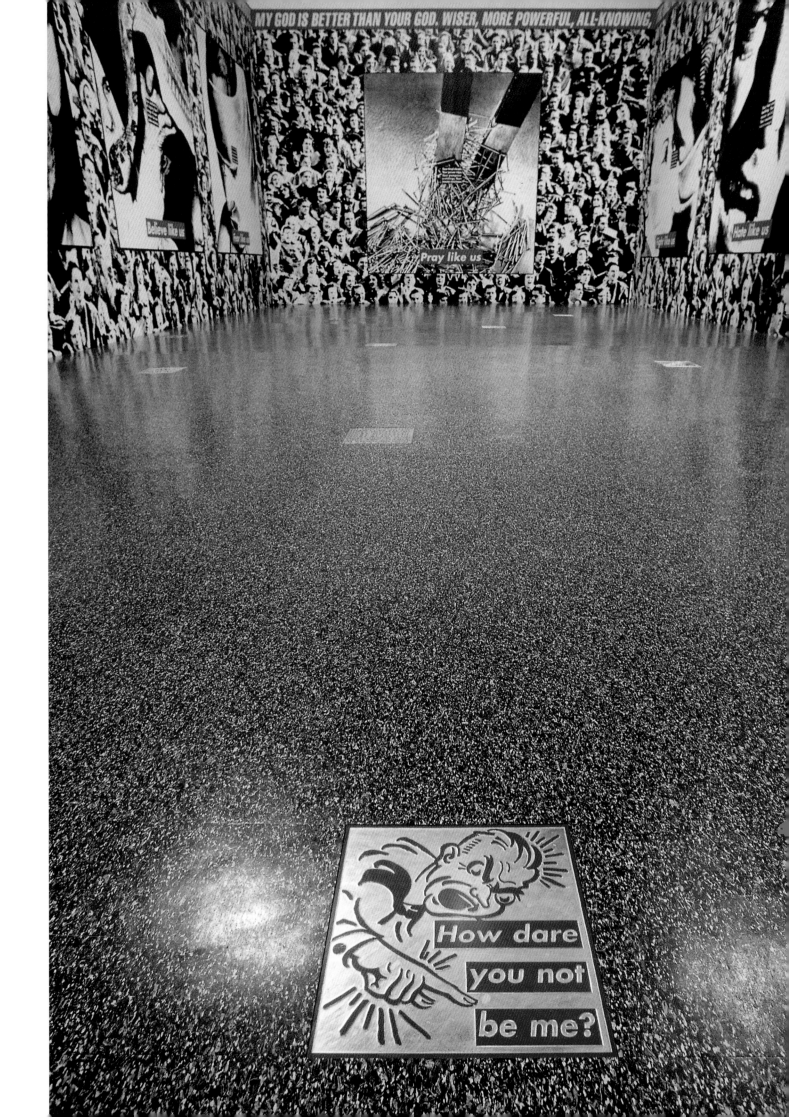

Installation view, **UNTITLED (WHY ARE YOU HERE?)**, in **NEW WORKS FOR NEW SPACES: INTO THE NINETIES**, September 29, 1990–January 6, 1991. Wexner Center for the Arts, Columbus, Ohio.

(214–15)
Installation views, **BARBARA KRUGER**, August 25–October 14, 1990. Kölnischer Kunstverein, Cologne, Germany.

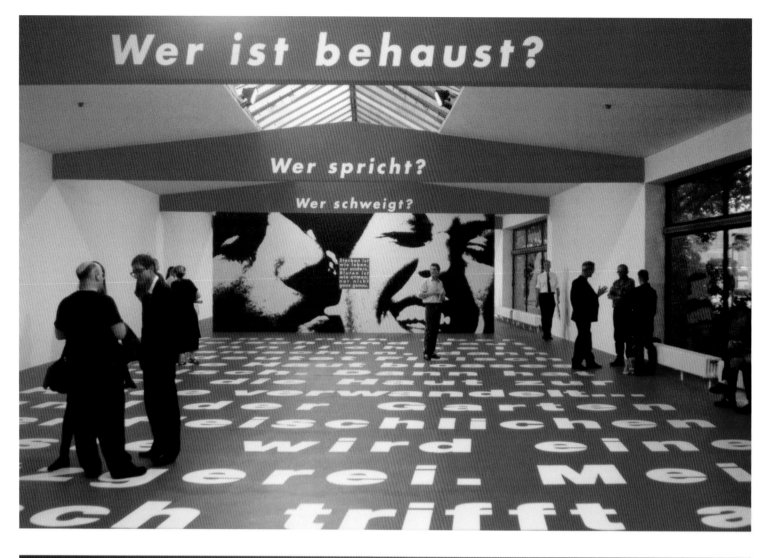

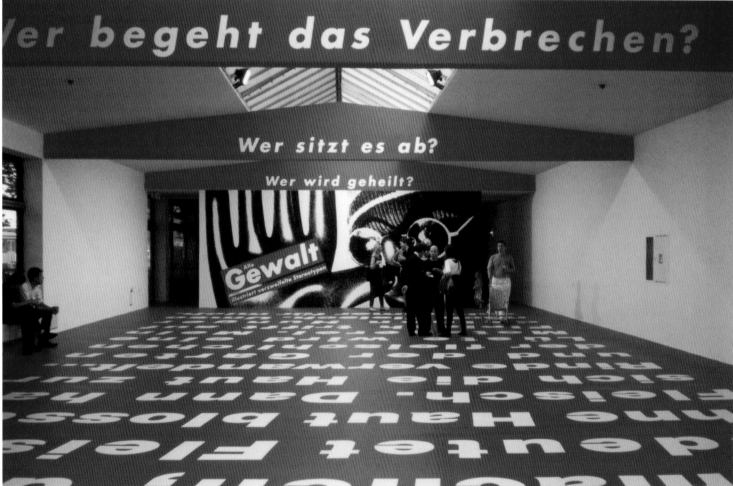

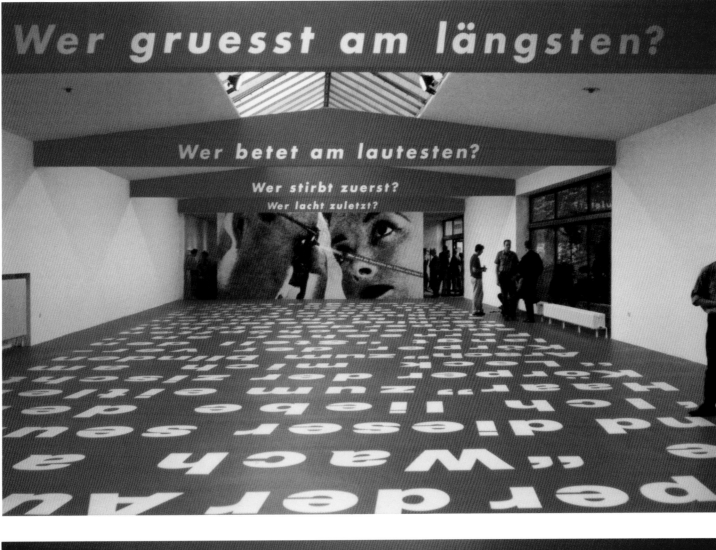

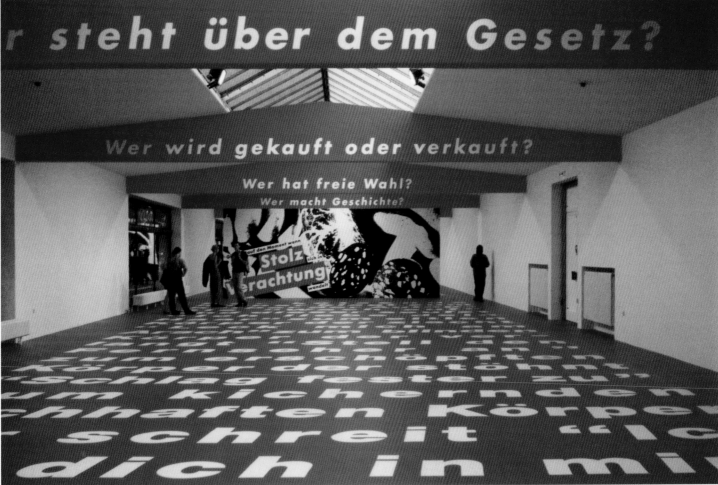

D MATTER

about this place

You are approaching this place from the southwest. You are thinking about love and disease. The wind is dividing your hair and you're glad you wore a jacket. You are not making assumptions about this place. You are thinking about crime and money. You look through the window. You walk up two steps. You have difficulty with the door. You enter. A conversation is going on which establishes familiarity between two people in this place.

You are thinking about power and waiting. The light in this place is white and clear. You are standing up. You are reading two books. You favor one with memory and the other with grasp. This place is divided in two parts. You are thinking about public and private. You are holding a book. You are gathering information through mental and physical embrace. You pay for a book. You turn around. You walk towards the door. The sun is out and you are hungry.

books

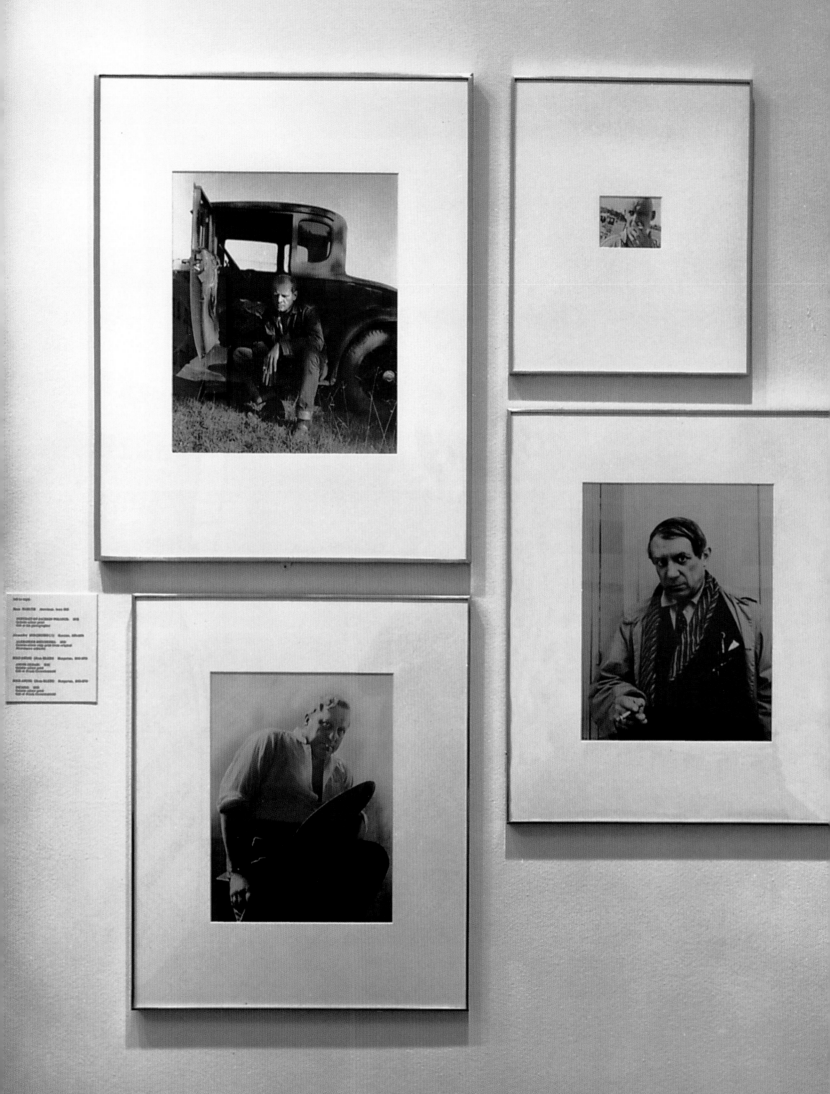

Picturing "Greatness"
The pictures that line the walls of this room are photographs of mostly famous artists, most of whom are dead. Though many of these images exude a kind of well-tailored gentility, others feature the artist as a star-crossed Houdini with a beret on, a kooky middleman between God and the public. Vibrating with inspiration yet implacably well behaved, visceral yet oozing with all manner of refinement, almost all are male and almost all are white. These images of artistic "greatness" are from the collection of this museum. As we tend to become who we are through a dense *(cont. →)*

crush of allowances and denials, inclusions and absences, we can begin to see how approval is accorded through the languages of "greatness," that heady brew concocted with a slice of visual pleasure, a pinch of connoisseurship, a mention of myth and a dollop of money. But these images can also suggest how we are seduced into the world of appearances, into a pose of who we are and who we aren't. They can show us how vocation is ambushed by cliché and snapped into stereotype by the camera, and how photography freezes moments, creates prominence and makes history.
—Barbara Kruger

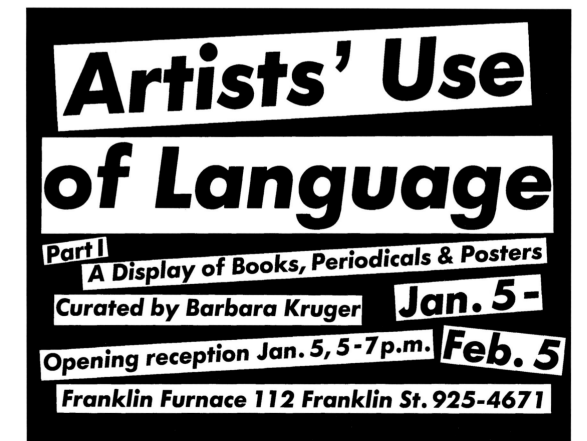

Installation views, **ARTISTS' USE OF LANGUAGE: A DISPLAY OF BOOKS, PERIODICALS, AND POSTERS,** February 5–May 2, 1982, an exhibition curated by Barbara Kruger, Franklin Furnace, New York City.

(222–23) Installation views, **PICTURES AND PROMISES: A DISPLAY OF ADVERTISING, SLOGANS, AND INVENTIONS,** 1981, an exhibition curated by Barbara Kruger, The Kitchen, New York City.

DOUBLE GUARANTEE

I might attack you . . . your blue glow is a pretty target. You might die from my blows . . . if it turns out that I do kill you, I want you to know I'll make it up to you someday. Because I don't hate you and I don't have anything against you— in fact, you look like decent folks. I promise that if I do kill you, I will save you in some future life. It may be a thousand transmigrations from now, we may not even be human, but I'll remember. I always keep my word, ask anyone, they'll tell you.

You and I, we are committed to this universe, there is no asylum, so let's get settled in— we could even be friends. I have this recurring image: you are far away in the darkness, cut off from everything, adrift in the winds without eyes (John Wayne shot them out). You are stranded between lives, your only memories are of astronauts. It's been years since you have touched anything and you long to get back to a life with a daily rhythm . . . And then, with one ringing shot and a chain of silver light, I pull you back.

Don't walk away, it's OK. I'm always under control when Star Wars is playing in the theatres. It's in between episodes that I swerve out of control. It's then that I will hunt you down. Star Wars II will have a long run, but in the late fall, when it is displaced by the latest stinking trash reels from the disintegrated corpse of a city they call Hollywood, I'll come at you. You will be the vent for my hatred of them. Black noise, like blindness will flow through your body.

You see, I go to Star Wars many times each week. I need it: in the daytime it is my school, my psychiatrist, my health club; at night it is my lover, my private jet airliner, my communion with the universe. And when I feel bad, it is my doctor. I'm going to call it Doctor from now on, you'll know what I mean.

You see, I didn't have any schooling, everything I know comes from the movies. Up until the Doctor, all I had was porno and horror and an occasional Clint Eastwood. You can imagine what my first trip to the Doctor was like. He laid me down on this special bed, and a woman in a white dress secured my arms and legs to the bed with leather straps. Then she attached a metal brace to my head and put this little rubber thing in my mouth. The Doctor attached these metal wires to my head and then he stepped back.

The only part I remember is the laser sword scene. God it hurt. He was demolishing me, slashing in deeper and deeper. I was falling into nothingness when someone in white came and saved me . . . it was you . . . Now, once again, take my hand and pull me through, maybe you can free me. With your courage and with your common sense, I promise that we will win in November and that America will continue to be a nation that faces the world as it is today and works with realism to bring a future of freedom, peace and justice. Thank you.

SHE IS AFRAID SHE IS FEARED

MORALLY SUPERIOR PRODUCTS

CENSOR

HEAR NOTHING SEE NOTHING

For wider streets
Vote Conservative

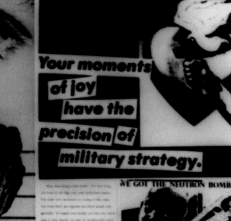

Your moments of joy have the precision of military strategy.

You construct Intricate rituals which allow you to touch the skin of other men.

CONTROL

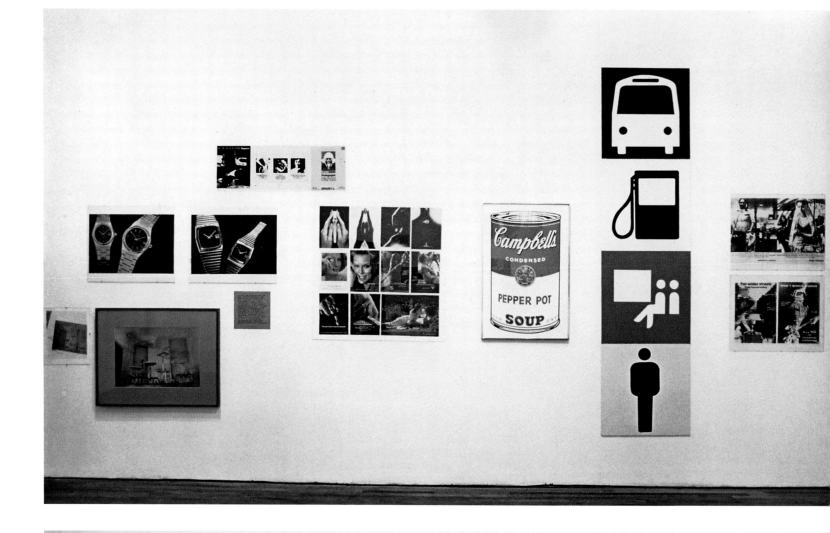

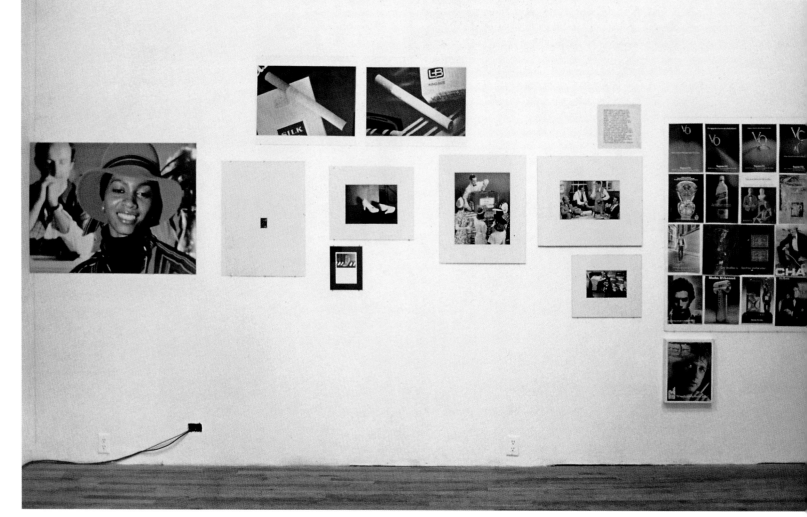

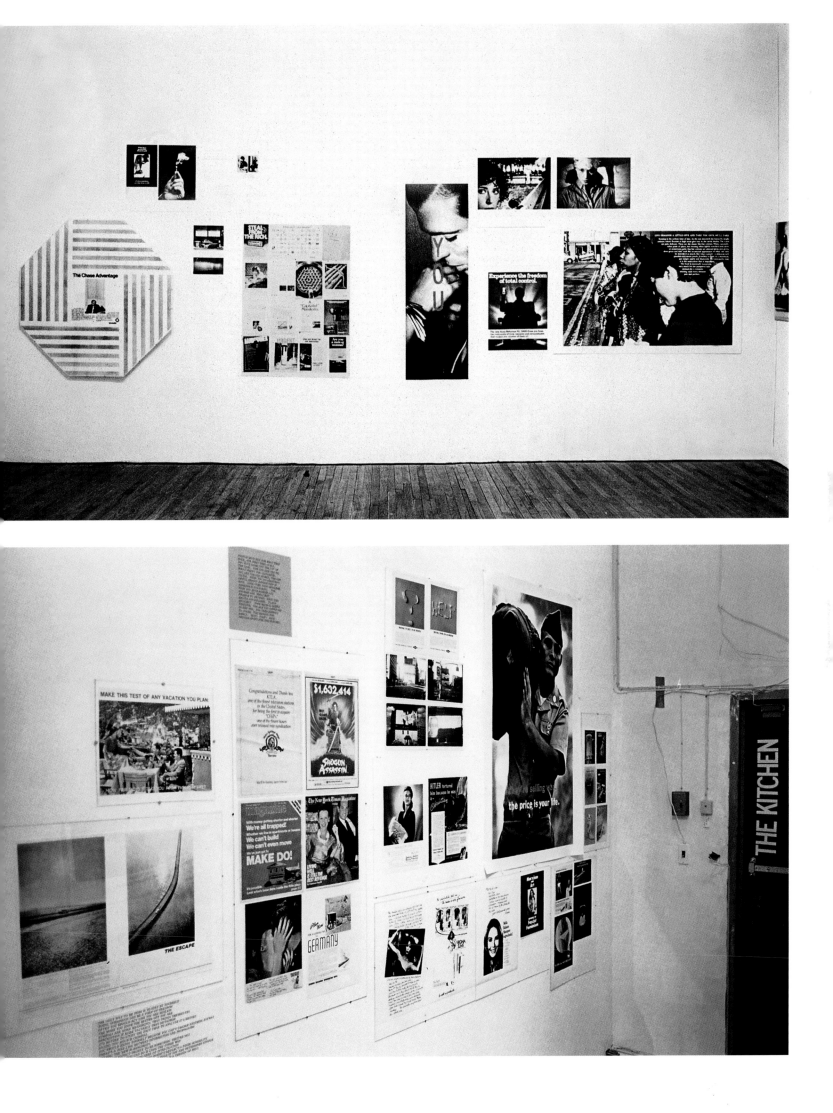

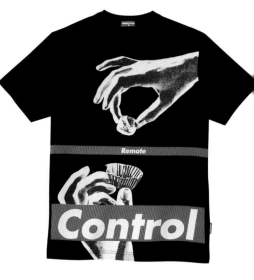

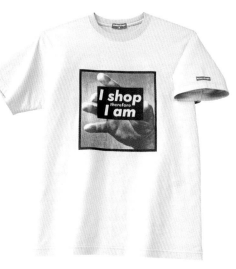
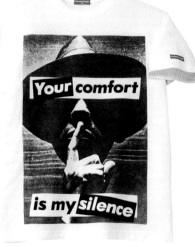
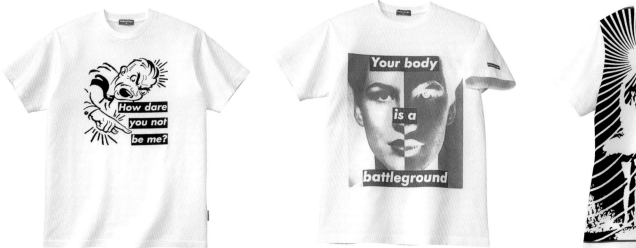
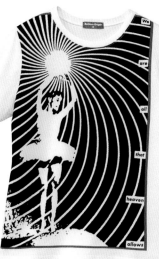

CAROL SQUIERS

Barbara Kruger at Mademoiselle

BARBARA KRUGER WAS AN ART STUDENT in 1967 when she began getting restless. She had done as much as she could in school and she needed to find a job. With the help of her teachers at the Parsons School of Design, Kruger put together a graphic design portfolio and was hired by Condé Nast Publications in New York. As assistant to the art director of *Mademoiselle*, Kruger would ultimately transcend this role. While she was a designer she began to understand certain crucial mechanisms and strategies for combining pictures and text to create an emotional, psychological, and intellectual impact on a magazine reader.

At the time, Kruger didn't realize that what she learned as a designer could be useful in creating visual art. But the skills she developed during her tenure at *Mademoiselle*, what she has long called "the biggest influence on my work," would form the basis for her mature art-making practice.[1] The dynamics of the photographic and design expertise she gained have been examined only in the most schematic way. A closer investigation of the magazine work that she and her colleagues did shows how important those visual and communication strategies were for her once she redeployed them to make art.

It has been noted before that among her teachers at Parsons were two important figures who would have tremendous and lasting effects on American visual culture and on Kruger herself. One was the artist and graphic designer Marvin Israel, a seductive, ornery painter who was enormously influential, as a teacher, as the art director for *Seventeen* and *Harper's Bazaar* magazines, and as a designer who worked for more than twenty years in collaboration with Richard Avedon on his exhibitions and publications. The other was Diane Arbus, who brought a unique and still controversial vision to photography with her intimate, unsparing images of people who were socially marginal, physically flawed, or otherwise vulnerable to a photographer's charm and the camera's scrutiny. Kruger was part of a circle of students and friends that orbited around Israel and Arbus, and the two became important supporters in her effort to begin a career.

1

Kate Linker, *Love for Sale: The Words and Pictures of Barbara Kruger* (New York: Harry N. Abrams, 1990), 14.

As a teacher Israel was both inspiring and intimidating, and his pedagogic methodology, according to Kruger, was "to provoke."[2] The provocation was mainly verbal, but it could take other forms, which was wryly described in a documentary on Israel's life. Photographer Deborah Turbeville said that for a time Israel "just ignored me"; artist Michael Flanagan remembered that Israel once kicked a student during class. Although Avedon was not a student but a friend and collaborator of Israel's, he acknowledged Israel at one point as "his greatest influence." Picaresque stories of Israel's verbiage, temper, and talent are legion among those who worked or studied with him, but so are stories of his ability to motivate and inspire. "I think he literally liberated people. He gave them . . . the right to believe in themselves and what they were doing in the most intense way," says photographer Neil Selkirk. "There's a sense of assurance that's inspiring."[3] Certainly Israel affected Kruger in that way: "He was the first person who said 'You can do something.'"[4]

Kruger's eventual goal when she started art school was to work in graphic design, perhaps as a fashion illustrator—the idea of becoming an artist hadn't occurred to her. Although she was an art student, she was from a modest background and wasn't familiar with the history of art or developments in contemporary art. She couldn't yet conceptualize what it meant to be an artist. There were few women artists in the art world at the time and Kruger didn't initially consider going against that trend. As she has said, Arbus was a particularly important figure for her as "the first female role model I had who didn't wash floors twenty times a day."[5] Israel and Arbus suggested she put a portfolio together to get work as a graphic designer. She did sample book cover designs and page layouts inspired by an original new British style magazine called *Nova* and took the portfolio to Condé Nast Publications. She was offered a job as a "second designer" at *Mademoiselle*, a fashion magazine for the youth market. Kruger was first listed on the masthead of the magazine as one of three art assistants in the April 1967 issue.

Mademoiselle was a quality magazine aimed at educated, affluent young career women. It was known for a sense of innovation and made news as the first mainstream fashion magazine to break the color barrier in modeling when an African American student modeled in its college issue.[6] In addition to featuring fashion in its pages, *Mademoiselle* was also recognized for its popular annual short story contest, which was most famously won by Sylvia Plath. The most exciting contemporary writers appeared in the magazine's pages, among them Carson McCullers, Truman Capote, James Baldwin, Flannery O'Connor, and Plath herself, who were chosen by editors such as Margarita Smith, a longtime fiction editor at the magazine and the sister of Carson McCullers.[7] Besides publishing quality fiction, *Mademoiselle* also had a reputation for "finding new talent" and for "fostering the professional development of young women."[8]

2
Barbara Kruger interview with author, July 7, 2009.

3
Writer Owen Edwards relays the statement about Israel by Avedon. Israel is one of the least known yet important figures who influenced magazine and book design in the post–World War II years until his death in 1985, a circumstance reflected in the title of the documentary about him, *Who Is Marvin Israel?* by Neil Selkirk, directed and produced by Neil Selkirk and Doon Arbus. Neil Selkirk, Inc., 2005, The Documentary Channel.

4
Squiers interview, July 7, 2009

5
Carol Squiers, "Diversionary (Syn)tactics: Barbara Kruger Has Her Way with Words," *ARTnews* (February 1987), 81. Indeed, Arbus was a more public role model as well, as she was featured along with Lee Friedlander and Garry Winogrand in the important exhibition *New Documents*, organized by John Szarkowski at The Museum of Modern Art and on view from February 28 through May 7, 1967.

6
"A Negro Student Models for Fashion Publication," *New York Times*, July 21, 1961, p. 26. The color barrier had actually already been broken by *Harper's Bazaar* in its February 1959 issue, when China Machado, a Portuguese-Chinese model appeared in its pages. But perhaps the *Times* considered the appearance of a black model a more startling and noteworthy development. See Carol Squiers, "'Let's Call it Fashion': Richard Avedon at *Harper's Bazaar*," in Carol Squiers and Vince Aletti, with an introduction by Philippe Garner, *Avedon Fashion 1944–2000* (New York: Harry N. Abrams, International Center of Photography, and The Richard Avedon Foundation), 174–75.

7
Smith worked at *Mademoiselle* from 1943 to 1960.

8
Kathleen L. Endres and Therese Lueck, *Women's Periodicals in the United States* (Santa Barbara: Greenwood Publishing Group, 1995), 198.

The September 1967 issue, for example, featured a substantial layout on young career women in fashion, including a copywriter at an advertising agency and several editors on *Mademoiselle*'s staff. They were photographed for the story "Girls in Fashion" by Barbara Waterston in an energetic documentary style, shown at work and out on the town, wearing the latest styles appropriate for young professionals.[9] In Kruger's estimation, Condé Nast was one of the few large corporations in New York "that hired women to do something besides make coffee."[10] Along with the evolving feminist politics of the day, this workplace recognition of women as creative decision-makers must have bolstered Kruger's developing sense of individual agency.

When Kruger began at the magazine, the art department was headed by art director Roger Schoening, who oversaw a designer, Valentyna Pawluk, and a production assistant, Florence Leslie. Schoening chose and assigned the photographers who appeared in the publication and collaborated with editors on fashion stories and pictorial ideas. Once the pictures were made, it was the job of the designers to scrutinize the numerous contact sheets of black-and-white photographs and hundreds of color slides and to choose the best images to use for the layouts. Pawluk designed the individual pages featuring the newest season's fashion in the editorial section. Kruger's task was to create ancillary layouts in the back section of the magazine featuring small images of single garments or accessories; she chose the photographs and cropped and sized them down to one-column width. Under the often-casual guidance of Schoening and Condé Nast's editorial director, Alexander Liberman, Pawluk and Kruger turned out a magazine design that was more visually diverse and engaging than it might appear to the fashion-conscious reader.

Every element in fashion magazine layouts is placed there to draw the reader's eye and to keep it there, page after page. The choice of photographer and the final photographs for use are the most obviously significant part of the visual mix. The liveliness and vigor that photographers from Martin Munkacsi to Avedon had injected into fashion photography beginning in the 1930s was a standard part of the repertoire at *Mademoiselle* by the latter 1960s.[11] Over the previous two decades Avedon had created a style in which a tightly wound, compressed energy seemed to burst off the pages, with models assuming bold poses that telegraphed physicality and vigor. Younger photographers took his innovation and worked endless changes on it, reshaping it according to the fashions of the moment, the magazine's audience, and their own aesthetic sensibilities. Since *Mademoiselle* targeted young women from polite society or those with similar aspirations, the models were often shown in its pages moving with a restrained, ladylike energy—forward, but not too aggressive, playful, but not too boisterous. In the "Girls in Fashion" story the pictorial emphasis was on the well-mannered but confident behavior of the young women featured whether at work or at play. How the photographs were handled in terms of editing, cropping,

9

"Girls in Fashion: Their Trendy Looks; Their Private Lives," *Mademoiselle*, September 1967, 125–39.

10

Squiers interview, July 7, 2009.

11

Both photographers worked for *Harper's Bazaar* at the time. Avedon moved to a Condé Nast magazine—*Vogue*—in 1966.

and size on the page, and the choice and placement of other visual elements including typography helped determine the emotional and visual temperature of a given article. For "Girls in Fashion," bold, modern type jostled its way across parts of the pictures and out onto the white space of the page, creating visual flurries that challenged the eye and kept it moving through the story.

In addition to the modern woman at work, the magazine also looked at other compelling aspects of urban life, including contemporary art and the growing contemporary art scene. A six-page story by photographer Gösta Peterson, "Black White: About Town," featured models dressed in sleek, graphic black-and-white summer dresses presented in ways that seem to mimic the black-and-white abstract contemporary art that was used as a backdrop and props for the pictures.[12] Peterson was one of the most inventive, fluid photographers working for *Mademoiselle* at the time, but his photos, like the others published there, weren't allowed to stand on their own; page layout and design elements were clearly valued as ways to provide additional graphic sparks. The photographs were closely cropped and visually supplemented by thin black lines that outlined and bracketed the pictures, along with a variety of typefaces. Each spread was crowded with visual information, with large black-outlined reverse-block type played against the lacy arabesques of italicized body type. In the same issue, photos by Marc Hispard of long-limbed young women in the newest little dresses from London and Paris were set off with thin red lines around the pictures and a block of type set in a circular shape.[13] These ruled lines were a house style for a time and were used in a variety of different ways to divide or organize pages. And there was a lot for fashion magazines both to hold together and to separate in the 1960s.

The increasing influence during the 1960s of popular culture on fashion—from rock-and-roll and alternative lifestyles to underground movies and contemporary art—must have been slightly disconcerting for editors who were schooled in the rarefied niceties of French haute couture and the sensible practicality of American fashion design. *Mademoiselle*'s well-educated career girl wore sporty American clothes, but she could evidently also afford couture styles or authorized copies of them. Youthful Paris fashions by top designers including André Courrèges and Marc Bohan for Christian Dior were covered in stories that clustered groups of same-size images across spreads like an upscale catalogue.

Like the magazines aimed at a more mature audience, the youth market was also segmented in terms of taste and spending power. An issue on budget fashion made clear that the *Mademoiselle* reader was still expected to wear a ladylike hat and white gloves with her proper "city" dresses, but that for leisure activities she could don the more daring styles of swinging London's minidresses. These conflicting fashion directives were reconciled

————— 12 —————
"Black White: About Town," *Mademoiselle*, April 1967, pp. 166–71. Some of the pictures were made in the Park Place Gallery, an artists' cooperative.
————— 13 —————
"London/Paris: Needling," *Mademoiselle*, April 1967, 172–73.

in the animated and sometimes agitated layouts in the magazine and blended into coherent stories by the use of graphic design.

One origin of *Mademoiselle*'s basic visual philosophy was probably Alexander Liberman, who espoused a design theory that was essentially anti-design. From the time when he was named the art director of *Vogue* in 1943 and then throughout his long tenure as editorial director of all Condé Nast magazines, Liberman was known as a man who could easily change with shifting tides. He had few real design hallmarks: one of them was a penchant for crowded, even busy pages.[14] "At *Vogue*, I wanted to break the design obsession, so I defended a more journalistic approach—rougher lettering, no white space, crowded pages, messier layouts."[15] With Liberman as a barometer, the designers at *Mademoiselle* had a certain freedom in how they handled type, design, and the sheer number of pictures they could use. "What I wanted . . . was to make [*Vogue*] something more than lovely and attractive," said Liberman in explaining how he had reacted against the luxurious elegance of rival *Harper's Bazaar* under Carmel Snow and Alexey Brodovitch.[16] "I thought there was more merit in being able to put twenty pictures on two pages than in making two elegant pages. The one clear idea I brought was the idea of anti-design. What is design? It's making use of the material—the way it's used—more important than the material itself."[17] For Liberman, pictures were things to be deployed, not for their own merits, but as graphic elements in a larger enterprise.

According to Kruger, Liberman paid less attention to *Mademoiselle*, and therefore interfered less, than he did with other Condé Nast magazines. He was much more interested in *Vogue*, *Glamour*, and *House & Garden*, publications for which he himself was the art director, than he was in *Mademoiselle*, which was not a Condé Nast creation but a 1959 acquisition from another publisher.[18] Practically speaking, Liberman's philosophy of "anti-design" meant that designers at *Mademoiselle* had a certain license, which was convenient because there was a lot of turnover in the art department. Pawluk left *Mademoiselle* in 1967 and in the November issue of that same year, Kruger was listed as the only "assistant" in the department. Her modest title didn't come close to describing the type and amount of work she did: choosing the photographs and designing the entire magazine. She was twenty-two years old.

Kruger's graphic ascension caused noticeable results as she grappled with the clashing social and stylistic developments of the time. Satin trench coats in one story were modeled by lustrous, well-groomed debutantes whose social and educational pedigrees were prominently displayed; among them was a young Sigourney Weaver, Sarah Lawrence, '71 (Junior League Ball, Grosvenor Ball).[19] The next story featured portraits of folk musicians, among them Paul Simon and Arlo Guthrie, who had been commissioned by *Mademoiselle* to write holiday poems. The sixties flower child

——————— 14 ———————
Dodie Kazanjian and Calvin Tomkins, *Alex: The Life of Alexander Liberman* (New York: Alfred A. Knopf, 1993), 136, 146, 231.

——————— 15 ———————
Ibid., 146. There are no footnotes in this biography, so direct quotes from Liberman are apparently taken from the authors' notes.

——————— 16 ———————
Brodovitch and Snow both left *Harper's Baazar* in the late 1950s.

——————— 17 ———————
Kazanjian and Tomkins, *Alex*, 143.

——————— 18 ———————
Endres and Lueck, *Women's Periodicals*, 198. *Mademoiselle*'s longtime editor, Betsy Blackwell, came along with the magazine and she would have had her own specific ideas about the magazine she had been editing since 1937 and thus been less influenced by Liberman's vision.

——————— 19 ———————
Photographs by David McCabe, *Mademoiselle*, "Presenting: The Partycoat," Dec. 1967, 91–93.

thematic was also played in a fashion story photographed by Gösta Peterson. The images featured somber, barefooted young women in peasant-inspired outfits posing in front of an unpainted wood cabin that recalled the impoverished rural housing made famous by Walker Evans photographs thirty years earlier.[20] For this article, Kruger let the photos stand on their own. But the type treatment was both more complex and more restrained than in previous issues, and visual impact was created with italicized text underlined with black ruled lines and headlines set all in italicized capital letters.

Deborah Turbeville was also featured in the same issue with some of her first published fashion photographs. Turbeville, an assistant fashion editor at *Mademoiselle*, created a story about two fictional society sisters of the 1930s disporting themselves in Newport, Rhode Island in tennis outfits, tidy checked suits, and little cotton dresses. Casually composed and shot in both black-and-white and color, the pictures were arrayed on the pages with the sprocketed black edges of the film showing. The informal-looking images show young women caught in between activities, but there is an energetic boldness to the layout, with pictures enlarged to crowd into each other on some pages, leaving no white space at all.[21] Throughout the issue, Kruger developed design solutions unique to each theme while also creating a unified flow within the magazine.

Kruger's tenure as the graphic designer for *Mademoiselle* was characterized by an increasingly cleaner, more modern look and the eye-catching use of type. For a spread on shiny, casual knitwear, Kruger broke the headline in two, and ran most of it horizontally in tiny type with the last word enlarged vertically in bold black type an entire column's width high.[22] "American Thoroughbreds," a story on "high-spirited, elegant breeziness," was shot in Central Park and featured the model Ali McGraw. In it the photographs of tailored woolens were enlarged to bleed off three edges of the page, with one narrow, clean band of white left at the outer edges. The type is reversed—white type on a dark background—and Kruger creates headlines out of a blocky but light modern face, mixing capital letters and small letters in mid-word and running the headline and text together, all of which adds visual appeal without drawing attention to itself as design.[23]

In the midst of all the picture stories on sportswear, party coats, and flannel suits, Kruger was also challenged by completely typographic pieces. Some of them were mere collections of miscellaneous short texts and quotes on specific topics such as travel or the demands of modern life. Spread across a couple of pages, Kruger had to link these disparate pieces with design. Her solution was to set each individual portion of the texts in typography of different sizes, styles, and weights, a strategy that she would return to as an artist. In one piece a paragraph by a doctor on why overweight girls lack energy is set in a bold, modern typeface, a following quote

————————— 20 —————————
"Yonder Peasant, Who Is She?" *Mademoiselle*, December 1967, 112–17. Evans's work for the Resettlement Administration and Farm Security Administration during the Depression had an ongoing impact on visual culture in America. One of the assignments that Arbus had given Kruger as a student was to take photographs in the style of Walker Evans—although Kruger did not assign Peterson to take these photographs. Arbus worked as a fashion photographer for a number of years.

————————— 21 —————————
"The Name of the Game is Newport," *Mademoiselle*, Dec. 1967, 129–33. Turbeville, as noted, was also a student of Israel's.

————————— 22 —————————
"Brown & White Glossies," *Mademoiselle*, January 1968, 96–97.

————————— 23 —————————
"American Thoroughbreds," *Mademoiselle*, February 1968, 104–9.

from Nietzsche about sleep is set in a light, attenuated font, while instructions for an invigorating session of yoga appear in a delicate, italic face. Along with a dozen other bits of text the whole thing was anchored across a spread under a large, bold, and somewhat puzzling headline, "Energy: The Experts Report," which sounds more like an essay on gasoline and coal than on calories and exercise.[24]

As the sixties progressed, fashion magazines had to confront some of the convulsive social and political issues that were a hallmark of the decade, among them racial tensions and increasing urban unrest. The June 1968 issue of *Mademoiselle* included an unusual feature story, "Riots: A Cool View of a Hot Summer." In it, the author expounded on recent racial unrest in the United States and gave examples of past troubles to show how the country's "long tradition of violent rebellion puts the current racial tensions into perspective." But he departed from his history lesson to assert that "whereas last year's violence was confined to the black ghettoes, this year's is expected to spill over into white communities. Suburban housewives are learning the use of firearms as frontier women once did to protect their log cabins against the red 'savage.'" In a picture-heavy publication, the essay stood out for its frightening message and dense columns of unillustrated text. Within a few pages, though, the reader was brought back to fashion with a slightly fantastic twist when Kruger mixed fashion photographs of models with playful fashion illustrations of long-legged, mop-topped misses in "Summer Fashions with Soul." And a new, starker aesthetic is introduced with the young Guy Bourdin's pointedly awkward images of shoes and handbags arrayed in a barren geometric composition that Kruger emphasized with a single triangular block of crowded type.[25]

Despite the fear-inspiring piece on riots, more affirmative aspects of the era's social change were also evident in *Mademoiselle*'s pages. Young black women, especially college students, were being featured more often in fashion and beauty stories, and black models began to appear in advertising.[26] And *Mademoiselle*'s definition of possible careers for women began to expand beyond fashion editor and advertising copywriter. The essay "Portrait of the Photographer as a Young Woman" covered the possibilities and difficulties of commercial and editorial photography for women and named fourteen top women photographers, including Bernice Abbott, Louise Dahl-Wolfe, Dorothea Lange, Margaret Bourke-White, and Diane Arbus—Kruger's mentor—who had been featured the previous year in the watershed *New Documents* exhibition at The Museum of Modern Art.[27]

Several versions of each layout in *Mademoiselle* were often produced before everyone, including Liberman, was satisfied with them. During the process, Kruger developed a finely honed understanding of why one design was preferable to another. This was particularly important in cover designs, which were made in eight different versions each month, and had to

24
"Energy: The Experts Report," *Mademoiselle*, March 1968, 184–85. An editor would have written the headline.

25
Gus Tyler, "Riots: A Cool View of a Hot Summer," *Mademoiselle*, June 1968, 102–3, 145–49; "Summer Fashion with Soul," 106–115; "Leather Weather," 122–23.

26
See "UCLA Campus Beat—Crash Beauty," 236–41 and Bell Telephone ad, *Mademoiselle*, April 1968, 52–53; "Campus Beat—College of the Virgin Islands: Beach Break," May 1968, 174–77.

27
"Portrait of the Photographer as a Young Woman," *Mademoiselle*, March 1968, 178–79, 216.

UNTITLED, by Barbara Kruger for **NEW YORK** magazine, March 24, 2008. Portrait of Eliot Spitzer by Henry Leutwyler/Contour by Getty Images.

(234–35) **BLACKPOOL** magazine, Paris, France, June issue, 2009.
DAZED & CONFUSED magazine, London, July issue, 2006.

function as the consumer beacons that determined if a magazine lured buyers to the newsstands. The design and the visual dynamics of the modern typefaces Kruger used would also have a substantial impact on her aesthetic sensibility and her understanding of the ways in which meaning can be created using a few, judiciously chosen elements. But by the late 1960s she became restless again. The last time her name appeared on *Mademoiselle*'s masthead was in the September 1968 issue; for nearly a decade after that she worked at Condé Nast part time. She became a freelance picture editor at *House & Garden*, a job that required a different sort of heightened visual discrimination to choose one photograph over another, a talent she would also find useful in the coming years.[28]

To make the leap from designer to artist, Kruger had to reject the advice of people who had been instrumental to her magazine success. "Marvin thought you had to paint to be an artist," she says of Israel. "I remember asking him, can't I just be an artist using photographs, cutting them up, using Magic Markers? And he said no." Kruger started making art in the late 1960s and for the next decade worked her way through a number of different techniques, from knitting and sewing to painting. In the mid-1970s she stopped making art for a while and spent time reading and contemplating the terms of her work and her relationship to the art world. When she resumed making visual art she did so using pictures, words, and a critical understanding of design, all of it influenced by her days as a young designer. This time she was not constructing eye-pleasing pages devoted to the newest coat or smartest buys. Instead, she began to pose questions about the construction of everyday life and the social mechanisms of consumption, seduction, and control, which flowed as much from her experiences in fashion and lifestyle publishing as they did from the critical theory she read. The young woman who hadn't imagined being an artist took her experience at shaping fashion's upbeat enticements and turned it to her own artistic ends: to challenge, lampoon, and subvert the protocols of power.

28

Kruger worked at *House & Garden* until about 1977, when her work as an artist and her travel as a visiting artist at various universities began to consume all of her time.

NEW YORK

The
Governor's
Fall
*Coverage begins
on page 18*

BRAIN

BE THE FIRST TO KNOW #MUSIC #FASHION #FILM #ART #IDEAS

DAZED

&CONFUSED

The Freedom Issue: Know Your Rights

VOLII#39

THE FREEDOM ISSUE

BUSY
UNMAKING
THE WORLD

They blind your eyes and drain your brain

VOL 2 ISSUE#39 JULY 2006
UK £3.40 IT €6.90 US $9.99 CAN $9.99 MADE IN THE UK
COVER BY BARBARA KRUGER

Project for **DAZED & CONFUSED** magazine, June 1996.

(238–39)
Project for **HARPER'S BAZAAR**, February 1994.

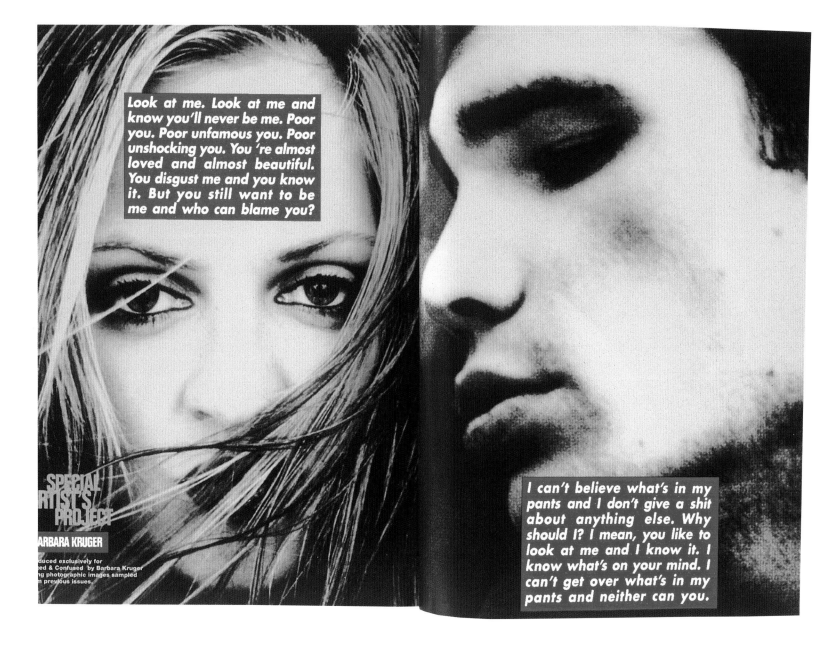

Look at me. Look at me and know you'll never be me. Poor you. Poor unfamous you. Poor unshocking you. You're almost loved and almost beautiful. You disgust me and you know it. But you still want to be me and who can blame you?

SPECIAL ARTIST'S PROJECT

BARBARA KRUGER

duced exclusively for
ed & Confused by Barbara Kruger
ng photographic images sampled
m previous issues.

I can't believe what's in my pants and I don't give a shit about anything else. Why should I? I mean, you like to look at me and I know it. I know what's on your mind. I can't get over what's in my pants and neither can you.

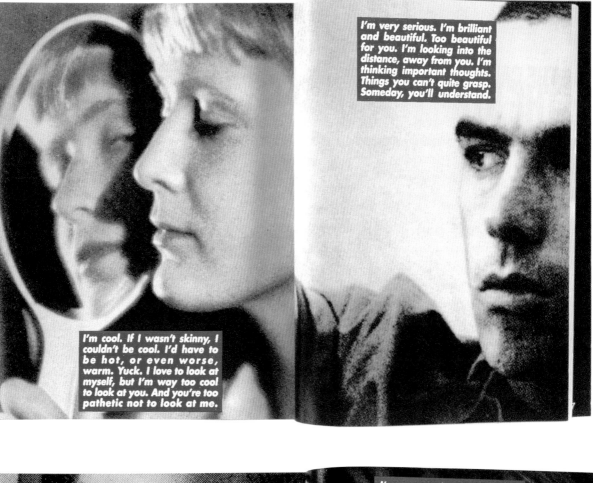

I'm very serious. I'm brilliant and beautiful. Too beautiful for you. I'm looking into the distance, away from you. I'm thinking important thoughts. Things you can't quite grasp. Someday, you'll understand.

I'm cool. If I wasn't skinny, I couldn't be cool. I'd have to be hot, or even worse, warm. Yuck. I love to look at myself, but I'm way too cool to look at you. And you're too pathetic not to look at me.

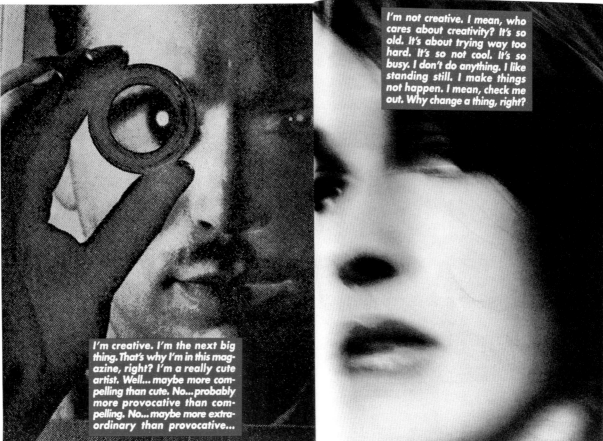

I'm not creative. I mean, who cares about creativity? It's so old. It's about trying way too hard. It's so not cool. It's so busy. I don't do anything. I like standing still. I make things not happen. I mean, check me out. Why change a thing, right?

I'm creative. I'm the next big thing. That's why I'm in this magazine, right? I'm a really cute artist. Well... maybe more compelling than cute. No... probably more provocative than compelling. No... maybe more extraordinary than provocative...

How much money do you make?

This is not a joke

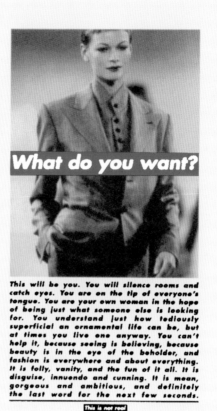

What do you want?

This will be you. You will silence rooms and catch eyes. You are on the tip of everyone's tongue. You are your own woman in the hope of being just what someone else is looking for. You understand just how tediously superficial an ornamental life can be, but at times you live one anyway. You can't help it, because seeing is believing, because beauty is in the eye of the beholder, and fashion is everywhere and about everything. It is folly, vanity, and the fun of it all. It is disguise, innuendo and cunning. It is mean, gorgeous and ambitious, and definitely the last word for the next few seconds.

This is not real

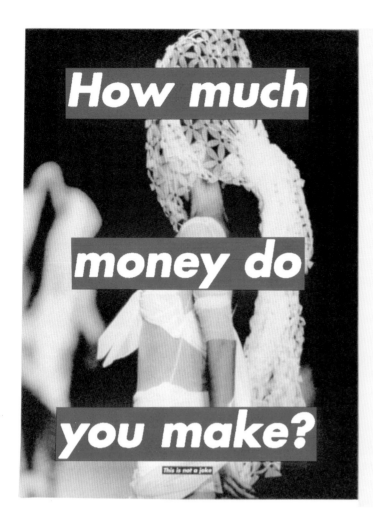

Who do you think you are?

This is not you

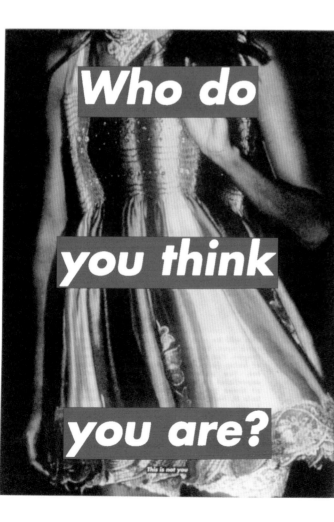

Who do you love?

This will be you. You are the image of your own perfection. You've got the look and you intend to keep it because you understand the precocious power of taste: how it instructs our desires, how it dictates not only what we put in our mouths, but how we put ourselves together, how we furnish our bodies, our homes, our governments, our museums, and our minds. You know that what you love and what you hate is inevitably a combo of where you've come from and where you think you're going. Your taste is both the fickle daydream of what you want and the moist choice of what you need.

This is not the end

Assorted T-shirts designed in conjunction with **YOU BELONG HERE**, installation at the Parrish Art Museum, Southampton, New York, July 19–September 6, 1995.

(242–43)
Article and photograph for **ESQUIRE**, May 1992.
Cover design for **ESQUIRE**, May 1992

(244)
FAILING UPWARD, 1992. Editorial page, **LOS ANGELES TIMES**.

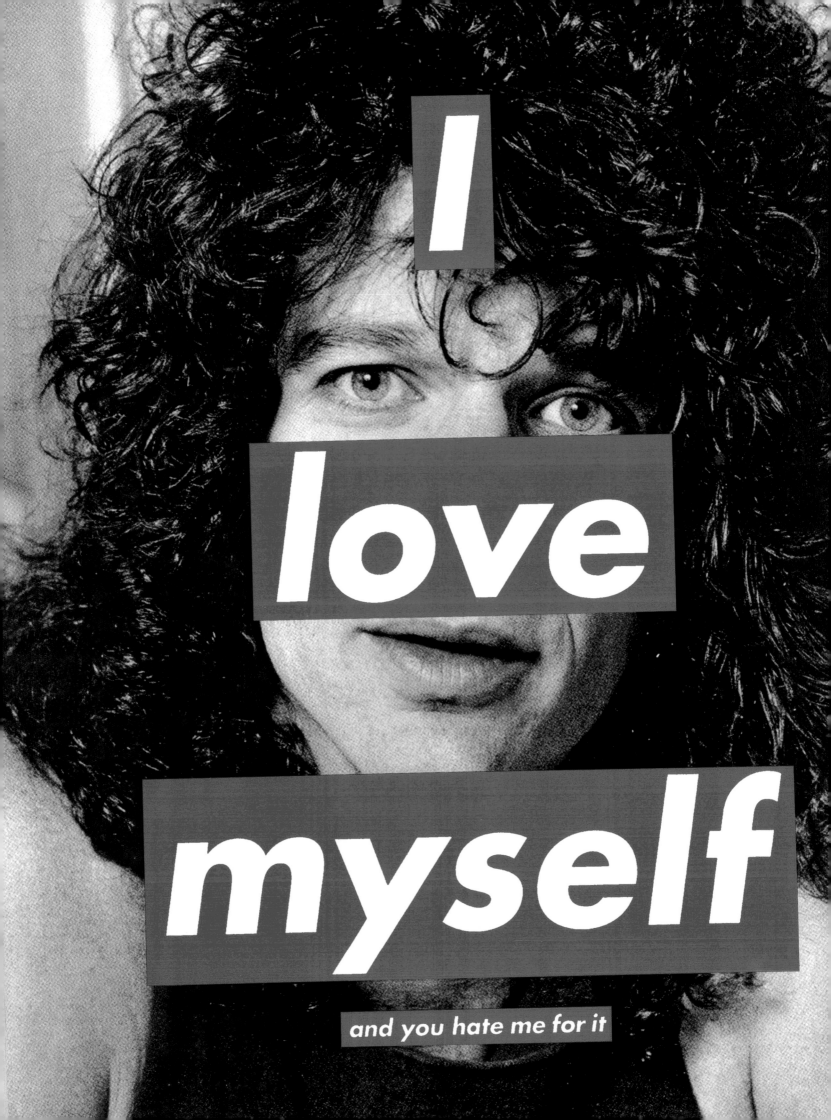

Esquire

MAGAZINE FOR MEN · MAY 1992 · $2

ocking but True!

WARD STERN

TZES AMERICA

Barbara Kruger

I

hate

myself

and you love me for it

On My Mind
A. M. ROSENTHAL

The Soviet Solution

Look at these people — politicians, economists, diplomats and journalists in the West. See how hard they work, to ignore the one overriding need of the people of the Soviet Union: the need for a brand new government.

Everywhere else that Communism has collapsed, the West has understood that the first thing the people wanted, and the starting point for any hope of real change, was to get rid of the collection of bureaucrats, policemen, wardens and propagandists that made up the failed, hated government — particularly the Communist political leaders who had perched for so many brutal years atop the whole corrupt apparatus.

Nobody questioned the urgent need for the Poles to get rid of what remained of the Communist Party and its disgraced leaders. Nobody warned Vaclav Havel against bringing a whole new democratic era to Czechoslovakia. Nobody scolded East Germany for trying to bring to trial some of the men who made death the penalty of climbing over the Berlin wall.

Life after the apparatchiks.

Yet when it comes to the Soviet Union the West not only agrees that the very men who ruled the empire at the center, who for years preached and enforced the wretched economic doctrine that wrecked the Soviet Union and who ran the whole national landscape of political prisons, should not only remain in control but solemnly considers how to raise a couple of hundred billion dollars to make sure they do.

Are we mad? Someday historians will write books trying to answer that question. How did it come to be that twice in less than a year, the West looked straight at the possibility of great achievement for civilization, shuddered and walked away?

In February, the United States walked away from the ouster of Saddam Hussein and allowed him to remain in power. In June the whole West looks at the possibility that the Communist system may disappear from the Soviet Union and scratches its head about how much money to contribute so that the apparatchiks who helped build it can stick around

for more years of criminal misrule.

Maybe we don't need historians. In Iraq, it was failure of moral stamina and political compass by a President and a few of the men around him.

About the Soviet Union it is more complicated. There are legions of Western specialists and diplomats — President Bush and Secretary of State James Baker included — who long ago committed their reputations to the political survival of Mikhail Gorbachev and cannot let go.

Money is involved, too — big money, the dreams of European and American businessmen of Western-guaranteed big deals with a Soviet Government they helped save.

But probably most important is fear: if Mr. Gorbachev goes, who knows what instability may follow in the Soviet Union and its neighbors?

Nobody knows that. But we do know that ever since World War II, what created instability in Europe has been the existence in the Soviet Union of a Government ruled by a Kremlin few and swallowing within its borders a variety of captive nationalities.

It is not the West's right to bring down the Gorbachev Kremlin-based Government or to plot against it. But neither do we have the right to intervene by using massive aid to prolong the present Government, which has dug itself deeper into disaster every year and whose rule is clearly sputtering to an end.

Mr. Gorbachev does not need hundreds of billions of dollars to do what his country requires. All he needs is to recognize that he has failed economically and resign while he has honor, first as head of the party and within three months as head of state. During those months, nationalities that want to secede should be allowed to do so — six to eight months. The rest could prepare for elections that would choose a new president and council. He would preside over a decentralized federation that would wipe out any special status for the Communist Party, and create a new economic and political nation. The West could assist to the best of its ability, without fear of merely prolonging tragedy.

The Soviet people would not then enter into a promised land of prosperity and guaranteed stability; seven decades of Communism are heavy heritage. But they would at last have the essential base — a new society, free not only of the gulag but its doctrines, its apparatus and its masters and servants. □

Observer
RUSSELL BAKER

Just Stumbling Around

The Democrats may not run anyone for President next year. Former Senator Paul Tsongas has offered to run for them, of course, but that doesn't mean the Democrats will let him.

Mr. Tsongas, being a Massachusetts man of Greek-American heritage, reminds them too painfully of the 1988 campaign when a Massachusetts man of Greek-American heritage lost to the Stars and Stripes, Willie Horton and two promissory lips that all America loved to read.

There's ample evidence the Democrats have simply decided not to show up in 1992. Example: With their convention scarcely a year away no one is seeking the wealth of the Indies which candidates must pay to lease the television industry's powerful thought-control emissions. Candidates normally start raising money two years before the convention.

Other evidence? What about the

The Democrats may not run in '92.

Congressional brethren rejecting Senator Moynihan's plan to give working folk a tax cut by reducing the regressive Social Security tax? That's right, Congressional Democrats said, "No dice." A party that won't offer its natural constituency a tax cut can't really be planning to show up for the election, can it?

As if that weren't peculiar enough, how about those Democrats who got together in Cleveland recently and said they were going to raise taxes on the rich so they could reduce them for everybody else?

Friend, I ask you, what is the one subject on which Republicans have been bludgeoning Democrats groggy ever since you were in high school? Of course. Taxes. Thus the winning Republican line: Democrats tax and tax. Democrats love taxes. Elect Democrats if you want to know what tax pain is.

So if you are a Democrat and mean to go for the Presidency, what is the one subject on which you remain silent? Tax increases for anybody. Anybody at all! You remain especially silent if your buddy Democrats in Congress have just decided not to give working stiffs any relief from a regressive Social Security tax.

Of course, those Demos who went

to Cleveland may have thought their promise to tax only the rich would fetch the great unrich majority. Alas, the mass mind doesn't work that way in this age of mass communications, which is to say when the mass political mind can be happily seduced by six-word slogans and 10 seconds of phonied-up TV film.

My own mind, which is as mass as the next mind, tells me, first, "There go those tired old Democratic taxers talking tax raises again." And in the next split second: "Sure they'll tax the rich, but the rich will never satisfy them, so then they'll come after me, and then ..."

If you are a Democrat with plans to compete at White House level, you either cut taxes or you leave taxes alone. You don't talk about raising taxes. You talk about how you're going to jail those swindlers who ripped off the taxpayer in the savings-and-loan racket, and you talk about how, while Republicans can find billions of public money not only to underwrite this catastrophe but also to restore Government by family tyranny in Kuwait, they can't find anything to help America's 34 million people without health insurance.

Despite the evidence, President Bush's crowd is taking nothing for granted. On the chance the Democrats may show up for a campaign at the last minute, the Bush people are already busy locking up the race issue once again. This has been theirs since the Nixon years when they discovered that if you aroused racial emotions, never hard to do in America, it was better to have the white vote than the black vote, if all you wanted was to win.

In Nixon's time this was called "the Southern strategy," though it worked as well for Republicans in the North as in Dixie, where race relations had become relatively civilized compared with places like Boston. "Southern strategy" has been Republican strategy ever since, though it was renamed "white backlash" once it was seen to work everywhere. In 1988 it turned into the frightening black face of the rapist-killer Willie Horton, Republican symbol for what Democrats meant when they said "civil rights."

Next year the Republican code word warning white America of Democratic intrigues for abusing the white population will apparently be "quotas." Perhaps it's for the good of the country's soul that the Democrats seem eager to sit this one out. Yes, I know that's preposterous. □

Any Suggestions?

By Barbara Kruger

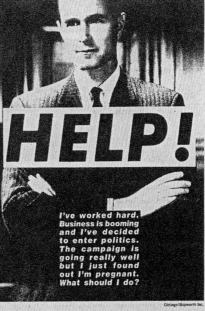

Gittings/Skipworth Inc.

The Male Manifesto

By Andrew Kimbrell

WASHINGTON

In recent years, many men have awakened to a crisis of their gender. These men have begun to realize that for them and their fathers' generation, the necessities of work and career and the rising divorce rate have eroded their relationship to family, community and the natural world. This frustration and alienation has led an increasing number of men to gather in an loosely organized men's movement.

Most commentators don't seem to know how to react to this movement. The poet Robert Bly's best-selling book, "Iron John," has encouraged thousands of men to venture into wilderness retreats to rediscover the mythic dimensions of masculinity.

While some have sympathized with Mr. Bly's work, many find the sight of men drumming in the woods more humorous than provocative. Others don't know whether to be chagrined or alarmed by the prospect of men rediscovering role models. Some confess to being a bit nervous about where the movement is headed.

However, few have realized the political potential of the men's movement. Although its roots are in consciousness raising, the movement is forming what many are calling a new politics of masculinity.

The politicization of the movement is based on an understanding that most men are increasingly victimized. Current statistics are grim. Teen-age and adult suicide, homelessness, unemployment, homicide, drug

Understanding the 'wild man.'

and alcohol addiction, heart disease and a variety of other stress-related health problems plague more men at far higher rates than women.

Men are also experiencing a crisis in the family. Recent polls show that an overwhelming number of men are torn between the hours needed to support their families and the need to share time with their families.

The situation among men who are minorities is even worse. For example, black men have the lowest life expectancy of any segment of the population; more black men are in jail than in college.

In understanding the victimization of men, the movement has not attempted to establish a hierarchy of victimization. Men are resisting the idea, espoused by some feminists, that maleness, and not society's system of controls and production, is responsible for the victimization of women. Finally, men can begin to understand their victimization of others only by acknowledging their own frustrations.

More important, men are realizing that they cannot resolve their problems within the current understanding of "masculinity." Over several generations, men have fallen victim to a defective mythology of manhood — a male mystique. This mystique, propagated during the industrial age, has substituted mechanical attributes — efficiency, autonomy, inhuman power — for such traditional masculine traits as husbandry, honor, relation to community and land.

Most significant, the factory system removed men from the home, leaving a vacuum that has left generations of young men without adequate male parenting or role models. Moreover, the romanticized wars of this century have killed millions of sons. It is a lingering irony that what many call a patriarchal production system significantly degraded both fatherhood and sonship.

Rejecting both the male mystique and anti-male ideology, men have begun articulating a male manifesto — a political agenda intended to re-establish ties with one other, their families, communities and the earth.

As men mourn the loss of fathers and family, they are devoting themselves to increased parental leave and work-at-home opportunities. As men recover a healthy sense of inner "wildness," they are calling for more environmental protection.

As men try to recover the dignity in their work, they avoid the obeisance often called for in the corporate world in favor of small-scale businesses. As men become aware of male drug addiction, self-destructiveness and stress, they are organizing around men's health issues. As men realize that modern techno-war mocks the inner warrior aspect of men, they reject modern warfare.

As the politics of the men's movement develop, it, like the feminist movement, could change the face of electoral politics. Up to now, women have been more likely than men to support environmental protection and peaceful solutions to world problems. The new politics of men could erase this gender gap.

For those who thought the men's movement was just about drumming or "wild men," they'd better look again. □

Andrew Kimbrell, a lawyer and environmentalist, writes frequently about men's issues.

The Dying Fields

By Anne E. Goldfeld

CAMBRIDGE, Mass.

As representatives of the Government in Phnom Penh and resistance factions meet once again to discuss a U.N. proposal for peace, the Cambodian people's suffering drags on. U.S. policy is contributing to the human toll. Washington cruelly maintains a trade and economic aid embargo against Cambodia, links humanitarian aid to a peace settlement, and fails to recognize formally the Khmer Rouge genocide of the 1970's.

In the last year, the Khmer Rouge, supported by China, have moved deep into Cambodia from their bases in Thailand. Because of heavy fighting between the resistance and Government, at least 180,000 Cambodians have been displaced. About 1,000 people a month are killed, mutilated or blinded by land mines alone. And the Khmer Rouge is now planting Chinese mines that metal detectors cannot find.

The U.S. must do more in Cambodia.

Cambodia is a land of widows, and women head about 60 percent of the households. Some 20 percent of the children die before the age of 5. There is no prenatal care, and death associated with childbirth is common. This year, many will go hungry because of a rice shortage.

Last fall, President Bush and Congress allocated $20 million for humanitarian aid. That could help begin to remedy these problems. But the money remains in Washington because of a reluctance to work with the Vietnamese-supported Government.

On the Thai border, hundreds of thousands of Cambodians who fled the Khmer Rouge have endured for 12 years in dangerous camps. There, hopelessness, insecurity and easy availability of arms have led to rising violence. At Site 2, the largest camp in Thailand, grenades thrown into a Buddhist temple recently killed 24 people, many of whom were girls rehearsing a New Year's dance.

Half the 300,000 people of the camps are under 18 years old. Denied refugee status and forced to live in

barbed-wire camps in a war zone, many have known no other life. In 1990, the Khmer Rouge forcibly moved up to 100,000 refugees from camps under their control back into the Cambodian jungle.

Washington officials must ask themselves what political agenda can justify this suffering. We must also ask what foreign policy objectives can continue to sanction the Chinese resurrection of the Khmer Rouge and the U.S. refusal to recognize the Khmer Rouge genocide. At the least, the U.N. peace process should guarantee that those responsible for the genocide will have no role in Cambodia's future. At the peace talks in Jakarta, Indonesia, yesterday, Deputy Foreign Minister Alain Vivien of France accused the Khmer Rouge of hampering efforts to end the war.

The terrible history we share with Cambodia charges us with a responsibility. The U.S. has taken an important lead in supporting the U.N. plan for a cease-fire and free elections. But this is not enough. We must end the trade and aid embargo and free up humanitarian assistance for the most urgent needs. We must also insure the neutrality of a new border camp to allow the refugees to choose a new life — out of the range of shells and terror. The suffering of Cambodia must not go unanswered. □

Anne E. Goldfeld, a doctor at Harvard Medical School, recently visited Cambodia with a delegation of the Women's Commission for Refugee Women and Children.

More Racism From the G.O.P.

By Don Edwards

WASHINGTON

When the landmark Civil Rights Act of 1964 was passed by the Congress, Republicans voted for it 4 to 1. But, in considering the Civil Rights Act of 1991, the G.O.P. seems less interested in a civil rights bill and more interested in reviving race as a campaign issue for 1992. This is part of a consistent pattern.

In 1988, the Bush-Quayle campaign exploited racial fears in the shameless Willie Horton ads. In the 1990 elections, the party successfully exploited the civil rights bill with race-based TV ads misrepresenting the bill and pandering to racist fears.

The party now seems intent on continuing this policy. Republican leaders have repudiated David Duke, the Republican Louisiana legislator and former Ku Klux Klansman, yet the President's men do not shrink from using the very code words — like "quotas" — that Mr. Duke uses to spread paranoia about blacks' taking jobs from whites.

The phony smoke screen of "quotas," fanned by a slick and expensive public relations campaign, has obscured the debate about the bill's real goals.

The Democratic leaders' bill, which has bipartisan support, will not create quotas. It merely reverses 1989 Supreme Court decisions that weakened anti-discrimination laws in employment that had worked fairly and effectively for nearly 20 years. In fact, the bill explicitly makes quotas illegal, permitting a quota victim to sue for damages.

The Democratic bill would bring consistency to civil rights damage suits. Existing law allows compensatory and punitive damages for intentional discrimination based on race; the bill extends this right to people intentionally discriminated against because of sex, disability or religion.

Today, the House is to vote on three bills: a bipartisan compromise sponsored by the Judiciary Committee chairman, Jack Brooks, and the committee's senior Republican, Hamilton Fish; the strong version written by

The Democrats' bill restores workers' rights.

the House Education and Labor Committee last year, and President Bush's substitute.

The compromise will be approved overwhelmingly. It includes understandings reached in discussions between civil rights and business leaders — discussions scuttled by White House intimidation, on Mr. Bush's orders, with Bush aides saying the quota issue must be kept alive for future elections.

The Brooks-Fish bill limits punitive damages for intentional discrimination to $150,000, a provision many of us have fought for two years but whose inclusion is essential if we are to approach the two-thirds vote needed to override a promised Bush veto. Last year's bill will be offered so members of both parties can vote for a stronger "pure" bill that does not limit punitive damages.

Attorney General Dick Thornburgh calls the Brooks-Fish substitute a "hoax." He is wrong. It is the Administration's substitute that is a hoax. It fails to reverse most of the Supreme Court cases the compromise bill seeks to overturn. It makes it easy for businesses to justify practices that have discriminatory effects.

The phoniest part of the Bush bill pretends to provide additional remedies to victims of harassment but actually places more obstacles in their way. The bill would even legalize harassment if the worker did not file a complaint with the employer's in-house grievance system within 90 days.

Enactment of the Democrats' bill would signal an end to the diminution of our rights by a Supreme Court now controlled by a Reagan-Bush majority. The bill would return to ordinary working people procedural rights like a reasonable time period for filing a complaint, equitable rules on proving discrimination and protection against discrimination in employment contracts.

In restoring these rights, the bill would give all workers — whites, racial and religious minorities, women, men and people with disabilities — a fair chance at fighting discrimination, and the right to seek damages. It is unworthy of the President to play racial politics to defeat it.

Don Edwards, Democrat of California, is chairman of the House Judiciary Subcommittee on Civil and Constitutional Rights.

(245)
Artwork for the **NEW YORK TIMES** Op-Ed page, Tuesday, June 4, 1991.

(this spread)
Artwork for the **NEW YORK TIMES** Op-Ed page: Friday, December 1, 1995;
Tuesday, January 7, 1997; Friday, October 11, 1991; Saturday, October 11, 1997.

(248–49)
Cover artwork for the **NEW YORK TIMES BOOK REVIEW**, September 19, 1993
Cover design for **NEWSWEEK**, June 8, 1992.

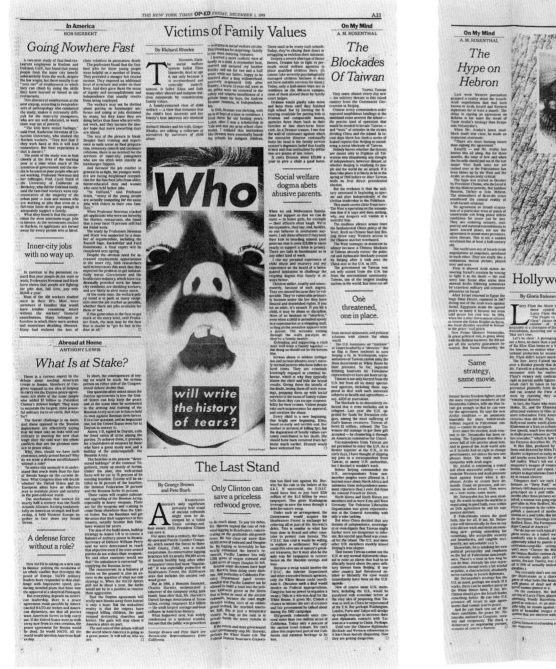

The New York Times

Book Review

September 19, 1993

Section 7 Copyright © 1993 The New York Times

What Is This Thing Called Rape?

The perceptions of a college student and a prosecutor.

THE MORNING AFTER
Sex, Fear, and Feminism on Campus.
By Katie Roiphe.
180 pp. Boston: Little, Brown & Company. $19.95.

SEXUAL VIOLENCE
Our War Against Rape.
By Linda A. Fairstein.
288 pp. New York: William Morrow & Company. $23.

By Wendy Kaminer

IN 1965 a doctor at Brown University hastened the decline of Western civilization by distributing birth control pills to women students 21 years of age and older. With "college girls everywhere" using the pill, "mating" might become "casual and random — as among animals," U.S. News & World Report warned the following year, bemoaning the loss of "the last vestige of self-restraint" — women's fear of unwanted pregnancies. The sexual revolution was, after all, a revolution in sexual mores for women, and 25 years ago, public concern about the new promiscuity reflected concern about the aggressiveness, even shamelessness, of the then new "ideal" woman.

Today, concern about promiscuity has been replaced with concern about date rape. Stories about sex on campus tend to focus on women's passivity and vulnerability rather than their aggressiveness. It's not that college women, in general, have embraced a traditional feminine ethic of sexual purity, as some skeptics about date rape suggest. Cosmopolitan, the magazine makeover spawned in 1965 by the sexual revolution, designed partly as a woman's answer to Playboy, is a campus best seller today. But feminism on campus does sometimes appear a bit Victorian; for the minority of women who might pledge their allegiance to Ms. magazine instead of Cosmo, feminism seems less a celebration of women's liberation than a cautionary expression of their oppression by men.

This partly reflects the left-wing equation of oppression and virtue. Protesting their sexual victimization enables privileged, heterosexual white women to claim a share of the moral high ground ceded to the victims of racism, classism and homophobia. But the primary difference between third-wave feminism and the nascent feminism of 25 years ago is the difference between women who came of age with the pill and women who came of age with AIDS.

Katie Roiphe's brave first book, "The Morning After: Sex, Fear, and Feminism on Campus," will be both heralded and condemned for its angry attack *Continued on page 41*

Wendy Kaminer is the author of "A Fearful Freedom: Women's Flight From Equality." She is a 1993 Guggenheim fellow.

Don't force it

BARBARA KRUGER

A Life of Fidel Castro/3

Newsweek

June 8, 1992 : $2.95

Whose justice? Whose morality? Whose community? Whose family?

Whose values?

By Joe Klein

Barbara Kruger with Stephen King, **MY PRETTY PONY**, 1988.
A limited-edition book published by the Library Fellows
of the Whitney Museum of American Art.

250

"Me neither," the old man said, releasing him. "I don't think it has one, and I don't think it matters. What matters is, will you know it?"

"Yes, sir," the boy said at once.

A glittering eye fastened the boy's mind and heart like a staple.

"How?"

"It'll be pretty," Banning said with absolute certainty.

Grandpa smiled. "So!" he said. "Clivey has taken a bit of instruction, and that makes him wiser and me more blessed . . . or the other way around. D'you want a slice of peach pie, boy?"

"Yes, sir!"

"Then what are we doing kicking around up here? Let's go get her!"

They did.

And Banning never forgot the name, which was time, and the color, which was none, and the look, which was not ugly or beautiful . . . but pretty.

Pretty.

Or its nature, which was wicked.

And never forgot what his Grandpa said on the way down, words almost thrown away, lost in the wind: having a pony to ride was better than having no pony at all, no matter how the weather of its heart might lie.

(top) **BELIEF**, Singapore Biennale merchandise, 2005.

(bottom) Assorted book cover designs, 1984–96.

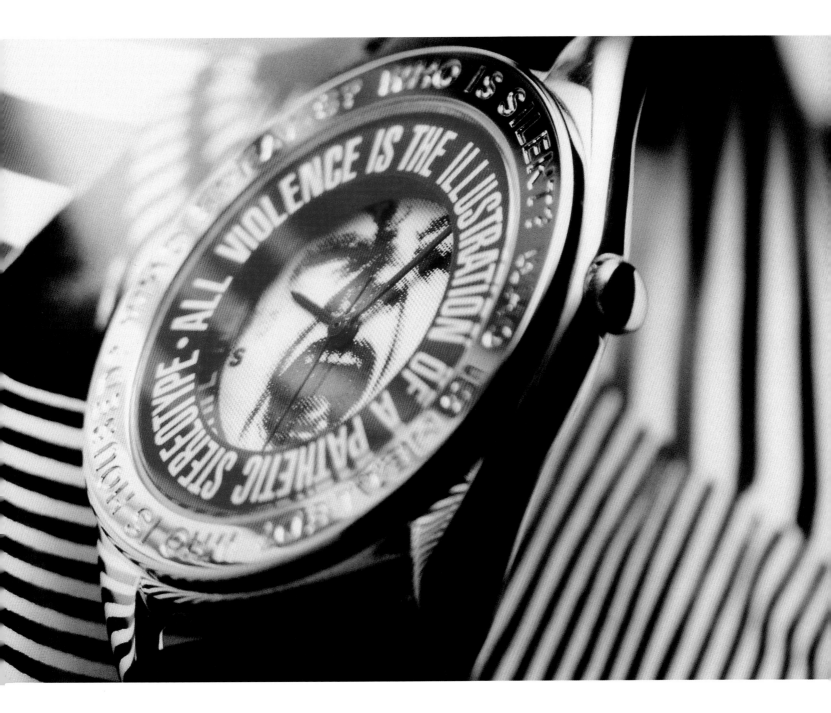

Decadism

Despite war, pestilence, terrorism, and the radical transformation of the American justice and electoral systems, we try to go on with our lives. Protesting, despairing, hoping for the best but fearing the worst, we zigzag from the big picture to the small screen, from ruminations on mortality to the media's power to mirror a particular rendition of the truth. We know we're encapsulated in a bubble of arrogant deceptions that isolate us from the realities of the rest of the world. But threaded through this ambient horror is the stuff of other discourses that fold together to make American culture. Amidst it all, and true to the fictive choreographies of rediscovery and nostalgia, it seems we've arrived at an '80s moment.

Yes, now it's all about "the '80s." They're loved and hated, hot and cool, over-praised or haughtily dismissed. In another twenty seconds they'll be chewed up, spit out yet again, and diners will be demanding a dollop of "the '90s." Remember them? But really, what's to be made of "the '80s," that cartoon of wild and craziness, that high-roller, art-star laden clump of been there and done thatism? And how does this '80s stuff connect to that equally rollicking but volatile thing called "the '60s"? And didn't "the '60s" begin in 1964 and end in 1973? And what about that numbed-out slice of white bread known as "the '50s"? Wasn't it also a time of charged accusation and paranoid conformity? If you think of histories as multiple threads of lived experience, as the gathering together of the social circumstances of a time, then how do you explain the reductivism of "decadism"? What are the advantages of biting off ten-year periods and plopping them into the symbolic without a second thought? I guess it makes things easier; easier for the practitioners of buzzword journaism, easier for idea-challenged curators, and easier for some critics to indulge in their unexamined arsenals of grudges and use-by dates.

But although life is messier than all the categories constructed to contain it, examinations of historical moments do call for a kind of periodizing. But this segmenting is best used with an understanding of the porous segues between eras, decades, days, and nights. And the best and brightest of historical reckonings also seem cannily sensitive to the multiple narratives, contradictions, and contestations that make for particular places and times.

Because of this, I'd like to think of "the '80s" as the collapses and seepages of meanings, happenings, and circumstances that arose between 1976 and 1988, but were set in motion around 1967 and proceed through 2004. Get it? And I call this thing "my '80s" because all experience is filtered through a subjectivity shaped by sex, money, race, geography, and age. "My '80s" are not recollected through "significant" artworks, clamorously glamorous exhibition openings, or any kind of "event." What draws me are the moments between the events: the constancy of the everyday. Of how hours add up to years, of how the vibrantly incremental process of "creating" gels into the inflationary value or abject worthlessness of objects and ideas. It's the everydayness of street corners, of buildings full of memories, of pleasantly mundane events transformed into "historical moments."

This sort of recollection tries to understand the fickleness and selectivity of remembrance. And if it's rigorous and keen enough as it travels back in time, it recognizes the visionary blind eye of youth as the agent of the ambition and desire that envelop it like weather. It tries to figure out who we are amidst the pressures of a relentlessly vertical, "professional" culture, rife with trust, competitiveness, betrayal, support, brittleness, and affection. This recollecting takes a long look at short attention spans, at taste, power, and the exhaustive and exhausting lunge for the brass ring of what's impressively cool for the next twenty seconds. And since the so-called "art world," like any other subculture, is a piece of a larger economic and cultural environment, these framings reflect the fluctuations, put into play by national and global events.

So why have "the '80s" been characterized almost exclusively as a time of big-ticket, blue-chip art and high living? Undoubtedly, the rise in disposable income around 1984 detonated a massive shopping spree, with collectors scooping up goodies with an eye on quick turnaround and big payoff. For what seemed like the first time, artists could actually make money from their work while they were still alive to enjoy it. But considering the seemingly billions of young hopefuls emerging from art schools, relatively few are ever fortunate enough to profit from this heat-seeking bounty. Yet the explosion of aestheticized acquisitions continued, with major and minor fluctuations, from the mid-80s to the present. If anything, 9/11 has changed everything and (horrifyingly) nothing. The incomes of a small posse of CEOs and the extremities between rich and poor have grown by leaps and bounds since the "greedy '80s." Whether under the thumbs of George I or II, the arts have become increasingly marginalized except as vessels of profit and speculation.

But despite the power of market forces to determine value and write history, artists continue to create commentary: visualizing, musicalizing, and textualizing their experiences of the world. And most do so regardless of their buzz appeal amongst the chattering classes. This is not to salute the romantic cartoon of the artist as beret-clad mediator between God and the public, but simply to suggest that work continues. But then the question becomes, What's to be made of the work? Not in terms of cold cash, but of the meanings it generates.

Increasingly, complex discourses around cultural production have been hijacked by a kind of thoughtless art writing that reduces ideas to mindless tags and buzzwords. Through these clever coinages and lazy gatherings, ways of working have been stereotyped and categorized, their specificities and contradictions collapsed into convenient clichés. Unnecessary battle lines have been drawn, creating ridiculously warring binaries: theory vs. beauty, irony vs. sincerity, painting vs. conceptual, and the dumbed-down accountings of "decadism." Considering the reigning duality of "good vs. evil," it's apparent that these simplistic but agenda-heavy orderings rule. But one would hope that critics and curators would have sharper descriptive capabilities than George II. Declaring "The End of Painting" or "The End of Irony" might make for juicy magazine cover lines or exhibition titles, but they're tired, easy glosses on complex situations.

Today, the juggling of mediums and media has become commonplace, allowing artists to develop simultaneous fluencies in painting, computing, film, audio, video, sculpture, photography, texts, and installations. Criticism pitting medium against medium appears defensive and severely limiting. Cultural productions have broadened and engage the choreographies of social relations, the hybridity of bodies, the relational possibilities of objects and events, the invasive constancy of surveillance, the intensive orderings of design, and the punishments and pleasures of the built environment. These developments are incremental and emerged in a continuum of fits and starts. They didn't happen in "the '80s," "the '90s," "the '60s," or "the '00s." They're the products of ongoing historical forces, global events, technological development, the flow of capital, the power of taste, and the sometimes site-specific reflections of how we are to one another.

Utopia: The Promise of Fashion When Time Stands Still

Utopia is at one end of town. Maybe not. At the other end is Fashion. They slowly approach one another. It is high noon and their guns are loaded. In the four minutes in which they have been facing one another, weapons raised, Fashion has changed outfits eight times. He is threatening Utopia, telling her he has promises to keep and moments to guarantee. He says that he wants her and must deliver her to his followers by sundown. She is aware that she has been mentioned. He drops her name, or codes for it, all over town. He proposes a taste of her. He produces desire in and around her. He appropriates her image. He makes all contextual information residue. He engages the physical envelope and dispels lived time. He ignores interiors. He desires lack. He plans and measures it through his production. He is deliberate. Her hands are quick, while his are encumbered by the pushed-up sleeves of his leather jacket. He shoots first and misses. She retaliates. He falters. He's down. He sprawls on the dirt, his jacket stained, his eyelids heavy. He thinks he knows how his face looks now, as taste, unlike other faculties, is able to register its own behavior. Reacting against itself, it recognizes its own lack of taste. She looks down at his body. She is outside of desire. Her gaze moves up his torso and settles on his mouth. She suppresses a grin. His head lolls slowly to the left and then to the right, his eyes roll up, his mouth opens and out of the hole, he greets his desire: "Mr. Death! Mr. Death!"

That was supposed to be an allegory. The idea is not one of ulterior motives because Fashion is an agent from the interior but it doesn't know it and hasn't even been there. The idea is that Utopia and Fashion are like going dutch on a rainy night. That the Utopian promise, the mind's eye of perfection, doesn't even entertain the idea of staying because it knows that Fashion is predicated on acceleration and distraction. Its particularly suggestive hook is the coupling of its aerosolic distribution with its cyclical archaisms, breakdowns, and disappearances. That it dances around the Utopian projection is a clue. It is a tease. A tool. A celebration. A cover. It promises contextual contentment. It hints at a constant ecstasy. It is organized through social production, falls back on the forces of production, and appropriates them. It creates empty spaces.

UNTITLED (ANOTHER ARTIST/ANOTHER EXHIBITION/ANOTHER GALLERY/ANOTHER MAGAZINE/ANOTHER REVIEW/ANOTHER CAREER/ANOTHER LIFE), 2003.

UNTITLED (**SEEING THROUGH YOU**), 2004.

(264–65)
UNTITLED (**LET GO**), 2004.

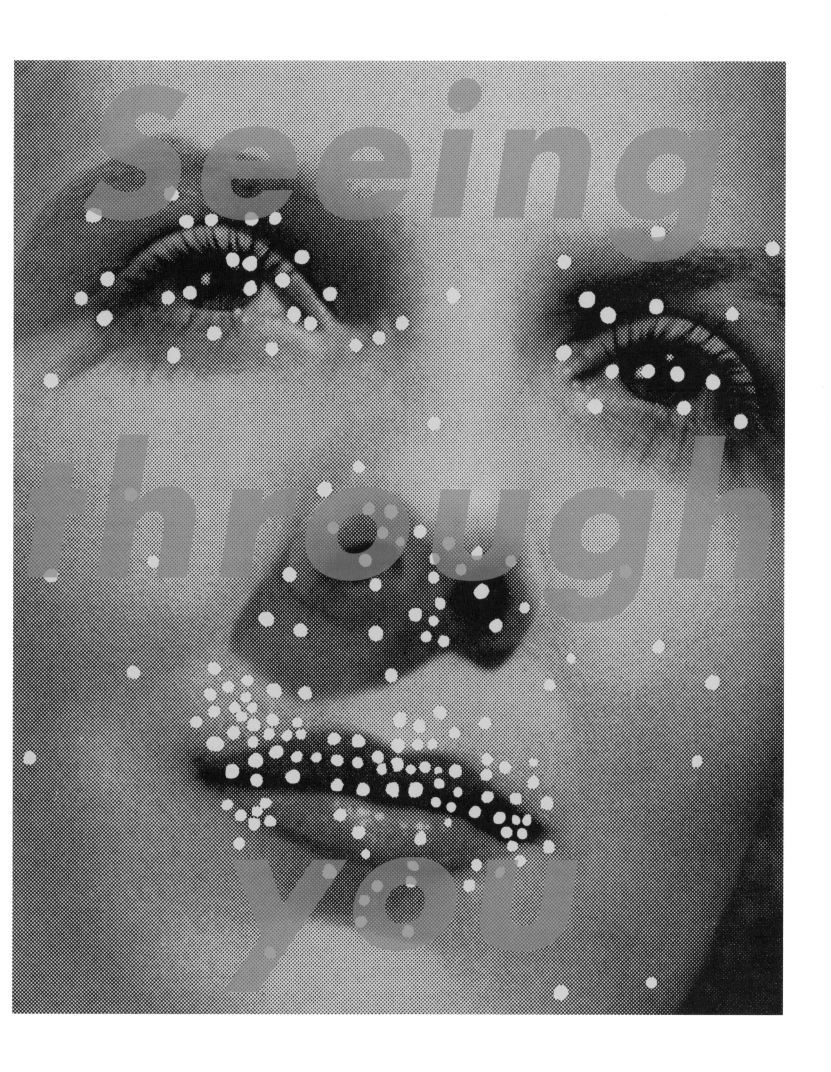

Let

FACE IT (YELLOW), **FACE IT** (CYAN), **FACE IT** (MAGENTA), **FACE IT** (GREEN), 2007.

266

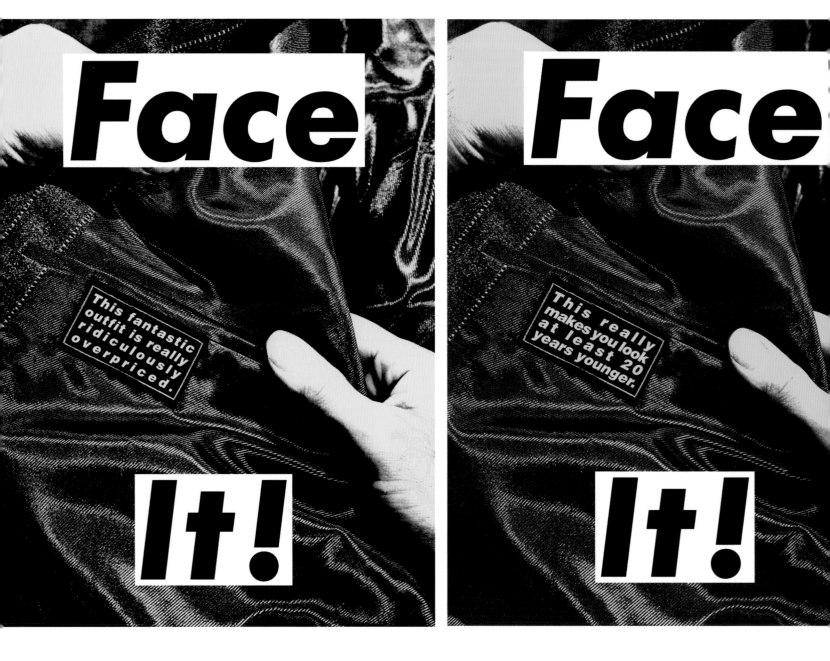

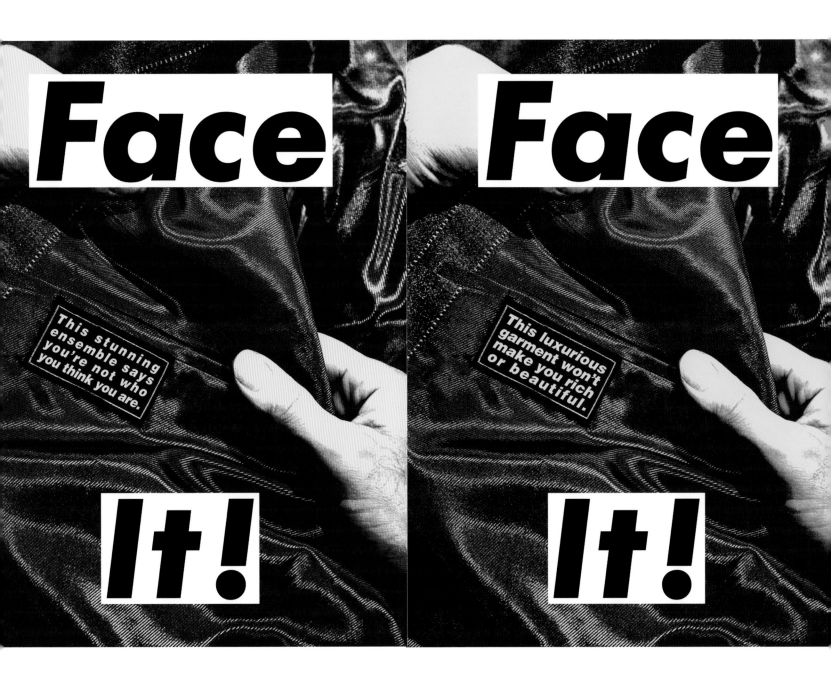

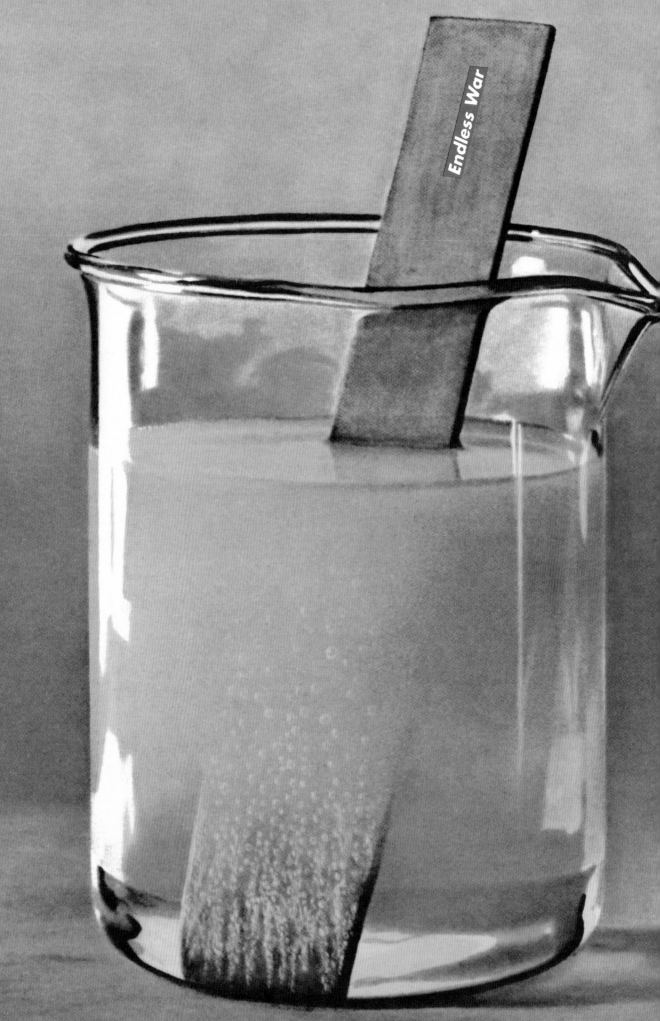

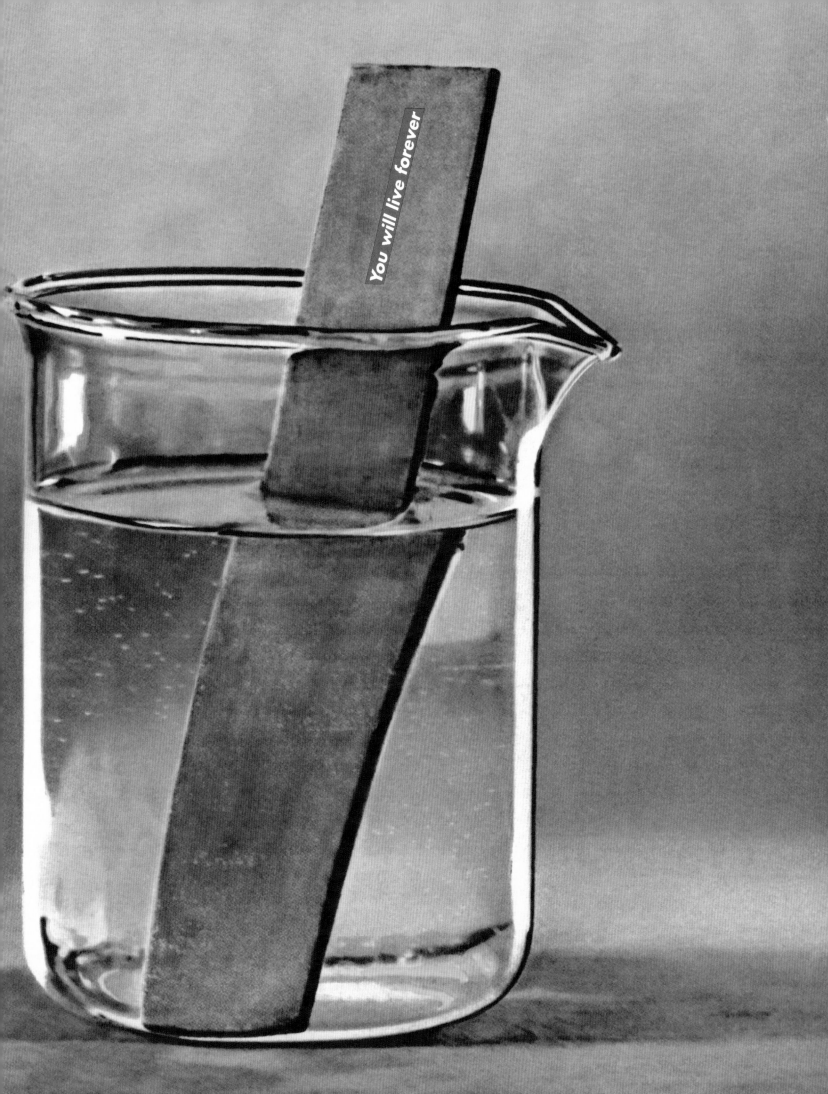

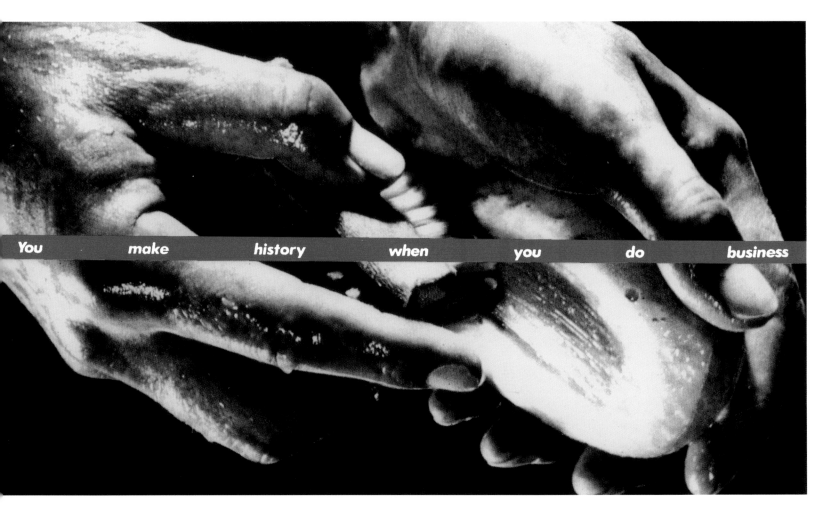

UNTITLED (ADMIT NOTHING/BLAME EVERYONE/BE BITTER), 1987.

(272–73)
UNTITLED (UNMAKING THE WORLD), 2008.
UNTITLED (DON'T TURN ME INSIDE OUT), 2008.

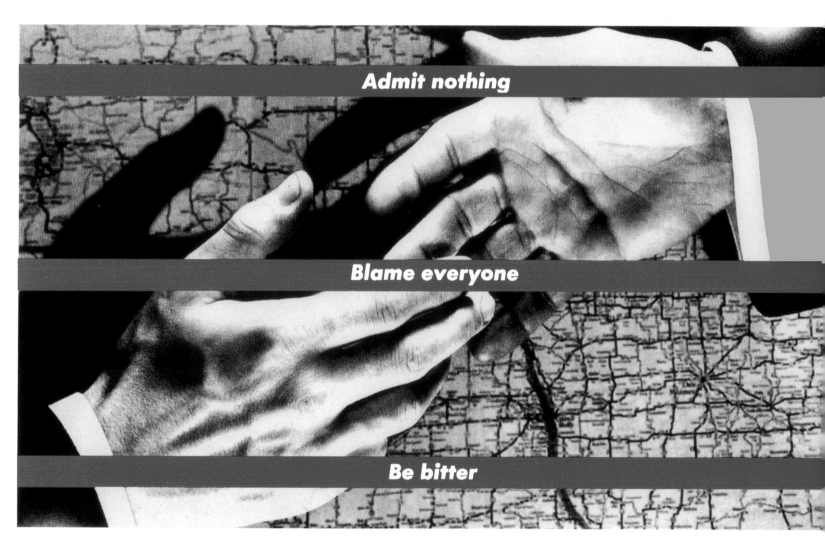

UNMAKING THE WORLD

Why is this woman smiling?

DON'T TURN ME INSIDE OUT

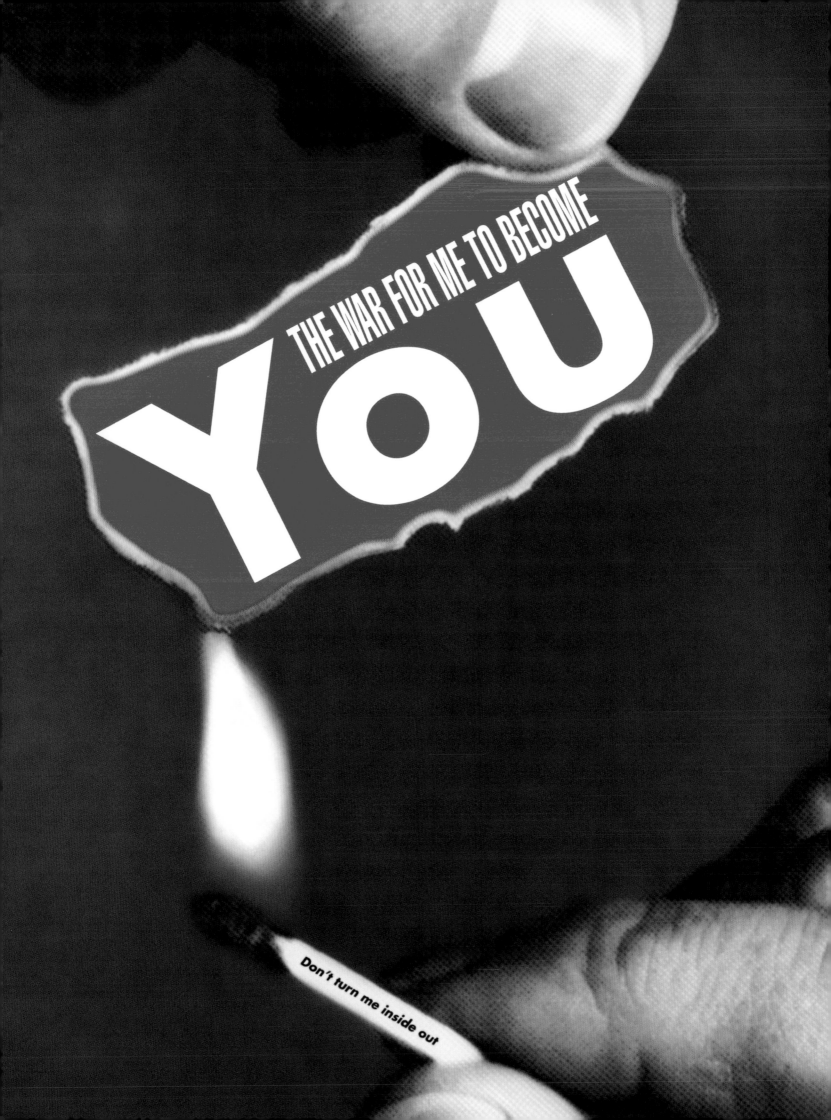

UNTITLED (THE WAR FOR ME TO BECOME YOU), 2008.

UNTITLED (I SHOP THEREFORE I AM), 1987.

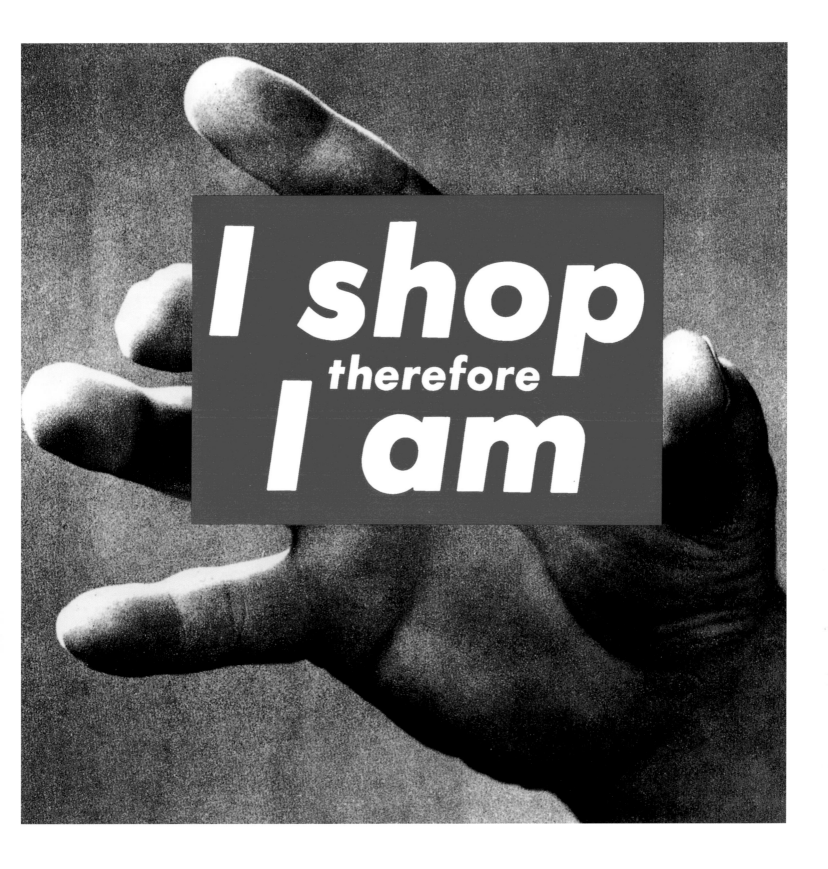

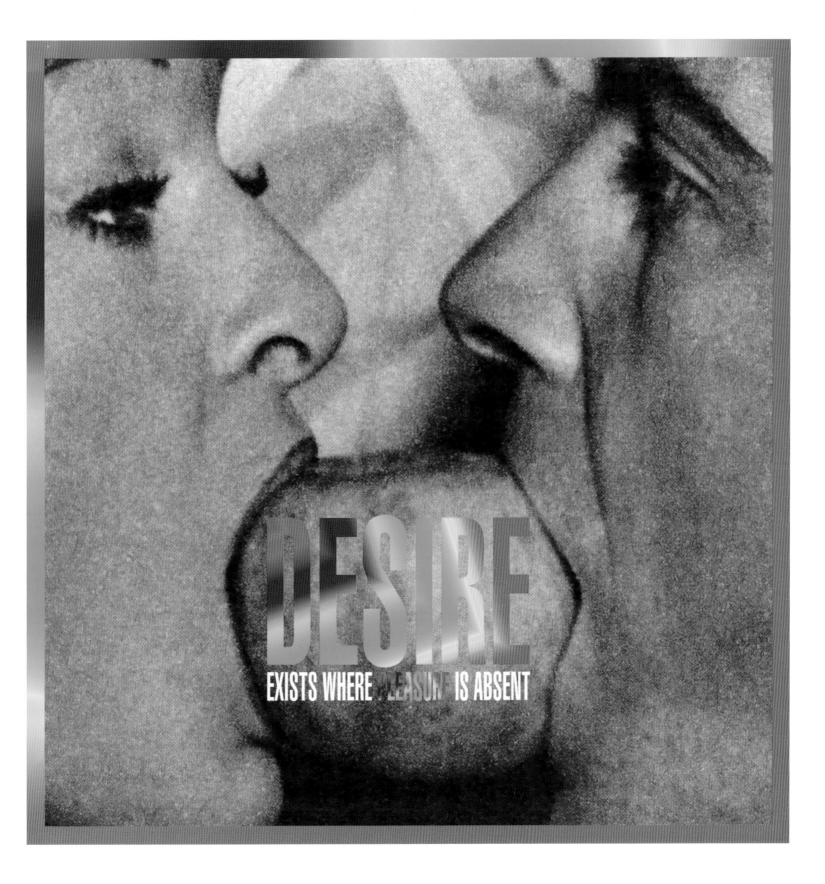

UNTITLED (IN THE BEGINNING THERE WAS CRYING/IN THE MIDDLE THERE WAS CONFUSION/IN THE END THERE WAS SILENCE), 2007.

(280–81)
UNTITLED (USE ONLY AS DIRECTED), 1988.
UNTITLED (WE HAVE RECEIVED ORDERS NOT TO MOVE), 1982.

(282–83)
UNTITLED (YOU THRIVE ON MISTAKEN IDENTITY), 1981.
UNTITLED (WE ARE YOUR CIRCUMSTANTIAL EVIDENCE), 1983.

(284–85)
UNTITLED (BUY ME, I'LL CHANGE YOUR LIFE), 1984.
UNTITLED (YOU ARE GETTING WHAT YOU PAID FOR), 1984.

(286–87)
UNTITLED (PUT YOUR MONEY WHERE YOUR MOUTH IS), 1984.
UNTITLED (YOU ARE NOT YOURSELF), 1982.

(288–89)
UNTITLED (YOUR FICTIONS BECOME HISTORY), 1983.
UNTITLED (YOUR COMFORT IS MY SILENCE), 1981.

In the beginning there was crying

In the middle there was confusion

In the end there was silence

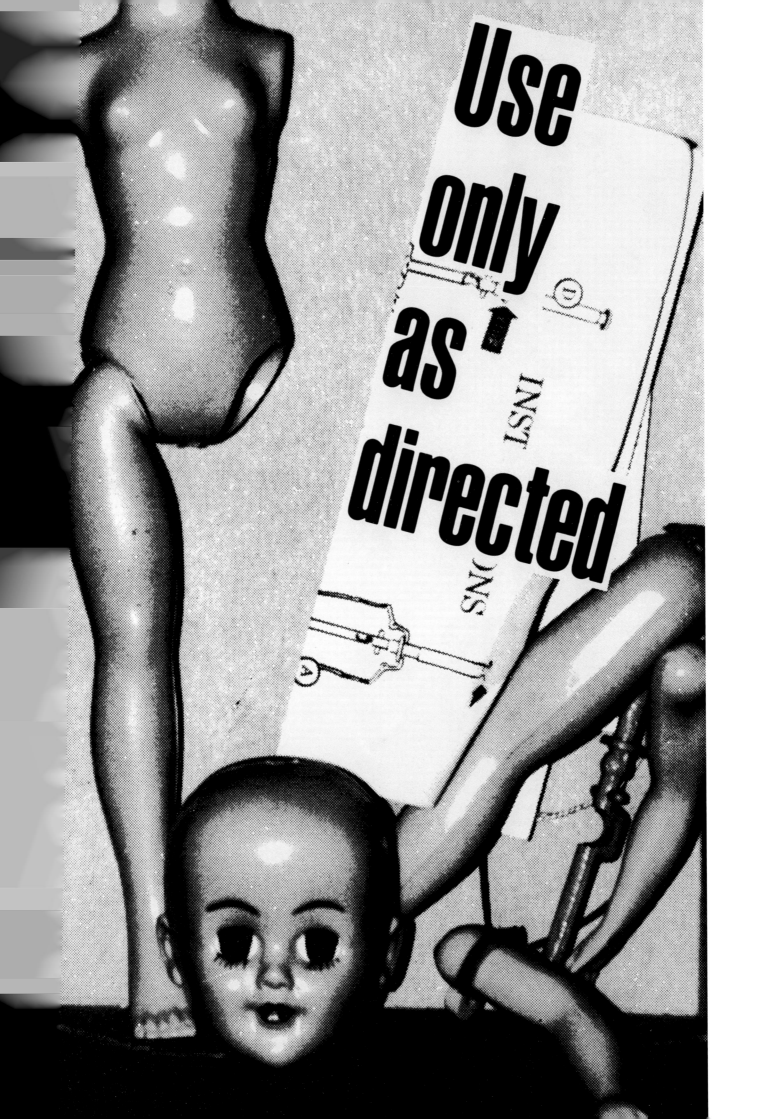

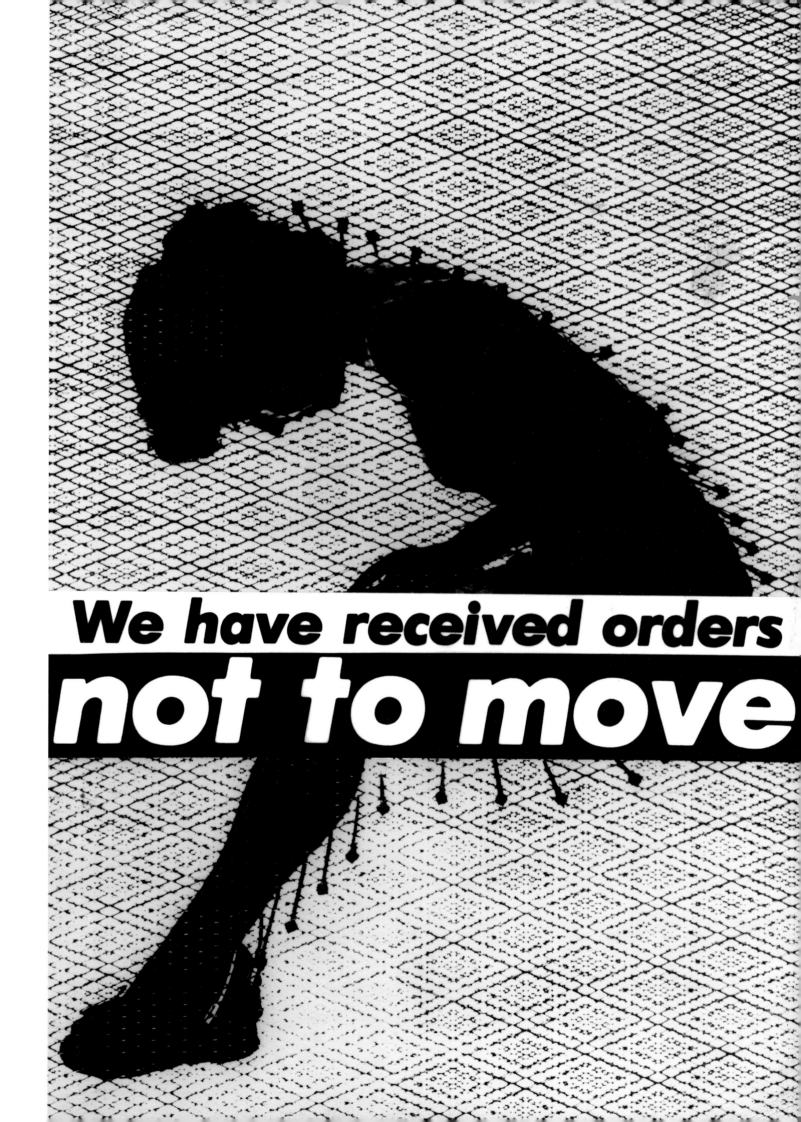

You thrive on

mistaken

identity

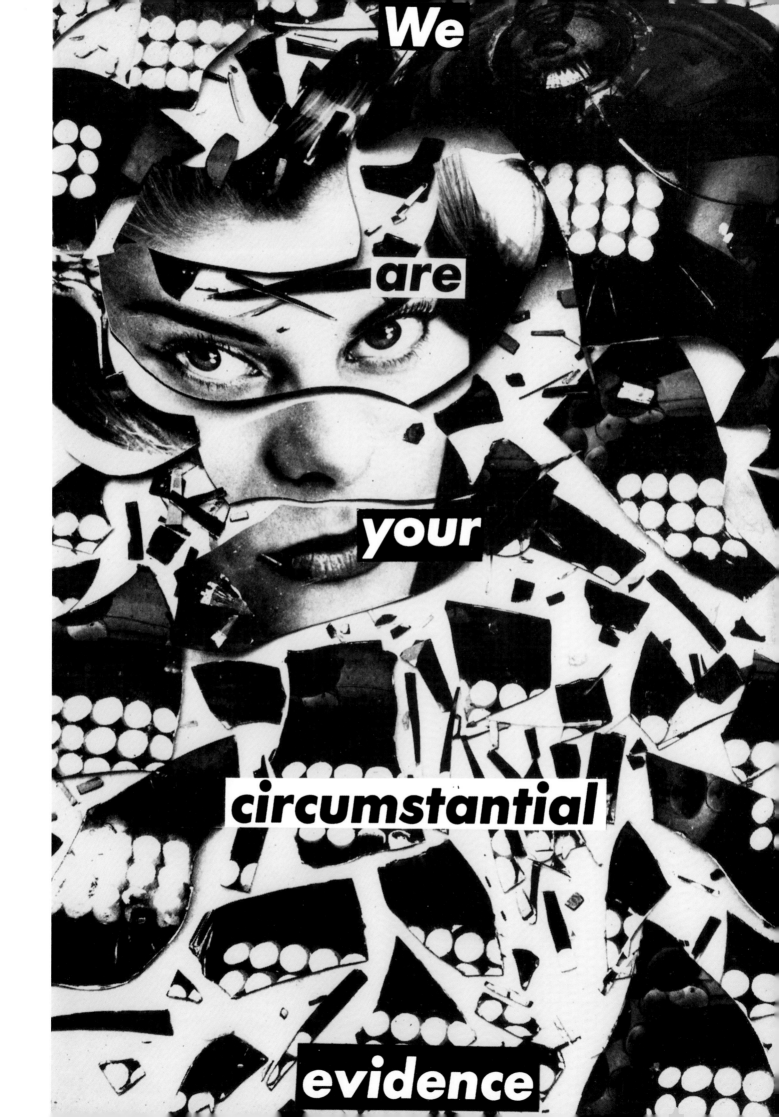

Put your money where your mouth is

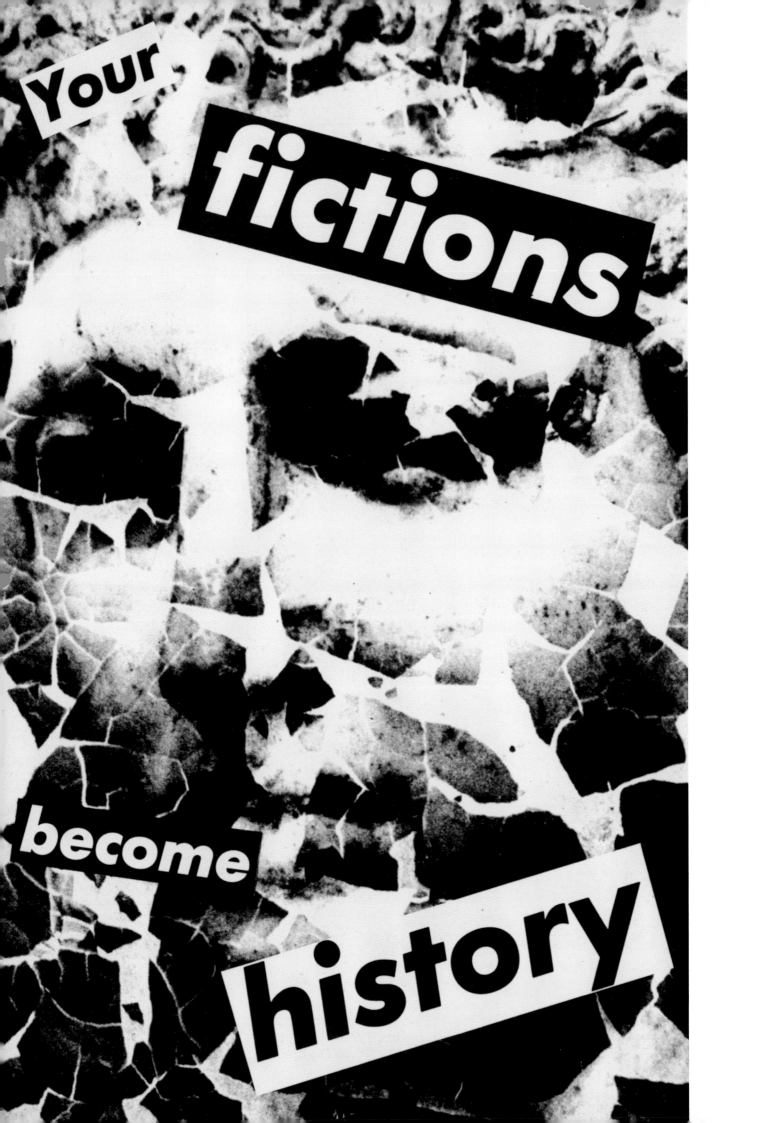

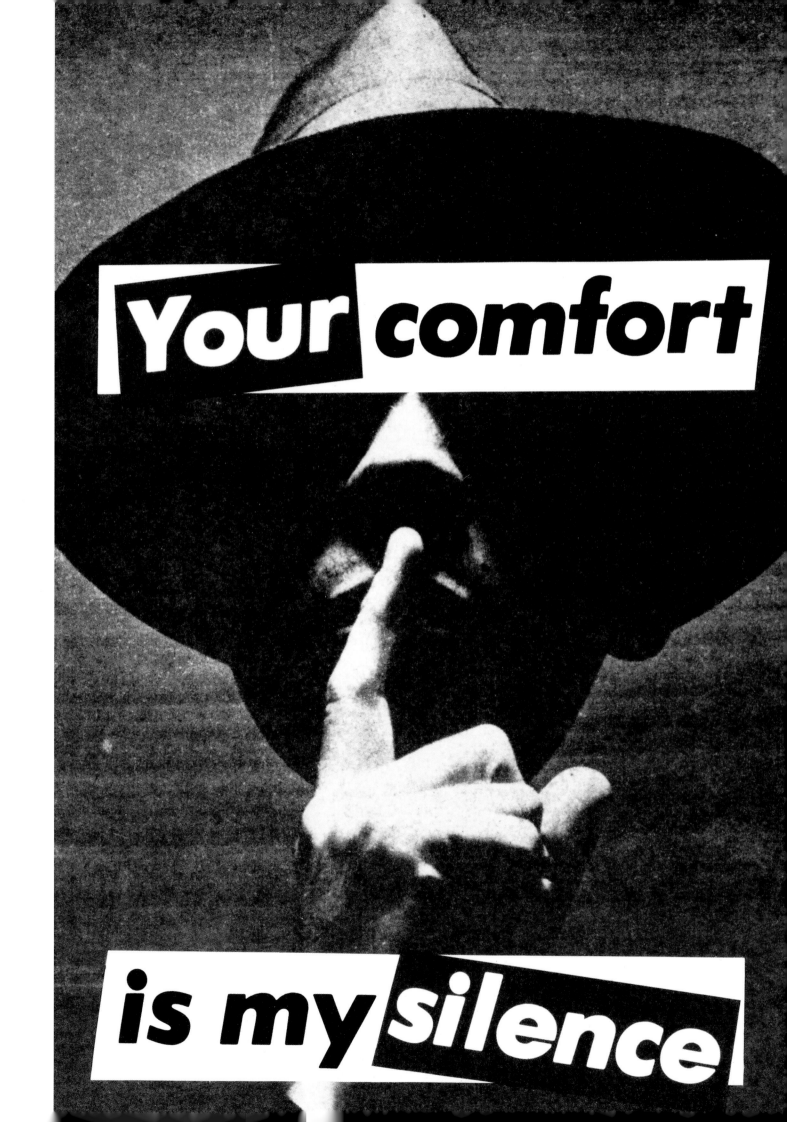

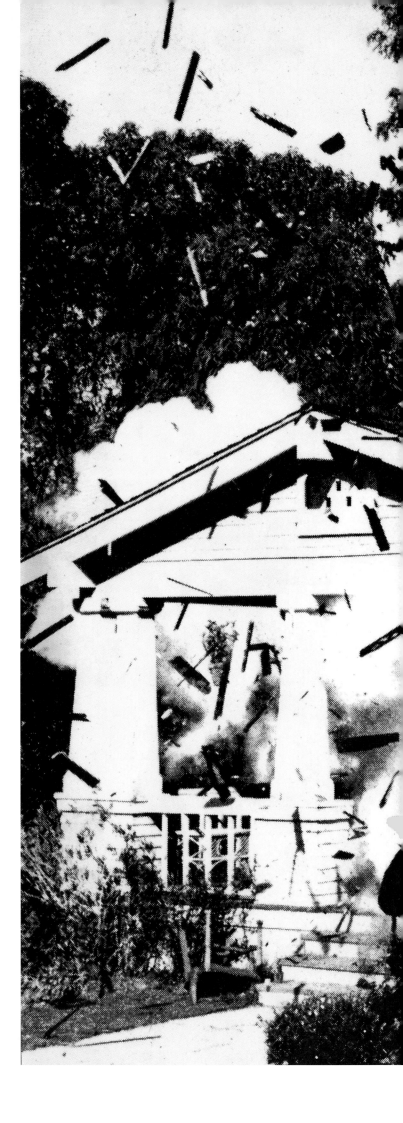

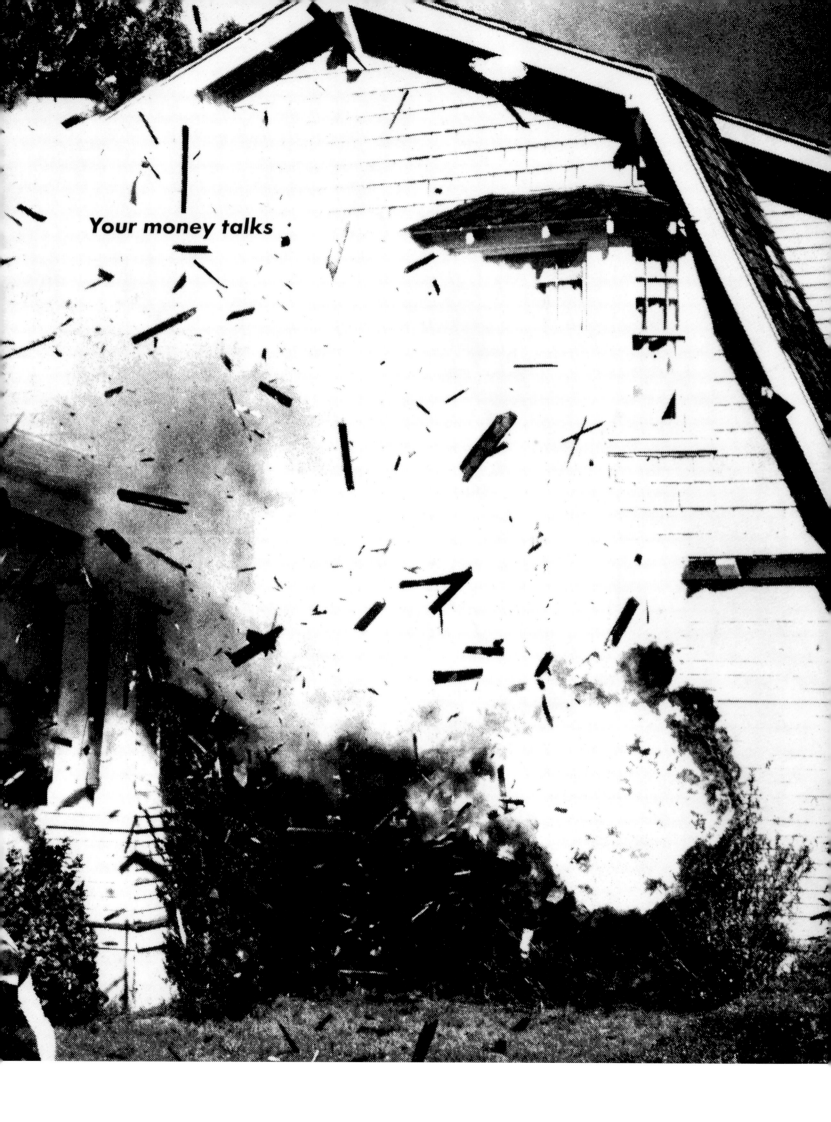

UNTITLED (**YOU ARE SEDUCED BY THE SEX APPEAL OF THE INORGANIC**), 1981.
UNTITLED (**BUSY GOING CRAZY**), 1989.

(294)
Paste-up for UNTITLED (**YOU ARE THE LONG COMPLAINT OF DESIRE**), 1986.
Paste-up for UNTITLED (**YOUR MANIAS BECOME SCIENCE**), 1981.

(295)
Paste-up for UNTITLED (**WE ARE NOTIFYING YOU OF A CHANGE OF ADDRESS**), 1986.

(296–97)
UNTITLED (**YOU ARE GIVING US THE EVIL EYE**), 1984.

(298–99)
UNTITLED (**HOW COME ONLY THE UNBORN HAVE THE RIGHT TO LIFE?**),
design for the **VILLAGE VOICE**, 1992.
UNTITLED (**MEMORY IS YOUR IMAGE OF PERFECTION**), 1982.

Busy going crazy

48"

DROP OUT TYPE - reverse to white type

choose the Impres...
unity and intensity
...shion of alternately
parts of any picture
no real picture at all.
whole composition,
...vised apprehension
...ent experiences, and
appeal to visual or
...tamination, a false
...at which is actually
...f art should be self-
...sthetes of modern
Has not Walter
all the arts aspire
...fect is the Impres-

take sides. Ev...
...pend on concen-
...to be attained
...cal beauties of
...e lines. To put
Chardin did, as
...ain the keenest
...t this may not
...operly affords.
..., memories, of
...ce more highly
...thetized than
out of a com-

plex of visi...
It took ti...
extra...
take
bloom gra...
dral front...
visual a...
of sigt a...
kin o...
y the...
In fac...
...king in
...ned fr
of all p...
dicated b...
and us...
process o...

general i...
the lovel...
of the p...
enha...
I
P...
the...
i the dig...
until on...
complet...
Indee

You

US

the

are

giving

evil

eye

...ory and must itself be complex.
...lysis to paint John...ent's...will
...ation of the Sacrame... It will not
...ysis to appreciate it. ...passive vision like a cathe-
...onet, for its appeal is both
...nd the parallel experiences
...ry must be adjusted into a spectator, as
...the old-fashioned way of
...ould be clearly distin-
...ling that is destructive
...egitimacy is best vin-
...spectator does in epitome
...the artist ...ed by
...When ...in the...
...ty, then, w...
...of my eye, o...
...nd the articul...
...come back...
...when I do this
...rocess by w...
...plete visi... of
...them
...art...tion,
...ched and
...d forth in its destined beauty
...t such a process of appreciation and

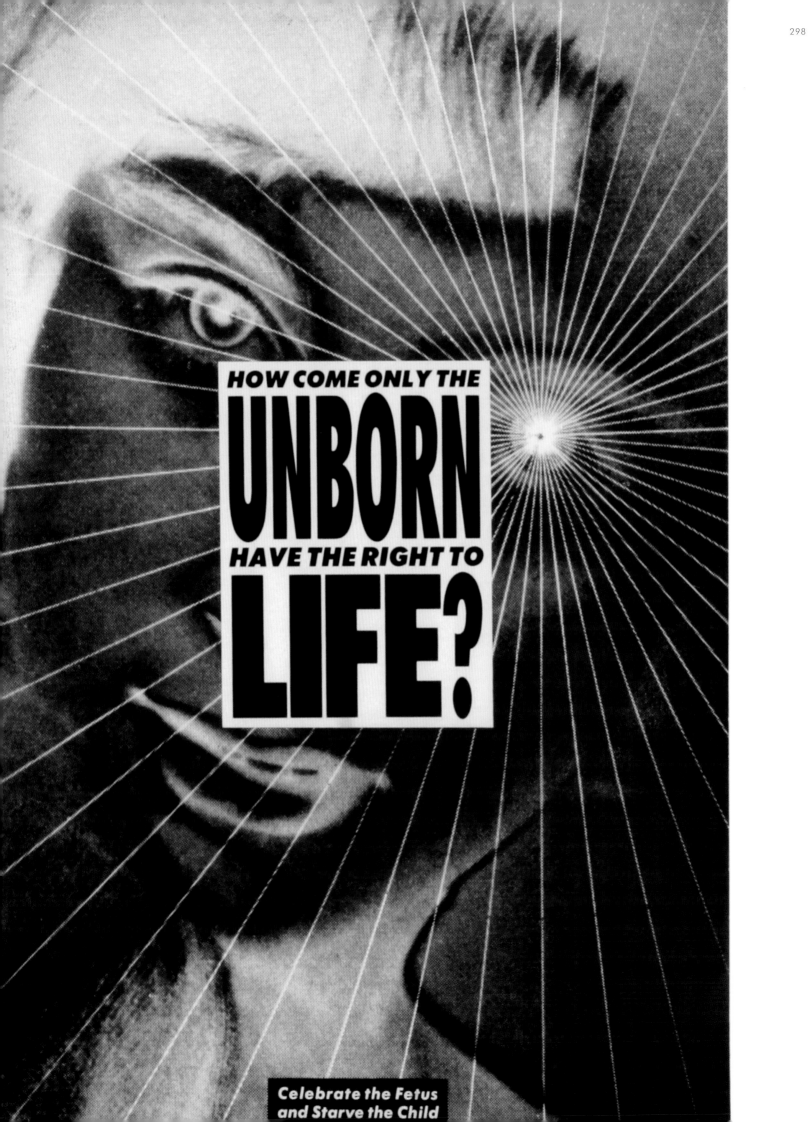

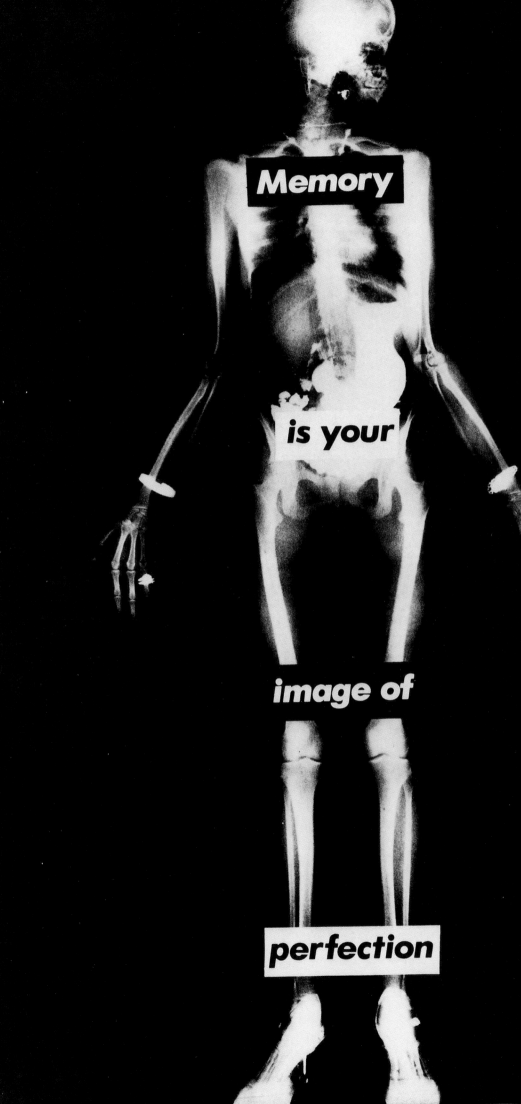

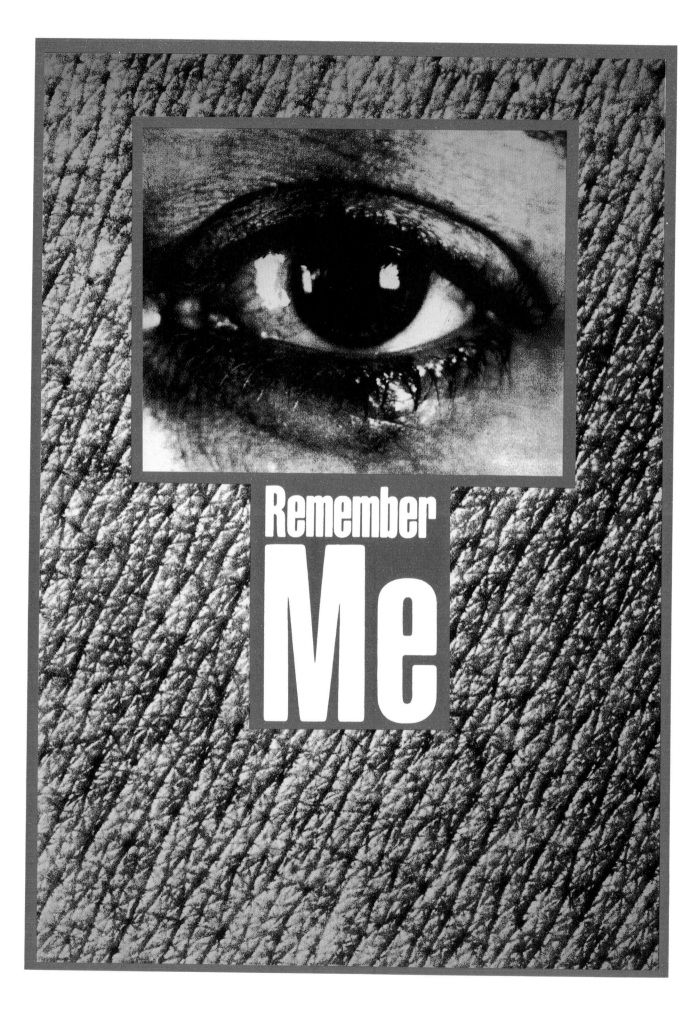

BARBARA KRUGER
1945 Born in Newark, NJ
Lives in New York City and Los Angeles

EDUCATION
1966 Parsons School of Design, New York, NY
1965 Syracuse University, Syracuse, NY

AWARDS, GRANTS, AND FELLOWSHIPS
2005 The Golden Lion for Lifetime
 Achievement, 51st Venice Biennale
1983–84 National Endowment for the Arts Grant
1976–77 Creative Artists Service Program Grant

SELECTED SOLO EXHIBITIONS
2009
Barbara Kruger: Pre-digital 1980–1992, Skarstedt
 Gallery, New York, NY, March 18–April 18
Between Being Born and Dying, Lever House, New
 York, NY, September 17–November 21
Paste Up, Sprüth Magers, London, England,
 November 21, 2009–January 23, 2010

2007
"Picture/Readings" 1978, Mary Boone Gallery,
 New York, NY, November 1–December 22

2006
Desire Exists Where Pleasure Is Absent,
 Kestnergesellschaft, Hannover, Germany,
 September 1–November 5; exh. cat.: Frank-
 Thorsten Moll.

2005
Barbara Kruger: Twelve, Museum of
 Contemporary Art San Diego, CA, October
 1–December 11
Gallery of Modern Art, Glasgow, Scotland, April
 21–September 26; exh. cat.
Ludwig Forum für Internationale Kunst,
 Aachen, Germany, April 23, 2005–April 23,
 2006
Twelve, Tramway, Glasgow, Scotland, August
 5–September 26; exh. cat.: Barbara Kruger
 and John Calcutt
Untitled (Blind Eye, Brain Drained, Shattered Skin),
 Australian Center for Contemporary Art,
 Melbourne, Australia, September 21–May 1

2004
Mary Boone Gallery, New York, NY, October
 28–December 18
Sprüth Magers, Munich, Germany, September
 10–October 30
Twelve, Mary Boone Gallery, New York, NY,
 March 6–April 24

2003
Sprüth Magers, London, England, May 29–July 31

2002
Palazzo delle Papesse, Centro Arte
 Contemporanea, Siena, Italy, June 22–
 September 5; exh. cat.: Paolo Fabbri, Marco
 Pierini, and Angela Vettese

2001
Barbara Kruger: Power/Pleasure/Desire/Disgust,
 South London Gallery, England, February
 2–March 18

1999
Museum of Contemporary Art, Los Angeles,
 CA, October 17, 1999–February 13, 2000
 [itinerary: Whitney Museum of American
 Art, New York, NY, July 13–October 22];
 exh. cat.: Rosalyn Deutsche, Katherine
 Dieckmann, Ann Goldstein, Steven Heller,
 Gary Indiana, Carol Squiers, and Lynne
 Tillman
Power/Pleasure/Desire/Disgust, Galerie Yvon
 Lambert, Paris, France, January 9–February
 28

1998
Parrish Art Museum, Southampton, New York

1997
Mary Boone Gallery, New York, NY, October 31–
 December 20
Power/Pleasure/Desire/Disgust, Deitch Projects,
 New York, NY, November 1–December 20

1996
Museum of Modern Art at Heide, Melbourne,
 Australia, October 17–November 24; exh. cat.:
 Juliana Engberg

1994
Mary Boone Gallery, New York, NY, March
 5–April 30

1992
Magasin—Centre National d'Art Contemporain,
 Grenoble, France

1991
Mary Boone Gallery, New York, NY, January
 5–26; exh. cat.

1990
Duke University Museum of Art, Durham, NC;
 exh. cat.: Christopher Fehlinger and Kimberly
 Smith
Galerie Monika Sprüth, Cologne, Germany,
 April–May Kölnischer Kunstverein,
 Cologne, Germany
Rhona Hoffman Gallery, Chicago, IL, April 6–28

1989
Fred Hoffman Gallery, Santa Monica, CA
Galerie Bebert, Rotterdam, The Netherlands
Mary Boone Gallery, New York, NY, January
 7–28; exh. cat.
Museo d'Arte Contemporanea, Castello di Rivoli,
 Turin, Italy, October 6–December 3; exh. cat.:
 Rudi Fuchs, Johannes Gachnang, and
 Cristina Mundici

1988
National Art Gallery, Wellington, New Zealand,
 March 5–May 1; exh. cat.: Lita Barrie and
 Jenny Harper

1987
Galerie Crousel-Hussenot, Paris, France,
 February 21–March 21
Galerie Monika Sprüth, Cologne, Germany,
 May–June
Mary Boone Gallery, New York, NY,
 May 2–30; exh. cat.: Jean Baudrillard and
 Barbara Kruger

1986
Annina Nosei Gallery, New York, NY, February
 8–March 2
Hillman/Holland Gallery, Atlanta, GA,
 September 21–October 17
Rhona Hoffman Gallery, Chicago, IL, October
 17–November 15
Slices of Life: The Art of Barbara Kruger, Krannert
 Art Museum, University of Illinois,
 Champaign, October 4–November 9; exh. cat.:
 Kenneth Baker
University Art Museum, University of California,
 Berkeley, CA, August 16–October 26

1985
*New American Photography: Barbara Kruger,
 Untitled Works*, Los Angeles County Museum
 of Art, CA, January 17–March 17; exh. cat.:
 Kathleen McCarthy Gauss
Striking Poses: Barbara Kruger, Contemporary
 Arts Museum, Houston, TX, April 27–June
 23; exh. cat.: Marti Mayo
Wadsworth Atheneum, Hartford, CT, January
 12–March 10

1984
Galerie Chantal Crousel, Paris, France, April
 19–May 16
Kajima Gallery, Montreal, Canada
Rhona Hoffman Gallery, Chicago, IL, March
 13–April 3

1983
Barbara Kruger: New Work, Larry Gagosian
 Gallery, Los Angeles, CA, October 13–
 November 5
*We Won't Play Nature to Your Culture: Works by
 Barbara Kruger*, Institute of Contemporary
 Arts, London, England, November 4–
 December 11 [itinerary: Watershed Gallery,
 Bristol, England, January 21–February 18,
 1984; Le Nouveau Musée, Villeurbanne,
 France, March 22–April 25, 1984; and
 Kunsthalle Basel, Switzerland (collaboration
 with Jenny Holzer), May 13–June 24, 1984];
 exh. cat.: Craig Owens and Jane Weinstock

1982
Annina Nosei Gallery, New York, NY
No Progress in Pleasure, Hallwalls/CEPA Gallery,
 Buffalo, NY, April 9–30
Larry Gagosian Gallery, Los Angeles, CA,
 March 3–April 3

1980
P.S. 1, Long Island City, New York, NY,
 December 1, 1980–January 25, 1981

1979
Picture/Readings, Franklin Furnace Archive,
 New York, NY, January 3–February 5

1977
The Ohio State University, Columbus,
 November 14–25

1976
John Doyle Gallery, Chicago, IL, March–April

1975
Fischbach Gallery, New York, NY, January 4–23

1974
Artists Space, New York, NY, January 21–
 February 18

SELECTED GROUP EXHIBITIONS

2009

Beg, Borrow, and Steal, The Rubell Family Collection Museum, Miami, FL, December 2, 2009–May 29, 2010

A Tribute to Ron Warren, Mary Boone Gallery, New York, NY, September 12–October 24

The Pictures Generation, The Metropolitan Museum of Art, New York, NY, April 21–August 2; exh. cat.: Douglas Eklund

Silent Writings, Espace Culturel Louis Vuitton, Paris, France, March 27–August 23

You Will Never Wake Up from This Beautiful Dream, Vanmoerkerke Collection, Oostende, Belgium, January–April

2008

Book/Shelf, The Museum of Modern Art, New York, NY, March 26–July 7

Burning Down the House: Building a Feminist Art Collection, Elizabeth A. Sackler Center for Feminist Art, Brooklyn Museum, NY, October 31, 2008–April 5, 2009

Here and Now. Part 2. Regina Gallery, Moscow, Russia, February 17–29

People "Weekly," James Gallery, The Graduate Center, The City University of New York, New York, NY, October 2, 2008–February 28, 2009

Las Implicaciones de la Imagen, Museo Universitario de Ciencias y Arte, Mexico City, Mexico, April 12–June 29; exh. cat.

Ringling Retro: Modern and Contemporary Art, The Ringling Museum of Art, Sarasota, FL, May 10–October 19

Southern Exposure, The Museum of Contemporary Art, Sydney, Australia, March 21–June 1

WALL ROCKETS: Contemporary Artists and Ed Ruscha, FLAG Art Foundation, New York, NY [itinerary: Albright-Knox Art Gallery, Buffalo, NY, July 24–October 25]

2007

20 Ans du Musée d'Art Moderne: L'Art Après 1960 dans les Collections, Musée d'Art Moderne Saint-Etienne, December 8, 2007–January 20, 2008

Affinities: New Acquisitions for the Deutsche Bank Collection, Deutsche Guggenheim, Berlin, Germany, April 28–June 24

Concept: Photography—Dialogues and Attitudes, Ludwig Museum, Budapest, Hungary, April 27–June 10

Dangerous Beauty, Chelsea Art Museum, New York, NY, January 25–April 21

Kiss Kiss Bang Bang, Museo de Bellas Artes, Bilbao, Portugal, June 11–September 7; exh. cat.

Incheon Women Artists' Biennale, Incheon, Korea, November 10–December 30

Multiplex: Directions in Art, 1970 to Now, The Museum of Modern Art, New York, NY, November 21, 2007–July 21, 2008

Panic Attack! Art in the Punk Years, Barbican Art Gallery, London, England, June 5–September 9; exh. cat.: Mark Sladen and Ariella Yedgar

Uneasy Angel/Imagine Los Angeles, Sprüth Magers, Munich, Germany, September 14–November 3

What Is Painting? Contemporary Art from the Collection, The Museum of Modern Art, New York, NY, July 7–September 17

The Word in Art: Research and the Avant-Garde in the 20th Century, Museo di Arte Moderna e Contemporanea di Trento e Rovereto, November 10, 2007–April 6, 2008; exh. cat.

2006

The 80s: A Topology, Museu de Arte Contemporânea de Serralves, Porto, Portugal, November 11, 2006–April 15, 2007; exh. cat.: Ulrich Loock

Belief, Singapore Biennial, Singapore, September 4–November 12; exh. cat.: Ben Slater, et. al.

Busy Going Crazy: The Sylvio Perlstein Collection, La Maison Rouge, Paris, France, October 29, 2006–January 14, 2007; exh. cat.: Bernard Blistène, Xavier Cannone, Marc Dachy, Antoine de Galbert, Emmanuel Guigon, and Georges Sebbag

Full House: Views of the Whitney's Collection at 75, Whitney Museum of American Art, New York, NY, June 29–September 3, 2006

L'Amour, Comment Ça Va?, Maison de la Villette, Paris, France, April 5–August 13

New York, New York: Fifty Years of Art, Architecture, Photography, Film, and Video, Grimaldi Forum, Monaco, July 14–September 10; exh. cat.: Germano Celant, Lisa Dennison, et. al.

Red Eye: L.A. Artists from the Rubell Family Collection, Rubell Family Collection, Miami, FL, December 4, 2006–May 31, 2007

A Short History of Performance—Part IV, Whitechapel Art Gallery, London, England, April 1–14

Surprise, Surprise, The Institute of Contemporary Arts, London, England, August 2–September 10, exh. cat.

Where Are We Going? Selections from the François Pinault Collection, Palazzo Grassi, Venice, Italy, April 29–October 1, exh. cat.: Jack Bankowski and Alison M. Gingeras

2005

American Matrix: Contemporary Directions for the Harn Museum Collection, Samuel P. Harn Museum of Art, University of Florida, Gainesville, FL, October 22, 2005–April 30, 2006; exh. cat: Kerry Oliver-Smith

The Art of Chess, Luhring Augustine, New York, NY, October 28–December 23

The Experience of Art, Italian Pavilion, 51st Venice Biennale, Venice, Italy, June 12–November 6; exh. cat.

Getting Emotional, The Institute of Contemporary Art, Boston, May 18–September 5, exh. cat.: Nicholas Baume, Jennifer Doyle, and Wayne Koestenbaum

Inside Out Loud: Visualizing Women's Health in Contemporary Art, Mildred Lane Kemper Art Museum, Washington University in Saint Louis, MO, January 21–April 24, exh. cat.: Barbara Baumgartner, Catherine Lord, and Janine Mileaf

LOOKING AT WORDS: The Formal Use of Text in Modern and Contemporary Works on Paper, Andrea Rosen Gallery, New York, NY, November 2, 2005–January 1, 2006

Miradas y Conceptos en la Collección Helga de Alvear, Museo Extremeño e Iberoamericano de Arte Contemporáneo, Badajoz, Spain, September 15–December 31

2004

Flowers, Mary Boone Gallery, New York, NY, March 4–April 24

The Last Picture Show: Artists Using Photography, 1960–1982, Walker Art Center, Minneapolis, MN, October 11, 2003–January 4, 2004 [itinerary: traveled to four venues throughout the United States and Europe]; exh. cat.: Geoffrey Batchen, Kate Bush, Douglas Fogle, Stefan Gronert, Pamela Lee, and Melanie Marino

North Fork/South Fork: East End Art Now/Part II, Parrish Art Museum, Southampton, NY, July 25–September 12

Perspectives @ 25: A Quarter Century of New Art in Houston, Contemporary Arts Museum, Houston, Texas, October 16, 2004–January 9, 2005; exh. cat.

White: Whiteness and Race in Contemporary Art, International Center of Photography, New York, NY, December 10–February 27; exh. cat.: Maurice Berger, Wendy Ewald, David R. Roediger, and Patricia J. Williams

2003

20th Anniversary Show, Sprüth Magers, Cologne, Germany, April 25, 2003–October 18, 2004

Living with Duchamp, The Frances Young Tang Teaching Museum and Art Gallery at Skidmore College, Saratoga Springs, NY, June 27–September 28

Me & More, Kunstmuseum Luzern, Switzerland, August 9–November 23; exh. cat.: Peter Fischer and Susanne Neubauer

Talking Pieces, Museum Morsbroich, Leverkusen, Germany, January 26–May 11

2002

Shopping, Schirn Kunsthalle, Frankfurt, Germany, September 28–December 1 [itinerary: Tate Liverpool, England, December 20, 2002–March 23, 2003]; exh. cat.: Christoph Grunenberg and Max Hollein, et al

Sans Commune Mesure, Musée des Beaux-Arts, Lille, France

2001

The Overexcited Body: Art and Sport in Contemporary Society, Palazzo dell'Arengario, Piazza del Duomo, Milan, Italy, March 29–May 13 [itinerary: traveled throughout Europe and the United States 2001–2002]; exh. cat.: Vladimir Petrovsky, Guy-Olivier Segond, Abraham Szajman, Danilo Santo de Miranda, Adelina von Fürstenberg, and Yorgos Tzirtzilakis

2000

Around 1984: A Look at Art in the Eighties, P.S. 1 Contemporary Art Center, Long Island City, NY, May 21–September 3; exh. cat.

Picturing Women, Steven Scott Gallery, Baltimore, MD

Sentimental, Galerie Yvon Lambert, Paris, France

S.O.S.: Scenes of Sounds, The Frances Young Tang Teaching Museum and Art Gallery at Skidmore College, Saratoga Springs, NY; October 28, 2000–January 28, 2001; exh. cat.: Charles Stainback

Televisions: Kunst sieht Fern, Kunsthalle Wien, Austria, October 18, 2000–January 6, 2001; exh. cat.: Gabriele Mackert, Gerald Matt, and Joshua Decter

1999

The American Century: Art and Culture 1950–2000, Whitney Museum of American Art, New York, NY, September 26, 1999–February 13, 2000; exh. cat.: Maxwell L. Anderson and Lisa Phillips.

Art at the End of the Century, Milwaukee Art Museum, Milwaukee, WI, January 31–April 4

Inner Eye: Contemporary Art from the Marc and Livia Straus Collection, Samuel P. Harn Museum of Art, University of Florida, Gainesville, FL, March 22, 1998–January 3, 1999 [itinerary: traveled to four venues throughout the United States]; exh. cat.: Budd Harris Bishop and Dede Young

Public Notice: Art & Activist Posters, 1951–1997, Alyce de Roulet Williamson Gallery, Art Center/College of Design, Pasadena, CA, May 9–July 3

1998

Art and the American Experience, Kalamazoo Institute of Arts, Kalamazoo, MI, September 13–December 6; exh. cat.: Jan van der Marck

Dreams for the Next Century: A View of the Collection, Parrish Art Museum, Southampton, New York, NY, July 19–September 6

Fast-Forward Trademarks, Kunstverein Hamburg, Germany, May 8–June 21

Isn't It Too Early for the Eighties Yet?, Rooseum Center for Contemporary Art, Malmo, Sweden, May 30–August 30

Matrix/Berkeley 1978–1998, University Art Museum, University of California at Berkeley, October–December; exh. cat.

The Promise of Photography: The DG BANK Collection, Hara Museum of Contemporary Art, Tokyo, Japan, October 1998–January 1999 [itinerary: traveled to four venues throughout Europe]; exh. cat.: Boris Groys, Rosalind E. Krauss, and Paul Virilio

Read My Lips: Jenny Holzer, Barbara Kruger, Cindy Sherman, National Gallery of Australia, Canberra, Australia, June 6–August 9; exh. cat.: Kathryn Weir

1997

Observations, Ydessa Hendeles Art Foundation, Toronto, Canada

1996

Caixa Nudo & Crudo, Claudia Gian Ferrari Arte Contemporanea, Milan, Italy

Family Values: American Art in the Eighties and Nineties. The Scharpff Collection at the Hamburg Kunsthalle, Galerie der Gegenwart, Hamburger Kunsthalle, Germany; exh. cat.: Christoph Heinrich and Stephan Schmidt-Wulffen

Making Pictures: Women & Photography, 1975–Now, Nicole Klagsburn Gallery, New York, NY, December 14, 1996–January 18, 1997

The Mediated Object: Selections from the Eli Broad Collection, Fogg Art Museum, Harvard University, Cambridge, MA, March 16–November 3 [itinerary: Forum for Contemporary Art, St. Louis, MO]

NowHere/Incandescent, Louisiana Museum of Modern Art, Humlebaek, Denmark, May 15–September 8

Sexual Politics: Judy Chicago's "Dinner Party" in Feminist Art History, Armand Hammer Museum of Art and Cultural Center, Los Angeles, CA, April 24–August 18; exh. cat.: Laura Cottingham, Amelia Jones, et al

Thinking Print: Books to Billboards, 1980–85, The Museum of Modern Art, New York, NY, June 20–September 10

1995

Civil Rights Now, Southeastern Center for Contemporary Art, Winston Salem, NC, January 28–April 5 [itinerary: Cleveland Center for Contemporary Art, Cleveland, OH, May 12–August 13]

In a Different Light: Visual Culture, Sexual Identity, Queer Practice, University Art Museum, University of California at Berkeley, CA, October–December

Laughter Ten Years After, Ezra and Cecile Zilka Gallery, Wesleyan University, Middleton, CT, October 31–December 9 [itinerary: Houghton House Gallery, Hobart and William Smith Colleges, Geneva, NY, February 23–April 16, 1996; and Beaver College Art Gallery, Glenside, PA, September 16–October 27, 1996]; exh. cat.: Jo Anna Isaak, Jeanne Silverthorne, and Marcia Tucker

Passions Privées, Musée d'Art Moderne de la Ville de Paris, France, December 1995 March 1996

Paste-Up: Past & Present, Kent Gallery, New York, NY, November 2–December 23; exh. cat.: Elizabeth Hayt

1994

Assertive Image, Armand Hammer Museum of Art and Cultural Center, University of California at Los Angeles, CA, June 1–October 9

Gewalt/Geschäfte, Neue Gesellschaft für Bildende Kunst, Berlin, Germany, June–August

Imprimatur, Saidye Bronfan Centre for the Arts, Montreal, Canada

Public Interventions, Institute of Contemporary Art, Boston, MA

Wall to Wall, Serpentine Gallery, London, England, January 19–February 27 [itinerary: Southampton City Art Gallery, Southampton, England, April 22–June 5; and the Leeds City Art Gallery, Leeds, England, May 12–July 2]; exh. cat.

World Morality, Kunsthalle Basel, Switzerland

1993

Biennale d'Art Contemporain, Lyon, France

Ciphers of Identity, Center for Art, Design and Visual Culture at the University of Maryland, Baltimore, MD, November 12, 1993–January 21, 1994 [itinerary: traveled to six venues throughout the United States 1994–1996]; exh. cat.: Maurice Berger

Commodity Image, International Center of Photography Midtown, New York, NY, April 23–July 18 [itinerary: traveled to five venues throughout the United States and Europe 1993–1995]; exh. cat.

Die Sprache der Kunst—The Language of Art, Kunsthalle Wien, Austria, June–August

Image Makers, Nassau County Museum of Art, Roslyn Harbor, NY

The Mediated Image: American Photography in the Age of Information, University Art Museum, University of New Mexico, Albuquerque, NM

Photoplay: Obras de The Chase Manhattan Collection, Center for the Fine Arts, Miami, FL [itinerary: traveled to six venues in Latin America from 1993–1994]; exh. cat.: Manuel E. Gonzalez and Lisa Phillips.

Zeitsprünge: Künstlerische Positionen der 80er Jahre: Sammlung Rudolf und Ute Scharpf, Wilhelm-Hack-Museum, Ludwigshafen, Germany, January 17–February 22

1992

15th Anniversary Exhibition, Rhona Hoffman Gallery, Chicago, IL

Ars Pro Domo, Museum Ludwig, Cologne, Germany

Chaos to Order, Art Museum of Southeast Texas, Beaumont, TX

Dissent, Difference, and the Body Politic, Portland Art Museum, OR, August 20–October 29 [itinerary: Otis Art Institute of Parson School of Design, Los Angeles, CA, February 20–March 25, 1993]

More Than One Photography: Works Since 1980 from the Collection, The Museum of Modern Art, New York, NY, May 14–August 9; exh. cat.

The Power of the City/The City of Power, Whitney Museum of American Art Downtown at Federal Plaza, New York, NY, July–August; exh. cat.: Christel Hollevoet, Karen Jones, and Timothy Nye

1991

Anni 80: Artisti a New York, Palazzo delle Albere, Museo Provinciale d'Arte Sezione Contemporanea, Trento, Italy

Art of Advocacy, The Aldrich Museum of Contemporary Art, Ridgefield, CT, May 18–September 22

Aussenraum-Innenstadt, Sprengel Museum Hannover, Germany, October–November; exh. cat.

Beyond the Frame: American Art, 1960–1990, Setegaya Art Museum, Tokyo, Japan, July 6–August 18 [itinerary: Museum of Art, Osaka, Japan, August 29–September 29; and Fukuoka Art Museum, Fukuoka, Japan, November 15–December 15]; exh. cat.

Compassion and Protest: Recent Social and Political Art from the Eli Broad Family Foundation, San Jose Museum of Art, CA, June 1–August 25; exh. cat.

Devil on the Stairs: Looking Back on the Eighties, Institute of Contemporary Art, Philadelphia, PA, October 14, 1991–January 5, 1992 [itinerary: Newport Harbor Art Museum, Newport Beach, CA, April 16–June 21, 1992]; exh. cat.: Robert Storr

Objects for the Ideal Home, Serpentine Gallery, London, England

Power: Its Myths and Mores in American Art, 1961–1991, Indianapolis Museum of Art, Indianapolis, IN, September 7–November 3 [itinerary: Akron Art Museum, OH, January 18–March 22, 1982; and Virginia Museum of Fine Arts, Richmond, VA, May 4–July 8, 1992]; exh. cat.: Anna C. Chave, Holliday T. Day, George E. Marcus, and Brian Wallis

Words and #'s, Museum of Contemporary Art, Wright State University, Dayton, OH, April 10–May 10; exh. cat.: Barry Rosenberg

1990

Art et Publicité: 1890–1990, Musée National d'Art Moderne, Centre Georges Pompidou, Paris, October 31, 1990–February 25, 1991; exh. cat.

The Charade of Mastery: Deciphering Modernism in Contemporary Art, Whitney Museum of American Art Downtown at Federal Reserve Plaza, NY, October 31, 1990–January 11, 1991; exh. cat.

Contemporary Illustrated Books: Word and Image, 1967–1988, Franklin Furnace Archive, New York, NY, January 12–February 28 [itinerary: The Nelson-Atkins Museum of Art, Kansas City, MO, April 5–June 3; and University of Iowa Museum of Art, Iowa City, IA, February 8–April 7, 1991]; exh. cat.: Donna Stein

The Decade Show: Frameworks of Identity in the 1980s, Museum of Contemporary Hispanic Art, New York, NY, May 16–August 19; The New Museum of Contemporary Art, NY, May 12–August 19; and The Studio Museum in Harlem, New York, NY, May 18–August 19]

The Indomitable Spirit, Sotheby's, New York, NY, October 14

Language and Art, The Aldrich Museum of Contemporary Art, Ridgefield, CT, October 20, 1990–January 6, 1991

New Works for New Spaces: Into the 90s, Wexner Center for the Visual Arts, Columbus, OH, September 29, 1990–January 6, 1991

Opening Exhibition, 20th Century Pavilion, The Israel Museum, Jerusalem, Israel

Reproduced Authentic, Galerie Via Eight at Barneys New York, Tokyo, Japan, November 3–16; exh. cat.: Joseph Kosuth and Martin Prinzhorn

1989

Bilderstreit: Widerspruch, Einheit und Fragment in der Kunst seit 1960, Museum Ludwig, Cologne, Germany, April 8–June 28; exh. cat.: Siegfried Gohr and Johannes Gachnang

Desire of the Museum, Whitney Museum of American Art Downtown at Federal Reserve Plaza, NY, July 12–September 12; exh. cat.

A Forest of Signs: Art in the Crisis of Representation, The Museum of Contemporary Art, Los Angeles, May 7–August 13; exh. cat.: Ann Goldstein, Mary Jane Jacob, Anne Rorimer, and Howard Singerman

Group Show: Domenico Bianchi, Alan Charlton, Günther Förg, Barbara Kruger, Toon Verhoef, Museo d'Arte Contemporanea, Castello di Rivoli, Turin, Italy, October 6–December 3

Image World: Art and Media Culture, Whitney Museum of American Art, NY, November 9, 1989–February 18, 1990; exh. cat.: John G. Hanhart, Marvin Heiferman, and Lisa Phillips

Magiciens de la Terre, Musée National d'Art Moderne, Centre Georges Pompidou, Paris, France, May 18–August 14; exh. cat.: Homi Bhabha , Mark Francis, Pierre Gaudibert, Aline Luque, Thomas McEvilley, Andre Magnin, Bernard Marcade, Jean-Hubert Martin, and Jacques Souillou

Making Their Mark: Women Artists Move into the Mainstream, 1970–85, Cincinnati Art Museum, OH, February 22–April 2; exh. cat.: Catherine C. Brawer and Randy Rosen

Prospect 89, Frankfurter Kunstverein and Schirn Kunsthalle, Frankfurt, Germany

1988

Art Against Aids, Pacific Design Center, Los Angeles, CA, December 15, 1988–February 5, 1989

Committed to Print, The Museum of Modern Art, NY, January 31–April 19; exh cat.

From the Southern Cross: A View of World Art, c.1940–88. The Biennial of Sydney, Art Gallery of New South Wales and Pier 2/3, Walsh Bay, Sydney, Australia, May 18–July3 [itinerary: National Gallery of Victoria, Melbourne, Australia, August 4–September 18]; exh. cat.

Modes of Address: Language in Art Since 1960, Whitney Museum of American Art Downtown at Federal Reserve Plaza, NY, July 29–September 23; exh. cat.: Walter Kalaidjian

1987

8 Million Stories in the Naked City: Lisa Bloomfield, Douglas Huebler, Anetta Kapon, Barbara Kruger, and Linda Nishio, LACE, Los Angeles, CA

1987 Biennial Exhibition: Contemporary American Art, Whitney Museum of American Art, NY, April 10–July 5; exh. cat.: Richard Armstrong, John G. Hanhardt, Richard Marshall, and Lisa Phillips

El Arte y su Duble/Art and Its Double: A New York Perspective, Fundación Caja de Pensiones, Madrid, Spain, February 6–March 22; exh. cat.: Dan Cameron

Avant-Garde Art in the 80's, Los Angeles County Museum of Art, CA, April 23–July 12; exh. cat.: Howard N. Fox

Constitution (Group Material), Temple Gallery, Philadelphia, PA, October 1–November 14; exh. cat.

Contemporary American Artists in Print: Eric Fischl, Jenny Holzer, Barbara Kruger, Susan Rothenberg, and David Salle, Yale University Art Gallery, New Haven, CT, March 25–May 31; exh. cat.: Laura Katzman

Documenta 8, Kassel, Germany, June 12–September 20; exh. cat.

Emerging Artists 1978–1986: Selections from the Exxon Series, Solomon R. Guggenheim Museum, New York, NY; exh. cat.: Diane Waldman

L'Epoque, La Mode, La Morale, La Passion 1977–1987: Aspects de l'Art d'Aujourd'hui, Musée National d'Art Moderne, Centre Georges Pompidou, Paris, France, May 20–August 17; exh. cat.

Implosion: A Postmodern Perspective, Moderna Museet, Stockholm, Sweden, October 24, 1987–January 1, 1988; exh. cat.: Germano Celant, Kate Linker, Lars Nittve, and Craig Owens

Made in U.S.A: An Americanization in Modern Art, The '50s & '60s, University Art Museum, University of California at Berkeley, April 4–June 21 [itinerary: The Nelson-Atkins Museum of Art, Kansas City, MO, July 25–September 6; and Virginia Museum of Fine Arts, Richmond, VA, October 7–December 7]; exh. cat.: Ben H. Bagdikian, James E. B. Breslin, Thomas Schaub, and Sidra Stich

1986

An American Renaissance: Painting and Sculpture from 1940 to the Present, Museum of Art, Fort Lauderdale, FL, January 12–March 30; exh. cat.: Malcolm R. Daniel, Harry F. Gaugh, Sam Hunter, Karen Koehler, Kim Levin, Robert C. Morgan, and Richard Sarnoff

Ein Anderes Klima: Künstlerinnen gebrauchen neue Medien, Kunsthalle Düsseldorf, Germany, October–December

In Other Words, Corcoran Gallery of Art, Washington, D.C., May 9–June 29; exh. cat.: Ned Rifkin

Jenny Holzer & Barbara Kruger, The Israel Museum, Jerusalem; exh. cat.: Suzanne Landau

Maelstrom, Joe and Emily Lowe Gallery, Syracuse University, NY, November–December

Matrix/Berkeley 100, University Art Museum, University of California at Berkeley, CA, August–October

Metro Pictures, New York, NY

New Acquisitions from New York, Memphis Brooks Museum of Art, TN

Painting and Sculpture Today: 1986, Indianapolis Museum of Art, IN

Paravision, Margo Leavin Gallery, Los Angeles, CA, July 12–August 23

Postmasters Gallery, New York, NY

Products and Promotion: Art, Advertising, and the American Dream, San Francisco Camerawork, San Francisco, CA, September 4–October 4 [itinerary: University Gallery of Fine Art, Ohio State University, Columbus, OH, April 30–May 31; and Franklin Furnace Archive, New York, NY, Winter 1987]; exh. cat.: Donna Stein and Lynn Zelevansky

The Real Big Picture, Queens Museum, Flushing Meadows, NY, January 17–March 19; exh. cat.: Marvin Heiferman and Janet Schneider

Rooted Rhetoric: Una Tradizione nell'Arte Americana, Castel dell'Ovo, Naples, Italy, June–July; exh. cat.: Benjamin H. D. Buchloh, Gabriele Guercio, Joseph Kosuth, Thomas Lawson, Charles Le Vine, David Robbins, and Angelo Trimarco

1985

1985 Biennial Exhibition: Contemporary American Art, Whitney Museum of American Art, New York, NY, March 13–June 9

Dissent: The Issue of Modern Art in Boston, Institute of Contemporary Art, Boston, MA, "The Expressionist Challenge," December 5, 1985–February 2, 1986; "Revolt in Boston: Fear vs. Freedom," February 18–April 20, 1986; "As Found," April 29–June 22, 1986; exh. cat.: Benjamin H. D. Buchloh, Serge Guilbaut, Reinhold Heller, David Joselit, and Elizabeth Sussman

Ecrans Politiques, Musée d'Art Contemporain de Montréal, Montreal, Canada, November 17, 1985–January 12, 1986; exh. cat.: France Gascon

Group Show, Galerie Monika Sprüth, Cologne, Germany, March–April

June Group Show, Nature Morte Gallery, New York, NY

Kunst mit Eigen-Sinn, Museum für Moderner Kunst Stiftung Ludwig Wein, Vienna, Austria, March 29–May 12; exh. cat.: Silvia Bovenschen, Jean-Pierre Dubost, Jean Fisher, Peter Gorsen, Friederike Hassauer, Gabrielle Honnef-Harling, Luce Irigaray, Gertrud Koch, Elizabeth Lenk, Eva Meyer, Craig Owens, Helke Sander, and Eva Weisz

New York, New Art, ARCA, Marseille, France

Peter Blum Edition New York II, Groninger Museum voor Stad en Lande, Groningen, The Netherlands, September 15–October 20; exh. cat.: Poul Hofstede

Secular Attitudes, Los Angeles Institute of Contemporary Art, CA, February 15–March 23; exh. cat.

Subjects and Subject Matter: Shelag Alexander, Barbara Kruger, John Massey, Cindy Sherman, Laurie Simmons, and Jeff Wall, London Regional Art Gallery, London, England, October–December

Talking Back to the Media, Multimedia Project, Amsterdam, August–December; exh. cat.

1984

El Arte Narrativo, Museo Rufino Tamayo, Mexico City, Mexico, June–July

The Axis of Sexuality, The Banff Centre for the Arts, Alberta, Canada

Content: A Contemporary Focus, 1974–1984, Hirshhorn Museum and Sculpture Garden, Smithsonian Institution, Washington, D.C., October 4, 1984–January 6, 1985; exh. cat.: Howard N. Fox, Miranda McClintic, and Phyliss Rosenzweig.

Difference: On Representation and Sexuality, The New Museum of Contemporary Art, New York, NY, December 8, 1984–February 10, 1985 [itinerary: The Renaissance Society at the University if Chicago, Chicago, IL, March 3–April 7, 1985; and Institute of Contemporary Arts, London, England, July 19–September 1, 1985]; exh. cat.: Kate Linker, Craig Owens, Jacqueline Rose, Lisa Tickner, Jane Weinstock, and Peter Wollen

Disarming Images: Art for Nuclear Disarmament, The Contemporary Arts Center, Cincinnati, OH, September 4–October 27; exh. cat.: Nina Felshin

Group Show–Photography, Institute of Contemporary Art Boston, MA, July 3–September 1

Holzer, Kruger, Prince, Knight Gallery/Spirit Square Arts Center, Charlotte, NC, November 28, 1984–January 20, 1985; exh. cat.: William Olander

New York: Ailleurs et Autrement, ARC, Musée d'Art Moderne de la Ville de Paris, Paris, France, December 21, 1984–January 20, 1985; exh. cat.: Claude Gintz, Suzanne Page, and Beatrice Pavent

Photography Used in Contemporary Art, The National Museum of Modern Art Kyoto, Japan

Private Symbol/Social Metaphor, The Sydney Biennale, Sydney, Australia, April 11–June 17; exh. cat.: Stuart Morgan, Annelie Pohlen, Carter Ratcliff, and Nelly Richard

Sexuality and Representation, Institute of Contemporary Arts, London, England April–May

Verbally Charged Images, The Queens Museum, Flushing Meadows, New York, April 28–June 10; exh. cat.: Nina Felshin and Susan Solins

1983

1983 Whitney Biennial: Contemporary American Art, Whitney Museum of American Art, New York, NY, March 24–May 22; exh. cat.: Tom Armstrong, John G. Hanhardt, Barbara Haskell, Richard Marshall, and Patterson Sims

1984—A Preview, Ronald Feldman Fine Arts (in cooperation with the *Village Voice*), New York, NY, January 26–March 12; exh. cat.: Carrie Rickey

American Graffiti Gallery, Amsterdam, Holland

Ansatzpunkte kritischer Kunst Heute, Bonner Kunstverein, Bonn, Germany, October 12, 1983–January 1, 1994 [itinerary: Neue Gesellschaft für Bildende Kunst, Berlin, July 4–November 3, 1984]; exh. cat.

Artist-Critic, White Columns, New York, NY

Art and Social Change, U.S.A., Allen Memorial Art Museum, Oberlin College, Oberlin, OH, April 19–May 30; exh. cat.: David Deitcher, Jerry Kearns, Lucy L. Lippard, William Olander, and Craig Owens

Comment: Cecile Abish, Dara Birnbaum, Victor Burgin, Vernon Fisher, Douglas Heibler, Barbara Kruger, Muntadas, Long Beach Museum of Art, Long Beach, CA, May 29–August 14; exh. cat.: Constance Fitzsimmons

Contemporary Photographers, Cranbrook Academy of Art Museum, Bloomfield Hills, MI

Contra-Media, The Alternative Museum, New York, NY, January 29–February 26; exh. cat.: Terry Berkowitz

Currents, Institute of Contemporary Art, Boston, MA

Fashion Fictions, White Columns, New York, NY

Group Show, Young/Hoffman Gallery, Chicago, IL

Mary Boone Gallery, New York, NY

New American Photography, Los Angeles County Museum of Art, Los Angeles, September 8, 1983–Septemenr 15, 1985

The Revolutionary Power of Women's Laughter, Protech/McNeil Gallery, New York, NY, January 15–February 19; exh. cat.: Joann Issak

Starting Points of Young Critical Artists, Bonner Kunstverein, Bonn, Germany, December 20, 1983–January 29, 1984

The Stolen Images and Its Uses, Light Work/Community Darkrooms, Syracuse, NY, March 16–April 15

Written Imagery Unleashed in the Twentieth Century, Fine Arts Museum of Long Island, Hempstead, NY, November 6, 1983–January 22, 1984; exh. cat.: Eleanor Flomenhaft

1982

Frames of Reference, Whitney Museum of American Art Downtown at Federal Reserve Plaza, New York, NY, May 6–June 4; exh. cat.: Nora Halpern

40th Venice Biennale, Venice Italy; exh. cat.: Johannes Cladders and Hanne Darboven

The 74th American Exhibition, The Art Institute of Chicago, IL, June 12–August 1; exh. cat.: Anne Rorimer and A. James Speyer

Atomic Salon, Ronald Feldman Fine Arts, New York, NY

Documenta 7, Kassel, Germany, June 19–September 28; exh. cat.: Saskia Bos, Coosje van Bruggen, Germano Celant, Rudi Fuchs, Johannes Gachnang, Walter Nikkels, and Gerhard Storck

A Fatal Attraction: Art & Media, The Renaissance Society at the University of Chicago, IL, May 2–June 12; exh. cat.: Thomas Lawson

Image Scavengers: Photography, Institute of Contemporary Art, University of Pennsylvania, Philadelphia, PA, December 8, 1982–January 30, 1983; exh. cat.: Douglas Crimp and Paula Marincola

Public Vision, White Columns, New York, NY, December 4–20

The Rebounding Surface, Edith C. Blum Art Institute/Avery Center for the Arts, Bard College, Annandale-on-Hudson, New York, NY, August 15–September 24

1981

5th Vienna International Biennale: Erweiterte Fotographie, Wiener Secession, Vienna, Austria, October 22–November 22; exh. cat.

19 Emergent Artists: 1981 Exxon Series, Solomon R. Guggenheim Museum, New York, NY, January 30–April 5; exh. cat.: Peter Frank

Inespressionismo Americano, Genoa, Italy

It's a Gender Show, presented by Group Material, New York, NY

Love is Blind, Castelli Photography Gallery, New York, NY

Moonlighting, Josef Gallery, New York, NY

Pictures and Promises, The Kitchen, New York, NY; exh. cat.: Barbara Kruger

Public Address, Annina Nosei Gallery, New York, NY

Window, Room, Furniture, Cooper Union, New York, NY, March–April; exh. cat.: Ricardo Scofidio and Tod Williams

1980

Four Different Photographers, Padiglione d'Arte Contemporanea, Milan, Italy, February–March; exh. cat.

1979

Imitation of Life, University of Hartford, Hartford, CT, November 6–28

The Manifesto Show, 5 Bleecker Street, New York, NY, April 15–May 6

Word/Object/Image, Rosa Esman Gallery, New York, NY, December 11,1979–January 5, 1980

1978

False Face, N.A.M.E. Gallery, Chicago, March 10–April 2

Artists Books: New Zealand Tour 1978, National Art Gallery, Wellington, New Zealand [itinerary: Govett Brewster Art Gallery, New Plymouth, New Zealand; and Auckland City Art Gallery, New Zealand]

1977

Narrative Themes/Audio Work, Los Angeles Institute of Contemporary Art, CA, July 9–August 26 [itinerary: Artists Space, New York, NY, January 21–February 25, 1978]

California Annual, San Francisco Art Institute, CA, June 5–August 28

1976

Thickening Surface, Florida State University, Tallahassee, FL, February 5–27

1973

1973 Biennial Exhibition: Contemporary American Art, Whitney Museum of American Art, New York, January 10–March 18

PUBLIC PROJECTS: BILLBOARDS, MOVIES, POSTERS, MAGAZINE WORKS

2009

Moderna Museet, Stockholm, Sweden, May 9, 2009–September 18, 2013

2008

Another, installation, Price Student Center at the University of California at San Diego, CA

Cover, *New York Magazine,* March 24

Untitled (Shafted), installation, Broad Contemporary Art Museum at the Los Angeles County Museum of Art, CA

Women in the City, a West of Rome project, Los Angeles, CA

2006

Exhibition design and graphic identity for *Consider This*, Los Angeles County Museum of Art, CA

2004

Cover, *ArtUS*, January–February

2003

Facade banners, subway posters, billboards, and bus wraps for Selfridges Department Stores, London, Manchester, and Birmingham, England

2002

Facade banners for Galeria Kaufhof, Frankfurt am Main, Germany

2000

Display windows for Saks Fifth Avenue, New York, NY, July

Untitled (It's a Small World But Not If You Have to Clean It), banner billboards at Eighth Avenue/42nd Street and Washington Street/West Side Highway, co-produced by the Public Art Fund and the Whitney Museum of American Art, New York, NY, July

1998

Floor mosaics in five locations, Fisher College of Business, Ohio State University, Columbus, OH

1997

Bus wrap project for New York City/Queens Transit Line, Public Art Fund, New York, NY, November

Cover, *Time Out New York*, October 30–November 6

1996

Billboards and public service announcements, Melbourne Festival, Australia

Cover, exhibition catalogue *Thinking Print: Books to Billboards, 1980–95*, The Museum of Modern Art, New York, NY

Editorial feature, *Esquire*, June

Public service announcements, Artist in Residence, Wexner Center for the Arts, Ohio State University, Columbus, OH

Subway posters and bus placards for *Thinking Print: Books to Billboards, 1980–95*, The Museum of Modern Art, New York, NY

Subway posters for *Monument et Modernité*, Paris, France

Works featured in Rage Against The Machine music video *Bulls on Parade*, MTV

1995

Design for outdoor theater, North Carolina Museum of Art, Raleigh, NC; collaboration with Smith-Miller & Hawkinson and Nicholas Quennell

Editorial feature, *New York* magazine, December 25: 114–15

Feature-story illustration, *Details*, October
Talk Show, a short film broadcast on KCET, Los
Angeles, CA, July

1994
Billboard project, Malmö Konsthall, Malmo,
Sweden
Design for train station, Strasbourg, France
Editorial feature, *Harper's Baazar*, February

1993
Umbrella edition for AMFAR, Barneys New York
Video spots for "Silence the Violence," MTV
Wall-mural, Museo Pecci, Prato, Italy, March
27–May 16

1992
Billboards, products, and radio spots, Women's
Work Project on Domestic Violence, Liz
Claiborne, Inc., Boston, MA, and Miami, FL
Billboard, bus shelter, and bus placard project
for *Dissent, Difference, and the Body Politic*,
Portland Art Museum, OR
Billboard project, Museu de Arte
Contemporanea, São Paulo, Brazil
Cover, *Ms.*, January/February
Cover and editorial spread, *Newsweek*, June 8
Cover and essay, *Esquire*, May
Magazine projects, *L'Autre Journal*, Paris, France
Music video, Vanessa Williams, "Work to Do"
Poster project, Magasin—Centre National d'Art
Contemporain, Grenoble, France
Poster for pro-choice project, New York, NY
Poster project for Visual AIDS, New York, NY

1991
Billboard project for *Projekt Gadetegn 1991*,
Copenhagen, Denmark, June–August; cat.:
BizArt and Patricia C. Phillips.
Billboard project, Von-der-Heydt-Museum,
Wuppertal-Elberfeld, Germany
Bus shelter posters, Public Art Fund, New York,
NY
Cover design, *Bomb*, Spring
Project plan for Los Angeles Arts Park
competition [Collaboration with Smith-Miller
+ Hawkinson and Nicholas Quennell]

1990
Billboard and subway posters for *Image World:
Art and Media Culture*, Whitney Museum of
American Art, New York, NY
Billboard project for *New Works for New Spaces:
Into the 90s*, Wexner Center for the Visual
Arts, Columbus, OH
Exterior wall-mural project, The Museum of
Contemporary Art, Los Angeles, CA
Poster project, Warsaw, Poland
Subway posters and electronic sign, Berlin,
Germany

1989
Billboard project for Art Against AIDS, San
Francisco, CA
Billboard project, Frankfurter Kunstverein and
Schirn Kunsthalle Frankfurt, Germany
Billboard project for Public Art Fund,
Manhattan and Queens, NY
Poster design for March on Washington, D.C. for
Women's Reproductive Rights
Seattle Waterfront Project, Pier 62/63, Seattle,
WA; collaboration with Smith-Miller &
Hawkinson and Guy Nordenson

1988
Billboard project, National Art Gallery,
Wellington, New Zealand
Billboard projects, Adelaide and Melbourne,
Australia; cat.: George Alexander

My Pretty Pony, published as a limited edition in
the Artists and Writers Series by the Library
Fellows of the Whitney Museum of American
Art, New York, NY; collaboration with
Stephen King
Picturing Greatness, exhibition curated and
designed for The Museum of Modern Art,
New York, NY

1987
Poster designs and events curated for *The
Regulation of Fantasy*, Dia Art Foundation,
New York, NY, March; collaboration with
Phil Mariani
Poster designs and events curated for *Remaking
History*, Dia Art Foundation, New York, NY,
October 1987–May 1988; collaboration with
Phil Mariani

1986
Billboard project for Artangel, London

1985
Billboard project for Film in the Cities,
Minneapolis, MN
Bus placard for Nexus Project, Atlanta, GA

1984
Billboard project, Providence, RI
Poster design for *Committed*, a film by Shelia
McLaughlin and Lynn Tillman
Poster design for *The Nicaragua Media Project*,
The New Museum of Contemporary Art, New
York, NY
Poster design for *The Revolutionary Power of
Women's Laughter*, Protech/McNeil Gallery,
New York, NY

1981
Design for *Flue*, a Franklin Furnace Archive
Centerfold Project; collaboration with Louise
Lawler and Sherrie Levine

1979
Window installation for Printed Matter
Bookstore, New York, NY

————————————————

SELECTED BOOKS AND MONOGRAPHS
2006
Gorner, Veit, Hilke Wagner, and Frank-Thorsten
Moll, *Desire Exists Where Pleasure Is Absent*.
Bielfeld, Germany: Kerber Verlag, 2006.

2005
Phillips, Lisa, and Barbara Kruger, *Money Talks*.
New York, Skarstedt Fine Art, 2003.

1999
Barrett, Terry. *Criticizing Photographs: An
Introduction to Understanding Images*. 3rd
Edition. New York: McGraw-Hill, 1999.

Goldstein, Ann, ed., with Rosalyn Deutsche,
Katherine Dieckmann, Steven Heller,
Gary Indiana, Carol Squiers, and Lynne
Tillman, *Thinking of You*, Cambridge, MA:
MIT Press, 1999.

1998
Kester, Grant H. *Art, Activism, and
Oppositionality: Essays from Afterimage*.
Durham: Duke University Press, 1998.
Preziosi, Donald, ed. *The Art of Art History: A
Critical Anthology*. New York: Oxford
University Press, 1998.

1997
Schor, Mira. *WET: On Painting, Feminism, and
Art Culture*. Durham: Duke University Press,
1997.

1996
Deutsche, Rosalyn. *Evictions: Art and Spatial
Politics*. Cambridge, MA: MIT Press, 1996.
Foster, Hal. *The Return of the Real: The Avant-
Garde at the End of the Century*. An October
Book. Cambridge, MA: MIT Press, 1996.
Weintraub, Linda, Arthur Danto, and Thomas
McEvilley. *Art and the Edge and Over:
Searching for Art's Meaning in Contemporary
Society: 1970s–1990s*. New Haven: Art
Insights, Inc., 1996.

1995
Brand, Peggy Zeglin. *Revising the Aesthetic-Non
Aesthetic Distinction: The Aesthetic Value of
Activist Art*. University Park: Pennsylvania
State University Press, 1995.
Doss, Erika. *Spirit Poles and Flying Pigs: Public
Art and Cultural Democracy in American
Communities*. Washington: Smithsonian
Institution Press, 1995.
Wills, Sara, ed. *Language and Gender:
Interdisciplinary Perspectives*. London and New
York: Longman Press, 1995.

1994
Broude, Norma, and Mary D. Garrard, eds. *The
Power of Feminist Art: The American Movement
of the 1970s History and Impact*. New York:
Harry N. Abrams, 1994.
Witzling, Mara R., ed. *Voicing Today's Visions:
Writings by Contemporary Women Artists*. New
York: Universe Press, 1994.

1993
Kalaidjian, Walter. *American Culture Between the
Wars: Revisionary Modernism and Postmodern
Critique*. New York: Columbia University
Press, 1993.

1992
Harrison, Charles, and Paul Wood, eds. *Art in
Theory: 1900–1990*. Oxford: Blackwell, 1992.
Kurtz, Bruce D. *Contemporary Art: 1965–1990*.
Prentice: Prentice Hall, 1992.
Mitchell, W.J.T., ed. *Art and the Public Sphere*.
Chicago: University of Chicago Press, 1992.
Owens, Craig, with Scott Bryson, Barbara
Kruger, Lynne Tillman, and Jane Weinstock,
eds. *Beyond Recognition: Representation, Power,
and Culture*. Berkeley and Los Angeles:
University of California Press, 1992.

1991
Chadwick, Whitney. *Women, Art, and Society*.
London: Thames & Hudson, 1991.

1990
Atkins, Robert. *Art/Speak*. New York: Abbeville
Press, 1990.
Ferguson, Russell, William Olander, Marcia
Tucker, and Karen Fiss, eds. *Discourses:
Conversations in Postmodern Art and Culture*.
Cambridge, MA: MIT Press, 1990.
Linker, Kate. *Love for Sale: The Words and Pictures
of Barbara Kruger*. New York: Harry N.
Abrams Inc., 1990.

1989
Mulvey, Laura. *Visual and Other Pleasures*.
Bloomington: Indiana University Press, 1989.

1988
Foster, Hal, ed. *Vision and Visuality*. Dia Art
Foundation. Seattle: Bay Press, 1988.
Kuspit, Donald. *New Subjectivism: Art in the
1980s*. Ann Arbor: UMI Research Press, 1988.
Siegel, Jeanne. *Artwords 2: Discourse on the Early
80s*. Ann Arbor: UMI Research Press, 1988.

1987

Foster, Hal. *Discussions in Contemporary Culture*, Seattle: Bay Press, 1987.

Frank, Peter, with Michael McKenzie. *New, Used, and Improved: Art for the 80s*. New York: Abbeville Press, 1987.

Taylor, Mark C. *Erring: A Postmodern A/theology*. Chicago: The University of Chicago Press, 1987.

Wallis, Brian, ed. *Blasted Allegories: An Anthology of Writings by Contemporary Artists*. Cambridge, MA: MIT Press, 1987.

1986

Fischl, Eric, and Jerry Saltz, eds. *Sketchbook with Voices*. New York: Alfred Van der Marck Editions, 1986.

Huyysen, Andreas. *After the Great Divide: Modernism, Mass Culture, and Postmodernism*. Bloomington: Indiana University Press, 1986.

Smith, Roberta, and Peter Halley. *Beyond Boundaries: New York's New Art*. New York: Alfred van der Marck Editions, 1986.

1985

Foster, Hal. *Recodings: Art, Spectacle, Cultural Politics*. Seattle: Bay Press, 1985.

1984

Wallis, Brian, ed. *Art After Modernism: Rethinking Representation*. New York: The New Museum of Contemporary Art, 1984.

1983

Foster, Hal, ed. *Anti-Aesthetic: Essays on Postmodern Culture*. Seattle: Bay Press, 1983.

SELECTED ARTISTS WRITINGS

2007

"Wangechi Mutu." *Interview* magazine (April).

2005

Kruger, Barbara, with Lisa Phillips. *Money Talks*. New York: Skarstedt Fine Art, 2005.

2001

"Reading 9-11-01." *Artforum* 40, no. 3.

1998

"Paradoxia: A Predator's Diary." [Book review]. *Artforum* 36, no. 7 (March): 34.

"Progressive Gene." [Exhibition review]. *Artforum* 36, no. 9 (May): 33.

1997

"Columbia Gold: The Rock Group Earwig and the Music Scene in Columbus, Ohio." [Music review]. *Artforum* 35, no. 10 [Summer]: 37.

"Is it Art? Is it Good? And Who Says So?" *The New York Times* (October 12).

"Super Nova: Galaxie 500." [Music review]. *Artforum* 35 (February): 28.

"Trouble Girls." [Book review]. *Artforum* 36, no. 2 (October): 23.

1996

"The Visual Nation." *The Nation* 262, no. 3: 25.

1993

Remote Control: Power, Cultures, and the World of Appearances. Cambridge, MA: MIT Press, 1993.

"Word Up!" *Artforum* 32, no. 1 (September): 183-84.

1992

"Prick Up Your Ears." *Esquire* 117, no. 5 (May): 94-98.

1991

"Quality." Written for a symposium on "Quality: Form and Content in Contemporary Art" at The Richard and Marieluise Black Center, Bard College (June 3).

1990

"Arts and Leisures." *The New York Times* (September 9).

"Remote Control." *Artforum* 29, no. 1 (September): 19-20.

1989

"Remaking History." In *Remaking History*, Barbara Kruger and Philomena Mariani, eds. New York: Dia Art Foundation; and Seattle: Bay Press, 1989.

"Remote Control." *Artforum* 27, no. 8 (April): 9-11.

"Remote Control." *Artforum* 28, no. 1 (September): 18-19.

"Remote Control." *Artforum* 28, no. 3 (November): 19-20.

1988

"Handsworth Songs." [Film review]. *Artforum* 27, no. 1 (September): 143-44.

"Mammame." [Film review]. *Artforum* 26, no. 8 (April): 145-46.

"Remote Control: Weather Reports on TV News Programs." *Artforum* 26, no. 7 (March): 13.

"The Passion of Remembrance." [Film review]. *Artforum* 27, no. 1 (September): 143.

1987

"Contempt and Adoration." *The Village Voice* (May 5).

"Dictation." *New Observations* 44: 10-11.

"Kim Ingraham." [Exhibition review]. *Artforum* 26, no. 2 (October); 133-34.

"Mar de Rosas." [Film review]. *Artforum* 25, no. 8 (April): 129-30.

"Not Nothing." *ZG*, 1982. Reprinted in *Discussions in Contemporary Culture*, Hal Foster, ed. New York: Dia Art Foundation; and Seattle: Bay Press, 1987.

"Superstar: The Karen Carpenter Story." [Film review]. *Artforum* 26, no. 4 (December): 107-8.

1986

"Dead People." [Film review]. *Artforum* 24, no. 6 (February):102.

"Great Balls of Fire!" *Parkett* 11: 111-24.

"Jews." [Film review]. *Artforum* 24, no. 6 (February 1986): 101-02.

"Remote Control." *Artforum* 24, no. 9 (May): 14.

"The Killing Floor." [Film review]. *Artforum* 24, no. 8. (April): 113.

"The Man Who Envied Women." [Film review]. *Artforum* 24, no. 10 (Summer): 124.

"True Stories." [Film review]. *Artforum* 25, no. 5 (December): 115.

"Zina." [Film review]. *Artforum* 25, no 2 (October): 133-34.

1985

"Centre Pages." *Block* 10: 32-33

"Collective for Living Cinema." [Exhibition review]. *Artforum* 23, no. 9 (May): 112.

"Committed." [Film review]. *Artforum* 23, no. 8 (April): 94-95.

"Death of a Dunbar Girl." [Film review]. *Artforum* 24, no. 1 (September): 124.

"Diary for My Children." [Film review]. *Artforum* 23, no. 6 (February): 63.

"Forty-Deuce." [Film review]. *Artforum* 23, no. 6 (February): 88-89

"Fury Is a Feeling Too." [Film review]. *Artforum* 23, no. 5 (January): 87.

"Insignificance." [Film review]. *Artforum* 24, no. 4 (December): 88-89.

"Je, tu, il, elle." [Film review]. *Artforum* 23, no. 8 (April): 95.

"Kids v. Us, or Viva Poland, or Laudable Odds and Ends." *Artforum* 23, no. 6 (February): 62-65.

"Our Marriage." [Film review]. *Artforum* 23, no. 10 (Summer): 106.

"Recoding Blackness: The Visual Rhetoric of Black Independent Film." [Exhibition review]. *Artforum* 24, no. 1 (September): 124-25.

"Remote Control." *Artforum* 24, no. 3 (November): 7.

"Stranger Than Paradise." [Film review]. *Artforum* 23, no. 8 (February): 62-63.

"Thriller." [Film review]. *Artforum* 23, no. 8 (April): 94.

"Tosca's Kiss." [Film review]. *Artforum* 24, no. 3 (November): 110-11.

TV Guides: A Collection of Thoughts About Television. New York: The Kulkapolitan Press.

"Virtual Play." [Exhibition review]. *Artforum* 23, no. 7 (March): 98-99.

1984

"American Pictures." [Film review]. *Artforum* 23, no. 3 (November):103-4.

"Cumulus...From America." *Parkett* 1: 81-84.

"Incorrect." *Effects* 2: 18.

"Portrait of Jason." [Film review]. *Artforum* 22, no. 10 (June): 93.

"The Business of Being An Artist." *Artforum* 23, no. 1 (September): 112-13.

"The Terence Davies Trilogy." [Film review]. *Artforum* 22, no. 10 (June): 93.

"The Ties That Bind." [Film review]. *Artforum* 23, no. 2 (October): 89.

"Zappa." [Film review]. *Artforum* 22, no. 10 (June): 93-94.

1983

"Science-Fiction." *New Observations* 17: 25-27.

"Sculpted in Marble Next to the Sparkling Pond." *Effects* 1 (Summer): 6.

1982

"Taking Pictures." *Screen* 23, no. 2 (July-August): 90-96.

1981

"Utopia: The Promise of Fashion When Time Stands Still." In *Just Another Asshole*, Barbara Ess and Glenn Branca, eds. New York: JAA, 1981.

"Work and Money." Statement for a panel at the School of Visual Arts, New York, 1981. First printed in *Appearance* 7 (Spring 1972): 30.

1980

"Devils with Red Dresses On." *Real Life Magazine* 4 (Summer): 24-25.

1979

"Game Show." *Real Life Magazine* 4 (October): 5.

"Irony/Passion." *Cover* 1, no. 1 (May 1979).

"The Trap Door." [Film review]. First published in *Ideolects: Film Journal of Collective for Independent Cinema* 9-10.

1977

"Four Poems." *Tracks* 3, no. 1-2 (Spring): 130-36.

"She Makes the Wrong Choices." *Tracks* 3, no. 2 (Spring): 137-40.

"She Makes the Wrong Choices." *Tracks* 3, no. 3 (Fall): 99-100.

1976

"She Makes the Wrong Choices." *Tracks* 2, no. 3 (Fall): 39-40.